MaRcEl DuChAmP

THE BACHELOR STRIPPED BARE

MFA P U B L I C A T I O N S

a division of the Museum of Fine Arts, Boston

MaRcEl

THE BACHELOR STRIPPED BARE

DuChAmP

a biography by

Alice Goldfarb Marquis

MFA PUBLICATIONS
a division of the Museum of Fine Arts, Boston
465 Huntington Avenue
Boston, Massachusetts 02115
www.mfa-publications.org

A substantially different version of this book was published by the Whitson Publishing Company in 1980 as *Marcel Duchamp: Eros, c'est la vie.*

For a complete listing of MFA Publications, please contact the publisher at the above address, or call 617 369 3438.

Because of space limitations, acknowledgments for copyrighted material begin on page 348.

Book design by Mark Polizzotti

ISBN 0-87846-644-4
Library of Congress Control Number: 2002104333

Available through D.A.P. / Distributed Art Publishers
155 Sixth Avenue, 2nd floor
New York, New York 10013
Tel.: 212 627 1999 · Fax: 212 627 9484

FIRST EDITION
Printed and bound in the United States of America.

CONTENTS

for a lifelong friend,

Hilde Cytryn

MaRcEl DuChAmP

THE BACHELOR STRIPPED BARE

W HEN MARCEL DUCHAMP DIED in 1968, the art world hardly considered him a central figure in the twentieth century. To be sure, a stubborn coterie of mostly American avant-garde enthusiasts revered him as a romantic hero exuding whiffs of an astringent perfume, a compound of Gallic wit, astute critical swordsmanship, and lean, long-limbed elegance. To some of his fans, Duchamp was a code word for a puzzling body of work that gleefully deviated from the modern works prized by collectors and enshrined in museums. Most, however, saw him as no more than a mystifying purveyor of puns and retailer of cheeky gestures, a persistent gadfly upon the checkered hide of the art establishment.

In his native France, Marcel Duchamp was barely known among art scholars and virtually unrepresented in museums. For a nation that resented being shouldered aside from the center of the art world by those brash, entrepreneurial Americans, a Frenchman who had adopted American citizenship in 1955 richly deserved obscurity. French mainstream culture shied away from an artist who regularly twitted the great modern ornaments of French art: the Impressionists and their heirs, and even the surpassing genius of the day, Picasso. A state still led by a towering war hero and champion of propriety, Charles de Gaulle, could hardly accept an artist who mocked art. Nor did the intelligentsia, dominated as it was by anti-American communist sympathizers,[1] waste much affection on a nonpolitical figure who had drifted into Paris only sporadically since fleeing to the United States in the early 1940s.

1 · WHY DUCHAMP?

In the United States at the time of Duchamp's death, the only place to see a cross section of his art was, as it is now, the Philadelphia Museum of Art. This massive classical temple to the visual arts devotes a spacious gallery to works donated by a single, indefatigable collector and by the artist himself. To the average visitor, the only familiar item continues to be the *Nude Descending a Staircase,* a painting that had scandalized some — and amused many — at the New York Armory Show in 1913. Duchamp's two other acknowledged masterpieces share the same gallery, but seldom engage the typical visitor. The *Large Glass* generally evokes some quizzical frowns, and perhaps a shrug over its formal name, *The Bride Stripped Bare by Her Bachelors, Even.* Considerably more challenging is the other masterpiece tucked away in a dark alcove. Some few gaze skeptically at the title, *Given: 1. the waterfall, 2. the illuminating gas,* but most visitors walk right by, completely unaware that the work itself lurks behind a massive, splintered wooden door across the room. Perhaps as the museum's sop to squeamish visitors, no sign, no arrow, nothing points to two tiny peepholes drilled in that door at eye level. Only the knowledgeable visitor will peer through those holes into a shocking diorama: a nude female body sprawled wantonly on a bed of twigs. This is Marcel Duchamp's last work, revealed only after his death.

Over the years, Duchamp had surfaced in the general press with relative frequency, usually as the "dada" of Dada, the artist who gave up painting in 1918, who abandoned art for chess in 1923; a sophisticated figure who was always good for a provocative statement or two, good copy to a news editor. The stories generated by these interviews usually portrayed a handsome, debonair fellow with an irresistible Gallic tone inflecting his speech. He lived simply, readers were repeatedly told; he was modest, exceedingly polite, witty, perfectly calm and composed, and seemed to subsist on almost nothing. From his first interview, in 1915, to the last, shortly before he died, Duchamp deplored not only the art currently being produced, but the very idea of taking art seriously. "As a religion," he volunteered in one much-quoted phrase, "art isn't even as good as God."[2]

Given Duchamp's diffident demeanor and his professed abdication from art so many decades ago, many of the art-loving readers of his obituary on the front page of the *New York Times* wondered how the paper could refer to him as "one of the most influential artists of the twentieth century."[3] But new styles of art had been moving in Duchamp's direction; artists and critics were revising the very idea of what constitutes art. The new vision would

propel Duchamp from the margin to the epicenter of postmodernist art. As style followed upon style — Pop, Op, Minimal, Conceptual, Happenings — Duchamp was identified as the inspiration for a horde of artists trying to make their mark in an overcrowded field. His art, his statements, and even his lifestyle engaged a significant party of historians, scholars, and critics of contemporary art. His example also seeped into music and dance, where John Cage and Merce Cunningham recognized debts to Duchamp's reliance on chance, and even into literature, as avant-garde writers attempted to repeal the laws of grammar.

The art market, always alert to profiting from a trend, responded to Duchamp's growing stature with stunning leaps in the prices of what few items by this notoriously unproductive artist came to market. Increased attention to Duchamp in the sale room has also spawned a band of artists whose work consists of "appropriation" of Duchampian motifs. One of them, Mike Bidlo, has drawn more than four thousand versions of what has become Duchamp's signature piece, a urinal he submitted to a 1917 New York art exhibition with the title *Fountain*. In exhibitions held simultaneously at prestigious galleries in New York and Zürich in 1998, Bidlo sold almost $100,000 worth of those drawings. Rocketing prices for replicas, editions, and even the most fleetingly ephemeral trace of Marcel Duchamp reached a pinnacle of absurdity with the sale of a 1964 replica of *Fountain* from an edition of eight, at Sotheby's in November 1999, for $1.7 million.[4]

Fanned by this lucrative market, the sum total of works attributed to Duchamp has escalated dramatically in the years since his death. His first biographer, Robert Lebel, stretched the Duchamp oeuvre to 207 works in his combined biography and catalogue, published in 1957. In 1969, a year after Duchamp's death, Arturo Schwarz's *Complete Works of Marcel Duchamp* listed 421 items. By 1997, the Duchamp *oeuvre* had posthumously achieved the first loaves-and-fishes miracle in two millennia: the revised and expanded *Complete Works* overflowed into two massive tomes listing 663 items.

Inside this increase lurks an irony typical of the many ironies surrounding Duchamp: even though his new catalog includes a multitude of replicas, re-creations, editions, and ephemera, an alert Duchamp scholar forced Schwarz to concede that he had omitted certain items.[5] Nevertheless, Schwarz's nearly one thousand pages document a life in which, it seems, nothing was ever discarded: no scribbled note, no graphic, no sketch, no trace of an idle thought, not even a few jottings about a lost bicycle lock.

Marcel Duchamp blossoms in these pages not so much as "the impresario of the avant-garde,"[6] as one critic put it, but rather as a thrifty French peasant, a man who quietly tucked into his mattress every scrap of paper on which he had scrawled a fleeting observation. While shuttling among an assortment of cramped domiciles in Europe and America, while eluding two world wars and repeatedly crossing the Atlantic, Duchamp obsessively conserved this baggage. When he needed money, he dipped into his virtual mattress, publishing precise copies of these notes in editions, sometimes of three hundred or more; he even left a few profitable scraps for his heirs to publish. Quite often, he re-created earlier works, or allowed others to make duplicates — which he also signed. When he fancied fame, he cheerfully scribbled his signature on editions in the hundreds, batches of replicas, and even the odd smudge of cigar ash on a paper napkin.

But despite such multiplication games Duchamp's total output remains meager; he was, as William Rubin wrote, "the only painter to have impressed the world of art as much by what he did not do as by what he did."[7] Picasso, for example, produced considerably more works before the age of twenty-six than Duchamp did in a lifetime. Few individuals in the crowds that squeeze into exhibitions of Picasso, or of Van Gogh, Monet, or Matisse have ever heard of Duchamp. Even today, most of the museum-going public is barely aware of him and would be startled to learn of his worldwide influence.

Marcel Duchamp's art, like tripe, is an acquired taste. His enduring impact on avant-garde art has emphasized the alienation between a small band of insiders producing densely academic, often arcane, texts and the masses that flock to blockbuster shows. Professors, critics, and museum curators have found Duchamp's cerebral gestures not only revealing but also grist for intellectual analysis, the common coin of academic work.

In sharp opposition to such gymnastics, Duchamp's biting visual humor often travels without any words at all. Scribbling a mustache and goatee onto a cheap print of the *Mona Lisa* speaks volumes about how we might regard the overblown icons of the past. Submitting a urinal to a dignified art exhibition reinforces the message: lighten up. And inscribing the handle of a snow shovel with a cryptic message, "In advance of the broken arm," suggests that everyday objects deserve our attention but not necessarily our reverence.

With such seemingly offhand, condensed gestures, Duchamp punctured the religion of art, which had spilled over from Victorian times into the early

twentieth century. For good or ill, the revolution Duchamp triggered was not one of visual appearances but of attitudes. While industriously recapitulating his work, he earned his reputation as the "In Art We Trust-Buster"[8] by pointing to the many entertaining, thought-provoking, and, yes, silly forms a work of art could take in our time: tinted photographs, visual puns, webs of string, the detritus of daily life rearranged in a slyly suggestive way. The power of Duchamp's suggestion does not derive from a body of work but instead radiates permissiveness: anything goes. Duchamp opened the door — even the museum door — to art featuring feces, urine, and other bodily fluids; to art based on junk recovered from the city dump; to art involving cadavers and maggots; and to art with aggressively sexual themes. Artists who display their own naked or provocatively clothed bodies may also point to Duchamp. In short, the avant-garde art of the late twentieth century flaunts impropriety, defiance, messiness, and snickering disdain for the vast majority of museum-goers.

As the Duchamp mode affected successive waves of artists, it was clearly not by his manner of wielding a brush or chisel, nor was it his particular talent in visually or verbally representing what he had in mind. Rather, his style was a way of presenting himself. In this endeavor, he succeeded so completely that many observers found his most important contribution to art to be his life. Indeed, several biographers and a herd of scholars have been overwhelmed by his cool elegance, his calm, enigmatic smile, and his quick intelligence. In Paris during the twenties and thirties, he seemed to be hovering always at the fringe of the current art sensation but never associated permanently with a group or style. In New York, he traveled through the fifties in a ghostly cloud, occasionally turning up at museum and gallery openings — and just as occasionally lobbing an aesthetic grenade.

When a spotlight of exceedingly narrow focus landed on Duchamp in the 1950s, a carefully crafted image emerged. Unlike the many artists who pranced into prominence during that era in paint-stained overalls and dripping creative juices, Duchamp arrived in neat corduroy trousers, benevolently, sardonically smiling. The quintessential outsider, he appeared to have drifted through several decades without producing any new works, though he was occasionally interviewed and willingly let himself be photographed. Nonetheless, the artistic tidbits he had casually scattered in the past were suddenly engaging a whole generation of young artists and art writers. One of those artists, Jasper Johns, admired Duchamp's distaste for the "stink of

artists' egos." Calvin Tomkins, whose admiration for Marcel Duchamp has flowed into a number of articles and books, describes how Duchamp "obliged" Johns by signing a collection of recreated notes, *The Green Box*, that Johns had bought as a tribute to Duchamp.[9]

In fact, Duchamp obliged virtually every interviewer who sought him out and sent each one away with a notebook larded with quotable morsels. He obligingly posed for a photo with Alfred Barr in 1943 when they served on an exhibition jury together. He had no qualms about obliging a *Time* magazine photographer by himself descending a staircase more than thirty years after the fact, and then repeating the performance for *Life* nearly ten years after that. He also obliged the organizer of his first important show in 1963 at the Pasadena Museum of Art by engaging in a much-photographed chess match with a naked young woman. In fact, Duchamp had been providing a multitude of admiring scribes with *le mot juste* ever since he obliged New York reporters in 1915 with such ingratiating remarks as: "The American woman is the most intelligent woman in the world today,"[10] and "New York itself is a work of art."[11]

As so often happens when tastes change, however, a variety of factors beyond Duchamp's wit and elegance converged late in his life to sweep him into the towering position he occupies in the avant-garde today. As in politics and society, the 1960s were a watershed in the art world. The professionals in museums and universities were the first cohort trained by the art historians who had been driven out of Europe by the Nazis. Scholars like Erwin Panofsky and Ernst Gombrich brought rigorous methodology to university art history departments that previously had leaned toward polite appreciation of the classics.

At the same time, New York's Museum of Modern Art

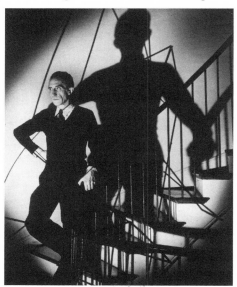

Duchamp descending a staircase for Time magazine, 1946

emerged as the central arbiter of contemporary taste. Since the museum's opening in 1929, its founding director, Alfred H. Barr, Jr., had forged a powerful schema for the development of modern art, welding the sometimes puzzling present onto the art movements, schools, and artists in the established past. As a subtext of his effort to link the shock of the new with the familiar tradition of the museums, Barr set up an expectation that today's avant-garde art would become tomorrow's classics.

The commercial world of art — galleries and auction houses — had also fed the collecting public's notion that a speculation in the outrageous art of today would become tomorrow's sound investment. So it had proved in Europe, especially in France, as wave after wave of avant-gardes — Fauves, Futurists, Cubists, Surrealists, Expressionists — moved from the needy fringe to the affluent center. In each case, they captured a piece of the marketplace by nudging aside (at least in part) the established art of the past.[12]

Following the Second World War, New York began to emerge as the world center for art, especially modern and avant-garde art. Dealers flocked to Madison Avenue and to Fifty-seventh Street, where arts and antiques were long established. But as the fifties came to a close, many dealers in contemporary art forsook such traditional neighborhoods and began settling in a raffish, low-rent downtown district of industrial lofts and abandoned warehouses. Located south of Houston Street in Manhattan, it soon acquired a name that could also be linked to London's bohemia — SoHo. Here, the uptown galleries that had promoted the Abstract Expressionists were humiliated by a new wave of radicals, both dealers and artists.

Soon, well-off suburban strollers could look forward to a Saturday of cultural entertainment, taking in the newest paintings and sculptures — and some as yet unnamed manifestations — in this new environment. In SoHo, Robert Rauschenberg's rumpled bed went on display, and so did Jasper Johns' targets and flags. They triggered an avalanche of everyday images: wall-size comic book illustrations, carpenter's tools draped across a paint-spattered canvas, a glass case filled with painted plaster pastries, a "soft toilet" stitched of white oilcloth. To persuade buyers, not to mention critics and museum folks, that this was not just nameless junk, a history and a philosophy had to be invented. And here, Duchamp proved to be the perfect antecedent. Leo Castelli was the dealer who shaped the aesthetic sensibilities of the sixties; when asked how he chose artists exhibited in his gallery, he replied with two words: "Marcel Duchamp."[13]

So Duchamp was relentlessly dragged from the wings to center stage, the dignified forerunner and historical validator of all this new, cheeky, aggressive stuff. Just as these artists and their dealers (and soon their patrons) argued, so had Duchamp declared that the mainstream art world was corrupt, that its established artists were repeating the same tired images. Furthermore, Duchamp had railed many a time against art bought and sold like so much spaghetti.[14] That he had abandoned painting and claimed to have created nothing substantial for decades was now considered a virtue; his apparent indifference and withdrawal from making any art at all was viewed as a noble gesture, a protest against the treatment of art as a commodity.

Duchamp's sometimes bitter mockery of the most successful artists now became a mantra. Hadn't he stated years ago that successful painters were in love with the stink of turpentine? Hadn't he repeated over and over his opposition to an art that appeals to the eye rather than the brain — what he called "retinal" art[15] — and his determination to "put painting, once again, at the service of the mind"? In the supermarket of artistic gestures that fascinated the sixties — that avalanche of Brillo boxes, soup cans, and Coke bottles — not many shoppers wondered about the weaknesses in Duchamp's assertions: Could any visual material fail to be retinal? How can any serious art fail to engage the mind?

Half a century earlier, Duchamp's rebellious gestures had liberated only a few artists and patrons from overblown nineteenth-century notions on the sanctity of art. But in the rebellious climate ushered in during the 1960s, such gestures became a license to dump a trash bin on the heads of the wider art-loving public. Duchampian excesses soured a large segment of this public on much of cutting-edge art. Grants of public money for such works became intensely controversial, and museum-sponsored exhibitions or performances often triggered a noisy free-for-all in the media, even in the courts. A substantial public agreed with Robert Hughes's assessment of the Duchampian model: "The hard thing to face is not that the emperor has no clothes; it is that beneath the raiment, there is no emperor."[16]

Though he hastened to take credit for some of the provocations perpetrated during his lifetime, no one can say how Duchamp would view some of the aesthetic stink bombs hurled by artists since his death. And if he were able to tell us from the Great Beyond, could we believe him? For Marcel Duchamp was one of the great tricksters of all time. While alive, he regularly contradicted himself in every imaginable way. Had he really given up

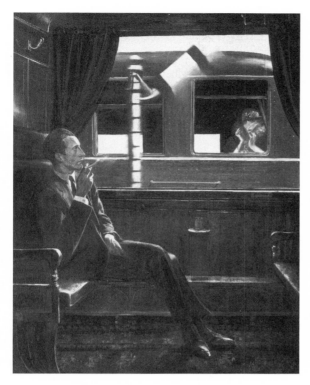

Mark Tansey, "The Enunciation," 1992

painting in 1918? Had he really stopped making art in 1923 and turned to playing chess? Was he telling the truth in 1961, when he told an interviewer, "I'm nothing else but an artist"?[17] Or was it when he told another interviewer a few years later, "I act like an artist but I'm not one."[18]

More than three decades after his death, Duchamp continues to tease and bedevil anyone interested in his career, his influence, or his real persona. No artist of any century, for example, has been able to enlist experts to expand his oeuvre posthumously by more than 50 percent. Nor has any artist of the past compelled the scholars who study his work to create what could well be called parodies of scholarly research. As the art critic Hilton Kramer tartly noted in 1995, much of the literature surrounding Duchamp "amounts to little more than pedantry in the service of uncritical adulation." The outcome may be the ultimate Duchampian irony, "a revolution of sensibility buried in a cemetery of scholarly footnotes."[19]

Nevertheless, the artist himself, stripped bare of elaborate scholarly apparatus, continues to tantalize, to challenge, to amuse, to trouble, and, yes, to irritate an increasing number of artists, teachers, and students. With all his contradictions, refusals, and illusions, he represents a figure who said "No" to mass civilization, who tried to subsist as an individual in the interstices of received ideas, who shaped his legacy with infinite sophistication, and who found inventive, hugely entertaining ways of reminding artists, as he told a group of them at London's Tate Gallery in 1966, to "beware of wet paint."[20]

Whether the twenty-first century will view Duchamp and his offspring so admiringly remains to be seen. As he and his acolytes pass into history, new media and new technologies may well trigger not only new kinds of art but also new venues for viewing it. Already, museums are rushing to digitize their collections, and artists are competing for the San Francisco Museum of Art's annual Webby Prize for Excellence in Online Art.[21]

Although Marcel Duchamp died only a few years before the desktop computer was born, he was aware early on of the intense pressure new media were exerting on traditional modes of expression. While dabbling in the possibilities of photography and film, he also perceived that the art masterpiece on the private wall or pedestal was receding into history. Such unique works of art, in forms that originated during the Renaissance, were arriving in the museum, a mausoleum for bygone arts; much-visited and much admired but a mausoleum nevertheless.

Like the influential artists of centuries past — Caravaggio, Rembrandt, Turner, Goya, Cézanne — Duchamp will take his place in art history according to the unfathomable tastes of future generations. But, despite the avalanche of scholarly dissections of Duchamp's oeuvre, precious little illuminates *why* he chose to perpetrate his various projects, and *how* brilliantly he rode the media merry-go-round of the twentieth century. The *why* is a matter of history intersecting with family, place, and personality. The *how* is a saga teased out of archives, interviews, and printed material. But the key to the Duchampian riddle remains the singular individual who tiptoed lightly through an altogether too serious world by never taking anything or anyone seriously, especially himself.

IN SUNSHINE, THE NORMAN LANDSCAPE sparkles magically, rich as the region's famous cream, crisp as its tasty apples. The shadows of the hedgerows draw dividing lines as precise as a surveyor's over the green quilt of tiny fields, the pattern spotted with cows or striped with rows of corn or blotched with trees and occasionally a patch of smooth, golden texture: fattening wheat. But it is the dappled shadows of clouds and their burden — frequent, sudden, and drenching rains — that uniquely color this landscape. The water eventually drains into innumerable rivers, streams, and rivulets, wandering northward toward the sea.

Historically, this crucial corner of France was forged by the Vikings. Beginning in the ninth century, bold and barbarian Norsemen terrorized the meanders of the Seine and every one of its tributaries deep enough to float their dragon-prowed boats. For a hundred years, they ravaged monasteries and settlements as far south as Paris and Chartres. If cornered, these wily heathen would cheerfully negotiate a truce and submit to baptism; some warriors boasted as many as twenty such "conversions." Seemingly pacified, they would retreat, only to reappear all too soon, garishly painted and as bloodthirsty as ever. Finally, in 911, a sensible French king names Charles the Simple ended their depredations — or at least channeled them in other directions — during a meeting at St. Clair-sur-Epte. No treaty was ever written, but the Viking chief solemnly placed his hands inside the king's hands to seal the agreement by which he became Rollon, the first duke of Normandy.

This was the dynamic stock that spawned generations of daring adventurers. If names mean anything, consider the unbroken line that leads from the son of Rollon, William Long Sword, through Richard the Fearless, Richard the Good, and Robert the Magnificent, straight to William the Conqueror.

Later, during the age of exploration, sailors and adventurers poured out of Normandy. Jean de Bethencourt of Caux was briefly king of the Canary Islands in 1402; Paulmier de Gonneville of Honfleur reached the Brazil coast in 1503. Another Honfleurais, Jean Delis, explored the mouth of the St. Lawrence River in 1506, while the sailors of Dieppe formed the crew of *La Dauphine*, the first European ship to reconnoiter New York Harbor, in 1524. Samuel Champlain, a native of Dieppe, founded Quebec in 1608 and was soon followed by four thousand Norman settlers; modern Quebec French is a variant of the old Norman dialect. Still today, the close ties of Normans with the New World are unique among Frenchmen.

Like the Norman weather, in which clouds can quench the sunshine in the space of fifteen minutes, so the Norman character enjoys sudden and extreme contrast. Joan of Arc was burned as a heretic in the marketplace at Rouen on May 30, 1431, and less than twenty years later, in the very same city, the move to rehabilitate her was launched. France's great classical painter, Nicholas Poussin, was a Norman, as was the great classical playwright Pierre Corneille. But Normandy also was the native province of the passionate assassin of Marat, Charlotte Corday, and of those modern pioneers of imaginative prose, Gustave Flaubert and Guy de Maupassant.

So many villages dot Normandy that there are not enough names for all of them: there is a Cauville in Calvados and another in Seine-Maritime; a Fresne-le-Plan in Seine-Maritime crowds a Fresne-Poret in Manche, while two Caudebecs jostle less than twenty-five miles apart in Seine-Maritime. So it is not unusual that there happen to be three Blainvilles spread among the six *départements* that comprise Normandy. And a foreigner must be sure to know whether she is heading for Blainville-sur-Orne, in Calvados; Blainville-sur-Mer, in Manche; or Blainville-Crevon, some ten miles outside Rouen.

The most notable village in the vicinity is Ry, the sturdy little market town that Gustave Flaubert, in disgust and bitterness, chose as the archetypical provincial setting for *Madame Bovary*. The pharmacy in which M. Homais inveighed against the *curé* is today a dry goods store; open on weekends is a Bovary Museum. From Ry, one drives three and a half meandering miles on

route D 12, paralleling the creek Crevon, the very stream along which, in the blind distress of dumb desire, Emma Bovary wandered toward Blainville.

This creek also divides Blainville. The village center sits on the flat floodplain at the crossing of routes D 7 and D 12. Sturdy houses of no striking architecture step up the bluff on the west side of the Crevon, and also on the east, toward a pile of stones and some recent archaeological trenches which are all that remains of the town's medieval chateau.

During the religious wars of the late 1580s, Christophe II d'Alègre gathered two hundred fighting men in this chateau. They regularly pillaged the countryside, ostensibly in support of Henry of Navarre, who was later to become Henry IV of France, but actually in search of revenues. In 1590, Christophe and his gang successfully besieged the chateau of Rouen. So outraged were the burghers of the city that the Rouen Parliament financed a retaliatory siege on the chateau at Blainville. It succeeded after four days; but the follow-up plan to destroy the fortress foundered because the necessary gunpowder was too expensive.[1]

The destruction of the Blainville chateau was finally accomplished two hundred years later, during the French Revolution of 1789. The chateau's contents were widely scattered; one of its fifteenth-century wood sculptures later came to rest in the collection of the Baltimore Museum of Art. As with many another ancient ruin, the chateau's site became the source of stones for new construction. Some of them went into the house where, on the 28th of July, 1887, at 2 P.M., Marcel Duchamp was born.

Though he was the fourth child, Marcel was the first in the family to be born in Blainville-Crevon; his parents had moved there from Cany-Barville, to the northwest, some three and a half years earlier. His oldest sibling was Gaston, born on July 31, 1875, almost ten months after the wedding of Lucie Nicolle and Eugène Duchamp on the previous November 5. The next oldest was Raymond, who was born on the parents' second wedding anniversary. In July of 1883, just five months before the family's move to Blainville-Crevon, the couple's first daughter, Jeanne, was born.

Marcel was conceived a month after his two oldest brothers, already twelve and eleven years old, went off to board at Lycée Corneille, the finest boarding school in Rouen. Left at home was Jeanne, a sickly girl who died of croup on December 29, 1886. In a sense, therefore, the new baby was a replacement for his mother of both her two oldest sons and her little daughter. The care of Marcel was divided between his mother, still grieving over

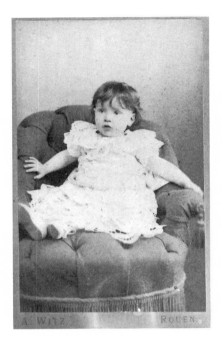

Duchamp in 1888

her dead girl-child, and Clémence, an ample country woman who worked as the family servant.

Almost a year after Marcel's birth, on July 7, 1888, the extended family gathered in Blainville-Crevon for his baptism as Henri Robert Marcel Duchamp. The abbé Jullien performed the ceremony in the stolid gray parish church. His father's brother, Mery, came from Paris, where he was a pharmacist, to be the godfather. The godmother was Julia Pillore, daughter of his maternal grandfather's second wife.[2]

Above the front door of the Duchamp house, not fifty feet north of the church, was the oval golden escutcheon which today still marks the office of every *notaire* in France: the rear two rooms on the ground floor housed the office of Duchamp's father. The profession of *notaire* has no equivalent in any other culture. *Notaires* are tax collectors as well as lawyers in the English sense of solicitors; they are civil servants as well as entrepreneurs. Like priests in a religious realm, *notaires* in civil life are "present at the origin and end of all things," says historian Theodore Zeldin. They draw up marriage contracts, deeds, wills, and trusts and serve as arbiters in business. For small savers, they provide advice and investment opportunities, usually in mortgages and state bonds yielding a safe 3½ to 5 percent. Zeldin estimates that in 1912, France's 8,164 *notaires* disposed of an investment capital of 748 million francs (about $136 million, more than six times the capital of the Crédit Foncier, France's largest land bank).[3]

Eugène Duchamp was typical of the "new men" who rose from humble beginnings to local, and even national, prominence during the nineteenth century. His professional and economic success was a living proof that at least one goal of the French Revolution a hundred years earlier — opening career prospects to talented individuals — had been attained. His parents

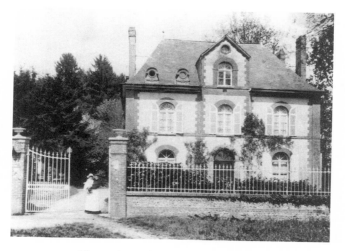

The Duchamp family home in Blainville

were thrifty petty bourgeois, owners of a cafe in Massiac, near Clermont-Ferrand. Eugène, who had been baptized Justin-Isidore at birth in 1848, was the youngest of their four sons, all of them consecrated by their ambitious parents to the professions. As a child, he was sent to study at the Petit Seminaire de Saint-Flour more than a hundred miles from home. At the age of twenty-two, he served in the Franco-Prussian War as a lieutenant in the Army of the Loire. Captured by the Germans, he was briefly held in Stettin, Pomerania, before taking up his first government post: assistant tax collector in Bresles, near Beauvais.

Upward mobility among French civil servants in the nineteenth century often also involved geographical mobility. Before settling in Blainville-Crevon, Duchamp *père* helped collect taxes in the towns of Fontainebleau, Damville, and Cany-Barville. To the post in Damville he brought his bride, Lucie Nicolle, whom he had married the same year his father died. Here, he clerked for a notary and his first two sons were born. But soon the family moved on again, this time to Cany-Barville, less than fifty miles from Lucie's birthplace, Rouen.

Lucie was the oldest daughter of Émile-Frédéric Nicolle, a Rouen shipping agent with strong artistic ambitions. She was only eleven when her mother died, and eighteen when she married thirty-year-old Eugène Duchamp. Her dowry paid for the notarial practice at Blainville-Crevon.[4]

Like many middle-class women, Lucie also sketched and painted, but it was her father's paintings and etchings that decorated her home.

Émile Nicolle had become a shipping agent in Rouen during the city's first great development as a port. A self-made man who benefited from Rouen's shipping boom, Nicolle was able to devote himself increasingly to his first love — fine art. At first he sketched and painted romantic views of Rouen, which were much in demand by the burghers of the dynamically industrializing town. Later, he began to specialize in graphics and on March 30, 1878, was admitted as an etcher to the Beaux-Arts section of the Universal Exposition in Paris.

By 1887, the year of Marcel's birth, Nicolle was considered one of Rouen's leading artists. While young Gaston and Raymond were absorbing Latin and Greek and geometry from the stern masters at the Lycée Corneille, they also experienced the sensuous delights of guiding the engraver's burin in their grandfather Nicolle's cluttered studio at 53 rue de Reims.

Even though Nicolle died in 1894, when Marcel was only seven years old, the grandfather's influence on him was deep and lasting. In 1949, Duchamp included a tribute to Nicolle, the only nineteenth-century figure among thirty-three brief sketches of modern artists' lives that he wrote for an art catalogue. Calling him "a passionate etcher," Duchamp recalled how "as children, we were surrounded by hundreds of his paintings on the walls of our home" and how strongly "this detail" affected "the atavistic and avocational careers" of four of his six grandchildren.[5]

In the lives of the two oldest Duchamp sons, Nicolle's artistic influence is directly traceable. Gaston, who was to become one of the foremost graphic artists of the twentieth century, learned the printmaker's craft from Nicolle; the second etching Gaston ever produced, in 1891, was a portrait of his grandfather. So was one of Raymond's earliest sculptures.[6]

Nicolle also influenced Marcel, but in a way far more subtle than simple technique. For one thing, Nicolle's career proved that one could become a successful artist on the basis of relatively few years' work and far from full-time devotion to the craft. For another, his graphics, issued in multiples and portfolios, must have indicated to the youngster that a work of art is not necessarily a unique object. Finally, Nicolle's influence on Marcel lay in the older man's paradoxical confrontation with technological progress. For while the march of technology had laid the foundation for Nicolle's fortune, allowing him the leisure for art, another branch of technology had robbed that art of

much of its magic. The catalogue of Nicolle's largest retrospective show, held in 1908 in Rouen, describes him as belonging to the school of nimble sketchers, "those quick observers with a supple, sure line that were spawned by the introduction of lithography and which the popularization of photographic processes is now destroying."[7] Issued in a limited edition of five hundred numbered copies, this catalog quickly became a rarity. Duchamp, at twenty-one, observed his grandfather's craftsmanship engulfed in a technological tide. This exhibition and its limited-edition catalog fed Duchamp's lifelong fascination with the paradox of the artist's role in a mechanized world, while also demonstrating the possibilities of limited editions.

As with most children, however, the primary influence on Duchamp came from his parents. From his earliest years, Duchamp had a chance to watch at first hand the kind of work his father did and the manner he brought to it. Eugène's office was on the ground floor of the family home. The years when Duchamp was growing up were also the years during which his father found his greatest professional and financial success. An ambitious, extroverted, and friendly man, Eugène Duchamp lost no time in taking up the leadership role in Blainville-Crevon to which his profession as *notaire* entitled him, as well as reaping its financial benefits.

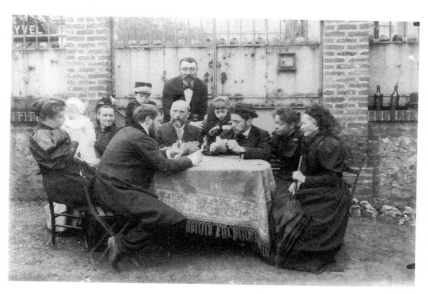

The Duchamp family in Blainville, 1896:
Marcel is fourth from left, in hat; Suzanne is at center.

The practice at Blainville-Crevon had been put on the market unexpectedly when its holder, François de Saint-Requier, died of a still-mysterious poisoning.[8] For Duchamp, it was a sound investment. In the 1880s, a practice like his could be bought for around 40,000 francs, an amount perhaps equivalent, in purchasing power, to $100,000 today. He could expect a comfortable annual income of 10,000 to 30,000 francs from fees, but his major source of income would derive from investments and real estate speculations.

Socially, in his role as "adviser and confessor to small people," the *notaire* ranked at the very summit of town and village society. Many were active in local politics, neatly blending self-interest with civic virtue in a pattern perhaps more jarring to cynical modern observers than to their nineteenth-century contemporaries. As a member of a municipal council or, better yet, as mayor, the *notaire* could, for example, initiate improvements to local roads or schools. This would benefit the public while also raising real estate values to his private gain. As recently as 1970, some two hundred *notaires* served, without pay, as mayors of small French towns.[9]

Having acquired the practice, Eugène Duchamp was soon deeply involved in the public life of Blainville-Crevon. In May 1884, less than six months after the family arrived in town, he was elected to the twelve-man municipal council and was immediately named secretary. Within a month, he was elected to the important budget committee. But when, on August 21, 1884, he tried to become vice-mayor, his name appeared on only one of the twelve white secret ballots.[10]

Duchamp's mother, Lucie — who had, after all, grown up in the bustling capital of Normandy — may well have regarded Blainville-Crevon as less than cosmopolitan, but at least it was closer to Rouen than the other posts where Eugène had served. There is some evidence that she yearned for life somewhere else. For one thing, the family did move to Rouen in 1905. For another, she chose to depict an urban setting when she occasionally painted street scenes of Strasbourg and Rouen. Some fifty of her watercolors were relegated to the basement of the Rouen Beaux-Arts Museum, deemed "totally uninteresting" by the museum's director in the 1970s, Olga Popovich. "She was forever painting the same scene of Strasbourg," Duchamp once told Popovich, with some contempt. Nevertheless, he hung onto his mother's paintings all his life. After Duchamp's death, his wife found them among his effects and, not knowing what to do with them, sent them to Rouen.[11]

Duchamp never concealed his dislike for his mother. While he described

his father as "kindly and indulgent,"[12] he recalled his mother as "distant and cold." According to Popovich, Duchamp "intensely disliked her," as did his older brothers and his sister Suzanne, who was born on October 20, 1889. To a friend, in 1957, Duchamp described his mother as "placid and indifferent." Resentfully, he recalled that she "never denied her preference" for the last two children in the family: Yvonne, born March 14, 1895, and Magdeleine, born July 22, 1898.[13] A year before he died, Duchamp told an interviewer that his mother "painted still lifes and wanted to cook them, too,"[14] characteristically turning a painful memory into a quip.

Lucie Duchamp may well have projected her grief over losing her daughter onto the next-born, Marcel. She herself had no brothers but, as the oldest in a motherless family, she had early experience in mothering her two much younger sisters. There is some evidence that she tried to turn the boy Marcel into a replacement for the little girl she had lost less than six months before his birth. Though it was not uncommon near the end of the nineteenth century for small boys to be dressed as girls, it is suggestive to contemplate the clothing in which Marcel was garbed for a portrait at the age of three: white Mary Janes, long white stockings knit in an elaborate clock pattern, and a lacy white dress tied with a long, stiff sash. His hair was long and girlishly curled, cut in bangs across the forehead.[15]

◆ ◆ ◆

From the perspective of today's travel speeds and instant communications, Blainville-Crevon seems like an idyllic place to raise a family. Indeed, what has kept the village viable into the present is the recent influx of suburbanite commuters who work in Rouen. But, as Flaubert sketched it so poignantly, existence in these villages in the nineteenth century could be stifling and provincial. By the time Marcel was born, the coach that bore Madame Bovary toward Rouen had given way to the train (leaving from the town of Morgny, twelve miles away), but the schedules were such that one still had to allow two days for the excursion.

Undoubtedly the flashiest public event in Blainville-Crevon during Marcel's infancy was the celebration of the hundredth anniversary of the French Revolution. The official celebration was on May 5, 1889, the day marked in every village and town in France in a manner designed, as the Chamber of Deputies' proclamation put it, to "engrave on the memory [of all participants] ... the efforts and energy of those who founded modern

society." According to a lavish volume printed at public expense later that year, the festivities at Blainville-Crevon followed a pattern similar to those of every other village and town in Normandy. The day dawned on the tricolor draping public buildings as well as the houses of all patriotic private citizens; salvos of artillery alternated with ringing church bells to wake the populace. In many villages, there followed an early morning distribution of bread to the poor, but Blainville-Crevon's indigent — perhaps there were not many — were treated to meat. At 2 P.M., the town's only tokens of military pomp, the men of the volunteer fire department, marched in review to the martial airs provided by the music society. At 4 P.M., the crowd assembled in front of the City Hall and heard an address by the vice-mayor on the origins of the Revolution and the benefits it had conferred on all citizens of France. At 6 P.M., the band was again pressed into service, this time for music at the *bal champêtre*, the traditional dancing in the streets. The big day ended at 8 P.M. with illumination of the hall and placement of a commemorative plaque. Citizens were invited also to illuminate their houses.[16]

Electric light did not reach Blainville-Crevon until 1895. That year the town purchased three primitive, glaring Bec Auer lamps for street lighting. One of them was installed on the rue de l'Église near the Duchamp house, an event that stayed with the eight-year-old Marcel for the rest of his life. In 1902, he made a charcoal sketch of a similar lamp, and a re-creation of it was a principal component of his last work of art, completed sixty-eight years later.

A few months after the street lights came, on November 7, 1895, Eugène Duchamp was elected mayor of Blainville-Crevon with seven out of eleven votes. His first official act, experienced politician that he had become, was to propose an eighty-franc appropriation from the welfare fund for purchase of a perpetual plot in the town cemetery for the recently deceased Mayor Ribard, whom he had replaced; it was unanimously approved. The following May, nominated for a full term as mayor, Duchamp won ten votes out of eleven.[17]

French law has never trusted local government; compared with Britain or America, the power of a French town council is indeed meager. The lifeblood of government — revenue — was strictly regulated on the national level. Laws promulgated in Paris likewise dictated rather minutely how local revenues were to be spent. In fact, one way of looking at the role of French municipal councils is to see them as genteel public works projects or status symbols for the rural elite, a convenient way of draining provincial

discontent into a pipeline of paper-work. All decisions of the municipal council, for example, had to be "imme-diately expedited," in writing, to the nearest subprefecture; the local deci-sions became effective only if the pre-fect, an appointee of the central gov-ernment, did not in the next thirty days "annul" them.[18]

French children were trained from an early age to accept this kind of tute-lage from above. In the one-room school at Blainville-Crevon, nine-year-old Marcel was drilled in the system, via a little book of "moral and civic instruction." Obviously modeled on the catechism of the Catholic Church, the

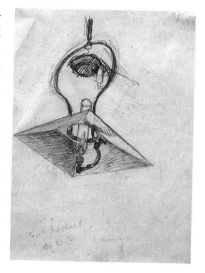

"Hanging Gas Lamp (Bec Auer)," 1903–4

book used a question-and-answer format to instruct children as to their duties toward parents, siblings, teachers and, finally, the state. To receive a primary school certificate, every student in France had to pass an examina-tion on its contents.

The unbroken chain of duties to superior authority began with the child's obligation to his parents of love, respect, obedience, and gratitude. "One must obey one's parents without discussing their orders," says the rule, "since one cannot acknowledge that they would order anything con-trary to our welfare or morality." Like parents, teachers were also entitled to unquestioning obedience and gratitude. The same kind of smarmy senti-ment also surrounded civic duties: "Must one pay taxes?" "One must pay taxes without a murmur." "Is it a duty to vote?" "Voting is a duty; we rely on it to see that taxes are not higher than necessary."[19]

It is amusing to imagine Marcel reciting these lines by heart in a chorus of young voices at the school, while in the adjoining City Hall, his father, as mayor, was dealing with the next level of this lock-step system. "Appointment of a secretary and other municipal employees is the right of the mayor alone," reads one manual of municipal government. "The munic-ipal council can vote only on the total payroll ... if [it] refuses, the prefect can write the sum in on the budget." A municipal council was to meet only

in regular sessions, unless authorized by the prefect. Nor could the councilors summarily refuse to consider a mayor's proposals; they had to give reasons for rejecting them. Municipal councils were to conduct the affairs of the commune, "like good fathers in a family."[20]

We can only try to picture the dinner table conversation in the Duchamp house during these years: the father naturally chafing at the limitations and caveats imposed by the prefect, or discussing the peculiarities and prejudices of the other councilors, or bemoaning the niggling requirements of laws written entirely in Paris. Such details may be speculations; we do know that, much later, Duchamp time and again brought calm and reason into artistic squabbles, often relying on humor to cool the contenders. We also know, from the minutes of the municipal council's deliberations, the texture and magnitude of Eugène Duchamp's work.

The municipal budget in the year Marcel was born, for example, amounted to 9,445 francs (about $2,000). The major item, more than one-third of the total, was for road improvements, but the budget also detailed such petty expenses as 25 francs for feeding the gendarmes and their horses on market days. A deficit was forbidden by law, so the budget also showed a surplus of 287 francs.

Judging by the minutes, Duchamp *père* was as activist a mayor as the multitudinous regulations would allow. In his first year, he persuaded the council to demand that the midday express train to Rouen make an extra stop near Blainville-Crevon. Also in the same year, he arranged for the Caisse d'Épargne, a bank for small savers, to open a branch in the village, and of course he served on the board of directors. By the following year, 1897, the town was readying a new girls' school, as well as inaugurating a public room for meetings, concerts, and parties.[21]

Writing about Marcel Duchamp's childhood, the French literary scholar Michel Sanouillet noted that his upbringing was hardly unusual. The father was a "good-natured and liberal patriarch," while strong emotional bonds united the six children and their parents. Sanouillet confessed he was puzzled by "something mysterious here — for never has so much steadiness and apparent happiness engendered such an upheaval in the emotional and intellectual character of two generations."[22]

Relationships within families are always extremely complicated, as psychiatrists are only too glad to remind us. Often, the least reliable testimony as to what those relationships really were comes from the family members

themselves. In the case of Marcel Duchamp, this stricture is particularly apt. He enjoyed spoofing all his life, and never more than when he was interviewed about his works, his intentions, or his family.

Part of Duchamp's flippancy sprang from his excellent sense of humor — a talent for smoothing social relationships cultivated by a successful politician and self-made man like his father. But humor is also a way of distancing oneself from an unpleasant reality, a refuge from pain within a cushioned and smiling absurdity. One is tempted to suggest that the mother whom he later called distant and cold, who seemed so distinctly to favor the two youngest children, was the first to elicit the son's own reflexive distance.

Not that young Duchamp was a hermit. Within the spacious stone and brick house in the shadow of the church at Blainville-Crevon, Marcel quite early developed an exceedingly warm attachment to his sister Suzanne. For six years these two were the only children living at home; they became inseparable playmates, "accomplices," as one observer put it.[23] Later, Suzanne expressed a dislike for her mother that she shared with her two oldest brothers and Marcel.[24] Decades afterward, many scholarly debates would circle around the close companionship between these two children.

Again and again these two, who were separated by less than two years in age, did appear together in photos and in the drawings of their oldest brother, Gaston. Here one sees Suzanne and Marcel marching for Franco-Prussian friendship, Marcel and Suzanne dancing, Marcel giving Suzanne a ride in a wheelbarrow. One drawing, published in *Le Courrier Français,* shows Suzanne holding up her doll for Marcel to sketch. The caption explains that he wants Suzanne to lift the doll's skirt and her scandalized reply: *"Oh! toute nue!"* Another, published in *Cocorico,* shows Marcel crouched on the ground, studying a glowworm while Suzanne warns him, in mock fright: "Look out! You'll burn yourself."[25]

For Gaston, his two much younger siblings provided handy models, and the drawings suggest the close relationship between Marcel and Suzanne. Seeing his brother's work in print must have impressed the ten-year-old Marcel greatly, even if they were comic cartoons sold for a few francs each. Three years earlier, Gaston, who had been sent to study law in Paris, had gradually abandoned the lecture hall in favor of sketching in the Cormon studio. Raymond, who was enrolled at the Paris Medical School, shared his apartment at 26 rue des Écoles, in the heart of the Latin Quarter.

In the fall of 1897, the same year Gaston's drawings first appeared in print,

Marcel took his first solitary steps out of the snug world of Blainville-Crevon. In October, he was sent to board in Rouen, while entering the sixth form at the Lycée Corneille. Henceforth, he would return to the village on the banks of the Crevon only on some weekends and during school vacations.

Duchamp was among the 729 boys, divided into six forms, who comprised the lycée's student body. Reading the anonymous reports of various headmasters through the nineteenth century, one gets a feeling of an iron lid of discipline barely containing a seething horde of inventive little barbarians. In 1899, for example, the headmaster recorded that "those students who abstain from communion no longer try to shame their better disposed comrades. This is important progress to which vigilant discipline has greatly contributed." The school's ideals lovingly reflected the aspirations of the nineteenth-century bourgeoisie, among them a pervasive competitiveness: a wide array of prizes for every imaginable achievement was awarded at a lengthy ceremony every July. The ultimate prize was admission to one of France's great professional schools, so that the whole curriculum was skewed toward this end. Nor did the masters hesitate to inject personal insult and coercion into their critiques of student work. One essay preserved in the lycée's files illustrates the prevailing tone. The assigned topic was "France: the Cradle of Love for Humanity." This particular young man had cleverly used examples of the school's patent inhumanity to question the topic's assumption. "This unpleasant elucidation is not acceptable," the master had scribbled on it in red, "and your incessant banter does nothing but make you ridiculous. Something like this would certainly get you an 'F' in your exam." The essay was preserved as the central exhibit in a file justifying that student's subsequent expulsion.

The school's classical curriculum and draconian methods were typical for its day. The Lycée Corneille prided itself on its ability to prepare students for a wide variety of successful careers. The headmaster in Duchamp's day boasted of specialized math instruction correlated with the exams for St. Cyr, the French West Point, as well as its comprehensive classical program designed to "give us a large contingent of admissions to the *grandes écoles*,"[26] France's equivalent of the Ivy League.

The rigorous and doctrinaire schooling dispensed by the lycées spawned an unintended current within French culture. This was the turbulent stream of rebelliousness and radicalism that could always look back to France's glorious revolutionary moment for justification. Amid the homilies in the

little book of "moral and civic instruction" was also printed, by vivid contrast, the "Declaration of the Rights of Man" with its ringing affirmation of human liberty. Reading in that little schoolbook Jules Michelet's account of the stirring events in the National Assembly on the night of August 4, 1789, when all aristocratic privileges and titles were abolished,[27] many a schoolboy must have compared that noble ideal with the narrow and authoritarian reality of the school around him.

This is the paradox, born of history, which is at the root of France's greatest achievements as well as its worst confusions. A revolution having once succeeded always leaves open the possibility of a repetition. Such an eventuality raised the most fervent hopes in some as it fanned the most desperate fears in others. Out of that jarring contrast grew France's innumerable political crises through the nineteenth and twentieth centuries.

In the arts, the effect was electric. All through the nineteenth century, one wave after another of *révolutionnaires* whetted its talents against the rock of a retrograde cultural establishment, always with enough success to encourage the next generation. By the turn of the century, radicalism in the arts had enjoyed enough triumphs to become, in itself, somewhat institutionalized, a trend that would swell throughout the twentieth century.

While Latin and Greek and geometry were mercilessly pounded into the heads of Marcel and his classmates, who were assumed to be resisting, many another world existed just outside the lycée's stout walls. Since he boarded elsewhere, Marcel could walk daily through the imposing portal, its architecture vaguely derived from the Hôtel des Invalides in Paris, pass beneath a monumental stone Pierre Corneille, and run out into the bustle of narrow streets in Rouen.

At the technological and commercial level, Rouen reveled in its progressive outlook. The population, which by the late nineteenth century had grown to more than 100,000, proudly pointed to a new bridge over the Seine, completed in 1886; Italian workmen had been brought in because, unlike French laborers, they were willing to breathe the "false air" pumped into the caissons beneath the Seine.[28] The imposing Beaux-Arts museum, its gray bulk looming over the formal flower beds, the beeches, and the oaks of a fenced park, formed a respectable cultural node along the town's widest boulevard, the rue Jeanne d'Arc. Housed in the same building, just two blocks from the Lycée Corneille, was the Rouen municipal library. Given the Duchamp family's lively interest in art and the model of the two older

brothers who were already artists in Paris, it seems persuasive that Marcel would visit both the museum and the library's rich display of ancient manuscripts, set out in glass cases around the walls.

While the cultivated public of Rouen enjoyed the reflection of its own refinement and good taste that the building provided, it also kept a sharp eye on expenditures for the museum's contents. From the beginning, some art lovers lamented the penuriousness of the trustees. "In an era when a Jules Breton painting sold for more than 100,000 francs [about $20,000], and the least drawing of Millet fetches 50,000," wrote one outraged art critic in 1886, "to grant a ... museum director 2,000 francs for the acquisition of several Rembrandts, not to mention a number of Teniers, is real nerve!"[29]

But worse, perhaps, than the miserly appropriations was the narrow, conservative taste of the trustees, reflected in the directors they hired. Judging by the museum's purchases during the first decade of the twentieth century, the lively art world of Paris could have been on the moon, rather than a scant seventy-seven miles away. Paintings there were to be had in profusion; the 1906 Paris Salon attracted more than three thousand entries, of which almost two thousand were admitted. But just the titles of the Rouen acquisitions from 1903 to 1907 tell a tale of provincial bourgeois taste rampant: *Lobster and Crayfish* by Bergeret, *Eve Recovering the Body of Abel* by Goulloux, *The Indiscretion* by Jolyet. These licked and varnished academic canvases were foisted off on Rouen by the French state, while local citizens righteously added *Mourning* by Boquet, *Roses and Lilies* by MacMonnies, and Lefèvre's portrait of M. d'Arthenay, a deputy from Calvados.[30]

As late as 1908, by which time the Impressionists were much sought after by Paris collectors — and already obsolete among the avant-garde — a Rouen critic was still heaping abuse on those aging revolutionaries. The Impressionists are "incomprehensible, a downright challenge thrown in the face of good sense," he spluttered. "If one received a transfusion of such blood, one would die."[31] Meanwhile the museum director, M. Minet, who had been born and educated in Rouen, serenely continued to collect works consonant with his own style of painting: flowers "charmingly colored," genre scenes "which have brought him great appreciation," and academic studies of the landscape around Pont de l'Arche.[32]

To any innovative young artist, such deep, provincial conservatism was not only galling but also, in its obtuseness, an encouragement to rebellion. The most promising setting for artistic no less than political revolution was obvi-

ously Paris. Duchamp's brother Gaston had given Rouen a chance. His very first drawings were published in a Rouen newspaper; in lieu of payment, he was given a pass to the funicular.[33]

By 1898, Gaston was scraping out a bare existence with his pen and burin in Montmartre under the pseudonym of Jacques Villon. All sorts of explanations have been offered for the name change, ranging from the obvious one that it was "in deference to his fond, but bourgeois notary father who preferred that there be no overt family connection with bohemian Montmartre"[34] to a possibility that he became fascinated with François Villon after seeing a comic opera based on the medieval poet's life.[35] Duchamp's comment on the name change, some seventy years later, was typically ambiguous: "There are periods when words lose their salt."[36]

Jacques Villon had already moved into a studio at the foot of Montmartre, bent on a career as an artist, when Raymond, in his last year of medical school, was stricken with rheumatism of the joints. While convalescing the following year, he, too, decided to quit school and devote his career to sculpture. Going only half as far as Gaston, he changed his name to Raymond Duchamp-Villon. Duchamp insisted all his life that his father had no objections to these drastic career and name changes; indeed, the old man financially supported his two eldest sons and, later, Marcel, until he died. For some time, in fact, Duchamp *père* went to Paris every month to settle Gaston's board bill at the restaurant of Mme. Coconnier, at the foot of rue Lepic.[37] And at least twice a year, the two older brothers would return to Blainville-Crevon, presenting dashing models of bearded and mustachioed urbanity. During one of these visits, Gaston taught Marcel how to play chess.

In the summer of 1898, Lucie, now forty-two years old, gave birth to the family's last child, Magdeleine. In the midst of the bustle over the new infant during that long vacation, Marcel and Suzanne drew closer, sometimes over the chessboard; they would see far less of each other after the vacation ended.

At school, Marcel was especially friendly with two fellow boarders at École Bossuet, Ferdinand Tribout and Raymond Dumouchel; another friend, Gustave Hervieu, was a day student. As Duchamp submitted to force-fed philosophy, history, rhetoric, math, science, English, German, Latin, and Greek in preparation for the second part of the baccalaureate exam, his brothers must have seemed like distant beacons of liberation.

There was an art teacher at the lycée, Philippe Zacharie, who taught drawing to all three Duchamp brothers; but for Marcel, the artistic model

was Villon, while Raymond offered a more intellectual standard. Many years later, Duchamp credited his two older brothers with giving him "eight years of swimming lessons." Villon's drawings, he said, profoundly influenced him: "I really admired his extraordinary manual facility."[38] Villon, in turn, tolerantly endured Marcel's rebelliousness. Many years later, he still described his younger brother as "the mischievous one" and said he "always found him very amusing."[39]

Villon had made his first print in 1891, a portrait of his father. His second print, made shortly thereafter, was a portrait of Grandfather Nicolle. After that, he gave up etching until 1899. Later, he would spend decades eking out a living by adapting the works of other artists to graphic reproductions. Not until he was in his seventies did Villon win recognition and a modest financial success.

To his father, the outgoing, drivingly ambitious politician, Jacques Villon presented a startling contrast. Where the father was a bluff and hearty public man, political platitudes tripping easily from his tongue, the son was retiring and modest. Where the father built up, over a period of less than twenty years, a fortune that was to sustain all six of his children for much of their lives, the oldest son had absolutely no head for money and, when he finally attained artistic success, abandoned most of the proceeds to a Paris gallery.[40] Where the father sired seven children and raised six into adulthood, none except Duchamp had any offspring.

The period from 1895 to 1905 comprised the crowning years of Eugène Duchamp's career. Financially, he built the resources that would enable him to retire at the age of fifty-seven and leave behind forever the petty provincial politics of Blainville-Crevon for the questionable cosmopolitanism of Rouen. As mayor of the village, he was undoubtedly its most potent political figure. The ink is fading on the records of those matters — Who would police the weekly market? How would the teacher of adult literacy classes be paid? Was the village priest entitled to repair the roof of the church? — to which Eugène Duchamp and his colleagues devoted themselves as they convened in the City Hall promptly at 10 A.M. on all those long-ago Saturday mornings. But the unruffled manner, the patience and persistence, and the detachment that Maître Duchamp brought to the affairs of Blainville-Crevon, would live on — partly in emulation and partly in parody — in the conduct and career of his third son.

◆ ◆ ◆

At the turn of the century, Blainville-Crevon was feeling the optimism, verging on smugness, which pervaded France and, indeed, all of Europe: *la belle époque* is the era's descriptive sobriquet. A great wave of construction of secondary rail lines now made the journey to Rouen an easy day's enterprise. Blainville-Crevon had separate schools for boys and girls, an annual fair, a thriving church that boasted fifteenth-century choir stalls. When Marcel Duchamp celebrated his second communion there, on May 29, 1898, he was among the four boys and five girls participating in the solemn ceremony, followed by a village procession.[41] No one suspected at the time that village life would not continue to flourish and progress, that Blainville-Crevon would not, every day in every way, become better and better. No one anticipated the social changes that later made Blainville-Crevon largely an administrative shadow, its substance erased by the great wars.

Within the Duchamp family, however, there must have been some disenchantment with Blainville-Crevon even while they were its leading citizens. All of his days, Duchamp resisted small-town life. He sought out the largest, most anonymous cities as places to live and even spent his summer vacations only in resorts like Cadaqués in Spain, which were filled with big city folk. He would never again live in a private house on a plot of land but only in apartments.

To a contemporary visitor, Blainville-Crevon's town plan reveals the architectural evidence of vast attitudinal and social change. The older houses huddle together close to the central square; they shelter each other from a nature seen as a hostile element to be conquered. If one needs to traverse unpaved streets, the muds of spring sucking at ankles and wagonwheels, the less distance to cover the better. The diamond-shaped central square of Blainville-Crevon is dominated by the *mairie*, the City Hall. With its strict symmetry and pedimental gestures, its architectural style echoes the grandiose monumentality of the great Parisian public buildings in decently parsimonious, almost parodic, fashion, much as the nineteenth-century French bourgeoisie adapted its model of an ideal style of living from the aristocracy. Some 150 yards north of the square stands the parish church, its seemly distance from the town center summarizing France's endless agonies over separation of church and state.

The front of the house in which Marcel Duchamp was born faces the north flank of the church. Adjoining it to the east is an open meadow that drops like a velvety green carpet down into a swale where the Crevon mean-

ders. On the far side of the river, a wooded rise reaches toward the ruins of the chateau from which Christophe II d'Alègre and his ruffians galloped forth. All this land, reaching northward to three parallel rows of precisely planted beeches, still belongs with the house.

In the garden behind this house, nine-year-old Marcel posed for a photo in his sailor suit as he gave Suzanne a ride in a wheelbarrow. On the trunk of one of the beeches in this park, fourteen-year-old Marcel deeply gouged his name and the day: 19 April 1901. Inside the house, the fifteen-year-old Marcel posed Suzanne on a red armchair for his first surviving work of art, a watercolor dated May 1902.[42] Just a few weeks before Marcel painted this watercolor, his twenty-six-year-old brother Raymond had received his first major recognition as a sculptor: one of his works was accepted for the Salon of the National Fine Arts Society and exhibited in Paris.

Home in Blainville-Crevon during the summer vacation, Marcel devoted himself to sketching and painting. One watercolor shows his grandmother Duchamp, who had joined the family in her old age, and, on the back of it, a quick ink sketch of his little sister Yvonne. The remaining five sketches are all of Suzanne — *Suzanne Duchamp*, gravely eyeing us from behind a chair; *Suzanne Duchamp Washing Her Hair*, a monotype in colored ink; *Suzanne Duchamp Adjusting a Roller Skate*, a wash drawing; *Suzanne Duchamp Skating*, a watercolor and India ink; and *Suzanne Duchamp Seated*, with her back to us, in a watercolor and Conté pencil sketch. Marcel gave Suzanne all five of these sketches; four of them were still in her collection when she died more than sixty years later.

These works show that, like many a fledgling artist, Duchamp avoided the difficult details: he draws hands, if at all, more like paws; in depicting faces, he wavers between the amateur's typical extremes, either insisting on rendering every hair or attempting the bravado of vague and shadowy suggestion that finally reveals nothing but a striving for style. He tries out pencil, ink, watercolor, monotype, Conté, and wash, in the understandable hope that somewhere there exists a medium that will do justice to what he wishes to express. He also seems to be searching for an artistic identity with a variety of playful signatures; some of these early works are signed with elaborately contrived monograms, and others not signed at all.

Three of Duchamp's paintings of that summer — his first oils — also survive. The very first was apparently *Landscape at Blainville*, a mostly green rendering of the beech trees on the banks of the Crevon, reflected in

a pool of the river, and a rude wooden bridge over the stream. In Paris, its Impressionist style would have been seen as old-fashioned, certainly by the avant-garde painters who were his brothers' friends. In Rouen, as we have

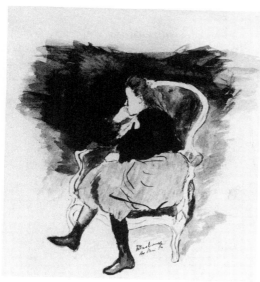

"Suzanne Duchamp Seated in a Red Armchair," *1902*

seen, this same style would be denounced as impossibly shocking. In Blainville-Crevon, one suspects, the very idea of anyone painting anything at all would have been remarkable; the fifteen-year-old Duchamp boy's choice of a summer pastime would be, perhaps to his secret delight, a choice morsel of gossip.

Duchamp's second canvas of that summer was a blue and shadow-riven view from his upstairs window, *Church at Blainville*. Again, like many a beginning painter, Duchamp shrewdly obscured the difficult passages in scumbled shadow and tried to cloak the uncertain rendering of perspective with flashes of bravura brushstrokes. The church building, with its massive buttresses and flamboyantly sculptured window openings, appears like a flat cutout, the roof separated from the sky only by a decidedly wobbly line. Equally flat is the tree at the left, its color undifferentiated by light and shadow, and its leafy bulk reduced to monochrome green and conventionalized brush-dabs.

The third painting is again mostly green, the paint this time richly daubed in the manner of Van Gogh to form an interesting composition. The subject was again right near home, *Garden and Chapel at Blainville*. The subject and style were strikingly similar to sketches and an aquatint done by Jacques Villon during this same period.[43]

Back at the Lycée Corneille that fall, Marcel was swept up in the cramming that precedes the important baccalaureate exams. These are the nationwide tests that are supposed to measure not only the scholarship of

individuals, but also the quality of instruction of every lycée in France. In the 1902—1903 academic year, the results of the *bachot* clearly indicate the conservative orientation of Duchamp's school. Both applicants to the French military academy at St. Cyr were admitted, and twenty-three of the thirty-three students who took the first part of the exams on the classics side were passed; but of the twenty-two who took the first part on the modern side — living languages and science — only eight passed. Of those who took the second part, twenty-two out of twenty-seven who chose philosophy passed, but only two of the five who chose math.

Some interesting clues to the spirit of the age are in the keynote speech given at the prize ceremony and graduation at the Lycée Corneille that year. The speaker was Emile-Auguste Chartier, the school's youthful philosophy professor, whose liberal articles under the name of Alain influenced such writers as Roger Martin du Gard and Georges Bernanos. (He went on to a distinguished career at Paris's Lycée Henri-IV, where bright young boys trained for the elite École Normale Supérieure.) To the assembled students and parents at Lycée Corneille, Chartier described his views on the relationship between mathematics and philosophy. Reflections on "the problems of pure geometry," he said, "have revealed to you your real power and the true sources of pleasure." Having learned that "clarity and order are to the spirit what fresh air is to the body," the students had been led, by mathematics, "on your first steps, harmonious and steady, on the road to wisdom." To succeed in life, however, required not only proper studies, but also proper attitudes. In his peroration, Professor Chartier gave the example of Archimedes, who studied conic sections, even though he did not expect to become a great discoverer. He did not expect to find "a unique route, my friends — and that's why he found it."[44] In other words, to be a great discoverer, one must expect nothing; only then might one discover something worthwhile.

To Marcel, sitting among those who had passed the first part of their *bachot*, the professor's words must have seemed exceedingly personal. The coveted medal of excellence given by the Rouen Friends of Art went to someone else that day, while Duchamp received only a paper certificate for drawing.

◆ ◆ ◆

If Duchamp applied himself to art during this period, few of his works survive, nor did he ever mention other works of this period that were lost. Of

the six known pieces from the year 1903, Suzanne is the subject of two: *Suzanne Duchamp Looking at a Painting* and *Suzanne Duchamp Seated*. However, she was the recipient of at least five of them, and possibly the sixth as well.[45] They included no oils, but were done in India ink, watercolor, Conté pencil, colored pencil, and lead pencil. One sketch was of Robert Pinchon, the winner of the Friends of Art medal.

In the summer of 1903, sixteen-year-old Marcel went off on his first trip alone, a two-week meander to the Norman coast, to the island of Jersey and to the spectacular fortress-church of Mont St. Michel. Back in Blainville, he wrote dutifully to his friend Tribout, "I am glad to return because a trip like this is exhausting."[46] He arrived home in the midst of preparations for the wedding of Raymond, which took place on September 9. The bride was a young widow named Yvonne Reverchon, the daughter of a doctor and the sister of Jacques Bon, a young artist studying with a well-known portraitist, Antonio de la Gandara. To distinguish her from Duchamp's eight-year-old sister, she was called "Big Yvonne."[47] The couple set up fashionable house-keeping in Neuilly, which was even then an elegant suburb of Paris.

To Duchamp, Raymond was to remain a lifelong hero. Even many decades later, he described Raymond as "the genius of the family" and felt that he would "always be in his shadow."[48] Sixty years later, looking over the old sketches Raymond had done at the age of eighteen, Duchamp still marveled at them.[49]

Despite his small oeuvre, Raymond Duchamp-Villon is today considered one of the pioneers of modern sculpture. By the turn of the century, sculpture had become "structurally weak," writes his biographer, George Heard Hamilton, because it was "dependent on the innovations of painting." Duchamp-Villon's goal was to "reassert for sculpture the autonomy and robust power it had traditionally enjoyed." His achievement, during a career of less than twenty years, was to "remove sculpture from the realm of modeled bibelots to the architectural."[50] Raymond's innovations in sculpture were rooted in the medical training he had abandoned in 1898. While an intern at the Salpêtrière in Paris, he had worked with Dr. Albert Londe, director of the Photographic and Radiographic Division and inventor of a camera that could capture, on one sheet of film, nine to twelve consecutive movements in space.[51] This was the origin of his fascination with depicting movement.

From his first crude attempts to depict figures in motion, Duchamp-Villon went on to develop more complex and intellectual notions of move-

ment, most notably in the *Great Horse* of 1913. In this sculpture, Duchamp-Villon condensed several sophisticated concepts of movement: first, the snorting and steaming jog of the individual horse; second, the horse as an archetype of all horses; and finally — and most subtly — the live animal transforming itself, as one walks around the sculpture, into a symbol of mechanical force, horsepower. Long after his brother's death, Duchamp saw to it that Raymond's plaster study was cast in bronze; several examples were sold to museums and one was bought, by public subscription, during the 1960s for the city of Rouen.[52]

As his sculpture indicates, Raymond possessed remarkable intellectual detachment. His head of Baudelaire, completed in 1911, surgically strips the poet of all extraneous humanity, down to the broad, bald cranium and the eyes closed in calm contemplation. Several years later, in a letter from the war front, where he served as a medical aide, there was neither mud nor blood, only his admiration for "the grandiose beauty of the battle lines."[53]

Marcel was still a schoolboy while his older brother was beginning to make a name for himself in the Paris art world. Yet the teenager's fantasies could wander to Paris, to a glamorous bohemian bachelorhood, to the animated discussions of art that his brothers described, to a rakishly impecunious existence, always cushioned by reliable remittances from home. Though less than a hundred miles away, Paris was a milieu at the opposite pole from Blainville-Crevon. Even the thought of moving to Rouen, of which there was talk in the family, would appear pale and provincial by comparison with Paris.

In the summer of 1904, Duchamp passed the second part of his *bachot*. To his son's plan for joining his brothers in Paris, Duchamp *père* had "no objection," Duchamp later said. He "was used to dealing with these questions" so "there was no difficulty."[54] The

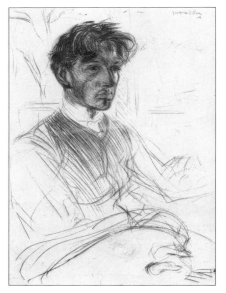

Duchamp by Jacques Villon, 1904

romanticized stereotype of an artist's life often includes the rabid opposition of parents to the choice of such a precarious career. But in fact, a surprising number of nineteenth-century bourgeois parents — such as those of Max Ernst, Hans Arp, Paul Klee, and Albert Gleizes — encouraged their children to become artists.[55] Often, the parents saw their children's artistic strivings as a reflection of their own cultivation and took pride in the fact that the family was wealthy enough to supply financial support. This was probably the attitude of Duchamp *père*, especially since Duchamp had received the Friends of Art medal at the end of this school year.

The graduation speech that year, given by a history professor named Debidour, must have been food for thought. The way of science, he said, "is the new road ... on which you will travel tomorrow, unifying in one religion the love of science and the love of liberty."[56] Duchamp would take this advice to heart but in ways that would shock not only Blainville-Crevon and Rouen, but also Paris and New York.

Duchamp in Munich, 1912

"**W**HEN I WAS SIXTEEN," Duchamp recalled some sixty years later, "I thought for about six months that I'd like to be a notary like my father. But that was just because I loved my father. There was all this drawing and painting and sculpting going on around me."[1] The example of his two older brothers before him, Duchamp hesitated far less than they did in choosing a career.

In October 1904, following his graduation and a vacation with his grandmother Catherine Duchamp at Massiac, Marcel was aboard the Rouen-Paris express, a lanky seventeen-year-old with a sketchbook in his pocket. Unlike Gaston, whose struggles to pursue his own artistic fantasies may be reflected in his choice of a new name; unlike Raymond, who also changed his name when he became an artist, Marcel set out for Paris unambiguously in possession of his baptismal tag. His destination was the apartment at 71 rue Caulaincourt in Montmartre, where Gaston, now Jacques Villon, had been established for some six years.

Montmartre was not the Paris fantasized by Madame Bovary in the mid-nineteenth century as she dreamed and schemed her days away in Ry. Nor was it the Paris immortalized by Edgar Degas, whose banking family had oriented him to the ballet and the racetrack. The chief virtue of Montmartre around the turn of the century, and its source of attraction to throngs of impecunious artists and writers, was that existence there was inordinately cheap. A resourceful artist could keep body and soul together on 125 francs per month, less than the sum a skilled Parisian laborer could earn working a six-day week.[2]

Though living was cheap, many of Duchamp's contemporaries abandoned their youthful ambitions fairly quickly. Either they had no money at all — and unsympathetic parents — or they were crushed in a turbulent artistic throng of varying tenacity and talent. Still, many others persisted.

Besides those who became rich and famous, like Georges Braque, Juan Gris, and Fernand Léger, hundreds of lesser known artists painted on for years, always hoping to be discovered. Typical were two occupants of the same building as the Duchamps: Louis Marcous (known as Marcoussis), a Pole who achieved moderate success only in the 1930s, and Frank Kupka, a Czech who was to exert a profound influence on Duchamp and who received his own modest recognition only after his death in 1957.[3] Jacques Villon himself was to create a lifetime's worth of fine paintings and graphics while subsisting as a hack engraver: forty years would pass before he could rely on fine art alone for his livelihood.

By the time Duchamp joined him in Paris, Villon was marginally supplementing his father's small stipend by selling stylish topical drawings to popular periodicals like *Le Charivari*, *Le Courrier français*, and *Le Rire*, as well as occasional cartoons with a gentle political bite to the anarchist-oriented *l'Assiette au Beurre*. Today, these drawings emit the nostalgic aura of illustrations for a Colette novel.

Meanwhile, perhaps to placate his father, who was sending him as well as his brothers a small monthly handout, Duchamp enrolled at the Académie Julian, a long-established art school with studios at four different locations. Its most famous teacher was Adolphe William Bouguereau, a painter of pseudo-Renaissance nudes and religious scenes of such cloying academicism that Renoir, on testing a new pair of glasses to correct myopia, reputedly exclaimed, "My God! I see like Bouguereau!"[4] Ironically, Bouguereau's old-fashioned instruction produced a host of revolutionary (perhaps rebellious) alumni, including Henri Matisse, André Derain, Albert Gleizes, and Fernand Léger.

By his own account, Duchamp's attendance at the Académie was desultory; he preferred to play billiards in a café across the street.[5] More than with the troublesome and often dispiriting reality of paint pots and turpentine, he was in love with the notion of being an artist. "Like every boy of eighteen," he once told an interviewer, "I wanted to be a painter."[6] A sketchbook, he later recalled, "was a constant companion in those days — everyone had them and brought them out on any occasion." In the "ardent drawing" of

this period, as Duchamp himself pointed out later, he was merely emulating Villon, the big brother already successful in the art trade.[7] In his painting, too, the younger brother was proud to draw on Villon's expertise. A subsequent owner of Duchamp's 1904 *Garden and Chapel at Blainville* pointed to its "striking color and composition parallels" with Villon's contemporary colored lithograph and aquatint, *Woman with a Pink Umbrella*. "Even the foliage on the right had the same glimmering softness that was found in Marcel's painting."[8]

At that time, Duchamp was simply following the centuries-long tradition of trying out various other artists' styles on the way to developing his own. To paint like Villon was just another phase in his education, much as he was later to paint like the Impressionists, Cézanne, or Gauguin. However, in his life goals Marcel did not ape his brother Gaston, or at least so he decided in looking back much later. Villon "aimed at fame," Duchamp told an interviewer in 1963. "I had no aim. I just wanted to be left alone to do what I liked."[9]

If he ever had such a simple ambition, it was soon thwarted. In April 1905, Duchamp sat for the exam to enter the École des Beaux-Arts. Despite the ridicule of at least two generations of avant-garde painters, this was still the most prestigious art school in the world. The year Duchamp took the exam, more than four hundred aspirants submitted drawings of nudes, perspectives, and classical plaster casts to a four-man jury headed by the ubiquitous Bouguereau. Duchamp's charcoal drawing of a nude was rejected.

At almost the same time, a new conscription law went into effect, requiring all young men to spend two years in military service. Only doctors, lawyers, and a few other occupations could still train for just one year. Among these favored categories were "art workers." Eager to minimize his time in the army, Duchamp speedily hied himself back to Rouen and an apprenticeship at the Vicomté Press. He learned the rudiments of typesetting and press work and also practiced the separate art of printing graphics, using his grandfather Nicolle's copper plates. Within a few months, he was able to impress a panel of printers and print shop owners with his skill at pulling a creditable print of an etching; each member of the panel received a proof as a gift. He also took an oral examination on the work of Leonardo da Vinci and, once the panel got over its surprise that a holder of a liberal arts baccalaureate and son of a *notaire* aspired to dirty his hands with ink, he passed.[10]

On October 3, 1905, Duchamp volunteered, if that is the correct word, for a year's military service with the 39th Infantry Regiment at Rouen. The following April, he was promoted to corporal, and in October he was discharged at the Drouet barracks at Eu and immediately returned to his old haunts in Montmartre, this time to a solitary apartment at 65 rue Caulaincourt.[11]

While his two brothers and Kupka had meanwhile moved to a complex of villas with adjoining studios at 7 rue Lemaître in suburban Puteaux, a steady stream of other young artists poured into Montmartre. Some stayed, like Jules Pascin, Maurice Utrillo, and Juan Gris; others paid extended visits. It was a cosmopolitan lot, including the Russians Alexei von Jawlensky, Wassily Kandinsky, and Kasimir Malevich; the Germans August Macke, Franz Marc, Paula Modersohn-Becker, and Emil Nolde; and from Italy Giorgio de Chirico, Gino Severini, Umberto Boccioni, and the whole provocative young tribe who later were called Futurists. Diego Rivera came from Mexico and Konstantin Brancusi from Romania. In fact, a visit to Paris, if not an extended stay there, is probably the one common denominator uniting every significant school or movement in art in the first half of the twentieth century.

Americans in particular flocked to Paris during those years, including such conservatives as Gutzon Borglum and Robert Henri; the Impressionist William Glackens; the monumental sculptor Jacob Epstein; the Cubist Max Weber; the watercolorist John Marin; the abstractionist Stanton Macdonald-Wright; and the Magic Realist Edward Hopper. Americans who stayed home occasionally received word of the strange images coming to life in the garrets of Paris. Reporting on the 1910 Salon des Indépendants for *Architectural Record*, Gelett Burgess described the newer works as "what a particularly sanguinary little girl of eight, crazed with gin, would do to a whitewashed wall ... there were no limits to the audacity or the ugliness of the canvases."[12] The striking fact about the Paris art world during those first fourteen years of the twentieth century is not that it harbored and nourished so many versions of the avant-garde, but that it included such an incredibly rich smorgasbord of all flavors of art, from the most backward-looking and naive to the most sophisticated and iconoclastic.

Just as the victorious side tends to write the history of wars, so the triumphant innovators tend to dominate the history of art. However, in the year 1906, when Marcel Duchamp settled into his studio on rue Caulaincourt,

none of the artists who are seen today as the dominant figures of that period were well known. Instead, the most powerful figure in the art establishment was the traditionalist Albert Besnard, a member of the Académie française, the director of the Beaux-Arts school and its branch in Rome, the Villa Medici, and a recipient of the Legion of Honor. (His funeral, in 1934, was the first ever to be held in the courtyard of the Louvre; Georges Braque's was the second, some thirty years later.) Close to Besnard in his academic painting style and influence was Jacques-Émile Blanche. He was the son of a famous doctor and a friend of Claude Debussy, Marcel Proust, and Henri Bergson. On Sundays, he held open house for the Paris elite; visits to London clubs had provided him with a striking pose — *le snob.*

The growing band of collectors, however, were increasingly drawn to the Impressionists. Auguste Renoir was still alive and productive. Though partially paralyzed in 1912, he would show forty-two new paintings at the Bernheim Gallery in 1913. (He died in 1919.) In 1909, Claude Monet successfully showed forty-eight studies for *Nymphéas* at Durand-Ruel. He was to live on and paint, despite progressive blindness, until 1926. Before Edgar Degas died in 1917, he saw his *Dancers at the Barre* become the most costly contemporary painting, when it fetched 430,000 francs (more than $78,000) in 1910. The Nabis, an offshoot of Impressionism, also were coming into their own. Pierre Bonnard eventually became the conservative Jacques-Émile Blanche's favorite painter. Bonnard and Edouard Vuillard, who styled himself an "Impressionist of the Shadows," were commissioned in 1913 to decorate the prestigious Théâtre des Champs-Elysées.[13]

The sudden success of these "modern" artists had stunned even professionals. In the early 1890s, the dealer Ambroise Vollard had bought a Degas monotype, "fished out of a box on the quays," for ten francs.[14] In 1895, he recalled, Edouard Manet's *Woman on a Sofa* was sold for less than 1,500 francs ($273), while Manet's portrait of Zacharie Astruc, priced at under 2,000 francs, found no buyers. Vollard tried to sell Renoir's *Femme Nue* for 400 francs, unsuccessfully. In 1897, Vollard offered a group of Van Goghs for 500 francs each, but again found no takers. That same year, he bought five paintings by Paul Cézanne, at 900 francs for the lot. Some fifteen years later, these same works had made Vollard rich and famous.[15]

The success of the Impressionists was a reference point for the Duchamp brothers and for the hundreds of artists struggling for recognition after the turn of the twentieth century. Though he tried a few times to emulate their

techniques, Duchamp would later see them as models of all that was wrong with visual art, its appeal to the eye rather than to the brain.

In fact, it was not a particular style of painting that was at fault. Rather, Duchamp, his brothers, and their multitudinous colleagues were caught up in a profound change in the way art was being appreciated, displayed, and marketed. In a relatively few years before the end of the nineteenth century, the art world began to undergo a stylistic upheaval that is still hotly debated and an economic restructuring still barely understood.[16] As dealers like Vollard and Paul Durand-Ruel successfully developed an eager public for Impressionism and Postimpressionism, they set off competitive waves of other "isms," that hoped to be recognized as the next collectable style. All sought to claim their "inevitable place in history."[17] In order to sell a new style to a new class of collectors, dealers had to offer it as something "modern," something that was inescapable, dictated by the historic evolution of art. This notion of permanent revolution in artistic styles profoundly affected the attitudes of subsequent generations, not only of artists, but of many other inhabitants of the art world as well. Critics learned that it might be dangerous to espouse absolute standards — or any standards at all; that ridiculing a new movement could, in surprisingly short order, make *them* look ridiculous. Collectors learned that a clever buy of works by an unknown could be a rewarding speculation. And the artists? Their personal drives and talents aside, the artists learned that sheer novelty — shock value — had become a powerful ingredient of success.

By 1906, then, Duchamp and his young contemporaries could look back on a series of newer art movements that had speedily vaulted from derision (and poverty) to admiration (and wealth). That cycle had, indeed, turned often enough that an acute observer might conclude that the artist's road to success unavoidably wound through an initial chorus of catcalls. It was only a small step from this conclusion to the belief that artists who were denounced and ridiculed, as for example Van Gogh and Gauguin had been, carried an especially meaningful, lucrative message.

As recently as 1905, the cycle had spun right before their eyes. At that Salon d'Automne, a group of painters had exhibited a mass of flat, riotously colored canvases. A critic thought to dismiss them by calling them *fauves* (wild beasts), but already the canvases of Henri Matisse and the other wild ones were catching the eye of art insiders. One thing was new: where the art scandals of the nineteenth century had been provoked largely by the artists'

choice of subject matter, this new scandal was triggered mainly by the artists' deliberately primitive technique. Though Duchamp and his colleagues were unaware of it, the artist's primary subject in the twentieth century would be art itself.

Consonant with the new times, too, alert artists developed new methods for presenting themselves to the public. Unlike the Impressionists or the Fauves, who were a shifting band of like-minded souls and who showed as a group only because they felt a spiritual affinity, future movements would organize more tightly and would express their beliefs more publicly. So ubiquitous were these groups and their manifestos to become in the following ten years that by 1915 a German artist, Franz Pfempfert, was to write an ironic proclamation, "A Call for Manifesto-ism."[18]

Was Duchamp immediately influenced by the aesthetic ferment swirling about him? To judge by his surviving drawings and paintings of 1906 to 1909, not at all. Rather, his work seems to embrace the traditional. The drawings often radiate a stylish slickness that echoes sometimes Toulouse-Lautrec, sometimes Daumier, and mostly the hack illustrations that peppered the popular publications of the day. Some were, in fact, cartoons, similar to Villon's, drawn for submission to various magazines and often featuring sexually suggestive captions.

In his painting, Duchamp recapitulated the various styles of the previous half century. The 1907 *Portrait of Yvonne Duchamp-Villon*, for example, is reminiscent of Courbet; the *Red House Among Apple Trees* of 1908 shows affinities with Monet; passages of the 1909 *Portrait of Yvonne Duchamp* refer to Degas.

Duchamp's major work of 1910, *Portrait of the Artist's Father*, provides some insight into the twenty-three-year-old's development. By this time he seems to have learned from the Fauves, using flashes of acid green and blotches of pure yellow ochre somewhat arbitrarily around the alert and sharp features of the patriarch. Though the face is acutely observed and rendered with the respect he had for father, the rest of the picture shows the persisting struggles of the amateur.

Maître Duchamp's hands, for example, illustrate the youthful painter's deficits: the left hand is finally reduced to three sausage-like fingers, while the right hand remains painfully deformed. Granted, a modern artist is entitled to distort reality in order to create a stronger composition, to make a personal statement about the subject or convey a fresh insight to the viewer.

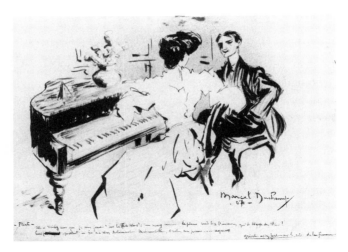

"Flirt," 1907

But the hands in this picture serve none of these functions. Indeed, the viewer is tempted to speculate that Duchamp's inability to draw hands propelled him toward his innovations in art; his entire oeuvre contains not a single full drawing of a hand.

In the same portrait, the chair's perspective is singularly unconvincing, either from the standpoint of traditionalist one-point perspective or from the Cézannesque point of view, in which perspective is often distorted for the sake of clarity. M. Duchamp does not sit in the chair, he floats; his left arm never seems to meet the chair's arm, nor does his right arm rest comfortably; it twists awkwardly back on itself.

Considering that the young artist intended to paint a portrait of record and also perhaps to demonstrate his proficiency after five years of devotion to the artist's métier, the painting's message is decidedly ambiguous. Beyond its few pseudo-Fauve touches, the *Portrait of the Artist's Father* shows no sign that Marcel intended to become an innovator, or that he had learned anything from the kaleidoscopic gyrations of the avant-gardes all around him.

◆ ◆ ◆

Early in 1907, a stocky Spanish painter who had been enjoying a modest success with his somber, El Grecoesque paintings of impoverished mountebanks and street people began working on a new picture. Much has been written about this one painting, its sources and its meaning, but there is still

no satisfactory explanation of exactly what Pablo Picasso had in mind when he produced the *Demoiselles d'Avignon*. We do know that Picasso intended his huge canvas, almost eight feet square, to include the figures of two men enjoying the sight of five naked women; perhaps he meant to top the scandal wrought by Manet's *Déjeuner sur l'herbe* in 1863, which featured two frock-coated men and two naked women. The picture, which was never finished, shows only five bizarrely distorted female figures.

Leering out from its easel in Picasso's studio, this "violent and iconoclastic" painting shocked all of Picasso's friends.[19] An early patron of the artist's, the Russian collector Sergei I. Tschoukine was "almost in tears" over it, according to Gertrude Stein.[20] Another scholar of Cubism, Douglas Cooper, echoes the consternation of those trying "to appreciate ... the angular and aggressive *Demoiselles* as a work of art." Significant to anyone studying Marcel Duchamp's later work is Cooper's observation that Picasso had abandoned "a perceptual for a conceptual way of representing things."[21]

The disquietingly ugly painting at which Picasso daubed and slashed so industriously in his cluttered studio on the rue Ravignan played a role in the liberation of Marcel Duchamp. It came to life just a few blocks from Duchamp's minimal space and was the talk of the many artists in the neighborhood. They could see the twenty-six-year-old Picasso deliberately making a statement about ugliness, looking for a way to widen the spectrum of art from the Kantian Good and Beautiful to encompass a far more modern, sophisticated, and troubling set of visions. A bright, ambitious, but none too facile young artist, like Duchamp, could take a cue from this work, and the many which soon followed, that any concept entertained by an artist might now be acceptable.

It was Picasso's colleague Georges Braque who inspired the disparaging appellation that codified these experiments: Cubism. The inventor of that word was again Louis Vauxcelles, the same influential critic who four years earlier had denounced Matisse and company as "*fauves.*" Writing in *Gil Blas*, Vauxcelles first tried to satirize the outlandishness of painting "with little cubes" by calling it Peruvian Cubism.[22] Since then a good deal of critical ink has been spilled in trying to prove, first, who between Braque and Picasso was the innovator and, second, whether the many other artists who called themselves Cubists are entitled to use the name.[23]

That question was to be deftly orchestrated by Daniel-Henry Kahnweiler, who would be a pioneer in transforming the role of an art deal-

er from simple middleman to impresario and tastemaker. He had signed Braque and Picasso to exclusive contracts and would soon add Juan Gris to his roster. Often and loudly, he insisted that only these three artists were "major Cubists."[24] The son of a German banking family, Kahnweiler brought dignity and intelligence to his campaign and had the resources to make his views stick. This coup left out dozens of artists, including the Duchamp brothers, who also were exploring Cubism.

Kahnweiler persuaded critics and scholars that Braque and Picasso had accomplished between 1908 and 1912 the most important change of style in art since the Renaissance. In support of this view, Douglas Cooper argued that the Cubist artist "assumed the right to fill gaps in our seeing and to make pictures whose reality would be independent of, but no less valid than, our visual impressions of reality."[25]

For Duchamp, the Cubists provided several important revelations. By the fall of 1908, he had seen examples of Braque's paintings, which were shown at the Salon d'Automne where three of Duchamp's works also were on display. His two older brothers were among the Salon's organizers, Raymond on the sculpture jury and Gaston on the steering committee. Duchamp also witnessed what happened when the painting jury rejected some other works by Braque: the day after the Salon closed, these contro-versial canvases went on exhibit at Kahnweiler's.[26] Also in this period, as Duchamp recalled much later, he used to visit the Sagot Gallery on the rue Lafitte, "where Picasso's drawings were five francs — one dollar — framed in those little blue mats."[27] For the general public, however, "Cubism" was mainly a catchall label for puzzling avant-garde works.

The Cubists' central position in museums and salesrooms today is as much the product of history by hindsight as it is of the increasing domination of tastemaking by speculators. To Duchamp, Picasso in 1908 was one of hundreds of artists working in Paris. Some forty years later, he described Picasso's "main contribution to art" as his ability "to reject the heritage of the Impressionist and Fauve schools and to free himself from any immediate influence." He attributed much of Picasso's fame to the world's search for "an individual on whom to rely blindly," a "worship" he tartly compared to "religious appeal" and which "goes beyond reasoning. Thousands ... in quest of supernatural esthetic emotion turn to Picasso, who never lets them down."[28]

Duchamp's bitter description conveys his desperation in the face of another artist's success. While Duchamp came to be recognized as the twen-

tieth century's most potent influence on other artists, Picasso continues to be the best known artist of the century, a desirable attraction in museums and a best-seller at auction. The art boom that began in the 1950s and continues today has inevitably seeped into the assessments of critics and the developments described by art historians.[29] Among the stratospheric prices recently paid for the works of artists active in the twenty years on either side of 1900, Picasso's works are by no means alone. Many other innovators of that time have caught the art public's fancy. In fact, the sheer volume of paintings produced during those years is staggering. The Paris salons that sprang up after the Academy was routed allowed any artist who paid a small fee to show at least two works. At the 1910 Salon des Indépendants, for example, the Duchamp brothers were among 1,182 exhibitors showing more than six thousand works.[30] The sensation that year was a new school called Excessivism.[31]

While avant-gardes erupted in major European cities, Paris remained central to cutting-edge experiments. The boisterous group of poets and painters who launched Futurism in Italy bought space on the front page of *Le Figaro*, a leading Paris newspaper, on February 20, 1909, to publish its inflammatory first manifesto. In it, the poet F. T. Marinetti affirmed "the beauty of speed. A racing car whose hood is adorned with great pipes, like serpents of explosive breath — a roaring car that seems to ride on grapeshot is more beautiful than the *Victory of Samothrace*." And he urged "gay incendiaries with charred fingers" to "set fire to library shelves! Turn aside the canals to flood the museums! ... Oh, the joy of seeing the glorious old carcasses bobbing adrift on those waters, discolored and shredded!"[32] Marinetti and his cohorts traveled ceaselessly, even to Moscow and to Brazil, issuing their passionate clarion call to revolution in music, painting, poetry, and even men's clothing. Their exotic mixture also included a glorification of war — "the world's only hygiene" — which, alas, soon found fiery support.

In Dresden, another group tried, in a more modest way, to attract "all the revolutionary and surging elements."[33] This was *Die Brücke* (The Bridge), whose paintings were influenced by primitive art and the turbulent style of Edvard Munch, as well as the violent colors of the Fauves. Founded by Ernst Ludwig Kirchner in 1906, its goal was to form a bridge between a traditional Germanic past and modern form. For two years, members poured out paintings and graphics in a frenzy of communal creativity, living and working together in a converted butcher shop before gradually dispersing.[34]

This group of Expressionists had a close relationship with the progres-

sive Munich artists who in 1909 formed the New Artists' Federation. Their leader was Wassily Kandinsky, a forty-year-old Russian who had earned advanced degrees at Moscow University in both social science and law before turning to art in 1896. By 1911, Kandinsky and the more radical artists had split off to form *Der Blaue Reiter* (The Blue Rider).

While even the most radical of his associates still dealt in subject matter, Kandinsky had already in 1910 executed the first nonobjective painting, a watercolor. Its celebration of pure color may well have been inspired by the artist's friendship with the composer Arnold Schoenberg, which began in 1909. Not only did Schoenberg become a painter, exhibiting with the Munich group from 1909 to 1911, he also tried to extend musical theory into poetry, publishing a volume called *Sounds* in 1913.[35] Kandinsky exhibited in Paris at the Salon d'Automne every year from 1905 to 1910; in 1907, he also showed with the Fauves at the Salon des Indépendants.[36]

It would be reasonable for a biographer to speculate that Duchamp knew something about these foreign movements, if only through artists' gossip and various articles in the Paris press. What makes this knowledge a certainty is that at least two friends of his brothers exhibited with the Munich progressives: Robert Delaunay in the winter of 1911 and Henri Le Fauconnier a year earlier.[37] But very likely the artist who exerted the strongest influence on Duchamp — and who had firsthand contact with the Central European art scene — was his brothers' close friend and neighbor, the Czech painter Frank Kupka.

Four years older than Jacques Villon (and fifteen years older than Duchamp), Kupka had lived in Paris since 1896; in 1901, he moved into a studio at 57 rue Caulaincourt and soon was acquainted with Villon, who lived next door. When the two older Duchamp brothers moved to Puteaux in 1906, so did their Czech friend; they all shared a garden. Villon and Kupka continued to be neighbors for more than fifty years, until the latter's death in 1957. But their intimacy included plenty of critical space; in 1903, the Czech painter wrote of Villon, "He suffers from Japonism and finds my painting old-fashioned."[38] Like Villon and Duchamp, Kupka tried to support himself by selling illustrations to Paris periodicals.[39] Because of his background and personal inclinations, however, he also introduced many exotic notions to the orderly, classical fund of ideas shared by the Duchamp brothers.

As a young man studying at the Prague Academy, Kupka developed such an intense interest in the occult that he became convinced he was a medium

and actually supported himself by holding séances.[40] In Vienna, where he settled in 1892, he studied art at the Academy, covering up his sketchy formal education with a bohemian veneer. Giving daytime drawing lessons allowed him evenings to visit salons, his biographer wrote, as "a blasé observer and wit."[41] Although Duchamp never acknowledged the older artist's influence, the trail of Kupka's ideas winds through many of his works and beliefs.

For much of his life, Kupka embraced passionate and rather confused anarchist beliefs. In an angry letter of 1902, he railed against "prostitution in art!" He deplored artists creating "works of bad taste against their will," only for the delectation of wealthy patrons "who have been stealing all day."[42] Duchamp, in turn, would frequently condemn artists pandering to an ignorant public. He grumbled at Renoir's repetitive nudes, and to a suggestion that Renoir was perhaps exploring variations on a theme, Duchamp testily interrupted with, "Far less than you would believe … Artists say they confront a problem each day; that's their fable … that we must mistrust. They are great liars."[43] He fulminated against artists like Monet: "Just house painters, taking pleasure in splashing greens and reds together and having fun."[44]

Some of Kupka's radicalism may well have been prompted not so much by political conviction as by his generally misanthropic outlook, his frequent bouts of depression, and his consequent difficulties in social relationships. Even his lifelong relationship with Villon was stormy; he was angry that the Duchamps did not consider him a mentor — after all, he was Villon's senior — and complained, with some justification, that when they saw his work, they stole his ideas.[45]

In his correspondence as well as in a considerable volume of essays, Kupka tried to elaborate a philosophy of art's role in the modern world. He believed that a painting should convey not just a pleasing image, but a philosophical message.[46] This view contributed to Duchamp's dislike of "retinal art," works that appeal only to the eye, not to the mind. Often, the titles of Kupka's paintings played on multiple meanings — for example *Fugue*, which refers both to the musical parallel of its variations on color themes, and to notions of flight or escapade.[47] Duchamp, as well, delighted in wordplay, frequently using puns.

Along with the Duchamp brothers, Kupka idolized Leonardo da Vinci, whose *Notebooks* had only recently been deciphered. For, while he abhorred

the social forms modern society had developed, like many radicals of his day Kupka adored its material inventions. Like Leonardo, he sought to draw philosophical conclusions from technical discoveries. "Music is but the art of sounds which do not exist in nature, but which are almost entirely man-made," he wrote. "Man has created the articulation of thought through words. He has created writing, the airplane, and the locomotive. Why then can he not create independently, in painting and sculpture, the forms and colors of the world which surrounds him?"[48] Duchamp would deal otherwise with Leonardo, but his references — including the famous bearded *Mona Lisa* — were just as persistent.

During his early Paris years, Kupka drew a series of technical inventions for *L'Illustration*. He also planned an ambitious allegory of universal progress, titled *Locomotive*. In his eyes, "the machine was almost a living being, a symbol of energy endowed with logic."[49] Photography and the movies, he believed, "reproduce more exactly what the most faithful realist painters attempted to give the world."[50] Many of Duchamp's works would reflect — and build upon — such notions. Kupka also audited courses in physiology at the Sorbonne and studied biology in laboratories[51] in a search for connections between science and art. Duchamp would also confront science and art, but in a far more irreverent manner.

Before the turn of the century, Kupka was impressed with the Praxinoscope, in which a cylinder of photographs and a series of mirrors gave the illusion of a moving picture. Around 1902, in a drawing called *The Horsemen,* he used a similar device to create the impression of movement.[52] In 1908, he rigged up a camera to take photos of himself running naked in his garden at Puteaux. Between 1909 and 1911, Kupka did a series of pastel sketches for a painting, *Planes by Color,* in which the movement of a figure was interpreted by showing the head and arms in several consecutive positions simultaneously.[53] Duchamp's persistent experiments with movement reflect his interest in Kupka's ideas, although, typically, he would skew Kupka's earnest investigations toward mockery.

Like Leonardo, Kupka believed in ideal proportions, based on mathematical calculations; he set forth in the notebooks he kept between 1910 and 1914 the scientific and philosophical basis of his work. These were years when Duchamp was also scribbling furiously into notebooks, recording the cryptic comments that still intrigue artists and scholars today.

Separating the mundane work that supported him (and that, after 1904,

also supported a wife and stepdaughter) from his experimental paintings and drawings, Kupka distinguished between two types of art: one was based on external life, like Impressionism, which was realistic and secular; the other, which to him was clearly superior, was based on speculative thought, aiming "to penetrate the substance with supersensitive insight into the unknown as it is manifested in poetry and religious art."[54]

Even as a student in Prague, Kupka was fascinated by stained glass. He had helped design Bohemian church windows and was familiar with the techniques for their execution. Soon after moving to Puteaux, he installed a stained glass window in a corner of his studio, a flash of color and shape that remained there to the end of his life. "The best solution" for what he was seeking, Kupka wrote in about 1910, "would be achieved by painting on glass"[55] — an intriguing notion that Duchamp would famously put to uses of his own some years later.

To Duchamp, who spent virtually every Sunday at the little artists' compound in Puteaux, these views were stimulating indeed, and he would soon elaborate on many of Kupka's notions in his own work. But not yet.

Instead, Puteaux was the setting for a number of Duchamp's still rather traditional paintings. There, he created an Impressionistic *Red House Among Apple Trees* in 1908. In 1910, the communal garden was the background for the largest painting he ever made, *The Chess Game*, measuring 45½ by 58½ inches. The models were his two brothers, thoughtfully hunched over a chessboard, while in the foreground their wives, Gaby and Yvonne, pensively lounged. In the same year, Duchamp sketched several nudes at Puteaux, possibly sharing a model with the other artists. For more playful occasions, he created the board for a steeplechase game, for which each participant apparently modeled his own tiny version of a thoroughbred. Though they were humorous, all the pieces interestingly show how closely the artists had observed sequential photos of horses in motion. Duchamp's two steeds were flippantly named *Gambit* and *Citron Pressé* (lemonade).[56]

◆ ◆ ◆

In mid-1907, Duchamp moved his studio four doors down the rue Caulaincourt, to number 73. But at the end of the year, the complaints of neighbors about a particularly riotous Christmas Eve dinner brought a six-months' notice from his landlord. In the next autumn, he would follow his brothers out to the Paris suburbs, settling at 9 rue Amiral-de Joinville in

Neuilly, an easy walk across the bridge over the Seine to Puteaux.

During the long summer vacations, Duchamp joined his family in a rented villa, "The Poplars," at Veules-les-Roses, some twelve and one-half miles from Dieppe. Here, amid the traditional amusements of such comfortably bourgeois resorts — a casino, bicycle excursions, nightly dancing, pavilions on the strand — Duchamp did most of his painting. Each New Year he attended the traditional family reunion in Rouen. In between, in Paris, he sketched and occasionally sold a drawing.

In May of 1907, five of his drawings were exhibited in the first Salon of Humorous Artists at the Palais de

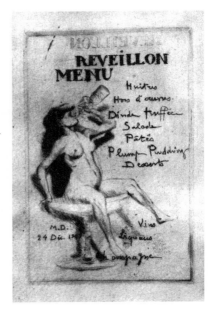

Christmas Eve Menu, 1907

Glace. The following year, four drawings were included in this group's second salon. Another drawing was printed that November in *Le Courrier français*. In the Salon d'Automne that year, he also showed three paintings. However, unless (as he later indicated) he subsequently lost or destroyed the major part of his work, Duchamp's output from 1905 to the end of 1910 is disappointingly scanty. Of the 179 items listed for these years in Arturo Schwarz's definitive *Complete Works of Marcel Duchamp*,[57] the vast majority are the barest of sketches, the sum of what a student might execute in a lazy fortnight's scribblings. Only thirty-six are paintings; presented without a signature, they would scarcely raise a flutter of interest. About thirty are finished drawings intended for publication, a meager portfolio indeed for a budding commercial artist. The rest are quick studies, mostly dedicated to friends.

Not only is this an unusually sparse oeuvre, but its quality would not excite even the most generous of art teachers; viewed as the work of a student, it would not elicit rosy predictions of future success. In fact, a reasonably diligent Sunday painter would produce more impressive results, underscoring the ambivalence that Duchamp felt about his chosen métier. Almost

sixty years later, he cheerfully admitted that he had never "known the strain of producing, painting not having been an outlet for me, or having a pressing need to express myself. ... to draw morning, noon, and night, to make sketches, etc." He became an artist, he said, "because one wants so-called freedom; one doesn't want to go to the office every day."[58] Duchamp was happy to escape his father's professional routine, but he was not ready to plunge headlong into the kind of full-time artistic activity in which he saw his brothers consumed.

Socially, Duchamp drifted among old friends from Rouen —Ferdinand Tribout, Gustave Hervieu, and Robert Dumouchel — as well as new contacts in Paris, especially the family of his neighbor, Gustave Candel. In two surviving group photographs, Marcel seems to be a part, yet apart. One, taken on a bicycle excursion to the Ailly lighthouse at Varengeville-sur-Mer, shows eight people linking arms for the camera. Marcel, in his white hat, stands behind them alone. Another snapshot shows ten young people standing with their arms entwined — all except for Marcel, who is leaning against a storefront at the extreme left, hands in his pockets.

Among his contemporaries who were later to make a name in art, Duchamp had only acquaintances. He sometimes played billiards with Juan Gris in a café on the rue Caulaincourt. He said he learned of Cubism through seeing an exhibit at Kahnweiler's and recalled that Villon once mentioned having seen Braque from a distance. He may have visited Braque's studio "toward 1910 or 1911," he said later.[59]

Nor did he remember discussing such important prophets of modern art as Cézanne, Gauguin, or Van Gogh, even though traces of their styles appear in his early sketches and paintings. Instead, when the conversation in his circle turned to artists, Manet seems to have been the center of discussion. Otherwise, as Duchamp remembered it many years later, the artistic talk was about practical matters: possible markets for drawings, the quirks of magazine editors, and the difficulties of getting paid even the ten or twenty francs ($2 to $4) which were the usual fee.

Duchamp's recollections slide over the intense theoretical discussions among the Puteaux artists, discussions in which they hammered out their own Cubist manifesto and the criteria for joining their exhibitions. As he hinted later, he "didn't just float along." He viewed these youthful Paris years as "swimming lessons" and characterized his chief impetus during that time as "an extraordinary curiosity."[60] It was this curiosity, surely, that led

Duchamp to consider as grist for an artist's fantasies notions far beyond the ends of the usual spectrum of artistic perception. At the time, he was the youngest participant in the Puteaux circle. Intimidated, perhaps, by its cerebral discussions, especially Kupka's wide-ranging speculations, Duchamp turned to mockery, a defense he would cherish the rest of his life.

In the popular culture of the time, one of the most common forms of humor was the pun or double entendre. The music hall songs of Yvette Guilbert, for example, were studded with double meanings.[61] The name of one of Montmartre's most popular cabarets, Le Lapin Agile, was itself a pun on the name of its owner, M. Gill: *Lapin à Gill* (Gill's rabbit).[62] In a revue at another cabaret, La Cigale, the master of ceremonies would provoke uproarious laughter by asking the naive question: "*Pour qui votait-on?*" ("Who did you vote for?") because the audience immediately heard it as "*Pour qui vos tétons?*" ("Who are your tits for?").[63] Duchamp, like Kupka, enjoyed the verbal shimmer of an ambiguous title. His painting *The Bush* of 1910-11 was the last, he later said, whose name was not descriptive. "From then on," he wrote, "I always gave an important role to the title, which I added and treated like an invisible color."[64]

A study of Duchamp's published drawings suggests that he was developing a talent for slyly sexual double meanings. In one drawing of 1909, a woman says to her male companion: "See how many people are wearing tricornes this year." He replies: "Oh, you know, a horn or two is always in fashion," a broad reference to the cuckold's horns. Even more suggestive is another drawing of 1909 titled *Dimanches* (Sundays). It shows a man pushing a baby carriage alongside his obviously pregnant wife. The double meaning lies in the reading *dix manches,* which in French slang means "ten erections." Such prurient allusions were a signal that, even in the mainstream media, nineteenth-century delicacy was yielding to twentieth-century liberation.

Throughout culture and thought, the assumptions of the previous century underwent scrutiny during the first decade of the new era. To some, science was still a fresh and powerful god; "the basis of well-nigh all our knowledge," wrote George Sarton, the distinguished Harvard historian of science, "the most powerful factor in human progress."[65] But despite the manifestos of the Futurists or the little-known experiments of the Cubists, the standard theories of aesthetics perceived only conflict between art and science. "Science is progressive and therefore ephemeral," wrote Sarton,

"art is non-progressive and eternal. A deeper contrast could not be imagined."[66] In 1913, the philosopher Oswald Spengler could still speculate on whether it was acceptable to apply artistic thought to mechanical forms.[67]

But life had already overtaken the philosophers. For one thing, they were still seeing Europe as the world's center for science and technology as well as culture, even though significant contributions were being made elsewhere. By 1907, for example, the United States was leading the world in production of cars. Symbolic also was the world's largest locomotive, a 382-ton 2,500-horsepower behemoth built in the same year for the Atchison, Topeka and Santa Fe Railroad. In the arts, too, America was chipping at European hegemony. Control of the film industry, which in 1908 had been the virtual monopoly of two French companies, Pathé and Gaumont, had passed to the United States by 1912. And the first great master of the feature film was to be an American, D. W. Griffiths.

In the fine arts as well, the brash giant country that Europeans regarded with mixed condescension and awe had brought forth some unrecognized but peculiarly prophetic forms. In 1882, America's leading sculptor, Daniel Chester French, had designed a striking monument for the Boston Post Office. Its visual idiom was classical and rather clichéd, but French's theme was poignantly relevant: "Science Controlling the Forces of Steam and Electricity."[68]

America also produced the first artist to express another kind of relationship between science and art. His medium was the humble newspaper cartoon, his mode was humor, and his method was to draw absurd machines. Between 1909 and 1935, Rube Goldberg produced one or more cartoons every week. Most of them lampooned technology and, so wrote Goldberg's biographer, "helped to expose one of the grand ironies of the modern age."[69] Among the "inventions" he drew with loving, deadpan accuracy were an Automatic Collar-button Finder, a Simple Way of Hiding a Gravy Stain on Your Vest, a Self-Operating Napkin, and an Automatic Mosquito-Bite Scratcher. *Gulliver's Travels* was the only book Goldberg frequently reread; and such was the chord he struck in American culture that, in 1966, he became the only American whose name had entered Webster's as a dictionary word in his own lifetime.[70]

In a unique way, Goldberg was a prophet. Though six years would pass before Marcel Duchamp was exposed to his irreverent drawings, the ideas they conveyed so humbly were being expressed in a grander form by Henri

Bergson, France's leading philosopher, during the first decade of the twentieth century. His lectures at the Collège de France between 1900 and 1904 attracted a broad segment of Paris intellectuals. Within the following six years, a young man who claimed "extraordinary curiosity," as Duchamp did, could not fail to learn about the famous philosopher's notions. With Cartesian logic and clarity, Bergson had attempted nothing less than to reconcile technology and art, science and the human spirit.

Summarizing his ideas in *Creative Evolution,* Bergson made room for chance in an increasingly mechanized world. There were two kinds of order, he wrote, the physical and the "vital." The latter, he believed, "is essentially creation," and shows itself largely "in some of its accidents, those which imitate the physical and geometrical order."[71] Almost forty years after these words were written, Bergson's American editor, the philosopher Irwin Edman, described Bergson's stunning impact: "Everyone rebelling against convention in conduct, chafing against formalism in art, revolting against the fixed and stable in thought, found him an enchanting voice."[72] Duchamp's brother Villon was among those charmed. As a metaphor of the problem of depicting movement, Bergson had suggested "a series of snapshots ... This is what the cinematograph does." This is also what Villon attempted in his 1913 painting *Marching Soldiers* and how Duchamp would soon depict his famous nude on her way downstairs.

On the way to that nude, Duchamp was cautiously moving toward a more personally expressive style. In the portrait of his friend Dr. Raymond Dumouchel, for example, he surrounded his subject's hand with a mysterious halo. Some scholars recently have associated the halo with the X rays then becoming a part of the doctor's practice.[73] Duchamp in the 1960s offered Arturo Schwarz an explanation that fitted Schwarz's Freudian orientation: the halo was "a sign of my subconscious preoccupations toward a metarealism ... the satisfaction of a need for the miraculous."[74] Dumouchel also appeared in another possible allegory of the same period: he is the slender Adam in *Paradise,* modestly covering his genitals with his hands. Later in 1910, Duchamp painted several versions of two nude women which were also efforts at allegory: *The Bush* and *Baptism.*

One of the figures in *The Bush* has been identified as Jeanne Serre, a young artist's model with whom Duchamp was having an affair. This painting is one of a series of twenty-one paintings and drawings of nude women produced by Duchamp in 1910 and early 1911. The series ends with *Baptism,*

a resonant title, indeed, since Serre gave birth to Duchamp's daughter, Yo, on February 6, 1911. If paintings reveal wishes, Duchamp's depictions of Jeanne Serre in late 1910 and early 1911 do not show the reality of a woman heavy with child but rather a curvaceous nymph. Duchamp later gave a spate of intellectual explanations of these two pictures: They "seemed to satisfy the desire I had to introduce some anecdote without being 'anecdotal.'"[75] He immediately gave *Baptism* to Ferdinand Tribout, a Rouen friend studying medicine in Paris. As for his daughter, Duchamp reacted to the child's arrival (at least outwardly) with total indifference; he gave no further heed to her until 1967, the year before he died.

The birth of Yo and the end of his affair with Jeanne may well have influenced *Young Man and Girl in Spring* from early in 1911. It shows two elongated nude figures, with only the title giving a hint as to their sex. They stretch upward and toward each other, even as they are eternally separated. Within a circle in the center, several smaller nudes seem to be dancing; perhaps they represent younger versions of the two major figures or their offspring. Beyond these meager facts, the painting itself yields little, though several observers have been tempted by it into intricate iconographic analysis as well as esoteric Freudian conclusions.[76]

Duchamp was learning to avoid comments about any of his works that might reflect his inner life, but circumstantial evidence provides some basis for speculation. First, he painted this work during the spring of 1911, when his sister Suzanne was engaged to be married to a Rouen pharmacist, Charles Desmares. Second, when Suzanne married, on August 24, the painting was Duchamp's wedding gift to her. Finally, Duchamp would never paint in this style again, except for a sketch of an enlarged version which he would overpaint three years later with a radical experiment. In these respects, *Young Man and Girl in Spring* is an important painting. And in the light of subsequent developments it takes on the aspect of a turning point.

Projecting ourselves backward into the spring of 1911, we see no hint of Duchamp's future fame, no glint of the originality to come. Instead, we observe a quite ordinary, rather indolent, young man. We look at his works, and we want to agree with his brother Raymond's bleak opinion that his "intentions are insufficiently realized."[77] Perhaps this judgment was colored by the condescension of an older brother. On the other hand, Duchamp seems to be one of hundreds of young artists savoring the excitement of bohemian Paris on a small remittance from home. He is a very bright young

man, to be sure, and one who has the advantage of two much older brothers who are already establishing themselves within the avant-garde.

As an artist, this young man strikes us as amateurish, both in the quality of his work and in its quantity. The word that comes to mind is dilettante. A sympathetic friend, in fact, noted that in 1910 "he had not found his mode of expression" and that he conveyed "a kind of disgust with his work and an ineptitude for life." But, she added — and it should be stressed that her observations were written from memory and by the piercing light of hindsight: "Under a veneer of almost romantic timidity, he possessed an exacting dialectical mind ... [He was] in love with philosophical speculations and absolute conclusions."[78]

Eᴀʀʟʏ ɪɴ 1911, the calm world of Marcel Duchamp heated up. In quick succession came the birth of his daughter and the marriage of his sister Suzanne. With no visible compunction, he had abandoned the mother of his child and turned his back on the infant. In the meantime he counseled Suzanne about her own art; rather than consulting her two more experienced brothers about her art, she asked Marcel, who gave her a detailed critique when she sent him three paintings for submission to the Independents' salon in Paris. He also advised her on how much to charge.[1] Suzanne's career as an artist had started precociously in 1903 when her portrait of Jacques Villon, painted before she was fifteen years old, was exhibited in Rouen at the Salon for Norman Artists.[2]

By 1911, Marcel's older brothers were establishing themselves within the avant-garde, while he himself diddled with drawings and daubed derivative little paintings. At the age of twenty-four, Marcel was facing a marginal existence deep within his brothers' shadow. A bright young man with an insistent competitive drive, he had to move on.

So it was that midway through that year, Duchamp rushed headlong into new realms. He abandoned the landscapes or traditional studies of nudes that he had painted with increasing skill but questionable originality during the previous nine years. Over the next four years, he would work at art harder than ever before or since, exploring every theme that would occupy him for the rest of his life. And he asked every one of those nettling artistic and philosophical questions that still hang, like the smoke after a battle, over the

4 · THE JOY OF SHOCKING

landscape of aesthetic speculation. But personal issues continued to seep into his work. Henceforth, as his friend and first biographer Robert Lebel portentously described it, his art would "commemorate psychological events in his life."[3]

Teasing out such events, however, remains a painstaking and often frustrating task. Duchamp created many and varied means of masking his emotions, while developing an extraordinary capacity for distance from others. No matter who the addressee — acquaintance, friend, patron, dealer, or lover — Duchamp closes virtually every letter in a volume of his selected correspondence with the lukewarm cliché "Affectionately."

In terms of technique, he sought ways to challenge the very idea of painting itself. Literally thousands of European artists were pushing paint and canvas toward their outer limits. Already the Fauves had tested the limits of color, daubing acid shades into crashing contrasts. Abetted by their dealer, Kahnweiler, Picasso and Braque were planting flags all over the Cubist map. The noisy Italianate gaggle of Futurists was marching across Europe. Kupka kept ruminating, in his dark Central European manner, about how, beyond engaging the optic nerve, pictures should stimulate "the olfactory nerve, the acoustic nerve, and the sensory nerve."[4] Where to find that new thing that nobody else was pursuing?

Duchamp's surviving works emphatically answer this question, but altogether too coherently, too logically, to be completely convincing. Considerable evidence indicates missing links. In 1912, he told an interviewer from the Paris art magazine *Gil Blas* that he was working on a painting titled *La Section d'or,*[5] but no trace of this work exists. There is also a clue in Duchamp's assertion in the early 1950s to the art historian Marcel Jean that he had destroyed many of his pre-1910 works.[6] Moreover, an artist like Duchamp, who spent most of his life recapitulating and ringing changes on his own oeuvre, would hardly stop self-editing his work at the age of twenty-four. So the suspicion lingers that a number of the post-1910 works went the way of the earlier works that did not "fit in" with the image Duchamp wanted to create. As it stands, the visual record all too closely corroborates Duchamp's verbal explanation, mostly given decades later, of what he was about.

During 1913, so this record has it, Duchamp virtually abandoned all conventional painting and drawing. In the intellectual world of the early twentieth century, he explained to an interviewer much later, painters were con-

sidered stupid, while poets and writers were thought intelligent: "I wanted to be intelligent."[7] Thus did Duchamp embark on the wide-ranging series of aesthetic experiments that anchor his fame. "No four years in the work of any modern painter," wrote William Rubin in 1960, "witness so many radical departures in method and idea."[8] The critic Robert Coates finds the gap between Duchamp's earlier works and the post-1911 ones "troubling" and remarks that the "turnabout must be the most abrupt in all art history."[9]

On the one hand, Duchamp produced a group of paintings with precise, suggestive titles and increasingly abstract forms. On the other, he embarked on a series of increasingly dry and factual representations of mechanical objects. In the first group, Duchamp begins by trying to depict physical motion and culminates in the attempt to show, as Raymond had attempted, a far more subtle and abstract kind of movement, a metaphysical act of becoming: for example, the transformation of a virgin into a bride. The second group begins with Duchamp's humorous diagram of the movement of a simple machine, a coffee mill, and glides through increasingly static, even totemic visions of a mechanical object, a chocolate grinder, toward a startling synthesis of emotion-drenched machinery. But only once, in the large volume of his notes for 1911-15, is there a hint of emotion, a fragment which reads: "Given that...; if I suppose I'm suffering a lot..."[10]

Was his suffering related to family dynamics? *Sonata*, a painting that Duchamp began in Rouen in January 1911 and toyed with for nine months, provides a hint. It shows a formal, symmetrical arrangement of the women in the Duchamp family. Lucie presides magisterially over her daughters Yvonne and Magdeleine, making music, and Suzanne, seated in the foreground. Suzanne's eyes fall modestly downward onto what looks like a nude female form. Despite its sober composition, its melting pastel colors, and its Cubist mannerisms, this picture also carries a bitterly sardonic message. For the mother, who appears to be listening so appreciatively to her daughters' music, was deaf. Her hearing had already begun to fail noticeably in Blainville-Crevon. By 1911, the woman whom Marcel had described as "cold and distant" was in fact separated from the family by a wall of silence.

However, Duchamp's own remarks about this painting deflected this irony into another channel — a humorous parody of traditional art criticism. "The pale, tender tonalities of this picture, in which the angular contours are bathed in an evanescent atmosphere," he told a lecture audience more than fifty years later, "make it a definite turning point in my evolution." Some clue

as to how seriously to take Duchamp's many and varied subsequent comments about his own work comes in his account of a painting from almost the identical period, *Yvonne and Magdeleine Torn in Tatters*. In the same lecture, Duchamp emphasized that it also was a turning point, his first effort to introduce humor into a painting: "I tore up their profiles and placed them at random on the canvas," he explained.[11]

In another painting of this time, *Dulcinea*, Duchamp for once took a subject other than his family. This work, he said, was inspired by a woman he observed from afar almost daily, as she walked her dog in a park in Neuilly. In five overlapping stages, the artist coolly strips her of her decent bourgeois clothing and transforms her into an enticing naked houri, the walking embodiment of the *dulcinée* — a dryly ironic word for the woman (sweetheart or mistress) to whom one is irresistibly drawn.[12] Was she the real mistress displaced into a stranger? The critic Lawrence Steefel found that the background forms "a welter of nude limbs, torsos, and breasts" and attributed its "underlying erotic restlessness" either to Duchamp's comment on the repressed life of the woman or to the fantasy of the bachelor artist. "Once the double imagery is perceived," Steefel noted, "the viewer finds it difficult to suppress its disruptive emergence in favor of the ... public appearance of the lady."[13]

Duchamp's last overt study of women in his family was *A Propos of Little Sister*, completed in Rouen in 1911. The retrospective exhibition's catalogue describes it as "a study of Magdeleine Duchamp apparently seated reading or working by the light of a candle at her side."[14] But is the woman Magdeleine? Nothing within the picture supports this assumption. Is she actually "reading or working"? Again, the picture reveals nothing. Rather, the painting seems to illustrate the common fantasy wish of little boys who have sisters: to watch them using the toilet. For the young lady is quite obviously seated on a toilet — and Duchamp's inscription on the back of the canvas supports such a conclusion: "*Une Étude de femme Merde.*"

Next, Duchamp methodically scrutinized the men around him, including himself. He had already formally portrayed his father in 1910. Now, in October 1911, he began sketches of chess players, with his two older brothers as the models. Six sketches survive, as well as two paintings completed in December. The concepts that emerge leave little doubt that Duchamp saw chess as the violent symbolic conflict described by psychologists. One illustration of this is the artist's evident indecision as to scale: should the players

be immensely large in relation to the pieces, or be dwarfed by them?[15] Taking into account the generally accepted interpretation of chess pieces as phallic symbols, one can follow Duchamp's vacillations of attitude toward his brothers, those two much older men who loomed so powerfully over him.

The final version of *The Chess Players* was painted by gaslight. Duchamp probably was attempting to tone down his palette, because, as he explained it, "The first reaction of Cubism against Fauvism was to abandon violent color and replace it by subdued tones."[16] But the viewer is also struck by Duchamp's wavering between scumbled unspoken thoughts within the gaslight's flickering obscurity and the revelations that might emerge in the day's bright light.

During the same fruitful December of 1911, Duchamp also conjured up a surrogate self in the form of *Sad Young Man on a Train*. It was originally titled *Pauvre jeune homme M*, after a poem by Jules Laforgue, and showed what Duchamp later humorously called "a formal decomposition."[17] The inspiration for this work came to Duchamp aboard a train carrying him toward Rouen for the annual Christmas family reunion, this time the more poignant because it was to be his first visit with Suzanne since her marriage to the Rouen pharmacist. Alone with his pipe as the carriages rattled across the wintry Norman countryside, Duchamp depicted his fantasy as he was jolted by the movement of the train. At least one observer has noted that "the young man may well be masturbating; his penis occupies a prominent place in the center ... and an arc of dots trails down from the organ."[18] Again, the inscription on the back of the canvas wavers between revealing and concealing the real subject matter. It reads, *"Marcel Duchamp nu (esquisse) Jeune homme triste dans un train, Marcel Duchamp"* (Marcel Duchamp nude [sketch] Sad Young Man on a train, Marcel Duchamp).

Still fascinated by how to depict motion in painting, one of Kupka's concerns and now a central issue among the Futurists, Duchamp sketched a *Nude Descending a Staircase* in oils on cardboard. In this first version of the signature painting, a ghostly, disembodied robot appears to be clanking down a circular stairway. By the time anybody asked him about it, Duchamp had perfected a zest for obfuscation: it was an experiment, he told Arturo Schwarz in 1968, in "the demultiplication of movement."[19]

Without further sketches, Duchamp completed the final — and famous — version of the *Nude Descending a Staircase* in January 1912. Though it was painted in just a few weeks, the *Nude* is the only work associated with

Duchamp to attract a substantial non-specialist audience. It has also attracted a great deal of earnest analysis, to which Duchamp often responded in equally earnest terms, so earnest that a veil of mockery envelops it. An artist asked him, some twenty-five years later, whether the *Nude* was a painting. "No," replied Duchamp, with a straight face, "it is an organization of kinetic elements, an expression of time and space through the abstract expression of motion."[20] Coming from a man who seldom tolerated pomposity, such words elicit smiles of disbelief, but they do point to a more convincing key to understanding the *Nude*. For, with this work, Duchamp attached the ironic tone of his spicy drawings for humor magazines like *Le Rire* to his apparently serious paintings.

In this light, we should first consider the mocking title of *Sad Young Man on a Train*; he is *triste*, a sad sack. It foreshadows an even more ridiculous concept: a nude, the classical subject of artists since the Greeks, captured in an undignified, clattering descent of a stair. In depicting a "different" nude "in motion," Duchamp told Cabanne, "there was something funny there, but it wasn't at all funny when I did it. Movement appeared like an argument to make me decide to do it."[21]

The *Nude Descending a Staircase* presented a hostile, humorous challenge to the multitude of avant-garde artists around him: its subdued colors were a parody of Picasso and Braque's somber Cubist still lifes, while the figure's relentless descent lampooned the fascination with movement of his brother Raymond, of Kupka, and, of course, the Futurists. Duchamp's aim was to enlist the trappings of the artists all around him in an impudent parody capped by the faintly smirking title.

Near the end of his life, Duchamp underscored his delight that the public was actually shocked by the title: "A nude should be respected. It should not descend a staircase because that is ridiculous."[22] Far from being upset by the title, however, the public really was shocked by this work's ambiguous sexuality and its take-off on traditional nudes. In another hint at his mischievous intentions, Duchamp revealed that he had originally sketched a figure going upstairs, "but upward mobility would have been too flighty, too futurist."[23] On yet another occasion, he said he began to think it helpful "to have her descending, more majestic you know — the way it's done in the music halls."[24] Such waggish remarks underline the painting's playful yet caustic wit, a quality that, from then on, would infuse everything Duchamp created.

The interpretations of this work, one of the most famous in the twenti-

eth century, are legion. They range from the superficially psychoanalytic to the marginally poetic, but they do not grasp this work's penetrating humor, its caustic sendup of the prevalent reverence for art. The French art historian Marcel Jean presents the Freudian insight that walking down a staircase symbolizes the act of love.[25] The French photographer Étienne-Jules Marey's multiple exposures of figures in motion have also been cited as a possible inspiration for Duchamp. An international trio of scholars recently noted the compositional similarity of the *Nude* to a late nineteenth-century painting by the pre-Raphaelite painter Edward Burne-Jones, *The Golden Stairs*.[26] Indeed, two exemplars of this sentimental work are among the multitude of Duchamp-related illustrations at the Philadelphia Museum of Art.

However, when the painting was exhibited in New York, an anonymous American wag proposed a meaning that may harbor more than a grain of truth:

> You've tried to find her
> And you've looked in vain
> Up the picture and down again.
> You've tried to fashion her of broken bits
> And you've worked yourself into 17 fits.
> The reason you've failed, to tell you I can,
> It isn't a lady but only a man.[27]

Duchamp never positively asserted his figure was a woman; indeed, the title painted on the lower left corner of the painting uses the masculine *nu* rather than the feminine *nue*, suggesting that the unknown author of the doggerel quoted above may have gained not only a ten-dollar prize from *American Art News* for the best explanation of the *Nude* but a fair insight into its real meaning as well. Lending weight to this view is the fact that Duchamp repeats a number of painterly motifs from the *Sad Young Man* in the *Nude*. There is the curving series of drops near the center of the painting and nearby, to the right, a shape strongly suggesting a penis. Gender ambiguity parades down the stairway, a droll jab at the religion of art and at viewers' expectations, or a memory, perhaps, of a real event: the house at Blainville-Crevon did, indeed, have a quite imposing stairway.

What is certain is that the *Nude Descending a Staircase* represented little Marcel's bold challenge to his brothers' status. In March 1912, he submitted the work to the Salon des Indépendants, a show then dominated by the same

Cubists who were his brothers' friends. After all those lively Sunday discussions in the Duchamp-Villon kitchen, he must have known that orthodox Cubism at this point rejected motion and considered nudes anathema. The Sunday cronies, Albert Gleizes and Jean Metzinger, had just laid down the rules in a long essay, *On Cubism*, an obscure work today but immensely influential at the time. In less than a year, the French edition went into fifteen printings, and by 1913 there was already an English translation.[28] While Gleizes and Metzinger urged artists to seek "indefinite liberty,"[29] they hardly anticipated that their implicit rules against depicting nudes and movement would be so blithely flouted. Nor would they be pleased by the lifelong lesson Duchamp drew from *On Cubism*. On its very first page, this book extolled art for the mind while deploring "retinal art." It was a distinction Duchamp frequently repeated word for word, without mentioning the original authors.[30]

With the *Nude*, wrote one observer, Duchamp "performed the heroic task of simultaneously galling the public, the critics, and the avant-garde."[31] But one can imagine that he also savored embarrassing his two much older brothers who dwelled in the thick of avant-garde art theory and politics. The Cubist hanging committee sent Jacques Villon and Raymond Duchamp-Villon to demand that Marcel at least change his painting's title. His response was to cart the picture home quietly while deciding that "there's no question of joining a group"; as he later told Cabanne, "I'm going to count on no one but myself alone." Over time, Duchamp converted dismay over his brothers' lack of loyalty into ironic humor. They were "solemnly dressed," Duchamp gleefully told Robert Lebel more than forty years later, "as though come to challenge [me] to a duel."[32]

In fact, Duchamp could hardly have been surprised at the *Nude's* rejection. He had sat in on plenty of weekend discussions at Puteaux where depictions of nudes and movement were roundly denounced. While he had not seen the Futurists' Paris show that opened in February 1912,[33] before he began painting the *Nude Descending a Staircase*, he had heard bitter comments for several years deploring the Futurists' devotion to rendering movement. And his later insistence that he knew nothing about the Futurists until 1912 appears thin, since their 1909 manifesto, clipped from *Le Figaro*, had been pinned to the door of Frank Kupka's studio, right next door to Villon's.[34] In fact, we can only wonder whether the provocation of *Nude Descending a Staircase* wasn't above all else his declaration of independence not only from the influence of his brothers but also from the pious solemni-

ty enveloping the world of art. "Duchamp could never resist thumbing his nose in the teacher's face,"[35] the critic John Canaday once observed; and his further departures from the mainstream avant-garde after the confrontation over the *Nude* illustrate Canaday's observation.

The rejection of the *Nude* highlights a much-pondered facet of Duchamp's personality: an "obsession," as Lebel puts it, "with the distance, the separateness which exists between individuals ... [a] separateness ... simultaneously necessary and intolerable." A relationship with Duchamp could be extremely ambiguous because "at one and the same time he is very close and very aloof."[36] Over the years, Duchamp's brand of friendship would persistently be described as alternating between nearness and distance, almost passionate warmth incongruously accompanied by icy reserve. The art critic Cleve Gray noticed "a lordly secretiveness ... skeptical, private, self-controlled."[37]

So far, Duchamp's studies of motion dealt with movements in space, but beginning with the *Nude*, many of his works dealt with different states of being over time. The change in emphasis lends weight to the impression that the "latent eroticism" of Duchamp's fantasy erupted into consciousness, as a psychiatrically-minded scholar noted, "and he felt the need to depersonalize."[38] Nudes were on Duchamp's mind in the spring of 1912 as he quickly sketched several versions for a painting completed in May, *The King and Queen Surrounded by Swift Nudes*. In 1961, Duchamp said he referred to nudes in the title so that there would be no chance of "suggesting an actual scene or an actual king and queen." The two central figures, he said, "became a combination of many ironic implications connected with the words 'King and Queen,' while the nudes were included to suggest a different kind of speed, of movement."[39]

William Rubin discerns three major interpretations of the king and queen: chess images, machines as rulers, and parents surrounded by their children.[40] The French title, *Le roi et la reine traversés par des nus vites*, in fact, conveys a far more threatening message than one might receive from a casual translation; *traversée* also means "run through," as with a sword. Similarly, the title of *Yvonne et Magdeleine déchiquetées* (*Yvonne and Magdeleine Torn in Tatters*) has a more ominous connotation; for *déchiqueter* can also mean "to mutilate, mangle, slash, hack, or to cut into long ribbons" — an apt punishment, no doubt, for the two younger sisters who had absorbed all of their mother's love, to their brother's detriment.

As mentioned above, the swift nudes might have been an offshoot of Kupka's experiments in visually defining movement in space and time.[41] Or perhaps they were triggered by the Italian Futurists – though neither of these was even credited by Duchamp. The Futurists, of course, were fascinated by speed and movement. A manifesto from April 1910 included references to "retinal after-images" for suggesting motion. Like the Puteaux group, the Futurists were conjuring up "representations of time ... crystallization of a moment of dynamic, cosmic flux."[42] Like Duchamp, they were exploring the aesthetic possibilities of machines and the capture on canvas of a moving object. Their "Technical Manifesto of Futurist Sculpture" in April 1912 featured a statement by Umberto Boccioni admiring "the fury of a flywheel [and] the whirling of a propeller" as "plastic and pictorial elements."[43] But although he had met at least one of the leading Futurists, Gino Severini, Duchamp adamantly resisted acknowledging any debt to them in his own experiments with motion, such as *Sad Young Man on a Train* and the two versions of *Nude Descending a Staircase*. (Nor, for that matter, did he ever acknowledge the Futurists' call on artists, in the same manifesto, to use new materials such as glass, wood, cardboard, iron, cement, horsehair, leather, cloth, mirrors, and even electric lights[44] — despite his own experiments with some of these materials as of early 1913.)

The one possible influence that Duchamp did acknowledge in this regard was that rapidly growing popular art, the movies. In France, the entertainment pioneered by Georges Méliès was blossoming into theatrical art. Encouraged by the film entrepreneurs Léon Gaumont and Charles Pathé, respected writers wrote film scenarios and leading actors of the Comédie-Française starred in such epics as *The Assassination of the Duc de Guise* (1908) and *La Tosca* (1909). In 1912, Sarah Bernhardt appeared in a film of her signature vehicle, *La Dame aux Camélias*. These were among the first feature-length films to develop a flowing continuity rather than present a series of stage tableaus.

Duchamp maintained that his studies in motion came directly from the cinema and from the late nineteenth-century chronophotographs of Eadward Muybridge and Charles Marty. Multiple exposures of moving figures were "in vogue at the time," he told William Rubin in 1960, again without mentioning Kupka or the Futurists. "Studies of horses in movement and of fencers in different positions as in Muybridge's albums were well known to me."[45]

In July 1912, at the age of twenty-five, Duchamp abruptly left Paris for a solitary sojourn in Munich. It was his first venture outside France; to stretch the trip, and perhaps his money, he traveled third class on local trains.[46] "I took an intense pleasure in being away," he said in 1968. "I come of a sedentary family; my brother Villon never went anywhere if he could help it."[47]

Marcel's departure was at the behest of a casual acquaintance, "a German cow painter" named Max Bergmann, whom he had met in 1910. The two had sampled Paris nightlife, reputedly including a Pigalle bordello. In Munich, Duchamp looked up Bergmann and brought him a wooden toy the French call a *bilboquet*, a ball on a string attached to a wooden spike. The trick is to catch the hole in the ball on the spike, perhaps a reference to the young men's activities back in Paris two years earlier. Duchamp had inscribed on the ball: "Bilboquet / Souvenir of Paris / To my friend M. Bergmann / Duchamp spring 1910."[48]

By his own accounts, Duchamp spent little time with Bergmann, or with anyone else, during his two-month stay in Bavaria. He lived in "a little furnished room," he recalled many years later. "There were two cafés where artists used to go ... you could see paintings by Picasso in the gallery in the Odeonsplatz. Munich had a lot of style in those days. I never spoke to a soul, but I had a great time."[49] For the first time in his life, Duchamp worked hectically, almost obsessively. In less than two months, cramped in his little furnished room in Schwabing, then and now Munich's Latin Quarter, Duchamp finished two detailed drawings titled *Virgin*, and completed what many consider his finest paintings: *The Passage from the Virgin to the Bride* and *The Bride*. And he laid out the first pencil drawings for what would be his most important work.

Still, although Duchamp later characterized his stay in Munich as "the scene of my complete liberation," we have no idea of how much he absorbed, if anything, from the heady artistic atmosphere in the Bavarian capital. For Munich, during that summer of 1912, rivaled Paris as an avant-garde pressure cooker. In December 1911, six months before Duchamp arrived, the *Blaue Reiter* school of German Expressionists had opened its first show at the pathbreaking Thannhauser Gallery. Included were the earliest abstractions by Wassily Kandinsky. A few weeks later, Kandinsky published his most important theoretical work, *Concerning the Spiritual in Art*, and by April a second edition was out. In July, Duchamp saw it "in all the

shop windows,"[50] but he does not report reading it. If he had, he would have found echoes of his own fascination with new ways of depicting space, figures in motion, and a world of art divorced from visual reality — the same concerns with depicting invisible states that Kupka had expressed so often in Puteaux.[51] He would also have read Kandinsky's take on the contemporary art scene, an echo of the brawl in Paris: "The artist seeks material rewards for his facility, inventiveness and sensitivity. His purpose becomes the satisfaction of ambition and greediness. In place of an intensive cooperation among artists, there is a battle for goods … excessive competition; overproduction. Hatred, partisanship, cliques, jealousy, intrigues are the consequences."[52] A copy of Kandinsky's book was found among the effects of Jacques Villon; he had read it avidly enough to pencil notes in the margins, but it seems unlikely that Marcel, never much of a reader, saw more than a display in a bookstore window.[53]

Nor, so far as we know, did he meet any of the other artists working in Munich that summer — Franz Marc, the Burliuk brothers, Alexei Jawlensky, Kandinsky, and his mistress Gabriele Münter. Yet many years later, he would claim to have been "one of the first to recognize Kandinsky and Klee."[54] At the end of August, carrying what would become a lifelong preference for the German Behrendt pigments among his meager souvenirs, he returned to Paris via Prague, Vienna, Dresden, and Berlin. There, Herwarth Walden had recently purchased an entire Futurist collection to show in his Der Sturm gallery and tour throughout Germany and eastern Europe.[55] But Duchamp did not recall seeing their work in Berlin, either. While in Munich, his work had diverged from any Futurist influence.

His most complex Munich painting, *The Bride*, is acclaimed by many as Duchamp's masterpiece as an oil painter. Technically, this painting demonstrates the artist's ability to handle pigments and brush. But the work's title contrasts sharply with the clinical apparatus it depicts. A welter of tubing and organic shapes, this is hardly an erotic female beckoning for release from her virginal state. Rather, it mocks the very idea of sexual passion with a meticulous, but ultimately counterfeit, medical illustration.

Critics wax rhapsodic over its sensuous surface of paint smoothed with the fingertips rather than a brush. The critic and biographer Calvin Tomkins has raved over its "sensuously painted forms … in a completely new kind of space … luminous, tactile, and absolutely still."[56] One acolyte went so far as to assert that this painting convinced Duchamp that it was fruitless and per-

haps dangerous to carry the demonstration of his remarkable gifts any further, for fear of being "trapped ... by beauty."[57] Apart from its technical achievements, the painting, like most of Duchamp's works, carries meaning on a variety of levels, not all of them lofty. Lawrence Steefel, who has exhaustively dissected Duchamp's works, discerned a subliminal effect: the painting's background and foreground seem to "vibrate," inexorably forcing the viewer to shift his visual perception from deep within the canvas to its surface and back into its depths; a kind of visual simulation of sexual "intercourse between ourselves and the image." When Duchamp was consulted on this interpretation in 1956, he shrugged it off, telling Steefel he "was not aware" of it.[58] Tomkins revived the sexual aspect of *The Bride* in 1996, claiming to see in its "suggestions of mucous membranes and moist internal tissues" an illustration of Duchamp's dictum that art should grasp the mind "the same way the vagina grasps the penis."[59]

The Bride was also the first oil study for what became Duchamp's most elaborate and most baffling work. He told Steefel in the late 1950s that he created *The Bride* in a "state of virtual anesthesia," and that it was the first painting in which he glimpsed the fourth dimension.[60] In another interview at about the same time, Duchamp told John Golding a fancy story about its source: that the bride's mechanical appearance was based on youthful visits to fairgrounds where he saw the public invited to throw wooden balls at figures dressed as bride and groom.[61] Who the bride in the painting really is remains problematical. Perhaps she represents Duchamp's mother, an Oedipal fantasy of a woman programmed to receive mechanically his father's passionate advances; perhaps she represents the newly married Suzanne; perhaps she stands in for the mistress and the searing outcome of trafficking with a bride; perhaps she embodies every woman in the twenty-six-year-old artist's fantasy life, submitting meekly to decoration, as compliant and undemanding as a machine, yet also as threatening. Much later, in 1961, he was to call it his favorite painting[62] — a verdict Duchamp frequently changed, depending on when and by whom he was asked.

The Bride was the last work Duchamp willingly attempted in paint. Instead, he began to write in his sketchbooks and on the odd scrap of paper, seeking the "beauty of indifference" (a quality he later called "the blankness of Dada"[63]). His notes of the time reveal a desperate chase after new and different themes, thrusts into unfamiliar territory, consideration of any wispy notion, and mockery of a scientific world that was rapidly moving

into incomprehensible specializations. During Marcel's boyhood, several popular weeklies described scientific developments for middle-class readers. The 1900 Paris Exposition highlighted scientific advances and attracted 245 thousand visitors a day.[64] A mere decade later, the cutting edges of science and technology had fragmented into a multitude of disciplines beyond the grasp of the lay public.

In his obsessive note taking, Marcel was also reacting to a similar process in the world of art, the proliferation of "isms," manifestos and rampant theorizing. During his absence in Munich, Raymond and Jacques and their circle of Cubist painters had organized the "secessionist" Salon de la Section d'Or, its first exhibit scheduled for October 10 to 30 at the Galerie La Boétie. The salon's organizers have been described as "a gathering of forces against Picasso and Braque,"[65] but their show was probably another manifestation of the avant-garde's attempt to intellectualize its aesthetic program, not to mention of its Darwinian competitive drive.

The name Section d'Or was Villon's contribution and has been seen as an indication that he, like Marcel, was thinking in mathematical terms (though Duchamp took a more lighthearted view when he hinted to Calvin Tomkins: "We don't know the half of it"[66]). Exhibitors included the two oldest Duchamp brothers, their sister Suzanne, Francis Picabia, Alexander Archipenko, Juan Gris, Roger de la Fresnaye, Fernand Léger, Marcoussis, André Lhote, Metzinger, and Gleizes. Marcel exhibited six works, including the work rejected by the Salon des Indépendants, the provocative *Nude Descending a Staircase*.

◆ ◆ ◆

In the *Nude Descending a Staircase*, Duchamp had wanted "to break up forms, to 'decompose' them, much along the lines the Cubists had done." But, as he later put it, "I wanted to go ... much further."[67] In the later paintings of 1912, he had already gone much further. *The King and Queen Surrounded by Swift Nudes* had replaced a concept of physical motion with a mental concept of motion. *The Passage from the Virgin to the Bride* added mythical machinery while portraying erotic and psychological movement. But it was only with the beginning of his most elaborate work, the one eventually known as *The Bride Stripped Bare by Her Bachelors, Even*, that Duchamp ventured into the speculative stratosphere from which, blankly and ironically impregnable, he would eventually dominate the avant-garde's aesthetic debate.

In February 1913, Duchamp picked up on a way of achieving aesthetic distance that he had first tried more than a year earlier. At that time, he had gleefully produced an oil sketch of a coffee mill for his brother Raymond's kitchen, trying to express the machine's essence, movement, and function, using a series of arrows and multiple images. During the traditional New Year's visit to Rouen in the first days of 1913, he found another inspiration close to home, in the window of the Gamelin confectionery shop on the rue des Carmes. It was a chocolate grinder, a handsome tool of the candymaker's art, set on four delicately curving Louis XV legs.[68]

Back in Paris during February and March, Duchamp painted the first version of *The Chocolate Grinder* and also wrote some poetic notes about "the interrogation of shop windows ... the unreasonableness of the shop window."[69] The painting of the brass and steel chocolate grinder was intentionally dry and linear, more like an engineer's rendering than an aesthetic work. In its "immaculate precision," the machine he painted acquired an iconlike quality. And because it is lacking both raw material (chocolate) and function (the ridges of the original), this machine becomes absurd and impotent.[70] In his notes, Duchamp described a certain bachelor who "grinds his chocolate himself."

A year later, in February 1914, he created a second version of the *Chocolate Grinder*, even more arid and totemic. This time he indicated the ridges on the brass cylinders by gluing threads onto the canvas. In both of these versions (as well as a recently discovered third sketch), Duchamp claimed he did not allow his hand to interfere with his mind: "I unlearned to draw," he told Calvin Tomkins in 1961. "The point was to forget with my hand."[71]

While conducting these experiments in "forgetting," Duchamp pursued another avenue for achieving indifference. And what more impersonal, objective, detached, evenhanded process exists than the operation of chance? Not too surprisingly, considering the family milieu, his first experiment with the aesthetic potentialities of chance was musical. In 1913, during the same visit to Rouen in which he first spotted the chocolate grinder, Duchamp enlisted his two youngest sisters, Yvonne and Magdeleine, in creating the first *Erratum Musical*. This was a score for the voices of its three creators, derived from musical notes randomly pulled out of a hat, in an intriguing prevue of Tristan Tzara's cut-up newspaper poems of the 1920s. The "lyrics" also "arrived" by chance; they consisted of the dictionary definition of the verb "to print."

In his studio, Duchamp followed the *Erratum* with another, far more elaborate "composition," complete with instructions for building a machine that would automatically write music. He called it *The Bride Stripped Bare by Her Bachelors, Even.*

This first appearance of that provocative title would go far in the development of Duchamp's work. It also opens a small window into his thinking. The French title — *La mariée mise à nu par ses célibataires, même* — loses many nuances in translation, especially the puns which provide the key to its meaning. Thus, for example, it could read *"La mariée mise à nu par ses célibataires, m'aime"*: The bride stripped bare by her bachelors loves me. The artist's name is also embedded in the title: MARiée, CELibataires. Whatever the true meaning of the cryptic label (and likely more than one interpretation is "correct"), the major work to which he transferred this title, familiarly called the *Large Glass,* was to occupy Duchamp for the next ten years.

Since the summer of 1912, Duchamp had been sketching its various components, at the same time meticulously keeping every scrap of the notes that were to accompany it. *The Bride* and *The Chocolate Grinder* both passed into

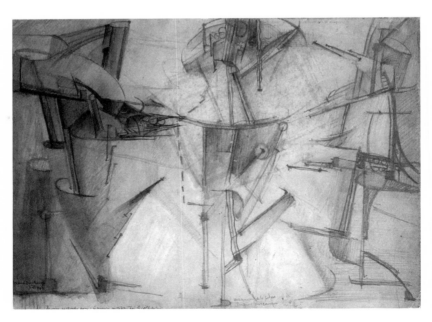

"The Bride Stripped Bare" (sketch), 1912

the *Large Glass* virtually intact. The final concept would include all the themes that Duchamp had gradually been developing during the previous year: mechanical representation of a subjective moment, graphic depiction of an invisible transformation, emotions as absurd machinery, the mysterious operation of chance, and a frigidly clinical view of sex.

Sometime during 1913, he had scribbled on a scrap of paper the question that provided the key not only to his own further development as an artist but also to his enormous influence on all the arts of the twentieth century: "Can one make works which are not works of art?" To this profound question, Duchamp attached, like crimson streamers, masses of cryptic notes and odd sketches that explored the radical possibilities it implied. His hurried notes, scribbled on scraps of paper, trace his search for an answer:

Make a painting or sculpture as one winds up a reel of moving picture film. With each turn, on a large reel (several meters in diameter if necessary), a new "shot" continuing the preceding turn and tying into the next one.

Construct one and several musical precision instruments which produce mechanically the *continuous* passage of one tone to another in order to be able to record without hearing them sculptured sound forms.

Buy a dictionary and cross out the words to be crossed out. Sign: revised and corrected.

Have a room entirely made of mirrors which one can move — and photograph mirror effects...

A whole series of things to be looked at with a single eye ... a whole series of things to be heard with a single ear.

To Duchamp, the act of simply writing down these descriptions became a work of art. He felt no need or even desire to create these extremely complicated works. Similarly, he proposed a series of verbal projects:

DICTIONARY — of a language in which each word would be translated into French (or other) by several words, when necessary by a whole sentence.

— of a language which one could translate *in its elements* into known languages but which would not reciprocally express the translation of French words (or other), or of French or *other* sentences.

Make this dictionary by means of cards. Find how to classify these cards (alphabetical order, but which alphabet).

Alphabet — or rather a few elementary signs, like a dot, a line, a cir-

cle, etc. (to be seen) which will vary according to the position, etc.

— Sound of this language, is it speakable? No. Relation to shorthand.

"Grammar" — i.e., How to connect the elementary signs (like words), then the *groups* of signs one to the other; what will *become of the ideas* of action or of being (verbs), of modulation (adverbs) — etc.?

In addition, he suggested a bizarre array of media culled from medicine cabinets and chemists' stock: toothpaste, Brilliantine, cold cream, soapy water, strong tea, picric acid, tincture of iodine, ground glass, rust, and graphite suspended in linseed oil.

The ideas tumble over one another like the crystals of a kaleidoscope. On café stationery, ruled school paper, and bits of wrapping paper, he wrote:

> Make a painting of *happy or unhappy chance* (luck or unluck).
> Make a mirrored wardrobe.
> Make this wardrobe for the silvering.
> The barrel game (tiny sketch) is a very beautiful *"sculpture" of skill.*
> A photographic record should be made of 3 successive performances; and "all the pieces in the frog's mouth" *should not be preferred* to "all the pieces outside" or (nor) above all to a good score.
> Perhaps make a hinge picture (folding yardstick, book...) develop the *principle of the hinge* in the displacements, 1st in the plane, 2nd in space.[72]

Duchamp pursued his question into the most shadowy corners of language, philosophy, mathematics, and physics. Some of his projects were obviously impossible to create and *therein* was art. Others could be easily materialized, but Duchamp chose not to — and *that* was the art. Still others pinned unexpected meanings onto familiar words:

> Regime of Coincidence.
> Ministry of gravity.
> Painting or Sculpture — Flat container in glass — (holding) all sorts of liquids. Colored pieces of wood, of iron, chemical reactions. Shake the container and look through it.
> Establish a society in which the individual has to pay for the air he breathes (air meters, imprisonment and rarefied air, in case of nonpayment simple asphyxiation if necessary — cut off the air).
> *Conditions of a language*: the search for "prime words" (divisible only by themselves and unity).

Musical sculpture: sounds lasting and leaving from different places and forming a sounding sculpture which lasts.[73]

Duchamp's excitement — or perhaps his anxiety — quivers in the crabbed and careless scribblings of these notes. He cannot bother with spelling, punctuation, grammar. The words fairly flow of their own accord onto bits of paper from his pockets. The pen clogs, and Duchamp cannot bother to stop and wipe it off. He impatiently scratches out an unwanted phrase, rewords it, stuffs another word into the space above. He abbreviates. He underlines and then double underlines. He circles portions in red crayon. He scratches blotty arrows to transpose words. He stabs commas, colons, and periods into the paper. But above all, he keeps every one of the crumpled paper butterflies carrying his thoughts. While many of his early drawings and other works were later lost, these notes were carefully preserved.

By the winter of 1913, the content of the *Large Glass* and the uniquely personal techniques Duchamp planned to use had jelled so firmly that he was able to pencil a full-scale study of it on the plaster wall of his studio. But the detailed execution would require, as his notes indicate, painstaking "research" followed by the formulation of bizarre and blackly humorous new "laws" of perspective, mathematics, and especially chance.

In hot pursuit of these laws, Duchamp created the *Three Standard Stoppages*. This work consists of three threads exactly one meter long, dropped from a height of one meter onto painted canvas strips glued to glass. The resulting curves were then traced onto three wooden slats and cut along the tracing to create what he called "canned chance ... a canned meter."[74] Finally, he enshrined all these objects in a specially made, fitted wooden box.

With the *Three Standard Stoppages*, Duchamp thumbed his nose at the positivism then prevalent in the Paris intellectual world. In 1914, when he canned the meter, the original platinum iridium meter (the standard for the world's measurements) was still enshrined "like a talisman of rationalism" in the French Academy of Science. However, Duchamp lived to see it defrocked. With his limp strings, Duchamp had "uncovered an affectation of precision in measurement that physics has since attempted to come to terms with." In 1960, the French General Conference of Weights and Measures redefined the meter as "1,650,-760.73 wave lengths *in vacuo* of the radiation corresponding to the transition between the levels 2p10 and 5d5 of the atom krypton-86."[75]

In his old age, Duchamp named the *Three Standard Stoppages* as his most important work. "That was when I really tapped the mainspring of my future," he modestly told Katharine Kuh in 1961. Not that he realized at the time what he had stumbled upon. "When you tap something," he explained, "you don't always recognize the sound."[76]

A critic recently suggested that with the *Three Standard Stoppages*, Duchamp had discovered "the fastest escape route possible from ... competitive influences." He was testing a radical theory: that there was no "aesthetic quality" necessary for a work of art, that such quality was actually detrimental because it appealed to the eye, was therefore "retinal" and unacceptable.[77] Such coherence may have come later, but in 1913, Duchamp was exploring a great many unorthodox directions, often plunging forward into murky terrain.

He immediately put the new yardsticks to use in creating *Network of Stoppages*, a multisided work — psychologically as well as formally. The background canvas is an unfinished, enlarged version of Duchamp's 1911 wedding present to Suzanne, *Young Man and Girl in Spring*. On the sides, probably in the autumn of 1913, Duchamp painted wide black borders so that the remaining canvas would approximate the proportions of his projected *Large Glass*. Then he penciled in a half-scale layout for the *Glass*. Over it all, he used each stoppage three times to paint nine curved lines. The number on each line lent a mock-scientific air to this creation. Humor aside, this work could represent Duchamp's diffusion of feelings about his disastrous affair with Jeanne Serre and his total denial of the offspring: part of the young man and girl in spring is now overlaid with funereal black while the rest is overlaid with a psychologically neutral, mechanized, random version of the bride and bachelors.

Duchamp's works between mid-1911 and mid-1915 exude a militant push for liberation, rebellion, and distance. Psychologically, Duchamp separated himself, however tortuously and obliquely, from family and childhood. Stylistically, he rebelled against the major forms and subjects, not only of the past, but also of his many competitive contemporaries. Technically, he was fearless in using new materials, notably string, glass, and lead. And above all, he perfected in himself sophisticated distancing devices that would leave him free of emotional entanglements with family, friends, and lovers.

In 1957, the art critic Robert Coates was "bothered" all through his visit to a New York art show featuring the works of the three Duchamp brothers.

He noticed a "faint but disturbing family resemblance": all the works in the show conveyed a "lack of emotion," coolness, an air of detachment.[78] The sources of this familial trait no doubt lie deep and early in their childhood history. But a further observation by Coates — that all three worked conventionally at first and switched to "modern" styles around 1911 — reflects their lives at this time.

In 1906, as we have seen, the two older brothers, already married but childless, had moved to adjoining studios in Puteaux, and in 1908 Marcel had also moved to nearby Neuilly. Both places were a far cry from such artists' haunts as the ramshackle Bâteau Lavoir in Montmartre, where Picasso and Braque were the center of a determinedly riotous bohemian crowd.

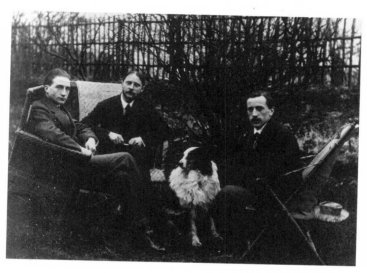

Marcel, Jacques (Gaston), and Raymond in Puteaux, 1912

Puteaux and Neuilly were respectable, middle-class colonies of sprightly villas, not unlikely places for the young up-and-coming sons of a solid provincial *notaire* to settle, even if they were themselves artists. Here, in a balconied and bay-windowed two-story house adjoining a garden where gladioli spiked their colors upward toward a canopy of ample shade trees, Jacques Villon steadily turned out the paintings and engravings that eventually established him solidly in the second rank of twentieth-century painters. Next door, in a similarly tranquil milieu, his brother Raymond was creating the works that would earn him an enduring reputation as a sculptor. His

bronze *Horse* of 1914 is considered "perhaps the most important work in the entire tradition of Cubist sculpture."[79]

All three brothers were "thinkers, rather than doers, asking questions more than answering," according to the art critic George Heard Hamilton, who knew them personally.[80] They saw a great deal of each other, though the two older men greeted their younger brother's notions with a certain skepticism. At the same time, they were drawn together not only by their art but also by their shared interest in chess, their intellectuality, and, as the art historian Robert Rosenblum has noted, their "persistent analysis, both constructive and destructive, of the relationship between art and nature."[81] Yet their very closeness may have triggered Duchamp's lifelong quest for emotional distance.

Most Sundays, they would meet at Raymond's or Jacques's, where the presence of a number of friends guaranteed stimulating, indeed passionate, discussions about art. The shifting "Puteaux Circle" included many would-be Cubists unsanctioned by D. H. Kahnweiler, along with Guillaume Apollinaire, the poet and leading critical writer on Cubism; Henri-Martin Barzun, a magazine art critic and father of the American man of letters Jacques Barzun; and Maurice Princet, a teacher and self-styled avant-garde mathematician, who was obsessed with the fourth dimension.[82] All were older than Marcel. On Tuesdays, a similar group met at Gleizes's studio in Courbevoie, unless some went to the Tuesday *soirée* given by the Symbolist poet Paul Fort, which was often attended by now-forgotten anarchists and by the Cubist sculptor Alexander Archipenko and a pair of Italian Futurists, the poet and novelist Filippo Tommaso Marinetti and the painter Gino Severini. On Saturdays, many of the same group would round out a busy social week by joining Picasso and Matisse at Gertrude Stein's salon in the Latin Quarter.

At the end of 1911, Raymond Duchamp-Villon asked each of his artist cronies to do a painting for his kitchen. Marcel contributed his *Coffee Mill*. In 1945, he told Sidney and Harriet Janis that it was his "key picture," embodying all his central concerns: "movement, mechanics and irony."[83] Certainly the painting showed Duchamp's "fascination with the artistic possibilities of the machine,"[84] as one critic wrote. But perhaps most of all the *Coffee Mill* reflects the zany humor and iconoclastic bent of Duchamp's newest friend, Francis Picabia.

The son of a wealthy Cuban diplomat, Picabia reportedly smoked opium every night and frequented such bohemian cafés as the Rotonde and the

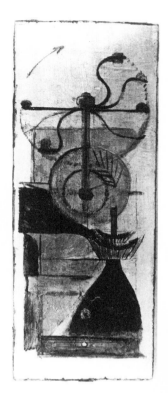

(left)
"Coffee Mill," 1911

(below)
Francis Picabia in his studio, 1911

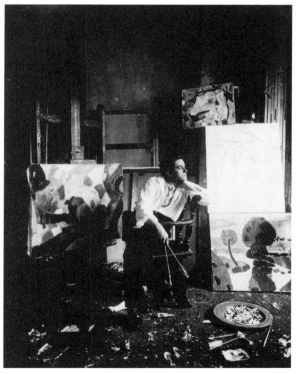

Dôme. He was described as "a negator" who leaped to contradict anything said to him. As an artist, he too was exploring the potentialities of machines. Picabia had submitted a painting of mechanical-looking bathers to the 1911 Salon d'Automne, calling it "a machine."[85] Like those in the Puteaux group, he was considerably older than Duchamp; he was born in 1878. Picabia's milieu of elegance, wealth, and sophistication dwelled some distance from Marcel's middle-class, provincial background. Duchamp told Cabanne that Picabia "came from a world that I had never seen before."[86] But their paths, both geographically and stylistically, were to run parallel for the rest of their lives. Later, Duchamp credited Picabia with "uncoupling" him from "the somewhat solemn world of Puteaux, where the problems of modern painting were discussed in serious, often highly theoretical terms."[87] By contrast, get-togethers between Marcel and Francis were "forays of witticism and clowning ... They emulated each other in their extraordinary adherence to paradoxical, destructive principles," Picabia's wife Gabrielle Buffet recalled later. Their goal? "The disintegration of the concept of art."[88]

To Picabia, Art with a capital "A" had long been stripped of its mysteries. He grew up in the household of his maternal grandfather, a well-known photographer named Davanne, who had been a friend of Louis Daguerre. While still a schoolboy, young Francis had raised money for his stamp collection by copying the "masters" hanging in his grandfather's apartment and selling the originals, after placing his own replicas in their frames. When the originals were all gone, the boy confessed and his grandfather was "not in the least put out," or so Picabia told interviewers much later. As a photographer, the old man had long harbored doubts about the values of traditional painting, the kinds of works "bound by the reproduction of appearances." For his grandfather, Francis's prank had merely confirmed these doubts. As a paradoxical reward, the young man was promptly sent for formal training at the École des Beaux-Arts, followed by a stint at the École des Arts Décoratifs. In 1907, he painted a landscape in which the sky was red and the ground blue — again to the delight of his grandfather.[89]

By 1911, Picabia, like Duchamp, had recapitulated in his work every experimental style of modern painting since Impressionism; and the two shared, as Duchamp later said, "a mania for change."[90] Unlike Duchamp, Picabia was enormously productive, spraying out paintings, drawings, and prints in every conceivable style until he died in 1953. Some 650 of his works have been sold since 1986, at prices nearing $1 million. Though prolific,

Picabia was hardly chained to his easel. His flamboyant lifestyle suited the descendant of a Spanish privateer for whom the King of Spain raised a statue in the Armada's port of La Coruña. Picabia's father, a scion of Cuban wealth, played at being an attaché at the Cuban embassy in Paris, and the son, according to Dadaist Richard Huelsenbeck, supported "a personal physician who was continually running after him with a loaded hypodermic."[91] Guillaume Apollinaire immortalized Francis's love affair with fast cars:

> The driver grips the steering wheel
> And every time along the road
> He blows the horn rounding a curve
> There appears on the horizon's rim
> A universe yet unknown.[92]

◆ ◆ ◆

Since his return from Munich, Duchamp had "lived quietly, seeing few people and often spent two weeks or more closeted in his studio." When he did emerge, it was usually for meetings with Picabia, which, when Apollinaire joined them, became "forays of demoralization."[93] Apollinaire had in 1912 written glowingly of Duchamp that he alone could "reconcile art and the people."[94] But Duchamp remained skeptical of such outpourings. The talk of literary people frustrated him, he later said, because "you couldn't get a word in edgewise." In Duchamp's judgment, "Apollinaire wrote awfully foolish things about art, but he was a charming man." Conversation with him and his literary cronies was a series of "fireworks, jokes, lies, all untoppable because it was in such a style that you were incapable of speaking their language."[95]

Though he may have felt tongue-tied in the midst of Paris's avant-garde, Duchamp was profoundly influenced by what he heard. It was during this period that he developed a lasting interest in verbal games. He may have been influenced by seeing Raymond Roussel's experimental play *Impressions of Africa*, a stage adaptation of his novel that relied heavily on word-games for its impact. Later, Duchamp would even credit the play's "madness of the unexpected" with inspiring the *Large Glass*, even though he could not remember much of the text. Duchamp passed up any opportunities to meet the eccentric writer, who was also a chess player: "I didn't need to become his close friend," he said. Perhaps he was also intimidated by Roussel's wealthy background, "very, very avenue du Bois," as Duchamp described it;

or perhaps he simply had not absorbed enough of Roussel's writings to converse cogently with him.[96]

Nevertheless, adapting Roussel's verbal fireworks gave him another outlet for the intense competitiveness he had earlier displayed vis-à-vis his brothers in the episode of the *Nude Descending a Staircase*. Duchamp's intimidation by the brilliant café table talk of the likes of Apollinaire and the elegant poet Max Jacob spurred him into increasingly intricate linguistic speculations. These gropings were a verbal parallel to the themes that were occupying Duchamp in visual form. Just as the *Chocolate Grinder* tried to replace the common meaning of an ordinary machine with an exotic — and erotic — significance, so the language games tended to drain words of their meaning and to recombine them in the form of puns or shocking associations.

Duchamp was one of many thoughtful young men speculating on the meaning of language during this period. One of the more bizarre examples of these "scientists" was an eccentric lexicographer named Jean-Pierre Brisset, to whom Apollinaire had introduced Duchamp the previous year. Brisset had made "a highly personal, not to say fantastical, scientific analysis of various languages." He had arrived at the conclusion that similar sounding words in all languages really meant the same thing. A group of writers among Duchamp's acquaintances found this discovery so striking that they organized a banquet in honor of Brisset, held in the street at the foot of Rodin's *The Thinker*.[97]

During October 1912, Duchamp enjoyed a concentrated week of aesthetic speculations along with verbal fun and games. He joined Apollinaire and Picabia on a car trip to Etival, in the Jura, to pick up Gabrielle Buffet, Picabia's wife, who was visiting her mother. The trip took place just as the Salon de la Section d'Or opened. In this regard, Duchamp's flight was a negative gesture typical of his later behavior, but the jaunt was also fruitful for all participants. They agreed that they would would have to react against an "already academic Cubism," as exemplified by Duchamp's older brothers' involvement with the Section d'Or. The travelers agreed to develop a new salon (which, in fact, was never held) and also decided to support publication of Apollinaire's *The Cubist Painters*.[98] Duchamp came home with cryptic notes on the excursion:

> The machine with 5 hearts, the pure child, of nickel and platinum, must dominate the Jura-Paris road.

On the one hand, the chief of the 5 nudes will be ahead of the 4 other
nudes toward this Jura-Paris road. On the other hand, the headlight child
will be the instrument conquering this Paris-Jura road.[99]

The puns in the original French of this passage illustrate some of the pit-
falls of translating Duchamp, for in fact this obscure string of words describes
a projected work of art. Titled *The Jura-Paris Road,* it was to be a two-sided
panel with the *Chef des Cinq Nus* ("chief of the five nudes," but also *"seins
nus"*: bare breasts) on one side and the *Enfant Phare* ("headlight child," but
also "fanfare") on the other.[100] In the end, this madly Oedipal fantasy of a
mother and child separated by glass was no more than a verbal fragment, a
merry distraction from Picabia's maniacal driving style: the panel described
never materialized — or else fell victim to Duchamp's periodic self-editing.

For a while, however, Duchamp became so caught up in the "theoretical
considerations" triggered by the *Paris-Jura Road* that he stopped all other
artistic work. He was seriously contemplating his future: "Was he going to
let himself disappear in the horde of painters pushing toward the threshold
of notoriety?"[101] Such was the rhetorical question posed by his first biogra-
pher, Robert Lebel. In his effort to stay above water in that creative tide,
Duchamp turned away from the contemporary art scene, and instead began
gathering his scribbled notes to create an original visual-literary crossover
project. Almost one hundred years later, scholars were still analyzing and
interpreting this puzzling assemblage of scattered fragments and hotly dis-
puting what they could possibly mean.

Most likely the project was simply abandoned in favor of an interesting
new possibility that appeared on the Paris art horizon. In early November
1912, three Americans organizing an International Exhibition of Modern
Art, to be held in New York the following February, visited the two older
Duchamps' studios. Walter Pach led the committee; he had met the older
brothers on an earlier visit in 1910. He brought along Arthur B. Davies and
Walter Kuhn, both artists with an eye for the spectacular as well as a vivid
sense of the excitement that had raged through European art during the pre-
vious three decades. That the three Americans expected to organize a major
exhibition in a brief span of three months testifies to the ease and casualness
of exhibition planning at that time.

The committee members saw themselves as missionaries for modern art;
they felt obligated to acquaint Americans with the best of the new. During a

hectic ten-day foray through the ateliers of the European avant-garde, they assembled more than four hundred European works to be shipped to New York. Their heavy emphasis on the French to the relative neglect of such significant movements as the German Expressionists and Russian Suprematists would help lure many American art collectors to Paris for at least two generations.

Furthermore, they mingled various consecutive movements of French art, so that the American public was offered a gigantic smorgasbord of Impressionism, Postimpressionism, Fauvism, and Cubism, with little sense that these movements had overlapped over a number of decades. Cézanne and Van Gogh, Gauguin and Redon, Toulouse-Lautrec and Picasso, all were jumbled together into an incredibly rich collation that was predictably indigestible. Among the works they chose at the Duchamp brothers' studio were four by Marcel: *Sad Young Man on a Train*, *Portrait of Chess Players*, *King and Queen Surrounded by Swift Nudes*, and *Nude Descending a Staircase*.

In a 1967 interview, Duchamp blamed the earlier rejection of the *Nude* by the Indépendants for his abandonment of painting — as well as for a brief foray of his into steady employment. It "gave me a turn, so to speak," he told Pierre Cabanne. "Cubism had lasted two or three years, and they already had an absolutely clear, dogmatic line on it ... As a reaction against such behavior coming from artists whom I had believed to be free, I got a job."[102] It is equally possible that murmurs from his father, who was still providing a monthly stipend, helped encourage Duchamp to find work.

Duchamp's various descriptions of that job, a position as a librarian at the Bibliothèque Sainte-Généviève that he obtained through Picabia's uncle, illuminate his attitude. "I was not a guard," he remarked later. "I sat at a desk from 10 to 12 and from 1:30 to 3:30. I got 5 francs [about $1] a day."[103] It was a way of making a livelihood that required nothing more than his daily presence. "I could sit and think about whatever I cared to. I was always glad to supply any information I could to anyone who asked me politely."[104] Duchamp also took courses at the School of Paleography and Librarianship. He knew he could never pass the exam for librarian, he told Cabanne, but it was "a grip on an intellectual position, against the manual servitude of the artist."[105]

These ironic statements, all made decades after the event, illustrate Duchamp's dandified, aristocratic disdain for any kind of steady work, an attitude he would maintain successfully for the rest of his life. He was never again to hold a regular job or earn a stable income. "I consider working for a

living slightly imbecilic from an economic point of view,"[106] he blandly commented many years later. This attitude was an echo of Picabia, Duchamp's closest friend as 1912 was ending. While the two artists' backgrounds contrasted sharply, they sparked each other into "blasphemies and inhumanities," as Gabrielle recalled, undermining not only "the old myths of art" but "all the foundations of life in general."[107] In this sense, Walter Pach's selection of *Nude Descending a Staircase* marked only a further step. For Duchamp, the painting so casually sent, like a bottled message to a foreign shore, would be a passport to notoriety, the validation stamp for his chosen identity as an exotic, maligned, sensitive, elegant, misunderstood genius, one for whom something as pedestrian as a job was now unthinkable.

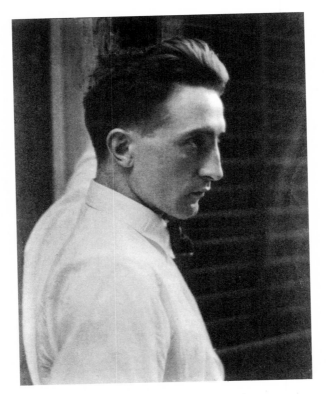

Duchamp in 1917, by Edward Steichen

THE INTERNATIONAL EXHIBITION OF MODERN ART opened in the Armory at Twenty-seventh Street and Madison Avenue in Manhattan on February 17, 1913, amid the tootling of Bayne's 69th Regiment Band. Its organizers billed it as "the most complete art exhibition ... held in the world during the last quarter century,"[1] and indeed, the 1,275 works on display, one-third of them by foreign artists, lent weight to the claim.

The organizers had intended the exhibition to celebrate the strength of American art, but the four hundred European works added in just a few weeks unmasked the American productions as provincial and old-fashioned. Attendance was disappointing until the first virulent reviews.

Contemporary observers generally agreed that the *Nude Descending a Staircase* was the high point of the show, all the more surprising since it was the work of a totally unknown French artist who had never exhibited in a gallery. From the four thousand invited guests who milled among the eighteen octagonal rooms on opening day, to the more than ten thousand who jostled through on the last day one month later, the *Nude* evoked puzzlement, laughter, quizzical looks, outrage, and, above all, utter fascination.

From press and critics, including ex-President Theodore Roosevelt, the *Nude* drew mostly furious assaults; but their volume and shrillness only added to its notoriety. The *Evening Sun* carried a cartoon, "The Rude Descending a Staircase (Subway Rush Hour)," and an academic artist — in a benefit show for the Lighthouse for the Blind, no less! — spoofed it with a work entitled "Food Descending a Staircase."[2] Teddy Roosevelt wrote a scathing article,

perhaps embittered by the fact that the Republican president's visit occurred on March 4, the day his Democratic successor, Woodrow Wilson, was inaugurated. T. R., no mean warrior with a pen, wondered why the avant-garde European painters called themselves Cubists and not "Octagonists, parallelopipedists, Knights of the Isosceles Triangle or Brothers of the Cosine." A Navajo rug in his bathroom, he wrote, threw more light on Cubist theory than what he called the "Naked Man Going Downstairs," which, he added in a parting shot, could just as easily be called "A Well-Dressed Man Going Up a Ladder."[3]

The way Duchamp had mangled the "female form divine" (if indeed it was female) most incensed American critics, who had surely not seen Picasso's unlovely *Demoiselles d'Avignon*. To art connoisseurs all through the previous century, the only justification for nudity in art had been as a depiction of God's work, or so they said. Distortion of the human form, especially female, was sacrilege. And article after article reacted. The Cubists in general were reviled as "Huns of the art world," "anarchic hordes," and "paretic"; while the *Nude* was described as "an explosion in a shingle factory," "a collection of saddlebags," "leather, tin, and broken violin." A few weeks later, when the Armory Show works went on view in Chicago, a local newspaper advised readers to "eat three Welsh Rarebits and sniff cocaine" if they wanted to understand the paintings.[4]

Though vituperative, the newspaper articles mostly did spell the Duchamp name right — and often. It became a household word, at least among urban sophisticates, and especially because of what can only be described as a publicity blitz that preceded the show. In thousands of news releases, a professional journalist, Frederick James Gregg, alerted editors across the nation to the forthcoming show. Almost invariably, these releases mentioned the stereotyped data about some of the featured creators: "Cézanne, the misanthropic banker-recluse; Van Gogh, the insane preacher-painter who cut off his ear and committed suicide; and Gauguin, the stockbroker who deserted his wife and family for art and then went to live with the natives in Tahiti."[5] Along with the news release, the editors usually received a print of the only photograph available to the Armory Show's organizers, a picture of the three Duchamp brothers posing in the garden of the studio compound at Puteaux.

It was no surprise, then, that the three young men whose picture had been spread across newspapers and Sunday supplements through the United

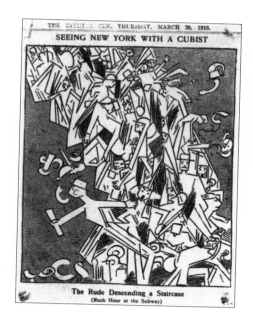

THE EVENING SUN, THURSDAY, MARCH 20, 1913.
SEEING NEW YORK WITH A CUBIST

The Rude Descending a Staircase
(Rush Hour at the Subway)

The New York Sun's spoof of Duchamp: "The Rude Descending a Staircase"

States were the most successful artists in the Armory Show. Jacques sold all nine paintings, Raymond sold three out of four sculptures (one was the first sale after the opening), and Marcel sold all four of his works, one of them at a higher price than any fetched by the works of his two older brothers.

The *Sad Young Man on a Train*, which was then called simply *Nu*, was sold for $162 to Manierre Dawson of Chicago, *The King and Queen Surrounded by Swift Nudes*, with the "Swift" omitted from the title, fetched $324; while the *Chess Players* also went for $162. The latter two went to the pioneering collector of modern art Arthur J. Eddy, a lawyer who had created a stir in his native Chicago some years before by being the first person to ride a bicycle there and the first to own an automobile. Eddy bought the *Chess Players* on March 1, 1913, then rushed back to the Armory the following day to pick up the *King and Queen Surrounded by Swift Nudes*. The notorious *Nude Descending a Staircase* was bought on March 5, via telegram, by the San Francisco art dealer and decorator Frederic C. Torrey. Torrey was a friend of Michael and Sarah Stein, the brother and sister-in-law of Gertrude Stein, all of whom collected modern art. Aboard a train to San Francisco, he was seized by a sudden desire to own the *Nude*. When the train stopped at Albuquerque, New Mexico, Torrey dashed into the station and wired the purchase money. He paid $324.[6]

As for the artists themselves, the only foreigner of any stature who was present in the United States during the Armory show was Duchamp's boon companion, Francis Picabia. Colorful, articulate, a master at generating publicity, he was interviewed repeatedly as to the meaning of Cubism, then a catchall description for all sorts of abstract art. He cheerfully described himself as one of its leading and most successful practitioners, attracting far more attention as a "Cubist" than Picasso or Braque. So provocative yet opaque were his pronouncements on the new art that the *Sunday World* offered, as a prize for the best explanation of Picabia's statements, a "Cubist" parody by one of its own artists.[7]

Along with spoofs, the Armory Show also attracted serious comments, a measure of the small but fervent congregation of American believers in avant-garde art. Joel Spingarn, a professor of philosophy at Columbia University, wrote, in a letter to the *Evening Post*: "The virtue of an industrial society is that it is always more or less sane. The virtue of all art is that it is always more or less mad. But here was madness and here was courage that did not fear to be mad." And the New York banker James A. Stillman commented prophetically: "Something is wrong with the world. These men know." [8]

After a six-month stay in America (he had planned only a four-week visit), Picabia returned to Paris so inspired that he quickly painted three of his best-known works. Certainly he told Duchamp about the great American art brouhaha as well as the opportunities for artists in the United States.

Duchamp had indulged his newfound taste for travel during the summer of 1913 with a trip to England. He worked on more notes for the *Large Glass* while spending several weeks at Herne Bay, Kent, chaperoning his sister, Yvonne, who was taking a course in English.[9] In October, he moved from Neuilly back to Paris, away from his brothers in Puteaux. It was in his new studio at 23 rue Hippolyte, during the winter, that he drew a full-scale study for the *Large Glass* on the plaster wall.

All traditional painting was now behind Duchamp, and the path ahead was strewn with scraps of science, literature, mathematics, philosophy — and mockery. "I wanted to get away from the physical aspects of painting," he told George Heard Hamilton in 1945. "I was interested in ideas — not merely visual products. I wanted to put painting once again in the service of the mind."[10] To engage the mind, Duchamp scribbled word upon word into his notes even though he found words unreliable. They are "absolutely a pest as far as getting anywhere," he told Arturo Schwarz in the 1960s. "You

cannot express anything through words because language is an imperfect form of communication."[11] But, in a typical contradiction, Duchamp himself blurred this cerebral self-portrait by a completely contrary image. As he confided to another interviewer in 1967, he had only a "mediocre desire" to be artistically cultured. "Deep down," he told Pierre Cabanne, "I'm enormously lazy. I like living, breathing, better than working ... my art would be that of living: each second, each breath is a work which is inscribed nowhere, which is neither visual nor cerebral. It's a sort of constant euphoria."[12]

During 1914, Duchamp found a way to reconcile these warring self-images in a visual form, at one stroke putting visual art "at the service of the mind" while barely ruffling his admittedly lazy nature. At a Paris costermonger's, he bought a wrought-iron bottle rack and inscribed on it a phrase or title that he claimed he soon forgot. He also bought three copies of a cheap, banal landscape print and added a touch of green and red paint to each. In the lower right corner, he carefully lettered the words *Pharmacie* — Marcel Duchamp, 1914." Though as yet unnamed, these two nonworks for the first time expressed a point of view that would run, like a shudder, through the world of art under the general title of "readymades."

Pharmacy, however, also had a more personal meaning. Once again, a trip to Rouen, to parents and Suzanne and childhood memories, jarred Duchamp's creative faculties. *Pharmacy* was executed on a homeward-bound train, a startling example of how Duchamp muffled his feelings inside an emotionally neutral aesthetic statement. Only the tiny red and green dots applied to the store-bought print indicate a personal meaning. The colors are those of the water in the bottles traditionally displayed in a drugstore window, suggesting (as did the overall subject) a reference to Suzanne, whose marriage to the pharmacist was to end in August of that year. The colors could also represent the "stop" and "go" of traffic signals in another cryptic reference to Duchamp's ambivalent, and perhaps only half-realized, feelings about his sister. He later told the Surrealist writer André Breton that the added spots were actually "two tiny figures, one red, the other green, walking toward each other in the distance."[13] Asked in 1961 whether they might represent Marcel and Suzanne, Duchamp scoffed, saying the work's significance was as "a distortion of the visual idea to execute an intellectual idea,"[14] a matter of wrenching something arbitrarily out of one context to place it in another. But perhaps Duchamp was himself wrenching this work out of an emotional context into a dry, intellectual one.

In 1914, the intellectual concept that most fascinated the artists around Duchamp was the fourth dimension, particularly speculation about it as a physical phenomenon added to the three spatial dimensions. While Hermann Minkowski had already done his key work describing the fourth dimension in terms of invisible time, the Puteaux artists were still chasing the chimera of somehow visually representing it. This had been the goal of several theoretical mathematicians during the nineteenth century. It also was a concept that fascinated Maurice Princet, a sometime teacher and insurance company actuary who floated among the Puteaux artists in the guise of a half-occult mathematician. The American artist Max Weber, who had studied in Europe (and who is not to be confused with the German sociologist of the same name), had described his notion of the fourth dimension in 1910 as "consciousness of a great and overwhelming sense of space magnitude ... the immensity of all things ... the ideal measurement." Princet claimed to see examples of this fourth dimension in African sculpture as well as in Classical Greek works.

When the Puteaux Cubists began to form their theory, they proposed a fourth dimension made visible through the artist's "systematically moving about objects, or by his turning them mentally." A mathematician named Jouffret believed that an individual could "see" the fourth dimension like a blindfolded chess player who carries on twenty-two games at once, by reflection in "an interior mirror." But Metzinger went further. He agreed with another mathematician, Jules-Henri Poincaré, that it was possible to depict the fourth dimension visually, "through a conceptual art form, freed from slavery to the illusion of perception, by the action of intuition and intellect."[15]

To the young Duchamp, the idea of solving the riddle which had baffled his two older brothers and their friends must have been enormously appealing. One is tempted to surmise that he took the job in the Bibliothèque Sainte-Généviève with research on this matter in mind, at least partly. His mass of notes on the subject indicate that he devoted a great deal of time and effort to speculation on how to breathe visual life into an essentially invisible concept. Citing Jouffret, he noted that "the shadow cast by a four-dimensional figure on our space is a three-dimensional shadow." Therefore, he reasoned, in the same way as architects draw two-dimensional representations (floor plans) of a three-dimensional building, "a 4-dim'l figure can be represented (in each one of its *stories*) by three-dimensional sections.

These different stories will be bound to one another by the 4th dim."

After much fruitless speculation along these lines, Duchamp must have concluded that Jouffret was right: the fourth dimension was visible only as the chessboard was to a blindfolded player, on an "interior mirror." He then considered representing the fourth dimension in terms of a trick: taking two deck chairs, for example, "one large and one doll-size ... to establish a 4-dim'l perspective — not by placing them in relative positions with respect to each other in space but simply by considering the optical illusion produced by the difference in their dimensions." And then, still with Jouffret's interior mirror in mind, he hit on the concept of simply using a real mirror. "Use transparent glass and mirror for *perspective*," he scribbled hastily. "The 4-dim'l continuum is *essentially* the mirror of the 3-dim'l continuum."[16]

By this time, Duchamp was scanning the library stacks for further data. "Perspective," reads one of his notes. "See Catalogue of Bibliothèque Ste. Géneviève the whole section on Perspective. Niceron (Fr., S.J.) 'Thaumaturgus opticus'" — a reference to a 1638 French translation of a work by Jean-François Niceron: *La Perspective curieuse ou magie artificielle des effets merveilleux*. Included in it is a suggestion for using a glass panel to create magical perspective.[17]

Duchamp's foray into such abstruse corners of scholarship hardly attracted many followers. After his appearance at one of her dinner parties, Gertrude Stein tartly wrote to Mabel Dodge: "He looks like a young Englishman and talks very urgently about the fourth dimension."[18] Picasso joked about Georges Braque's theoretical musings in similar terms: "Oh no! He'll be talking about the fourth dimension next."[19]

While Duchamp's speculations on the fourth dimension ultimately went no further than dinner table chatter and cryptic notes, his ruminations on the use of glass changed his entire concept of the major work he had begun in Munich, *The Bride Stripped Bare by Her Bachelors, Even*. While originally he had planned a large canvas, he now realized that to achieve the sought-after effect, the work would have to be done on glass. Like many other artists, he had been using a glass slab for a palette. He was also aware that a painting behind glass would be less prone to deterioration than on canvas. He had seen Kupka experimenting with this medium and on his Munich visit may well have viewed the glass paintings by some of the *Blaue Reiter* artists. Now, with the additional possibility of discovering the elusive fourth dimension, Duchamp set about a series of experiments with methods and materials.

The first was called *Glider Containing a Water Mill in Neighboring Metals,* executed in oil paints and lead wire on glass, and then sandwiched between two more glass plates. Later, he created the *Nine Malic Molds* on glass, using mostly sheet lead and wire instead of paint. In the *Malic Molds,* Duchamp envisioned first eight, then nine molds, each representing a "male-ish" occupation in which illuminating gas would be "cast" from a mold as part of the bachelor mechanism of the *Large Glass.*

Like the chocolate grinder, these figures originated in concrete experience. One of his favorite books, Duchamp later said, had always been the Larousse dictionary, a multivolume compendium which, far from merely defining words, also illustrates concepts and mechanisms, much like an encyclopedia.[20] The Larousse itself actually contains very few illustrations, but *La Grande Encyclopédie inventaire raisonné des sciences, des lettres et des arts* features many, showing mechanical and scientific hardware in a typically schematic, factual style. This was the same style that Duchamp adopted in 1913 in his sketches for the *Large Glass.*

Sometime during this period, Duchamp had scribbled a cryptic note:

> *Preface:*
> Given 1° the waterfall
> 2° the illuminating gas
> *we shall determine* the conditions for the instantaneous state of Rest (or allegorical appearance) of a *succession* (of a group) of *various facts* seeming to necessitate each other under certain laws, *in order to isolate the sign of the accordance between,* on the one hand, this *state of Rest* (*capable* of all the *innumerable* eccentricities) and, on the other, a *choice of Possibilities* authorized by these laws and also *determining them.*[21]

The material covered by this baffling note would occupy Duchamp for the rest of his life; the title of his final work came from the first three lines. But during these early years, he may well have consulted the *Grande encyclopédie's* thirty-eight-page entry under "Gas." Three of these pages describe various scientific devices for measuring and analyzing gases, and among the many illustrations is one for the Doyère, a device that strikingly resembles a prototype for the *Malic Molds.* Duchamp envisioned these objects as molds for the "illuminating gas" that the bachelors in the *Large Glass* spray fruitlessly in the direction of the bride. The encyclopedia drawing of the Doyère apparatus appears to have been his model.[22]

A playful explanation for the *Malic Molds* centers on malic acid, a wine-making additive derived from the apples that then were a principal crop in his native Normandy. Duchamp could well have found it amusing to imprison the bachelors inside molds derived from apples, the fatal fruit in the Garden of Eden. Tainted with the essence of apples, the bachelors were condemned to mortality. A more sinister explanation lies in Duchamp's title for a preliminary study of this work, *Cemetery of Uniforms and Liveries.*

In addition to being experiments in working with glass and in incorporating mechanical objects into works of art, the *Glider* and *Malic Molds* represent speculations on a new kind of perspective. The idea of using glass for such a purpose was widely suggested during the nineteenth century.[23] But such speculations all go back to the Renaissance, and most particularly to Leonardo da Vinci.

Leonardo was particularly fascinating to Europeans at the turn of the last century. The shadowy figure of the multisided Renaissance genius, the man whom Kenneth Clark described as "the most relentlessly curious man in history,"[24] had just recently been revealed in his full dimensions. Only in 1883 did Jean Paul Richter decipher all known da Vinci notebooks and publish an English version.[25] Between 1881 and 1889, Charles Ravaisson-Mollieu published four volumes of facsimile and translation into French, a labor considered so astounding at the time that the Académie française awarded it the Prix Bordin as "a first-rate monument of scientific and artistic restoration."[26]

Each age selects its own heroes from the past. They are invariably the men and women who reflect its own concerns, who dreamed similar dreams, and, above all, asked similar questions. To the world of the 1880s, no historical figure could have been more appropriate than Leonardo.

This world was obsessed with exploring itself, whether it sent expeditions to find the source of the Nile or scrutinized bacteria through a microscope. Leonardo was the perfect hero for such an age; his notebooks revealed, for example, how he waited for the death of a centenarian in a Florence hospital so that he could dissect the old man's veins. Europe was fascinated with great works of engineering, most notably the Eiffel Tower, built in 1889, and the Firth of Forth Railroad Bridge, completed in 1890. Leonardo had suggested ways to divert the River Arno that not even modern engineers could accomplish and planned a colossal (twenty-six-foot) equestrian monument to his patron, Francesco Sforza, that defied the bronze-casting technology of his day.

During the last quarter of the nineteenth century, the invention of machines was so prolific that it can only be described as a craze. Popular encyclopedias devoted hundreds of pages to detailed descriptions and drawings of machines for embroidery, hemming, generating electricity, harvesting wheat, or pitting cherries. And it was during this period that Leonardo was first revealed as, not primarily the painter of the *Mona Lisa*, but the man who invented new catapults and a type of tank, and who drew and built model after model of contraptions for flying. The age that was in love with the gadgetry of swivel chairs, folding beds, and electric massagers could not fail to fall in love with Leonardo, who described a type of alarm clock that wakens a sleeper by violently jerking up his feet at the required time.

The English and French translations of the notebooks triggered a decades-long surge of interest in the workings of Leonardo's mind. The poet Paul Valéry, in a long essay in 1895, was struck by Leonardo's peculiar comments on sexual intercourse: "Love in its fury is so ugly a thing that the human race would die out if those who practice it could see themselves."[27] In 1910, Sigmund Freud chose Leonardo as the first subject to undergo posthumous psychoanalysis. And to the German sociologist Max Weber, Leonardo was the archetype of those "artistic experimenters [to whom] science meant the path to *true* art."[28] For many artists in the early twentieth century, the new and complete versions of the *Treatise on Painting*, previously translated only in jumbled and abridged form, were hardly more fascinating than the scientific portions of the notebooks, with their emphasis on mechanics, optics, and perspective. When the Puteaux artists at Villon's suggestion had styled themselves La Section d'Or, it was after the Golden Section that Leonardo had described in his treatise.[29] But no other artist of this period assimilated Leonardo da Vinci as closely as Marcel Duchamp — and Duchamp did so much more than artistically.

"My landscapes begin where da Vinci's end,"[30] Duchamp told an interviewer in 1963. Given the da Vincian footprints visible in Duchamp's oeuvre, he could only have been referring to those inner landscapes of heart, mind, and spirit that shape the work and life of an artist. For the parallels between the two men are striking, in their speculations as well as in their lifestyles and personalities.

The sketches and scribblings gathered in *Notes and Projects for the* Large Glass, just like the *Notebooks* of Leonardo, are a collection of wide-ranging reflections on such matters as the relationship of art and science and the aes-

thetics of machines. The tone of Duchamp's notes, most of them written between 1911 and 1915, seems almost self-consciously da Vincian. Duchamp noted, for example: "Comparison. Given a cube — its reflection in a mirror — one could say that a straight line (perpendicular to the plane of the mirror) will not intersect the cube's image — because the eye goes around the line without thickness."[31] Here is a typical note from da Vinci: "Perspective is nothing else than seeing a place (or objects) behind a plane of glass, quite transparent, on the surface of which the objects behind that glass are to be drawn."[32]

Like da Vinci, Duchamp interlarded his written thoughts with sketches of mechanical objects, some of them remarkably similar in style to Leonardo's. Duchamp's problem was that in the twentieth century, an artist would look ridiculously presumptuous if he overtly identified himself with such a genius as Leonardo da Vinci. Moreover, an artist of the avant-garde, who claimed to be overthrowing the past, could hardly invoke a figure from the Renaissance as his model. Yet in many ways Duchamp, the most cerebral artist of the twentieth century, saw himself as a spiritual heir of Leonardo, the most cerebral artist of the Renaissance.

Like Duchamp, Leonardo built his reputation on a shockingly meager oeuvre (only seventeen of his paintings survive). And, like Duchamp, he left many of his works unfinished — the *Mona Lisa* is just one example — while others, like the *Last Supper*, quickly deteriorated because of his persistent technical experiments. Similarly, Duchamp's masterpiece, the *Large Glass*, was left definitively incomplete in 1923 and broken almost beyond repair four years later.

"This is to be a collection without order," da Vinci wrote in his first note on painting on March 22, 1508, "taken from many papers which I have copied here ... hoping to arrange them later."[33] Duchamp, too, scribbled his hasty notes on paper scraps and even published them on separate sheets in no particular order. And, like da Vinci, he saw his writings as the key to understanding his works.

However, where da Vinci's inquiries are relentless, direct, and earnest, Duchamp skims over the surface of his queries and twists them into a mockery of themselves. Thus, Leonardo describes a recipe for Greek fire: "Take charcoal of willow, and saltpetre, and sulfuric acid, and sulphur, and pitch, with frankincense and camphor, and Ethiopian wool, and boil them all together. This fire is so ready to burn that it clings to the timbers even

under water."[34] Duchamp echoes with absurd instructions for breeding colors in a greenhouse:

> *Perfumes* (?) of reds, of blues, of greens or of grays heightened towards yellow, blue red or weaker maroons ... These perfumes with physiological rebound can be neglected and extracted in an imprisonment for the fruit.
>
> Only the fruit still has to avoid being eaten. It's this dryness of *"nuts and raisins"* that you get in the ripe imputrescent colors.[35]

Da Vinci tries to bring order into the natural world: "There are 11 elementary tissues ... the divisions of the head are 10, viz. five external and five internal";[36] and Duchamp mockingly describes a parallel process: "Classify combs by the number of their teeth."[37] The curiosity of these two men, so separate in time, so congruent in temperament, ran in the directions dictated by their milieu. By 1911, of course, many of the questions da Vinci had been asking so persistently had been answered. Duchamp's questions, like his mental landscapes, begin where da Vinci's end. But it was not only in the tone and drift of their notions that these two men, almost four centuries apart, walked the same road.

Viewed psychologically, as personality types and as products of a particular background, the parallels between Duchamp and da Vinci become even more suggestive. Like Duchamp, da Vinci was the son of a notary and restlessly traveled all his life. Vasari accused Leonardo of having wasted his life and abilities on a thousand chimeric projects. What significance could Duchamp's contemporaries possibly see in his sketch of a coffee mill? Da Vinci never married and is generally considered to have been homosexual. Duchamp's behavior prompts questions about his sexuality: he married once momentarily and once very late, chose a female pseudonym, and frequently had himself photographed as a woman. Da Vinci never held steady work, but was supported by a series of patrons. To this life style Duchamp also aspired, quite successfully.

Emotionally, da Vinci was utterly detached. As Freud notes in his famous retrospective psychoanalysis of the Renaissance genius, the only reference Leonardo makes to his mother's death in his *Notebooks* is a careful accounting of her funeral expenses.[38] Similarly, the only way Duchamp could express his feelings about Suzanne's marriage or his own misadventure with a mistress and child was through a series of mechanized paintings suppos-

edly depicting a disembodied bride. Both men also channeled deep aggressive drives into mild and passive behavior. Leonardo was a vegetarian and bought birds in the public market in order to release them from their cages. He also designed devastating weapons. The easygoing Duchamp endowed portraits of his family with murderous titles and was to become addicted to the war game *par excellence*: chess.[39]

In the early years of the twentieth century, Leonardo was seen as a consummate genius. His "greatest contribution," wrote the historian of science George Sarton, "was his method, his attitude; his masterpiece was his life."[40] Of Duchamp, his old friend Henri-Pierre Roché said: "His finest work is his use of time."[41]

Even physically there seems to have been an arresting resemblance between the two men. Because of his "extraordinary physical beauty and nobility of character," Leonardo appeared divinely endowed to his contemporaries.[42] In 1922, André Breton described Duchamp as having "a face [of] admirable beauty ... elegance ... a truly supreme *ease*."[43]

In his paintings, da Vinci was preoccupied with defining space and creating illusions of depth as three-dimensional space. He also strove to represent pictorially the inner essence of natural phenomena. Duchamp, too, devoted himself to the quest for pictorial representation of an inner essence, and built onto da Vinci's typically Renaissance search for the third dimension a typically twentieth-century quest for the fourth.

Both da Vinci and Duchamp chafed at the popular notion of the painter as a mere craftsman and deplored not only those painters who imitated the work of others, but those who aped themselves. "He who despises painting loves neither philosophy nor nature," wrote da Vinci. "Painting surpasses all human works by the subtle considerations belonging to it ... Painting declines ... when painters have no other standard than painting already done."[44] Duchamp bridled at the nineteenth-century French phrase *"Bête comme un peintre"* (dumb as a painter) and wanted to put painting, as he had said, "at the service of the mind." But this is also where we see an important divergence between the two men. In answer to da Vinci's perennial search for new craftsmanlike techniques in painting, Duchamp abandoned technique entirely and bitterly attacked those artists who took pride in it. In this regard, the mustache he was to scribble on the *Mona Lisa* represents far more than an act of artistic nihilism: it is also a gesture that points to the *Mona Lisa*'s ambiguous sexuality and a means of mocking its creator. It was

Duchamp's way of simultaneously identifying with and rejecting an attractive yet troubling model.

For the model of da Vinci was bound to have fatal flaws. There was no way, for example, to use science in the twentieth century as Leonardo had in the fifteenth. Duchamp therefore created "a simulacrum of science ... an amusing physics," which, while using the methodology of science, created an "ironic critique through humor." The result was works like the *Three Standard Stoppages*.[45] As Duchamp saw it, the difficulty in starting his landscapes where da Vinci's ended was in "getting away from logic."

In the way he sought to undermine the early twentieth century's faith in science and in art, Duchamp pointed not only to the radical, experimental forms of avant-garde art, but also to a return of the classical, the literary, and the ideological content of painting. But when this content returned, it was wearing a mocking smile, if not a cynical leer. Duchamp's notions of machines and chance as vehicles for creative expression filled an aesthetic niche, especially when they wore the already familiar cloak of an iconoclastic bohemian dandy. "What do you believe in?" Duchamp was asked; his reply: "Nothing, of course."[46]

Duchamp's speculations of 1911–15 had led him to the conclusion that the essence of the twentieth century is not in its beliefs, but in its doubts; not in its answers, but in its questions. His key question, "Can one make works which are not works of art?" parallels Wittgenstein's question, "Can one have thoughts which are not language?" But where Wittgenstein finally concluded that the answer was "No," Duchamp left his reply dangling even after he had died. The paradox is that while Wittgenstein's clarity brought about a revolution in the definition of language, Duchamp's ambiguity also set off a revolution in the definition of art. Because of his personal background and talents, Duchamp became a painter rather than a writer; he was more comfortable in a visual world than in a verbal one. But he could never entirely banish language from his life. Instead he chose as his secret model an artist out of the past, who was also a scientist, philosopher, inventor, and writer. Just as da Vinci felt that the mysterious quality of his notebooks was enhanced by his self-invented code — mirror-writing — so Duchamp pushed language to the ultimate horizon of its ambiguities, in his notes and in writings and interviews, and sometimes in seemingly cryptic gestures. In 1965, when a photographer asked Duchamp to sign his autograph book, the artist "jotted down his signature in a perfect mirror image."[47]

Leonardo had looked around him, seen a world brimming with problems, and then devoted his life to energetically exploring solutions. Duchamp had also scanned his world and derisively concluded, "There is no solution because there is no problem."[48]

Where Leonardo, perhaps naively, trusted science, Duchamp sardonically mocked it. He drew wholesale upon the hilarious spoofs of science developed by the playwright Alfred Jarry called Pataphysics. This pseudosystem entailed a contemporary alternative to Leonardo's antiquated wonderment, a combination, as the critic Roger Shattuck put it, of "scientific rigor and farcical wand-waving."[49] Jarry attacked the most sacred notions of conventional wisdom, drawing on the tradition of the French avant-garde since Flaubert and Baudelaire: *épater la bourgeoisie*. Thus, he gleefully called himself an abbé, specializing in positing such "canonical innovations" as the "Virgin and the Mannekinpis" and "The Suppository Virgin" and writing a short story titled "The Passion Considered as an Uphill Bicycle Race." As he was dying of malnutrition, Jarry asked for a toothpick. In 1935, Duchamp was to pay a peculiar tribute to the playwright by designing a binding for a special edition of Jarry's masterpiece, *Ubu Roi*.

Like da Vinci, finally, Duchamp used art as a means of asking questions — some necessary, some perturbing, some waggish and farcical. Many have considered him a scientist, philosopher, social critic, and missionary. Certainly, he tried to liberate the artist from being the pampered pet of a patron-dealer and the focus of a tiny coterie of avant-garde cultists. Duchamp indicated the way toward a broadened role for the artist, from being simply a tickler of aesthetic sensibilities, as in the nineteenth century, to being an investigator, a commentator, and an interpreter of the world.

In 1913, Guillaume Apollinaire had predicted that Duchamp would "reconcile Art and the People."[50] While Duchamp put little stock in such portentous prophecies, and while the People find much of his work obscure, in his own, idiosyncratic way he did much to bear out Apollinaire's prediction. First, he asked the right questions. Second, he put these questions in such obtrusive form that they would attract attention. The supposed idleness and artistic "outrages" of the years after 1915 make sense if viewed as the clever contrivances of a publicity agent. In fact, as the number of works declined, the number of writings by, interviews with, and articles about Duchamp increased dramatically.[51] And yet, maddeningly, any attempt to bring logical analysis to Duchamp's work is doomed to failure.

There is an unmistakably Cartesian cast to the way Duchamp asked his questions and the way he answered them. He approached the question of what art is in precisely the fashion Descartes has famously approached the question of existence: "I think of art, therefore it is." At the same time, his relationship with Descartes was just as tenuous as his relationship with any other serious thinker. Late in life, Duchamp told an interviewer, rather drily: "I am not a Cartesian by pleasure. I happen to have been born a Cartesian. The French education is based on a sequence of strict logic. You carry it with you."[52] In fact, books in general were not among Duchamp's preoccupations; when he was offered a book to read, his stepdaughter recalled, Duchamp would sniff it, make a face, and turn away.[53]

◆ ◆ ◆

What would formally be called *The Box of 1914* was Duchamp's first halting recapitulation of his own work, the first of many. It was unique in its lack of uniqueness: an "edition" of five identical sets of notes mechanically reproduced. Of course, generations of artists, including Marcel's grandfather, had explored the multiplication of their work via etchings, lithographs, or engravings. But the notion of painstakingly reproducing scribbled notes and sketches in an "edition" was something new. Included were facsimiles of sixteen manuscript notes, some for the projected *Large Glass* and others for some even more esoteric works, plus a drawing, all mounted on matboards and assembled into a cardboard box that had formerly contained photographic plates.

For Duchamp to believe that the scribbled notes and casual sketches of an obscure young artist in Paris would interest anyone at all is surprising. That he would go to infinite trouble — another ritual — to match the paper stock and odd shapes of the originals is another surprise. But in fact, in "publishing" the *Box of 1914*, Duchamp displayed the steady arrogance that so often possesses outwardly modest people who are very bright. To further his intense ambition, he chose methods and media that would not tax his limited artistic talents, while highlighting his evident intellectual abilities.

Fernand Léger remembered Duchamp from this period as "a dry type, with something inscrutable about him." At an aviation show that Léger visited with Duchamp and the sculptor Konstantin Brancusi, the painter recalled that Duchamp "walked around the motors and propellers without saying a word. Suddenly he turned to Brancusi pronouncing that 'Painting

is finished. Who can do anything better than this propeller? Can you?'"[54] Brancusi certainly tried; in 1915, he created the first of several versions of the sleekly aerodynamic *Bird in Flight*. But Duchamp's defiant remark illustrates his profound disgust with contemporary painting and sculpture, not to mention with the aesthetic politics swirling around them.

And not only aesthetic politics: as Europe lurched toward war, the atmosphere among the Paris avant-garde was fostering the kind of absurd manifestations that would break out as Dada in 1916 in Zurich and New York, and later spread, like an epidemic of grotesquerie, all over postwar Europe.

The anxiety and excitement called war fever gave a new, manic dimension to what had long been a tolerant haven for eccentricity. The sophisticated milieu of the Paris artistic avant-garde was suddenly outraged by the antics of Arthur Cravan, a Swiss-born Englishman whose real name was Fabian Avenarius Lloyd and who loudly maintained that he was a nephew of Oscar Wilde. Viciously reviewing the 1914 Salon des Indépendants in his private magazine *Maintenant*, Cravan decreed that "the first requirement for an artist is to know how to swim." The monumental Cravan — 6 feet 8 inches tall, weighing 240 pounds and a sometime heavyweight boxer — was once challenged to a duel by the chubby, sedentary Guillaume Apollinaire: the Englishman, Apollinaire said, had grossly insulted his mistress, the model and painter Marie Laurencin (a challenge that Cravan answered by publishing further insults in the next issue). Then a group of ten or twelve other artists who also felt injured by Cravan's reviews ambushed him one afternoon as he appeared to sell his publication from a pushcart at the Indépendants gallery. The resulting fracas ended at the nearest police station.[55]

The Cravan incident illustrates how explosive tempers were, even in the bohemian community of Paris. With France at war and almost all his friends mobilized, Duchamp understandably felt uneasy at home. Jacques and Raymond had been drafted, but Marcel was found "unfit for service," he said. He later claimed it was due to a heart condition, although no further evidence of heart trouble appeared until the day he died, at the age of eighty-one.[56] *The Box of 1914* contains a note that points toward another draft-evading condition:

> Removal.
> Against compulsory military service:
> a "removal" of each limb,

of the heart and the other anatomical units;

each soldier being already unable

any longer to put on a uniform, his

heart feeding telephonically

a removed arm, etc.

Then, no more feeding; each

removed part isolates itself.

Finally, a Regulation

of regrets from one removed part to another.[57]

In an interview barely a year later, Duchamp underlined that it may well have been his attitude, rather than his ailing heart, that kept him out of the army. "From a psychological standpoint," he told a reporter, "I find the spectacle of war very impressive. The instinct which sends men marching out to cut down other men is an instinct worthy of careful scrutiny." He found such a notion of patriotism "absurd," he said, because all people are alike. "Personally, I must say I admire the attitude of combating invasion with folded arms."[58] Small wonder that if he expressed a similar point of view in the xenophobic Paris of late 1914, he was, as he later said, "spared nothing in the way of malicious remarks," that Raymond's wife "reproved him for being behind the lines," and that "the atmosphere soon became intolerable."[59]

Toward the end of 1914, Walter Pach returned to Paris. Visiting with Duchamp, he described the excitement over the Armory Show and perhaps showed him some of the press clippings garnered by that signal event. As Duchamp recalled it, Pach one day urged him to come to the United States, while the two men sat on a bench in the Avenue des Gobelins.[60] Actually, however, Pach was surprised that Marcel wanted to leave France. "He says he would be glad to come to New York," the curator and critic wrote to his patron, the collector John Quinn. "I imagine his not serving in the war makes his position less pleasant."[61]

A few weeks later, Duchamp booked passage to the United States. When he arrived in New York in June, he was greeted as a Frenchman whose reputation, in one journalist's words, was "equaled only by Sarah Bernhardt and Napoleon."[62]

THE SS ROCHAMBEAU slid into New York Harbor on June 15, 1915, after a nine-day voyage from Bordeaux. Much later, Duchamp recalled being dumbfounded by the heat — "I thought there must be a fire somewhere" — but as quite often happened his recollection went astray, for it was actually a luminous spring day with a high temperature of seventy-one degrees.[1] At The Narrows, a small group of reporters climbed onto the ship from the bobbing pilot's boat. They jostled to interview a tall, slim, elegant young French artist, the creator of the most famous modern painting in America: Walter Pach, always alert to publicize modern art, had tipped off the press to Duchamp's arrival. Now, with his shock of light brown hair ruffled by the moist wind, the twenty-eight-year-old artist was modestly answering, through an interpreter, "a great many rude questions" with what one witness later called "smiling composure."[2]

Duchamp's reputation in America rested on the storm of publicity unleashed by the Armory Show in New York, Chicago, and Boston in 1913. In these cities, as well as in others where the public learned of the scandalous new art only through reading the Sunday supplements, the Cubists (as all modern artists were indiscriminately labeled) had been described with awe and puzzlement. Over the picture of the Duchamp brothers, the *New York Times* in March 1913 had run the headline: "Brothers Who Paint Those Queer Cubist Pictures." The caption beneath read: "These 3 Creators of 'Advanced Art' Seem Quite Normal and New Yorkers Who Know the French Cubists Assert that Outside of Their Studios They Look and Act not Differently from Other Men."[3]

The young man who found it difficult to get a word in edgewise among squabbling French avant-gardists suddenly found himself surrounded by "a halo of popularity," the result not only of the notorious *Nude Descending a Staircase* but also simply because he was French. While the Parisian elite may have viewed the Duchamps as provincial upstarts, New York's bohemian upper class revered anything French, whether dresses, literature, soufflés, or artists. The presence of a "smiling corrupter"[4] like Duchamp released a whiff of Paris far more delectable than a visit to the wartime city. Furthermore, Americans appreciated mavericks, and had even sent one to the White House in the person of Theodore Roosevelt. This was a public that welcomed iconoclastic attacks on "the precious and solemn and costly," the "fragile, aristocratic beauty" purveyed by American museums and critics.[5]

It was also a public that relished reading about the wild artistic doings in the ateliers of Montmartre. Gelett Burgess breathlessly described his visit to Georges Braque's studio in 1910: "To see him blush, when I asked to photograph him, and then turn to the monster on his easel, a female with a balloon-shaped stomach — oh, it was delicious to see big, burly Braque drop his eyes and blush." Of Picasso, Burgess had wondered, "Who buys his paintings? Germans, I suppose." He had described the Spaniard's studio as "an incredible jumble of junk ... a pell-mell of rubbish and valuables," studded with "pictures that raise your hair [and] fairly reek of the insolence of youth ... We gaze at his pyramidal woman, his sub-African caricatures, with eyes askew, with contorted legs, and — things unmentionable."[6]

In 1913, the Armory Show had not only brought such art to Americans for the first time, it had also pulled together a dynamic group of home-grown collectors, connoisseurs whose evangelism on behalf of modern art could only be augmented by their eccentricity, their flair for publicity, and, paradoxically, their typically American business acumen. The New York lawyer John Quinn would be described, a bit extravagantly, as "the twentieth century's most important patron of living literature and art."[7] His investment of $756 at the Armory Show brought into his growing collection a Duchamp-Villon bronze and three oils by Villon. These were hefty prices for those times. A year or so after Duchamp arrived in New York, Quinn bought at auction two Jules Pascins at $52.50 and $105, a Picasso at $37.50, and a Maurice Vlaminck at $67.50.[8] As for the bohemian bon vivant Walter Arensberg, along with a Villon oil bargain priced at $81, he acquired an enduring interest in the Duchamp family.[9] Particularly with Marcel, he

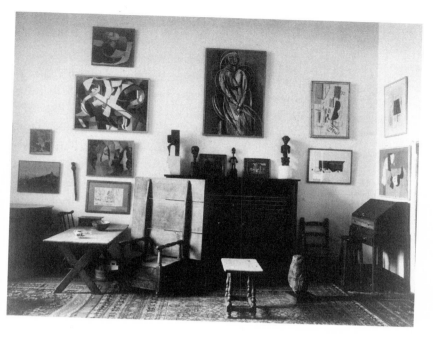

A study in contrasts: Walter and Louise Arensberg's New York apartment as photographed by Charles Sheeler, c. 1918, and (below) Duchamp's studio at 33 West 67th Street during that same period.

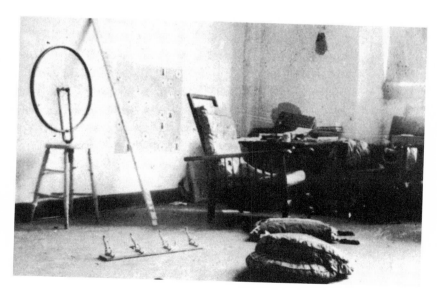

carried on not only a lifelong friendship but also a fascinating business relationship.

These patrons had been prepared for the outrageousness of the new European art by Walter Kuhn, one of the Armory Show's instigators. Surveying the Paris avant-garde, Kuhn was stunned to find that these artists made "absolutely no concession to any public, other than the will of the artist."[10] Such intransigence enchanted Walter Arensberg and his wife Louise, a couple who supported the new art, as well as new lifestyles, including open marriage. And so it was only natural that Walter Pach would soon bring Duchamp to their spacious, high-ceilinged apartment at 33 West 67th Street. The Arensbergs were away at their summer place in Connecticut, but Walter willingly allowed the young artist to stay on for three months in his absence.

Duchamp spent nearly all of his first half year in New York at a succession of such lodgings. After leaving the Arensbergs' in October, he passed a month house-sitting for friends of theirs in plush digs at 34 Beekman Place. In November, he came to rest a few blocks from the Arensbergs in the Lincoln Arcade Building at 1947 Broadway (a grimy, nondescript edifice later razed to make way for Lincoln Center). Arensberg paid the rent and in exchange was promised the *Large Glass*, which Duchamp now began to execute in its final form.[11] "Helping artists was a virtue for rich people," Duchamp explained in his comfortable old age. "Every period before democracy has done it to protect painters, to protect the arts, etc." Besides, Duchamp added, his needs were extremely modest; he "never borrowed much money, except for some small amounts from time to time."[12]

Despite a hectic new social life, Marcel still missed prewar Paris. The city he had left, he told a reporter in October, was "very different from the happy, stimulating life one used to encounter. Paris is like a deserted mansion. Her lights are out. One's friends are all away at the front. Or else they have been already killed." He also gave the first of many reasons for living in the United States: "I came here not because I couldn't paint at home, but because I hadn't anyone to talk to." But in New York, where there were lots of people to talk to, and (for the moment, at least) no danger of being drafted into a murderous war, Duchamp was also blocked. "I am very happy here," he said, "perhaps too happy. For I have not painted a single picture since coming over."[13]

Another interviewer was surprised that "instead of proving to be a very queer individual, he turned out to be retiring ... keenly interested in all New

York, from the latest musical comedy to Coney Island." Furthermore, the artist "dresses most correctly in the mode and is quite handsome, with blonde curly hair. One would take him for an Englishman rather than a Frenchman." Always providing the quotable snippet, Duchamp told this reporter that he had tried to obtain a studio in a skyscraper, "one of the highest," but was dismayed to learn that "people are not allowed to live in them." He also predicted that the postwar period would bring "a severe, direct art," whatever that might mean, and that it would originate in America. And he praised the American woman: she has "intelligence," he said, and "a wonderful beauty of line possessed by no other woman of any race at the present time."[14]

Finally, Duchamp rejoiced over the social freedom he discovered in America. As a Frenchman used to class distinctions, he told an interviewer many years later, he was struck by "the feeling of what a real democracy, a one-class country could be." He marveled that "people who could afford chauffeurs went to the theater by subway."[15] Such endearing remarks set the tone for a lifetime of such tidbits that Duchamp laid upon friendly interviewers.

Of course, few of the humble masses who actually had to ride the subway to work were ever guests of the Arensbergs. The gracious duplex, with its two bedrooms above a study, kitchen, and dining room, and with an immense eighteen-foot high studio/living room, was the setting for a distinctly American blend of old wealth and young talent. The apartment was in a substantial brick and sandstone high-rise built in 1904, one of a row which still stands, impassive and bulky, on the north side of West Sixty-seventh Street, off Central Park. Their polished brass plaques still call them studios, but they are far from being the cramped one-room quarters so styled today. The carved pseudo-Gothic portals of number 33 open into a cool and spacious marble lobby where a uniformed elevator operator waits by a red plush sofa. During 1915 and for a few years afterward, a parade of creative artists passed through the doorway and into that lobby, bound for the Arensberg apartment. It was "an incongruous international group," wrote one participant, "which turned night into day and was the rallying point of conscientious objectors of all nationalities expressing themselves in a fantastic outburst of sexual activity, jazz, and alcohol."[16]

Duchamp later described Arensberg as a Harvard man "with enough to live on."[17] Though Walter encountered the philosopher George Santayana

and the art historian Charles Eliot Norton at Harvard, he was not a scholar; he tried writing poetry, edited the *Harvard Monthly*, and was president of a literary society. After graduating in 1900, he toured Europe and lingered in Italy, where he translated Dante. Back in Cambridge, he flitted around Harvard, a desultory graduate student and teaching assistant in the English Department. In 1907, he married Louise Stevens, blending his own substantial Pittsburgh assets in banking and steel with her Boston fortune, derived first from rum and jute and later from textiles. When Charles Eliot Norton died in 1908, the newlyweds bought his home, Shady Hill, a showplace estate in suburban Brookline, Massachusetts.[18]

Arensberg was born in Pittsburgh in 1878; significantly enough, in view of his subsequent close friendship with Duchamp, he was exactly the same age as Marcel's older brother Raymond. But unlike Raymond, he flitted from the mundane — a brief stint as a reporter for the *New York Evening Post* — to the exotic, translating such French modernist poets as Laforgue, Verlaine, and Mallarmé. By 1914 he had published a volume of his own Imagist poetry.[19] His personality veered from obsessive, even paranoid, suspicion to ease, wit, and charm.[20] Louise shared his interest in avant-garde arts, especially in modern music.

While shunning heiress and patron Mabel Dodge's downtown "soirées," perhaps because they were too intellectual, Duchamp spent three or four evenings each week in the Arensbergs' virtually nonstop salon. In the midst of chess games and whiskey glasses and animated multilingual babble, he quickly became, as his first biographer swooningly put it, "a legendary figure," the "center of the Arensberg circle" for whose company the "entire New York intelligentsia vied."[21]

Certainly a significant cadre of America's avant-garde took part in the Arensberg gatherings. Until they ended, with the Arensbergs' move to Los Angeles in 1921, ostensibly because of Louise's asthma, the lively salon on Sixty-seventh Street attracted the best of American artists — John Sloan, George Bellows, Morton Schamberg, John Covert (Arensberg's cousin), Arthur Dove, Charles Sheeler, Joseph Stella, Charles Demuth, Man Ray, Marsden Hartley — as well as a number of European exiles, including Albert Gleizes, Jean Crotti, and Francis Picabia. Other frequent visitors were the poets William Carlos Williams and Mina Loy; the composer Edgard Varèse, who would meet his wife, Louise Norton, there; the theatrical Helen Freeman and the exotic dancer Isadora Duncan; the socialist writer

Max Eastman; a neurologist and art lover named Ernest Southard; and an assortment of art collectors and connoisseurs: Walter and Magda Pach, Katherine Dreier, Beatrice Wood, and the future novelist and sometime art dealer Henri-Pierre Roché, as well as the intellectual Stettheimer sisters — Florine, who painted; Ettie, who wrote; and Carrie, who would create the most unusual doll house in America.[22] Without a doubt, the most outré individual who appeared in these gatherings was Elsa von Freytag Loeringhoven, a self-styled baroness who claimed to be a hermaphrodite and waggled plaster penises at people. The baroness fell in love with Marcel and built his portrait out of found objects. Later, angered by his lack of interest, she wrote:

> When I was
> young — foolish
> I loved Marcel Dushit
> He behaved mulish.[23]

Man Ray recalled "a mixed crowd ... various women and Duchamp, who sat quietly in a corner playing chess with a neurologist" (Southard, no doubt). Bellows, whose paintings often depicted sporting scenes, threw an apple core into the fireplace "with the skill of a baseball player," while Southard rose from his chess game to give an extemporaneous lecture on modern art; he classified painters into categories: the rounds, the squares, and the triangles. Around midnight, Louise Arensberg would emerge from the kitchen, bearing a huge tray of cordials and brandy, Beatrice Wood recalled. This would be followed by an immense platter of chocolate éclairs, in a scenario that was repeated almost every night. The evenings rarely ended before 3 A.M.[24]

Small as New York's avant-garde community was, it nevertheless had its factions. While there was no overt break, relations were cool between the Arensberg circle and the group gathered around Alfred Stieglitz, whose Photo-Secession gallery at 291 Fifth Avenue was the first in America to exhibit European modern art, as well as the most advanced American painters. Since 1903, Stieglitz had sporadically published *Camera Work*, a magazine devoted to modern art.

After the Armory Show, *Camera Work* regularly carried articles trying to explain what were usually referred to wholesale as "the Cubists." Duchamp, Picabia, and an American follower, Arthur Dove, are all "trying to express

their emotions," Maurice Aisen explained in the magazine's pages in June 1913. They are "attracted to the same infinity ... the higher perceptions of things [which] at all times have been unable to express themselves with the already existing vocabulary."[25]

The Stieglitz group fostered a political and social radicalism quite foreign to the Arensberg salon's determined hedonism. From the point of view of an artist like Duchamp, who believed himself entitled to patronage, the moneyed, French-speaking folk around Arensberg were obviously better prospects than the hot-eyed radicals who noisily debated Art and Life in the back rooms at "291." As for Stieglitz, he was probably put off by Duchamp's aloofness from any kind of commitment, political or personal, though later he "repeatedly expressed regret" for not having exhibited the man's work.[26]

When asked about how he supported himself, Duchamp was vague; he later dismissed the question by remarking that he "wasn't getting so much per month from anyone ... things didn't cost much [and] rent was cheap ... I can't even talk about it."[27] One area he studiously avoided talking about was his dealing in art. Even before coming to New York, Duchamp had given Walter Pach several of his own works to sell, one of which had been bought by Arensberg.[28] After his arrival, Pach enlisted John Quinn to get him a job, "some sort of work that will save him from the necessity of living by the sale of his pictures." Quinn had already arranged for Belle Green, the formidable manager of the Morgan Library, to interview Duchamp but without result.[29] A few weeks later, Quinn paid Duchamp $120 for a study for the *Nude Descending a Staircase*.[30] During these months, the two men frequently saw each other, as Quinn invited Duchamp to posh dinners at Delmonico's or the Brevoort: "I like him very much,"[31] wrote Quinn to Pach. Near the end of August, Quinn decided that Marcel "looked thin," and invited him for a restorative week at The Essex, a hotel in Spring Lake on the stylish Jersey Shore; Duchamp thanked his benefactor with a quick pen-and-ink portrait.[32] And in October, again at Pach's urging, Quinn helped get Duchamp a job at the Institut Français, paying $100 a month, to perform unspecified work from 2 to 6 P.M.[33] "My hope is surpassed," Duchamp wrote in halting English. "I assure you that instead this work will be an obstacle for my own work, I will have the entire freedom which I need."[34]

Meanwhile, Duchamp was still trying to deal in others' art, notably a quantity of works by his brother Jacques Villon that he had brought with him to New York; the following summer he was still dickering with John Quinn

over three unsold Villon paintings. Quinn at last offered to buy all three for 2,850 francs ($550), at a discount of 25 percent, to which Marcel agreed.[35]

With Arensberg covering his rent, Duchamp augmented the income from his job by giving French lessons, mostly to socially prominent, well-off young women. Louise Norton recalled that "Marcel taught me all the French expressions no lady needs to know."[36] After 1917, he would also drop by at the elegant West 76th Street apartment of the Stettheimer sisters for light-hearted, flirtatious French lessons; they paid him two dollars per hour, even though they all spoke excellent French.[37]

All three Stettheimer sisters were considerably older than Marcel, and each one toyed at being in love with him. Yet, said one biographer, he was peculiarly able "to resist the devotion of his female admirers." He seemed to be "simultaneously in the midst of life and yet completely unapproachable."[38] In one of Florine's paintings of 1917, *La Fête à Duchamp,* he appears twice: once in the upper left-hand corner, waving from a car driven by Picabia, and again in the center, responding to a toast by her sister, Ettie. The cultivated and affluent daily life enjoyed by the Stettheimers — a round of parties, vacations, and celebrations — was supported by a married older brother who had acquired a fortune in the underwear business in California.[39] Florine usually drew the inspiration for her nostalgic, brightly colored paintings from this lifestyle. Often, among the flower-decked picnics and garden fetes, she included a dark bulky figure sitting alone, her neck severely encased in a black velvet choker, perpetually dealing Russian Bank. This was her mother, a formidable presence in the lives of her three spirited daughters. The father, Joseph, had "disappeared from the immediate life of his family," Florine's biographer tactfully wrote, when the children were still "extremely young." So bitter were his offspring toward him that, after Florine's death, Ettie carefully went through her diaries and cut out all "family" references.[40]

In *Sunday Afternoon in the Country,* another of Florine's paintings from 1917, Duchamp appears at the left, shyly posing for Edward Steichen's camera. *Picnic at Bedford Hills,* painted a year later, shows Florine looking wistfully on while her sister Carrie and Marcel set out the repast; Ettie reclines on a carpet, conversing with the sculptor Elie Nadelman. Florine's portrait of Duchamp, done in 1923, shows Marcel seated, rigidly elegant in an armchair on which the French and American flags are fraternally crossed. Perched high on a stool is an unidentified woman, probably Ettie.[41]

Though she was sixteen years older than Marcel, Florine found him a romantic figure, and apparently made him the subject of a coy and suggestive poem, "To a Gentleman Friend":

> You fooled me you little floating worm
> For I looked for the wings
> With which you seemed to fly
> And made you different from other worms
> And then I discovered the slender thread
> That fastened you safely to a solid tree
> I touched the thread
> With my fingertip
> And you wiggled
> I snapped the thread and you fell to earth
> And you squirmed and wormed
> And only wiggled.[42]

Frail and petite, with prominent blue veins streaking her thin white arms, Florine fixed a penetrating gaze upon the colorful world around her.[43] She painted herself as a bride, but never married. As for the man the sisters nick-

named "Duche," he "only wiggled." Despite his affection for Florine, he later complained that she "had no female body under her clothes." He found the three sisters "eternally ageless and girlish — forever romantically possible — but never probable."[44] When Florine died on May 13, 1944, she had seldom shown her works in public. But two years later, in September 1946, the Museum of Modern Art in New York sponsored a comprehensive show of her work, with Duchamp as guest director.[45]

With Carrie Stettheimer, Marcel also maintained a close yet impeccably distant friendship. Carrie took care of her mother and worked, until her death at over ninety, furnishing one of the world's most elaborate doll's houses, now at the Museum of the City of New York. The model even contained a doll-size art gallery, displaying tiny sculptures by Gaston Lachaise, Alexander Archipenko, and William Zorach, a miniature replica of a painting by Albert Gleizes, and Duchamp's 3-inch version of the *Nude Descending a Staircase*.[46] In 1974, the museum peopled Carrie's creation with tiny figures representing Mrs. Stettheimer, presiding over the tea table in black taffeta and lace, and the three daughters in glittering harem skirts.[47]

Ettie was the oldest sister, and, with her Ph.D. from Heidelberg, was considered the philosopher of the trio.[48] Everett "Chick" Austin, director of the Wadsworth Atheneum, described her entry into a room, "like a gypsy with a tambourine." The critic and novelist Carl Van Vechten — who, like Duchamp, was a frequent dinner guest of the three sisters — described how they would greet visitors: Florine, in white satin trousers and a flowing overdress of spangled net; Carrie, in satin, taffeta, or velvet and lace designed by Callot Soeurs or Bendel; and Ettie, in diamond-shaped garments of flowered brocade. Sometimes she wore a red wig. On fine china — Worcester, Rockingham, or Crown Derby — dainty morsels would be paraded before the diners: oyster salad, smelts stuffed with mushrooms, lobster in aspic and, perhaps, a Brabanter Torte, shipped all the way from Sacher's in Vienna.[49] The table talk would ramble through the latest artistic and personal scandals, both in New York and Paris. Occasionally, "when 'Duche' or Van Vechten attempted to spare the ladies too risqué a bit of gossip, Ettie would snap: 'We may be virgins, but we know the facts of life.'"[50]

In her novel *Love Days*, which she published under a pseudonym and which became a best-seller in 1923, Ettie drew a shrewd portrait of Duchamp, or, as she dubbed him (with a side-glance at Baudelaire), Pierre Delaire. The name suited him, she wrote: "stone of air ... hard and light;

like stone, dependable and definite, and immaterial and imponderable and cool like air; and as mysterious as their paradoxical combinations." He was "a cold-blooded fish, who can lose his head over no one, and doesn't pretend to." At the same time, Ettie noted Duchamp's flawless taste in art. "It was said he had turned down many a lucrative job as first aid to ignorant dealers." While he was beautiful, with "vital, fluid and adventurous long fair hair, brushed firmly back," he was also somehow lacking: "His delicate, fairish classicality of a dry and cerebral quality had all of beauty except beauty's peculiar thrill." And she was positively alarmed by his complete rejection of "convention," including "all intellectual tools that had become masters: language and logic itself and indeed all forms of culture that were past and yet potent." This iconoclasm, she suspected, was "the intellectual-aesthetic mask of his cerebral personality."[51]

◆ ◆ ◆

Ettie's "cerebral personality," meanwhile, was throwing himself into riotous New York night life. "We get to bed earlier (3 instead of 5)," he reported wryly to Louise Arensberg in August 1917, when she was in Boston visiting her family. In the same letter he also described a drunken brawl in a restaurant, begun supposedly when some ruffians at an adjoining table insulted the ladies with Arensberg and Duchamp: "Walter was knocked to the ground and I was boxed on the ear."[52]

Cocktails and the life that revolved around them fascinated Duchamp. He was often drunk in the midst of a crowd. His friend Henri-Pierre Roché describes one evening at a dance hall when Duchamp insisted on climbing the flagpole inclined at forty-five degrees over the gyrating throng; Duchamp would not be dissuaded, even though he almost fell several times.[53] On another occasion, Duchamp led a group of merry pranksters on a dawn raid of Albert Gleizes's icebox. After the hungry revelers had picked clean a roast leg of lamb, he returned it, along with a small check, to Gleizes's doorstep.[54] Out in a group, Duchamp gave an impression of great affluence. "He reached for the check so often," Roché recalled, "I assumed he was rich."[55]

In the midst of the nonstop party, Duchamp worked only fitfully at his art. This did not keep him from advising his benefactor John Quinn that he was "working hard. I have almost finished that big glass you have seen when I began it."[56] In truth, he had not touched it for weeks.

One of Duchamp's new friends, the photographer Man Ray, was surprised

Landscape at Blainville,
1902

(below)
*Portrait of the Artist's
Father,* 1910

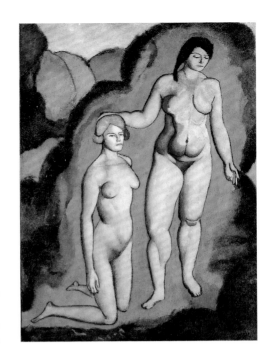

The Bush, 1910

(below)
Paradise, 1910

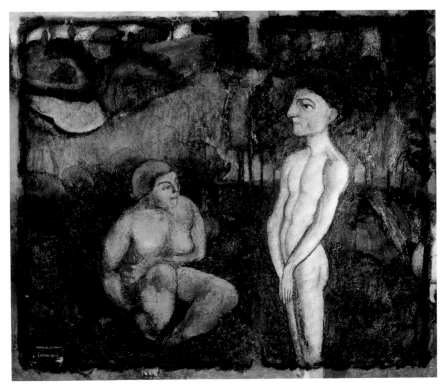

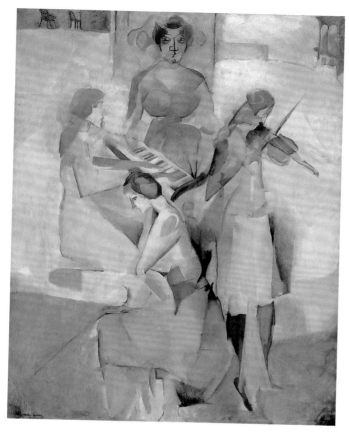

(top)
Sonata, 1911

Apropos of Little Sister, 1911

(top)
Yvonne and Magdeleine
Torn in Tatters, 1911

Young Man and Girl
in Spring, 1911

Dulcinea, 1911

(bottom)
Sad Young Man on a Train, 1911

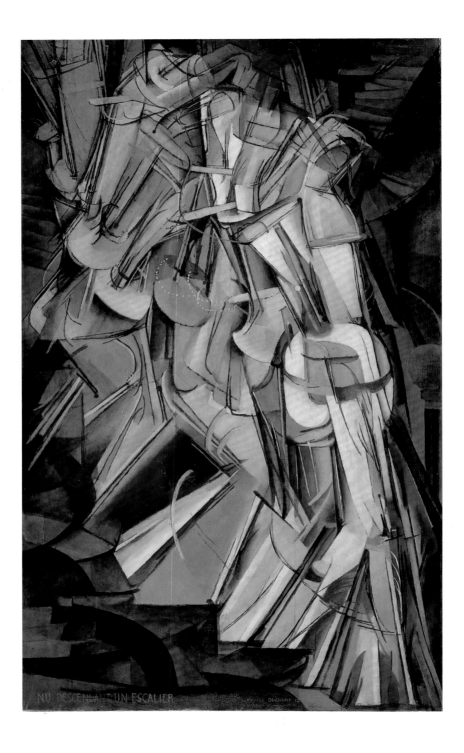

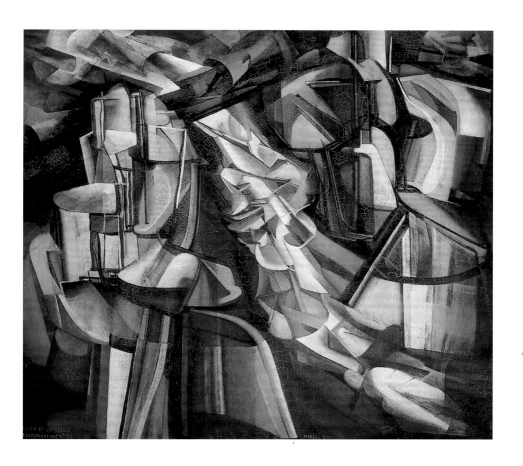

(left)
Nude Descending a Staircase, no. 2, 1912

(above)
The King and Queen Surrounded by Swift Nudes, 1912

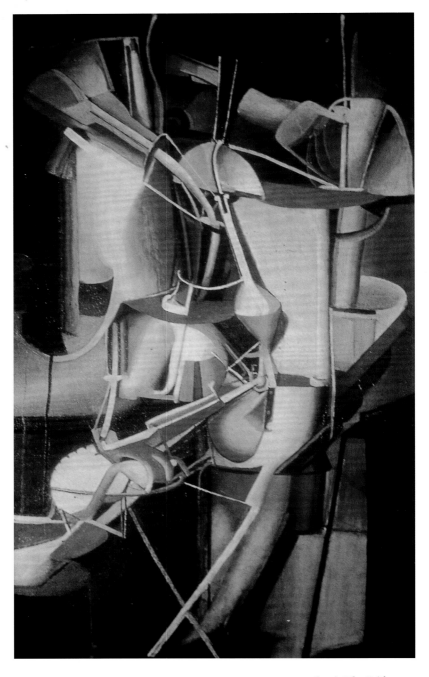

(top) *The Bride*, 1912

(top right) *Network of Stoppages*, 1914

(bottom right) *Nine Malic Molds*, 1914

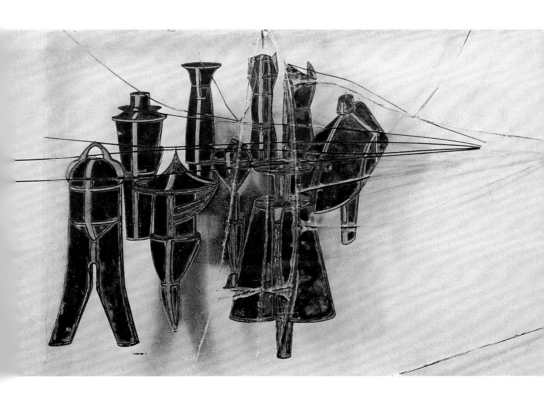

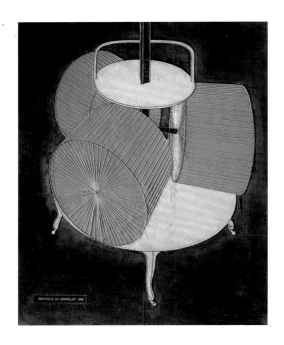

(left)
Chocolate Grinder II, 1914

(right)
Apolinère Enameled, 1916

(bottom)
Tu m', 1918

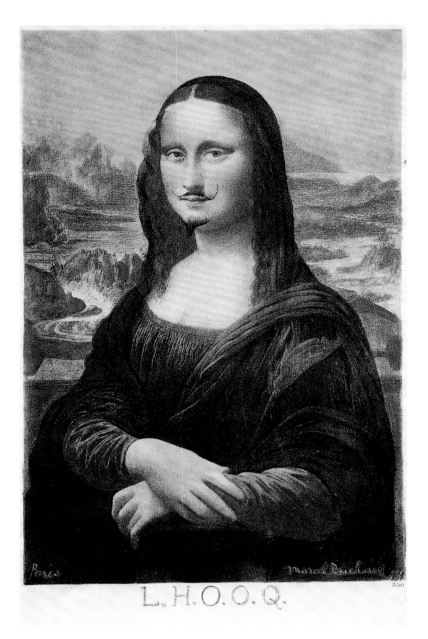

L.H.O.O.Q., 1919

(right)
The Bride Stripped Bare by Her Bachelors, Even, 1915–23 (unfinished)

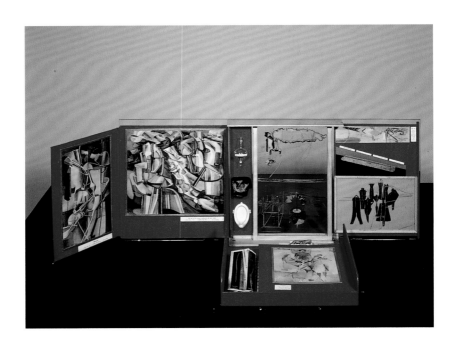

(top)
Box in a Valise, 1940

Genre Allegory, 1943

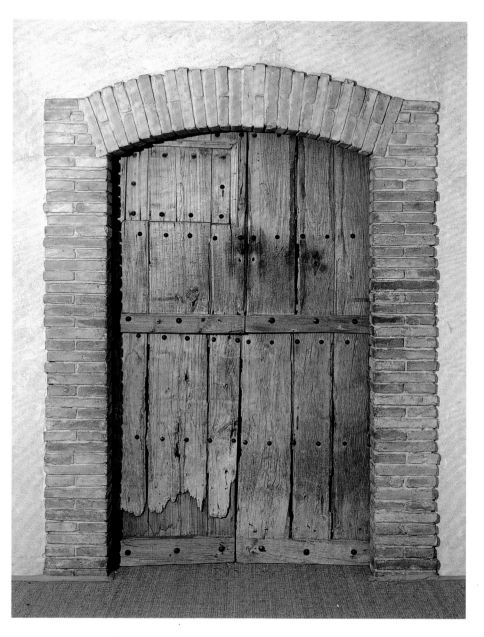

Given: 1. the waterfall, 2. the illuminating gas (exterior), 1946–66

(overleaf)
Given: 1. the waterfall, 2. the illuminating gas (interior)

to find that nothing in Marcel's Lincoln Arcade digs suggested a painter's workplace. Cheek by jowl with "printers, tire vulcanizers and nondescript shops," the large barren room looked "abandoned," the very center occupied by "a naked bathtub," with pipes running to the sink plumbing against one wall. "The floor was littered with crumpled newspapers and rubbish." By the light of a single unshaded bulb, Ray made out a few pictures by Villon, hung on the ceiling; a study of Suzanne leaning against one wall and, on a small easel, a glass and metal construction by Crotti. In a far corner, Ray saw a large piece of heavy glass, supported on trestles and "covered with intricate patterns laid out in fine lead wire." Only then did he become aware of the sooty, cracked and peeling walls, covered with "various precise drawings ... symbols and references." It was the beginning — but by no means the completion — of *The Bride Stripped Bare*.[57]

Man Ray and Duchamp first met in September 1915, when Arensberg brought the French painter to the artists' colony in Ridgefield, New Jersey, where Ray was then living with his first wife, Donna. Marcel spoke little English but "carried on a rapid dialogue" with the French-speaking Mrs. Ray. Ray brought out a couple of old tennis rackets, and he and Marcel batted a ball back and forth on the lawn in front of the photographer's ramshackle cabin. When Ray called out the score, Duchamp "replied each time with the same word: yes."[58]

Another lifelong friend met at the time was Beatrice Wood, who would become a leading twentieth-century potter. She first met Duchamp in 1916 in a hospital room, while visiting Edgard Varèse, who was recuperating from a broken leg. "We began to *tutoyer* immediately," she recalled sixty years later. "His smile was entrancing ... such a beautiful personality." But — and her hand moved level with the bridge of her nose — "he was dead from here down."[59]

"Why don't you paint?" Duchamp asked Beatrice, who was then perhaps twenty-three (she was always coy about her age)[60] and working in New York's National French Theater "to make money to run away from home." She explained that there was no room in her parents' apartment for a studio. Duchamp immediately offered his own, and for the next two years, Beatrice Wood spent one or two afternoons a week in the littered room in Lincoln Arcade, drawing and painting. "Sometimes he would be there, sometimes not," she later said. Wood recalled that Duchamp had a superb eye for drawing. "He would just point at something and say '*c'est bien*' or '*c'est pas bien*.'

I never could figure out why, but he was invariably right."

Duchamp introduced Beatrice to the Arensberg salon, where she met and fell in love with hia friend Henri-Pierre Roché. Another Frenchman eluding his country's wartime draft, Roché would later become known as the author of *Jules and Jim*, the basis for François Truffaut's classic film about a sexual triangle. He, Duchamp, and Wood formed a fun-loving threesome, exploring the jazz dens of Harlem or drinking wine in the Gallic atmosphere of the Hotel Brevoort in Greenwich Village. "Everybody fell for [Marcel]," Wood remarked, "though he was definitely not an emotional

Duchamp, Picabia, and Beatrice Wood at Coney Island, 1917

person." When her affair with Roché ended, she became intimate with Duchamp. It was "a close, easy friendship," she recalled. "I loved him, I dreamt about him, but somehow it didn't break my heart when we parted."[61]

In a new country and among new contacts, Duchamp also maintained his old relationship with Picabia, who had arrived from Paris almost at the same time as he. The publicity wave from the Armory Show had passed, but Picabia had decided that life in New York was more pleasant than driving a French general at the Western Front. Because of his Cuban connections, he had wangled a special mission to his father's native country, supposedly to buy molasses. But once in New York, Picabia fell suddenly and mysteriously ill and was declared medically unfit by a French military commission.[62] Psychologically, his condition was "feverish and tormented," shuttling between manic visits to the Arensberg salon[63] and fits of Iberian brooding in his Eight-second Street apartment "where chess reigned day and night" and "where the eccentricities of Marcel Duchamp were admiringly discussed."[64]

By the summer of 1916, after financing several issues of Alfred Stieglitz's avant-garde publication *291* — including a double number devoted to himself — Picabia had left New York to join his wife, Gabrielle, in Barcelona.

Though surrounded by admirers, Duchamp had also managed to make a few enemies among the American avant-garde. Some, like the art dealer Robert Coady, believed that all European art was effete, and that Americans would have to draw on native sources, especially the vitality of American industry and the spirit of the westward pioneers. Duchamp was hardly opposed to Coady's notion that American art should be inspired by the Panama Canal, the Portland cement works, and Charlie Chaplin; nevertheless, in 1917 Coady's little magazine, *The Soil*, published a parody of the vague, overblown discussions of European art that sometimes appeared in *Camera Work*. Under the headline "Cosmopsychographical Organization," he printed a collage of modern art, described in the caption as "infinity struggling for birth in the womb of the soul … surrounded by swift moving nudes … Pay[ing] homage to the absence of M_____ D_____." A few other American literati shared such views. In 1921, the poet Hart Crane would describe an ephemeral publication edited by Man Ray and Duchamp, *New York Dada*, as "a most exotic and worthless review … billets in a bag printed backwards on rubber deluxe, etc. What next!"[65]

But perhaps Marcel's harshest critic was William Carlos Williams, although for reasons that were more personal than aesthetic. The poet and physician was admiring *Sonata*, which hung in the Arensberg salon. "I like your picture," said Williams shyly, his French not up to carrying on a witty conversation. "Do you?" Duchamp coolly replied. "He had me beat all right," Williams sourly recalled in his autobiography. "I could have sunk through the floor, ground my teeth, turned my back on him and spat … I realized … there wasn't a possibility of my ever saying anything to anyone in that gang from that moment to eternity."[66]

The truth is that, in his disdain for the ruling Paris avant-garde, Duchamp had much in common with Coady and Williams. "Cubism means nothing at all," he flippantly told an interviewer. "It might just as well, for all the sense it contains, have been policarpist. An ironical remark of Matisse gave birth to it. Now we have a lot of little Cubists, monkeys following the motion of the leader without comprehension."[67] Interviewed in September 1915, he declared that "the American character contains the elements of an extraordinary art. Your life is cold and scientific … New York itself is a work of art

... and I believe that your idea of demolishing old buildings and souvenirs is fine ... The dead should not be so much stronger than the living. We must learn to forget the past, to live our own lives in our own time."[68] How much of that mélange of flattery and fiction was artistic credo and how much was simply contrarian piffle? Considering the multitude of contradictions Duchamp delivered over a long lifetime, it quite possibly signified little except the artist's desire for attention.

To his friends in New York, Duchamp insisted that his bridges were burned. It was "easier to isolate oneself in New York," thought Roché, presuming that an artist would benefit from isolation. Duchamp found it "more agreeable to participate in a budding culture than in one that is ripe and over-sure of itself." To an interviewer, much later, Duchamp indicated that "their urbanity permits the Americans more easily to withstand the shock of other people's idiosyncracies."[69]

For Duchamp, embracing America was more than anything a way of repudiating France and everything it symbolized: contentious artists, destructive patriotism, perhaps his own bourgeois roots. He had learned that the avant-garde in France, even the Cubists, evolved rules about art, rules by which his *Nude Descending a Staircase* could be rejected. Better to cast his lot with a brash, dynamic country whose artists would find inspiration in cement factories and steel mills.[70] The artist who could appreciate the beauty of a bicycle wheel slowly revolving atop a kitchen stool would surely find his staunchest admirers among the people who invented the Pullman railroad car and the automatic rocker, the sewing machine and the patented mechanical apple peeler.

◆ ◆ ◆

One crisp day toward the end of 1915, Duchamp impulsively bought a snow shovel in a hardware store on Broadway. Even he was never able to explain why. Perhaps it was part of what Ettie Stettheimer described in *Love Days* as "his philosophy of complete rejection of the trammels of convention."[71] Perhaps he was driven by what Beatrice Wood called "obsession with being anti-art."[72] After carving on the snow shovel's handle the enigmatic words, "In advance of the broken arm," he signed and dated it. Before the year was out, he had similarly chosen a sheet-metal chimney pot, this time inscribing it even more bizarrely: "Pulled at Four Pins," a literal translation of the French expression "*tiré à quatre épingles*" (dressed to the nines).

These were not Duchamp's first dabblings with everyday objects. Two years earlier, he had set up a strange contraption in his studio: a bicycle wheel, mounted vertically on a kitchen stool. As he later told Arturo Schwarz: "To see that wheel turning was very soothing, very comforting ... I enjoyed looking at it just as I enjoy looking at the flames dancing in a fireplace."[73]

Duchamp described these items as "brain facts" (*cervellités*), and named them, with his typical flair for publicity angles, "readymades." Almost immediately, too, he laid down rules for their selection, the first being: "Limit the number of readymades."[74] As he explained the procedure in 1961, "the choice ... was never dictated by esthetic delectation" but rather based "on a reaction of visual indifference with at the same time a total absence of good or bad taste ... in fact a complete anesthesia."[75]

This disclaimer of artistic value has not discouraged art critics from finding wondrous aesthetic qualities in these objects. Robert Motherwell called another famous readymade, the metal *Bottlerack*, a "more beautiful form than almost anything made, in 1914, as sculpture."[76] Various scholars have attempted to explain Duchamp's readymades as a reaction to improved technology in mechanically reproducing art. However, they could also have been part of the long-term reaction of artists to the inroads of photography on their traditional role.

Perhaps the strongest endorsement of readymades has come from the multitude of artists who have attempted to transmute everyday objects into works of art. These tributes respond to the evident aesthetic qualities of the readymades, which belie Duchamp's protestations of "anesthesia." If Duchamp had really been able to suppress his taste completely, he might have walked into the hardware bazaar on Broadway blindfolded and chosen an object by pointing to it. Instead, he chose a sturdy and functional snow shovel. In fact, every one of the early readymades speaks to the loftiest standards of contemporary good taste — honest materials, careful design for a particular purpose, natural color, simple shape. What Duchamp contributed to art with the readymades was not the *suppression* of taste, as he claimed, but the *extension* of taste to include the ordinary objects of everyday life.

By his selection of readymades, Duchamp also asserted that a work of art need not be unique but could be widely reproduced and still increase strikingly in both aesthetic and monetary value. Almost all the originals of the early readymades, including the bicycle wheel, the bottle rack, the snow shovel, and the chimney vane, were casually discarded and lost, a fact that

(left)
"Bicycle Wheel," 1913

"Bottlerack (Bottle Dryer)," 1914

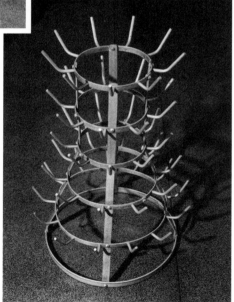

has been interpreted as a profound commentary on the ephemeral artifacts of modern society.

Duchamp amused himself for the rest of his life by resurrecting new versions of these objects from the scrap heap of contemporary civilization. As his financial needs dictated, he authorized reproductions and gleefully underlined the irony of getting respectable museum officials to re-create his works by signing the reproductions. The history of the *Bicycle Wheel* is typical of the persistent reincarnations undergone by the readymades. The 1913 original was lost, as was a 1916 replica; Duchamp merely signed a 1960 version in a Stockholm museum, and he also signed eight replicas marketed by Arturo Schwarz.[77] Yet, the many copies did not detract from their dollar value; an investment of $25,000 in one of the 1964 replicas would bring more than $1 million twenty-five years later.

Over the years, the readymades have also taken on a mythological and even occult aura. Duchamp's friend, the artist William Copley, once spent many days checking out a rumor that the original *Bottlerack* had been found, complete with signature, date, and forgotten inscription, on a New York junkman's truck. It was just a rumor.[78] Similarly enthralled, this author, visiting Blainville-Crevon in the fall of 1977, was startled to discover, while strolling from the central square to the Duchamp family home, a giant version of the *Bottlerack* protruding above a roadside hedge. She excitedly pursued this find into the farmyard where it stood; but on interviewing the farmer, she learned that this outsize homage to Duchamp was totally unconscious: it had been acquired in 1926 and was used simply to dry bottles.

To find oneself surprised that a bottle dryer should be used as a bottle dryer, rather than as a valuable art object, is to confront the enormity of Duchamp's originally rather casual act. One senses the aesthetic ground slipping away from under one's feet; the resulting uncertainty leaves one trying, on the one hand, to find beauty in both the bottle rack and the *Bottlerack*, and on the other, to avoid feeling tricked. The experience is as disquieting as coming upon a beast swallowing its own tail.

To Man Ray, who was profoundly influenced by Duchamp's readymades, the idea and not the object was always paramount "so that the loss or destruction of a readymade was of little consequence."[79] Duchamp obviously agreed: in 1916, he suggested the Woolworth Building as a monumental readymade, merely awaiting the proper title. Despite his principles, Duchamp found it hard to limit the number of readymades when his only

source of income was an occasional job, a tiny and problematic remittance from home, the sale of a sketch or two, plus a few superfluous French lessons at two dollars per hour.

During 1916 and 1917, Duchamp tested the market, so to speak, and found it to consist of exactly one reliable customer: Walter Arensberg. Even this loyal friend had to be primed, from time to time, with a gratuitous gesture. For example, one evening in January 1916, during dinner with the Arensbergs at the Café des Artistes at 1 West 67th Street, Duchamp leaped up and impulsively signed his own name to a huge old-fashioned battle scene painted on the wall behind him. The gesture, he explained, made the mural his own readymade; it had "everything except taste."[80] Early in 1916, he followed instructions on a note to himself scribbled some months earlier:

> Specifications for "Readymades," by planning for a moment to come (on such a day, such a date, such a minute) "to inscribe a readymade." — The readymade can later be looked for. — (with all kinds of delays). The important thing [then] is just this matter of timing, this snapshot effect, like a speech delivered on no matter what occasion [but] at such and such an hour. It is a kind of rendezvous.[81]

On February 17, 1916, at precisely 11:00 A.M., Duchamp kept that rendezvous by selecting a metal comb used for grooming animals and lettering on it, in white paint: "3 or 4 drops of height have nothing to do with shyness" — plus his initials and the exact date and time. A few months earlier, he had made a note to himself to "classify combs by the number of their teeth"[82] so that the comb may be seen as some sort of philosophical statement, perhaps the absurdity of scientific classifications of the material world. Much later, he said exactly the opposite; the comb was "a remark about the infinitesimal ... when you look at a comb, you just look at your hairs ... the number of the teeth of the comb is really unimportant."[83] But in view of its immediate fate, purchase by Arensberg, the comb also had a practical purpose: income.

Duchamp had tried a sort of dry run for the comb less than two weeks earlier, when he sent a block of four postcards, closely covered with a typed nonsense message in French, to the Arensbergs. It was titled *Rendez-vous du Dimanche 5 Février 1916 / à 1 h. ¾ après midi* and included such puzzling remarks as, "How not to marry one's least oculist rather than stand their curls?" This document is most interesting as a demonstration of the "auto-

matic writing" that would fascinate the Dadaists and Surrealists a few years later. How Duchamp's ironic soul must have glowed, after the passage of many decades, when he helped install this casual joke, now lovingly framed and labeled and lit, as a prominent part of the Arensberg Collection at the Philadelphia Museum of Art!

Also in the collection is the sole survivor of a trio of identical "semi-readymades" which Duchamp whipped out for Arensberg at Easter, 1916. For each, he pressed a ball of twine between two metal plates, held together with long bolts. One of the three contained a secret object, placed in the center of the ball by Arensberg before the final assembly; thus its title, *With Hidden Noise*. In 1955, Duchamp revealed that only his patron knew the nature of the object: "I will never know whether it is a diamond or a coin."[84] By October 1963, however, in connection with his first major retrospective show at the Pasadena Art Museum, Marcel knew exactly what it was. He whispered the secret to curator Walter Hopps,[85] who never shared the lonely burden of this confidence.

The message engraved on one of the metal plates was hardly less obscure. It was part English, part French, with certain letters left out or garbled. Even "deciphered" it is still a cipher, a blurred fragment from the unconscious of a man who consciously strove to obscure what he meant and often insisted it meant nothing. Perhaps more than anything, it was designed to intrigue Arensberg, who was fascinated by cryptography: Duchamp's

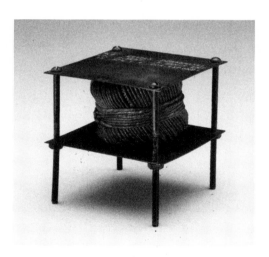

"With Hidden Noise," 1916

wealthy mentor spent a good part of his life trying to unlock a code in the works of Shakespeare that would prove they were written by Francis Bacon, and he left much of his large fortune to a foundation in Claremont, California, to pursue the search.

By making three identical versions of *With Hidden Noise*, only one of which harbored "noise," Duchamp perpetrated an artistic shell game that continues to fascinate the art world while mocking its pretensions. With these works, he exercised his characteristic talent for raising maddeningly unanswerable questions. For example: How many exact replicas of a work can an artist make and still call each one a work of art? Does the amount of hand labor or artistic talent invested by the artist bear any relationship to his work's aesthetic, or even monetary, value? To what extent does the "hidden noise" inside one of three apparently exact duplicates enhance its value, and why?

With his next readymade, Duchamp momentarily retreated from these nettling questions, in favor of a perhaps equally unsettling eroticism. It was an Underwood typewriter cover titled *Traveller's Folding Item*. The work was exhibited only once, during a three-week show at the Bourgeois Gallery in New York, from April 3 to 29, 1916, before disappearing from public view forever. As Duchamp explained it much later, the idea was to display this early example of soft sculpture on a stand high enough to suggest a woman's skirt, inducing the viewer to peek under it. "You have here another victim of gravity," he said archly.[86] Much later, too, it was reproduced in quantity and Duchamp duly signed each replica. Whether Arensberg bought the original typewriter cover or received it as a gift remains problematical; at one time, apparently, it was on display in a corner of his study.[87]

But the Duchamp that Arensberg most coveted was the one that had been sold from under his nose back in 1913 at the Armory Show, *Nude Descending a Staircase*. F. C. Torrey had hung his impulsive purchase in his home in Berkeley — on the stairway. His daughter recalled many years later how she would arrange to meet her dates "at a nearby sorority house, rather than subject my father to unkind remarks about his treasure."[88]

With the original out of his grasp, Arensberg kept pestering his friend to produce a replica and in 1916, Duchamp finally did. He obtained a photographic copy of the original and, using watercolor, pencil, pen and ink, and pastels, created a handmade reproduction; he playfully signed it "Duchamp (*fils*) 1912 … 1916."[89] Years later, Arensberg remembered Marcel's obliging gesture and repeatedly urged that his friend reproduce other works still out-

side the Arensberg collection. But, just as with the readymades, Duchamp realized that one must limit production. Arensberg persisted in his pursuit of the original *Nude* and eventually captured her in 1933; he paid Torrey $4,000.[90]

Despite the ready market for new paintings, or even replicas of old ones, Duchamp produced none, only a steady but sparse stream of further ready-mades. He suspended a wooden hat rack from the ceiling of the 67th Street studio and nailed a coatrack to the floor. This baffling obstacle he titled *Trap*, a word that in French (*trébuchet*) is also chess jargon for a pawn placed to trip an opponent's piece.[91] Both originals are lost, but replicas appear from time to time on the auction circuit.

Early in 1917, Duchamp returned to a readymade theme he had first touched on in 1914, in *Pharmacy*: he created *Apolinère Enameled*, an adver-tisement for Sapolin enamel which he doctored to make a wry suggestion that his faraway friend Guillaume Apollinaire fancied very young girls.[92] The reflection he painted in the mirror was also ironic, a parody of the clas-sical painter's skill in rendering reflections. Apollinaire himself was never to see it: the poet died of influenza during the epidemic of November 1918. But Arensberg was enchanted with Marcel's wit and readily bought this expres-sion of it.

So far, the readymades had been little more than a private joke between Duchamp and his enraptured patron. Visitors sometimes commented on the objects scattered so peculiarly around Duchamp's littered studio. But the idea that these humble items could be Art had not been tested against a wider public. At the very end of 1916, such an opportunity began to loom.

A group of Armory Show veterans organized an exhibition with the motto "No Jury. No Prizes. Hung in Alphabetical Order." The letterhead of the Society of Independent Artists, Inc., listed virtually every artist of any standing in New York: William Glackens, president; Charles Prendergast, vice president; and a board that included John Covert, George Bellows, Rockwell Kent, Joseph Stella, John Marin, Man Ray, and Maurice Sterne.[93] Duchamp was among the founders, along with Pach and Arensberg. He also was named chairman of the hanging committee with Bellows and Kent. As the entries arrived for the show, which was scheduled for April 10 to May 6, 1917, even the liberal, tolerant Independents were shocked to find among them a cast porcelain urinal, signed R. Mutt and titled *Fountain*.

With this work, the battle for artistic freedom that Duchamp had first directed at his brothers erupted again. When his urinal was "censored," as

expected, Duchamp indignantly resigned, charging that the no-jury promise had been violated. Stieglitz expressed his protest by taking a sensuous photograph of the offensive bowl.[94] Arensberg went even further: he marched down to the show at Grand Central Galleries and demanded to see the R. Mutt entry, insisting that he wanted to buy it. At first he was told that *Fountain* could not be located; but he strode directly toward a curtain behind which he knew it was tucked, placed it under his arm, and nonchalantly strolled through the crowded gallery toward the door. There he lingered, as Man Ray and Duchamp stood by, chatting with acquaintances, chain-smoking cigarettes, and tenderly grasping his new acquisition "as though it were a marble Aphrodite."[95]

A few months later, in an ephemeral publication ironically called *The Blind Man*, Duchamp defended *Fountain*:

> Whether Mr. Mutt with his own hands made the fountain or not has no importance. He CHOSE it. He took an ordinary article of life, placed it so that its useful significance disappeared under the new title and point of view — he created a new thought for that object ... As for the plumbing, that is absurd. The only works of art America has given are her plumbing and her bridges.[96]

The statement certainly reflected Duchamp's point of view, but the reality is that his English was not up to such a polemic. Arturo Schwarz has claimed that it was written by Roché and Beatrice Wood, who comprised the "editorial board" of *The Blind Man*.[97] But Roché's command of English was also uncertain, and Wood also disclaimed responsibility, not only for the statement on *Fountain* but for any portion of *The Blind Man*. While her name appeared on the publication's masthead as publisher, it was, she said, partly as a joke, partly as an expression of Roché's and Duchamp's affection for her, and partly because both men, as foreigners, feared that this daring publication might get them deported back to France, where they were liable for immediate induction into the hard-pressed French military.

Wood did, however, accompany Duchamp and Roché on endless visits to the printer while *The Blind Man* was being readied. It was financed by Mrs. Cornelius Whitney, who had been persuaded by Frank Crowninshield, the editor of *Vanity Fair*, to contribute $500. "Since my name was listed as publisher," Wood recalled, "the printer delivered all the copies to my house, ready for mailing." Her father, "a typical middle-class businessman," read

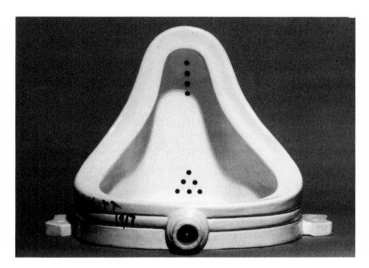

"Fountain," 1917

the sheet and was "horrified" to see "three words that no young girl should know." He persuaded Wood to contact Crowninshield and insist that *The Blind Man* not be mailed. "My father said otherwise I might end up in jail as a pornographer," Wood recalled. The magazine finally was distributed by hand to a small circle of initiates.[98]

As to who wrote the statement on *Fountain*, Arensberg, the experienced journalist, was probably the principal author. But the work itself made its own statement, and this was pure Duchamp. For it expressed once again the kinds of paradox and ambivalence that had occupied him ever since he stopped painting in 1912. Was it art or industry? Phallic or vaginal? "It was a man-made female object for exclusively male functions,"[99] ventured one critic — and that only begins to cover it.

By no means all New York champions of modern art approved of *Fountain*. John Quinn's relationship with Duchamp cooled considerably after the urinal was unveiled. Even before the show opened, Quinn expected "a lot of very poor and very bad and very rotten stuff."[100] Some weeks after the Independents' show closed, he wrote to Villon that he had "seen little of your brother" but had spotted him, looking "quite well," on a recent evening in a restaurant with Picabia.[101] No further letters to Duchamp appear in Quinn's papers until 1920.

Given this climate, it is also unlikely that Quinn would have approved of Duchamp's next sensation. In conjunction with the Independents' show, he had arranged for a lecture by an old acquaintance from Paris, Arthur Cravan. Traveling on the same "old tub" as an unknown young Russian radical named Leon Trotsky, Cravan arrived in New York from Barcelona on January 13, 1917. In his autobiography, Trotsky admiringly remembered that the boxer Cravan "confesses openly that he prefers crashing Yankee jaws in a noble sport to letting some German stab him in his midriff."[102] The self-styled nephew of Oscar Wilde now billed himself as "The World Champion at the Whorehouse."[103] Introduced by Duchamp as a Parisian authority on art, Cravan was soon asked to lecture on this subject before a select audience.

New York's most prominent hostesses and their escorts crowded the Grand Central Gallery's auditorium on the appointed evening, chattering and sipping cocktails as they awaited the lecture on modern art by the former editor of the Paris art magazine *Maintenant*. The buzzing grew louder as time passed and no lecturer appeared. Finally, after more than an hour's

wait, the audience quieted as the 240-pound Cravan appeared on the podium. As Man Ray recalled the scene, "He came in with a red valise, already dead drunk ... He slams the valise down on the table, opens it up and starts throwing out all his dirty linen."[104] His lecture on modern art consisted of shouted obscenities, including "one of the most insulting epithets in the English language." As he spoke, Cravan began to strip off his clothes, tossing shirt, pants, socks indiscriminately into the elegant crowd. Before the end of the "lecture," the police arrived to drag him off, in handcuffs, to the police station. Walter Arensberg, tolerant to the end, later bailed Cravan out and took him home, where a "beaming" Duchamp joined them, burbling, "What a wonderful lecture."[105]

Among New York's avant-garde, the Independents' exhibition reignited a fire that had dwindled since the Armory Show. The few small galleries that dared feature contemporary art, including the Modern Gallery (which Arensberg had briefly sponsored in 1915), had gone conservative or closed in the face of public indifference. During 1917, the magazine *The Blind Man* and its successor, *Rongwrong*, briefly flourished the banner of free verse and modernistic prose, then folded. Later, they were to be seen as important forerunners of Dada; but at the time, no one in New York had yet heard of that iconoclastic movement already under way in Switzerland.

The few Americans who cared about the new art split into two small bands. One included the fashionable bohemians, like the Arensbergs, who were wealthy, lighthearted, and hard-drinking: art, to them, was a party. A second group, such as the circle around Alfred Stieglitz, treated the cause of modern art as a missionary crusade. People like Stieglitz believed that modern art would "bring among us bigger ideals of life, pure ideals, deprived of materiality." The new art, they thought, foreshadowed a transformation of society, with a "new ethics of life, where material needs for all will be a question of *sine qua non*, " and even "a humanity without criminality or prostitution."[106] Duchamp had always shied away from this earnest, proselytizing group, but a young man still thinking of establishing some kind of artistic career could ignore no potential sponsors.

While working on the Independents' show, he had met a towering specimen of these missionary types, a serious, large-boned woman whose penchant for painting abstractions seemed in harsh contradiction to her stolid, duty-oriented German background. Ten years older than Duchamp, Katherine Sophie Dreier had been involved in obscure but worthy causes for

years. In 1911, she had substituted for one of her sisters as a fraternal dele-
gate to Carrie Chapman Catt's international suffragette meeting in
Stockholm. She had also founded the Little Italy Settlement House, one of
the first in Brooklyn, and devoted much energy to her mother's pet project,
a vacation refuge for tired working women.[107]

Dreier was one of five children of a strict, black-bearded German immi-
grant who had succeeded in iron import-exports. Her parents wanted her to
train for a music career, but she instead studied painting.[108] In 1913, she
showed two paintings at the Macbeth Gallery, a restless work featuring
pounding horses on a turbid sea and *The Dolly House*, a portrait of a sweet
woman with a doll-like child on her lap.[109]

To the Armory Show she had lent her own small Van Gogh, bought on
a trip to Europe — the first Van Gogh owned by an American.[110] When the
critical storm broke over modern art, especially the common accusation of
charlatanism, Katherine Dreier, in her typical no-nonsense manner, decided
that the only way to answer such accusations was by "getting to know the
artists" and helping them.

With a characteristic eye for useful friendships, Duchamp had intro-
duced to the Arensberg crowd this militant Brünhilde, a woman who had
once remarked casually: "I am the reincarnation of Friedrich Barbarossa."
Walter was cool, but Dreier made herself so useful and remained so stalwart
that he finally had to accept her. "She might trudge after the fleet esoteric
humor of Duchamp et al., like an admiring, gawky girl trying clumsily to
follow the lead of an exquisite tango partner," wrote the chronicler of
American art collectors Aline Saarinen, "but she had earned the privilege of
being there."[111]

The mark of her devotion to modern art was that she commissioned
Duchamp to paint a picture; the mark of her inexorable will was that it had
to fit a particular space in her library. That space was only 28 inches tall and
all of 125 inches wide. In due course, Duchamp produced *Tu m'* which
some have completed as *Tu m'emmerdes* (You're a pain in the ass); and one
hardly knows whether the statement referred to Dreier or to the painting.
In point of fact, Duchamp never painted again, but he did see a great deal
more of Katherine Dreier.

The picture was a trompe l'oeil lexicon of readymades, including shad-
ows of the bicycle wheel and the hat rack as well as the shadow of a work
Duchamp never realized, a corkscrew. A sign painter was commissioned to

execute a pointing finger near the bottom, and he penciled in his own signature, A. Klang. A real bottle brush projects phallically near the center, while a vaginal-looking painted rip is neatly held together by two real safety pins.

Besides its multitude of unconnected focal points and subjects, this painting again presents a Freudian landscape of sexual symbols, perpetually canceling each other into something like neutrality. Likewise, Duchamp's attitude toward it was sharply ambivalent. In the late 1950s, he told Robert Lebel that he was "particularly attached" to it.[112] A few years later, he told Arturo Schwarz, "I have never liked it because it is too decorative."[113]

◆ ◆ ◆

World events could well have contributed to Duchamp's mixed feelings. On April 6, 1917, the United States entered the European war; and by mid-May Congress had passed America's first compulsory military service law. Although few of the eligible men between the ages of twenty-one and thirty-one had actually been inducted by the end of the year, Duchamp, who was then thirty and a bachelor, would almost certainly be drafted in 1918. In October 1917, he went to work as a secretary to a captain at the French Mission in New York. "I had left France basically for lack of militarism," he later told an interviewer, "for lack of patriotism, if you wish." Now he "had fallen into American patriotism, which certainly was worse."[114] The draft registration card in his pocket reminded him "disagreeably of Paris in 1915."[115]

Meanwhile, in the studio on Sixty-seventh Street, a new readymade began to grow, strips of variously colored rubber cut from bathing caps and stretched obstructively between walls and floor. Duchamp called it *Sculpture for Traveling*. It was part of his meager baggage when he boarded the USS *Crofton Hall* on August 13, 1918, bound for Barbados and Buenos Aires. To finance the trip, he had sold the unfinished *Large Glass* to Arensberg, who promised to store the two massive panes until Duchamp returned to finish the work.

Duchamp's traveling companion was Yvonne Crotti, the reluctant fourth leg of a bizarre romantic rectangle. Yvonne and her husband, Jean, were already among those involved with the Arensberg group when Duchamp arrived in 1915. The following year Crotti returned to Paris; as a Swiss national, he was immune from draft into the military. He carried letters from Duchamp to his favorite sister, Suzanne, who had given up painting in 1914 and was serving as a nurse in a military hospital. Suzanne fell passionately in

love with Marcel's messenger and Crotti returned to New York to seek a divorce, meanwhile wooing Suzanne with "a series of love letters in the Dada style." And then Yvonne, newly divorced, embarked for South America with Marcel.[116]

In his first letter to Arensberg, mailed from Barbados on August 24, Duchamp did not mention Yvonne, but instead described the ship gliding, dark and wary, through the submarine-infested Caribbean; "no lights except in the smoking room ... no chess, no one to play with ... I work arranging my papers."[117] Nor, for that matter, did he ever mention Yvonne Crotti in his letters. In mid-September, the couple arrived in Buenos Aires. By October, when they had found an apartment, and Duchamp was settling into a separate small studio at 1507 Sarmiento, a surprise visitor appeared — the indomitable Katherine Dreier.

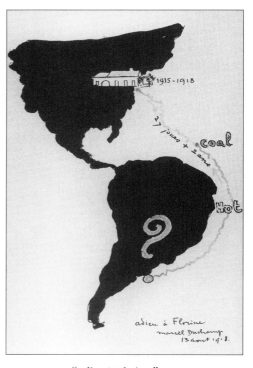

"Adieu à Florine," 1918

As Dreier would explain it in the book she wrote about her journey, her trip to South America had been somehow foreordained ever since 1902, when a card she was given during New Year's Mass in a small Roman church carried the name of St. Rose of Lima, Peru. "I never wanted to go to South America," she wrote. "There were so many countries calling me from the artist's or philosopher's point of view ... but I had to go." Disembarking at Valparaiso, Chile, in October 1918, Dreier trekked, not twelve hundred miles north to Lima, but east over the Andes to Buenos Aires. "I had travelled much alone," she said. "I had arrived alone at 4 A.M. in London and Paris, but never in my life had I felt so alone ... South America does not believe in

women traveling alone unless it is to join their husbands."[118] For his part, Duchamp was taken aback by "the insolence and crudity of the men here," telling Arensberg that Dreier was "busy with things for the studio ... but [she] suffers from the city ... Buenos Aires does not accept women alone."[119]

In her book, Dreier tolerantly tried to explain the local mores, which both fascinated and repelled her. Attending movie theaters, she always insisted on sitting in the orchestra, rather than in the balcony among the women, even though she usually had to change her seat three times because of "the habit of the Argentines to make love to every woman they see ... One can easily see," she concluded from such experiences, "that if one did not have the spirit of the missionary in one's heart, one could soon lose interest in going to these places." But Dreier brimmed over with missionary zeal. She met with professional women, became involved in trade unions and local charities, and studied the attitudes of Argentines toward women's suffrage.[120] She also found time to paint, completing an abstract portrait of Duchamp that is now in the collection of New York's Museum of Modern Art. It is difficult to escape the picture's Freudian symbolism: it shows a great diagonal horn, snagged by a petite hook shape.

Despite the concern for Dreier he had expressed in his letter to Arensberg, Duchamp pursued his own life. He spent much of his time holed up alone in his studio, making sketches for the *Large Glass*, while optimistically advising Arensberg that he "should finish in a few months."[121] To the loyal Dreier, he allowed the privilege of acquiring the one serious art project he completed in South America: a collage he had begun in New York, composed of silver leaf, lead wire, oil paint, and a magnifying lens on glass. Its disturbing title is *To be looked at (from the other side of the glass) with one eye, close to, for almost an hour.*

This work presents an amusing twist on Leonardo da Vinci's instruction for accurately drawing a scene: interpose a piece of glass, lock the head into position behind it, and then close one eye while tracing the forms seen onto the glass.[122] Duchamp not only used the work to pursue his technical experiments with materials for the *Large Glass* but also created a disconcertingly attractive invitation to the viewer to become a voyeur. Visitors to the Museum of Modern Art in New York, where *To be looked at* is on display, almost invariably find themselves with one eye glued to the magnifying glass, peeking at... what? The title was added, Duchamp explained much later, "to complicate things in a literary way."[123]

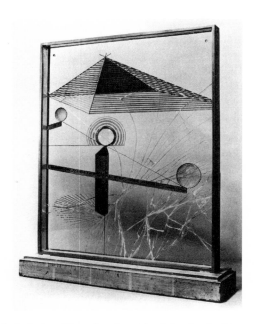

"To be looked at (from the other side of the glass) with one eye, close to, for almost an hour," 1918

For Marcel, waiting out the war in Buenos Aires was tedious and depressing. Although he had rented an apartment with Yvonne, he spent most of his time in his dingy studio. There, "far from the comforts I got accustomed to on 67th Street," as he wrote to Arensberg, he savored "the smell of peace" when news of an armistice arrived on November 8, three days before the end of hostilities.

But his pleasure was mingled with grief. Two weeks earlier he had learned that after nearly two years' suffering from a lingering fever contracted at the front and possibly typhoid, his brother Raymond had died in Cannes of uremia on October 9.[124] "It is frightful," he wrote to Arensberg. "You know how close he was — and how dear..." Then, in the next paragraph, Duchamp skipped on to plans he was making for a Cubist show in Buenos Aires. He had written to Henri-Martin Barzun, asking him to gather "about 30 good things." He knew the city "by heart," he added forlornly. "No hotel life."[125] A few days later, he rambled on for two pages about Buenos Aires and his fantasies of New York before apprising the Stettheimer sisters of the "bad news" of Raymond's death.[126] In a postscript

to a previously written letter to Jean Crotti before the news of Raymond's death arrived, he wrote: "Tell Suzanne my despair at being so far from everyone in such circumstances." He still could not believe the news, he said, "so much the less since I have not seen him for such a long time and he was in good health then. I do hope the family bears up!!!"[127]

His messages resonate faintly, as though the writer were sequestered behind thick, murky glass. Had he no feelings? Or was he unable to express them? In Ettie Stettheimer's novel, his surrogate, Pierre Delaire, was "a creature who met demands as little as he made them."[128] Throughout his life, Duchamp would confront the most shattering events with uncanny sangfroid, a pose he may have learned at his deaf mother's knee. In a defense mechanism he would display over and again, he frequently converted emotions into humor.

"I work here because there is not much else amusing ... only a few tangos," he confessed in his next letter to Arensberg on January 7. Except for the glass collage, no major work from this period survives; and one suspects that Marcel was simply reassuring his old friend that the investment in the *Large Glass* was safe. Despite — or more likely because of — the presence of Yvonne and Dreier, Duchamp sought solitude. In a repeat of his solitary sojourn in Munich, his activities in Buenos Aires remain shadowy, recorded only in surviving letters and notes. Still, Dreier hovered nearby, silently demanding, perhaps, "to be looked at with one eye, close to, for almost an hour."

Duchamp went to the movies, again and again watching the few Charlie Chaplin films circulating in South America. He planned a return to Paris the following June or July. Meanwhile, his days and nights were increasingly swallowed up by what had until now been mainly a pleasant pastime — chess.

In New York, chess had been one of the intellectual challenges that amused the Arensberg crowd. On most evenings, a few people would frown and glower over the chessboard in a corner of the salon on Sixty-seventh Street, listening distractedly to the passionate babble all around. When everyone had gone home, in the wee hours amid the empty glasses and stale ashtrays, Marcel and Walter would often pore over the board with its stark black-and-white contrasts, its symbolic murders of pawns, knights, and bishops, and the final Oedipal triumph granted to one player only: the opposing king-father immobilized, checked and impotent.

In Buenos Aires, during the first few months of 1919, Duchamp's previously warm interest in chess began to flame. On January 7, he sent Arensberg

diagrams of several recent games. "I lost," he wrote, "but the blows I struck are proof of my progress and my pleasure in playing seriously."[129] Rummaging through obscure bookstores, he had come across a volume of old games by José Raúl Capablanca. He replayed forty of the Cuban chess master's championship matches alone and planned on joining the local chess club.

By the end of March, Duchamp was playing chess "en masse" and taking lessons from the club's best player. He proposed that once he got back to France, he and Arensberg carry on two simultaneous games by cable, and sent along a key for coding each move to keep costs minimal. He used a set of rubber stamps he had ordered, made to his own design, to record chess games on paper, and also carved a set of wooden chessmen (all except for the knight, which was made by a local craftsman). The shapes were traditional, except, significantly, for the king, who had no cross on his crown. Laughing heartily as he recalled it much later, Duchamp explained: "That was my declaration of anti-clericalism."[130]

But this was not Marcel's only hostile declaration. His fixation on chess drove Yvonne Crotti back to France. Early in April 1919, Katherine Dreier also fled, decisively checked by Marcel's devotion to the chessboard. She left for New York on April 3, along with a newly acquired sulphur-crested cockatoo named Coco[131] and enough memories to produce, in her thrifty and dutiful fashion, a book, published the following year, called *Five Months in the Argentine*. Also in her baggage was the fragile *To be looked at*. It broke in transit.

Marcel barely glanced up from the chessboard to wave good-bye. But he soon took time out to "create" an unusual wedding present for Suzanne, when he learned that she and Crotti had been married. "She was to attach a geometry textbook with strings to the balcony of her apartment in the rue de la Condamine," he recalled later. "The wind was to go through the book, choose the problems, thin out its pages and tear them."[132] Suzanne found it significant enough to make a painting called *Unhappy Readymade*, completed in 1920. "I knew that the rain would fall and the wind would blow and the book would be unhappy for being in the open air like that," was the oblique explanation he offered in his old age.[133] With a typical shotgun effect, Duchamp had punctured a scattered group of targets with one blast: Suzanne's marriage, the complex geometry embodied in the languishing *Large Glass*, and his own creative strivings, trapped as they were in psychological check.

On May 3, he wrote to the Stettheimer sisters that his attention was "completely absorbed by chess. I play night and day and nothing in the world interests me more than finding the right move ... I like painting less and less."[134] By June 15, a week before he boarded the SS *Highland Pride* for Europe, he confessed to Arensberg that he had become a "chessmaniaque — everything around me takes the form of the knight or queen and the outside world has no other interest for me than its transformation into winning or losing positions."[135] With Duchamp's arrival in Paris a month later, this episode of "chessmania" seemed to have passed, but the game would always be a refuge from artistic impasse, grief over losses (such as the death of Raymond), and the demands of other people.

In Paris, Duchamp stayed in Picabia's apartment on the rue Émile-Augier. There he made a startling discovery: from having been, just a few years earlier, the promising enfants terribles of modern art, he and Picabia were suddenly cast as iconoclastic "old men" in the midst of a younger, far more radically rambunctious group that called itself Dada.

Instead of trying to recapture his former status, Duchamp explored a possible road back into what was now the respectable mainstream. He joined the Salon de la Section d'Or, which Gleizes had revived upon returning to Paris from New York, though he exhibited nothing in its first show, in 1919. He seemed suspended in self-imposed limbo, repelled by the Puteaux survivors, perhaps because of the nagging absence of Raymond, but also rejecting the young Dadaist hotheads who gathered in Picabia's salon to plot their outrages. Except for the writer and gigolo Jacques Rigaut, Duchamp found them too "systematic" in their "enterprise of destruction."[136]

Several times during these months, he traveled to Rouen to visit his aged parents, a nostalgic journey backward into the world of the *Sad Young Man on a Train*. But by mid-fall, he was ready to return to New York. In December, he paid for treatment by his dentist, Daniel Tzanck, with a beautifully hand-lettered check for $115, drawn on "The Teeth's Loan and Trust Co., Consolidated, 2 Wall St., New York." Some twenty years later, he was to buy the check back "for a lot more than it says it's worth!"[137] The check, especially in view of its subsequent rise in value, has been seen as an ironic statement about art: that the value of a work derives largely from the signature of the artist. But the *Tzanck Check* can also be seen as a challenge to the Dada artists now gathering in Paris.

The Dada movement had originated in neutral Zurich in 1916 as a reac-

tion to the meaningless slaughter of the war. Pursuing the black humor of forerunners such as Jarry and wedding it to the exhibitionism of the likes of Cravan, the Dada artists and poets lashed out angrily and destructively at all established forms and conventions.[138] When the war ended, the members of the Zurich group had scattered back to their native countries, carrying the grim yet zany message of Dada, like an hilarious infectious disease. To Berlin went Richard Huelsenbeck, who later became a respectable New York psychiatrist under the name Richard Hulbeck; to Cologne went Hans and Sophie Arp, where they enlisted the young artist Max Ernst; in nearby Hanover, Kurt Schwitters caught the bug; and by mid-January of 1920, Picabia, along with the young French poets André Breton and Louis Aragon, welcomed the Grand-Dada himself, Tristan Tzara, to Paris and to the staff of their new publication, *Littérature*. Breton would soon assert leadership of the French group.

Picabia was host to their outré literary salon, but his houseguest, Duchamp, had departed for New York a month before Tzara arrived, avoiding the new wave of literary and artistic bomb-throwers who were passing through. Among these latter were Georges Ribemont-Dessaignes and Pierre de Massot, Jacques Rigaut, and "the whole Cocteau bunch." Although he did not meet him until 1922, Breton fastened on Duchamp as the archetypal Dada; but Duchamp recalled being put off by Breton's "strictness ... [his] desire to arrange everything into theories and formulas."[139] Much later, Duchamp would write to a friend that "it was cheap fun living off what Dada did ... I intended to discourage the aesthetic hullabaloo."[140]

In fact, Tzara, no less than Breton, tried to codify the mad chaos of Dada by the same means as the prewar Futurists and Cubists had publicized their ideology: a manifesto. Already in 1918, in Zurich, he had proclaimed:

> We are a furious wind, ripping through the wet wash of clouds and prayers, preparing the great spectacle of disaster, fire decomposition ... Dada: the abolition of logic, the dance of the impotents of creation ... Dada: abolition of absolute and unquestionable faith in every god that is the product of spontaneity.[141]

Reacting to the First World War as the triumph of unreason, the Dada artists had regressed into the world of childhood, even choosing a baby word — Dada — as their label. Hugo Ball, who had been one of the instigators of Dada in 1916, later called the movement a "procreative hankering after the perambulator."[142]

On the surface, it looked as though Duchamp and Dada were a perfect match; many observers still see Dada as his "natural environment," the only one in which he could "breathe freely," where "time is suspended in the perpetual rapture of childhood, in the ambiguity of play and the delightful ecstasy of disdain."[143] But Duchamp hovered perpetually on the fringes of this group; his stubborn iconoclasm would not permit him to fly wholeheartedly even in a flock of iconoclasts. He soon warned the Stettheimer sisters: "From a distance, these movements evoke a charm that they do not have close up."[144] Later, he observed, with some pride: "They always liked to take me in, but I never signed any of their manifestos."[145]

In typically casual fashion, on his way back to New York, Marcel presented Dada with its most enduring symbol. Duchamp was packing his things when Picabia spotted among them a cheap reproduction of the *Mona Lisa*, hardly measuring 8 by 5 inches. On the face Duchamp had penciled a crude moustache and goatee, while in the margin below, carefully centered, were the letters "L.H.O.O.Q." Spoken quickly in French, the legend reads *"Elle a chaud au cul,"* a vulgar sentence generally translated as "She's got a hot ass." To the English-speaking viewer, the configuration of letters also cries out, "Look!" Duchamp had quietly perpetrated this work back in October, telling no one. Now Picabia was so enchanted that he carefully studied the sacrilegious scribble before Marcel packed it away. Three months later, the *Mona Lisa* with graffiti and mustache, but sans goatee, appeared in Picabia's revue, *391*, with the title *Dada Picture by Marcel Duchamp*.

It is possible that Duchamp had in mind another accepted meaning for the slang phrase *"avoir chaud au cul"*: to have a narrow escape, perhaps in reference to the widely publicized theft of the *Mona Lisa* from the Louvre in 1911. The painting was missing for more than two years, while French police questioned many suspects, including, briefly, Pablo Picasso. During that time, the thief, Vincenzo Perugia, extracted $300,000 from six American art collectors to whom he promised the painting. Instead, they received crude copies, while Perugia fled back to Italy with their money. He was caught when he tried to sell the real *Mona Lisa* to a Florentine art dealer in November 1913. Leonardo's most famous work may not have had a "hot ass" (*le feu au cul*) after all, but merely a close shave.[146]

Breton and his followers, however, saw in *L.H.O.O.Q.* the essential Dada message: "The most famous and beautiful picture in the world, treated like any vulgar mass-produced reproduction and casually disfigured."[147] But at

the same time the rude graffiti on the *Mona Lisa* and the crude legend below also reinforced Duchamp's relationship with Leonardo da Vinci. The year *L.H.O.O.Q.* came to life happened to be the four hundredth anniversary of Leonardo's death, prompting any number of articles reviewing the great genius's career. Duchamp's hostile scribbles on the famous face conveyed the Oedipal rivalry that he could never verbally express. More than twenty years later, he took the original *L.H.O.O.Q.* to a New York notary to have his own signature certified on what he now called a "rectified readymade." Since Leonardo had never signed the original *Mona Lisa,* it was Duchamp's signature, not Leonardo's, that clung to the work.[148]

With a few strokes of a pencil, Duchamp had also underlined the sexual ambiguity inherent in Leonardo da Vinci's masterpiece. He had confronted the great artist's homosexuality, which had so fascinated Freud, and tried to resolve it in a graphic way. As with *Fountain* and *Tu m'*, humor and vulgarity cloaked the sexual ambiguities that increasingly fascinated him. Much later, in 1961, Duchamp explained to an interviewer that "the curious thing about that moustache and goatee is that when you look at it, the *Mona Lisa* becomes a man. It is not a woman disguised as a man," he emphasized, "it is a real man."[149]

L.H.O.O.Q. personifies the cynical wit that was Marcel's only recourse for expressing unsettling feelings, whether frustration, grief, or anger. A departure often followed. This time, he fled from the Paris of Dada, of Picabia and Breton, of Jacques Villon and the Cubists, of the memory of Raymond, of Suzanne newly and happily married to Crotti. Bearing a glass vial of *Paris Air* for Walter Arensberg, he embarked once again, in the last few days of December, for New York.

N<small>O REPORTERS BRAVED</small> the frigid January gusts on New York Harbor when Marcel Duchamp arrived from France for the second time. Their absence nearly five years after his first arrival indicated not only a decline in Duchamp's media status but a significant shift in public attitudes. The First World War had brought Europe far closer to Americans than ever before. After it ended, many American patrons of modern art were able to see for themselves what was going on — or not going on — "over there." The war had devastated much of France, including its financial stability. While the dollar had been pegged at 5.18 francs for decades, it rose to 13.50 in 1921, and would leap to 31.33 by 1926. Thrifty John Quinn embarked on an art buying spree, while the cheap franc attracted many American artists to Paris, the outriders of what would be called the Lost Generation. Just before leaving Paris, Duchamp had touched base with this group's grande dame; in December of 1919, he, Dreier, and Roché had dropped by at the vaulted studio at 9 rue Fleurus to pay their respects to Gertrude Stein.[1] Nearly a year later, Stein learned that Arensberg, Duchamp, and the New York art critic Henry McBride had spent a sober evening discussing the possibilities of publishing her work in the United States.[2]

As he had in 1915, Marcel brought along some Parisian art works to sell in New York. Among them was a multiple edition of a portfolio of caricatures by Georges de Zayas of Matisse, Picasso, Gleizes, Metzinger, Picabia, Brancusi, and Duchamp. "It is not so very important as art," Walter Pach wrote to John Quinn, "but is more than a little clever." And the price was right — $6 for an edition Duchamp would place in bookstores at $15.[3] Duchamp also sold Quinn two Villon watercolors for all of $30; he delivered them personally.[4]

Upon landing in New York, Duchamp may have expected to resume his place at the center of bohemian social life from which he had sailed, with hardly a backward glance, in 1918. But by the spring of 1920, a new atmosphere redolent of Dada dominated smart New York, and a different, younger crowd was making waves. F. Scott Fitzgerald, reveling in the success of his first novel, *This Side of Paradise*, threw off his clothes at the *Scandals* revue and was lionized. His wife, Zelda, impetuously dived into the fountain at Union Square one night; and when the couple were taken to meet Dorothy Parker, he perched on the roof of the taxi, while she straddled its hood. Far from being rejected, the Fitzgeralds, according to Zelda's biographer, were "the arch-type of what New York wanted."[5]

Just as a freshly minted avant-garde in Paris had begun to overshadow Duchamp's previously shocking iconoclasm, so in New York the beginning of the Jazz Age was drowning out the old avant-garde's summons to the barricades. Prohibition, which started the same month Duchamp arrived, was a sobering influence. Among Duchamp's friends, everyone was getting older, settling down, going to bed earlier. He himself was now thirty-three.

Duchamp continued to visit with the Stettheimer sisters; but he also joined the Marshall Chess Club, located in a dark and silent loft above the Pepper Pot Restaurant on West Eighth Street in Greenwich Village. Meanwhile, he brought the unfinished *Large Glass* to his apartment at 246 West 73rd Street. He said he was determined to bring the project to completion.

This new studio was in a brick row house on the south side of the block between Riverside Drive and West End Avenue. Its conventional four stories with a semibasement were set off from neighbors by two turretlike bulges. Built for a single well-off family, it had been split up, like so many of these dwellings, into cramped little apartments. However, it was conveniently close to Broadway, and a bustling hub around an express subway station — and it was an easy walk to the Arensbergs' place.

Much like the earlier ateliers, the interior belied Marcel's elegant, cerebral, and ascetic pretensions. The painter Georgia O'Keeffe, who had met Duchamp at Alfred Stieglitz's 291 Gallery, dropped by Duchamp's studio one day while he was out and found a barren space containing a rumpled bed, a makeshift chair, a nail on the wall, and a bureau spilling a tangle of neckties out of its bottom drawer. "The room looked as though it had never been swept," O'Keeffe recalled many years later. "I was sick with a cold. I just seemed to be sick from having seen this unpleasantly dusty place."[6]

But the dust apparently served a purpose. With the legendary thrift of a Norman peasant, Duchamp was planning to use the feathery soot as a sort of pigment for a portion of the *Large Glass;* having allowed it to settle undisturbed for three or four months, he then brought in Man Ray to photograph the accumulation. By the light of a single bulb, Ray opened the shutter of his battered wooden view camera for a time exposure and they "went out to eat something." About an hour later, they returned and the shutter was closed. That night, in the basement he used as a darkroom, Ray developed *Dust Breeding,* a spooky lunar landscape which Duchamp called a Bred Readymade.[7]

Once again, the spirit of da Vinci hovers over this work. In his notebooks, Leonardo describes a way of using dust as a measure of time: "The glass should be varnished or soaped on the inside so that the dust that falls ... may attach itself to it."[8] Duchamp treated the dust in exactly this way: he fixed it with varnish to the areas that were to form the Sieves of the *Large Glass.*

At this point, Duchamp had completed most of the upper half of the glass, the Bride, and was laboring over the Bachelors. "All who knew him stress the prodigious effort Duchamp devoted to this work," wrote an admiring friend. Yet, despite its supreme importance to him, Marcel found himself unable to complete it, or even to make much progress. As the months went by, "the slightest details required prolonged meditation and calculation," but the "moment of actual execution" always proved "most difficult."[9] In fact, Duchamp never worked on it more than two hours a day. "It interested me but not enough to be eager to finish it," he told an interviewer later. "I'm lazy, don't forget that."[10]

Meanwhile, he and Man Ray, "his constant companion,"[11] began experimenting with a mechanized contraption-cum-art. Duchamp traced black and white lines onto five glass plates; each plate was larger than the next. When the plates were attached to an axle and whirled by a motor, as Duchamp later described it, "the lines gave the effect of continuous black and white circles."[12] The motor whirled the plates at uncontrollable speed, faster and faster. One day a fan belt broke and a glass plate flew off, nearly decapitating Man Ray. Duchamp was unperturbed. As his friend later recalled, Marcel "ordered new panes and with the patience and obstinacy of a spider reweaving its web repainted and rebuilt the machine."[13] Equally patiently, Man Ray photographed the gyrations of this completely purpose-

less device. The original contraption is now in the Yale University Art Gallery. Unsigned and undated, it also is immobile, a static museum piece drained of any rationale.

Duchamp vaguely explained that "the idea of movement preoccupied me."[14] Not only in his art or in moving himself halfway around the world four times in four years, but in the most intimate way possible, Duchamp now launched himself into a startling variation — a totally foreign identity. Sometime during the fall of 1920, after relocating to the Lincoln Arcade, Duchamp began to be obsessed with a search for an alter ego.

Some four years earlier, Duchamp had accidentally acquired a fictitious name when Henri-Pierre Roché, after a drunken evening at the Vanderbilt Hotel, had started calling him "Victor," which soon turned into "Totor." And the following year, he had signed the urinal he entitled *Fountain* with the name "R. Mutt." To Duchamp, name changes were old hat: after all, hadn't his brother Gaston become Jacques Villon, and Raymond hyphenated Duchamp with Villon?

"I wanted to change my identity," he said, without elaborating on his reasons. Perhaps inspired by Man Ray, who had started out in life as Emmanuel Radnitzky, he at first considered a Jewish name, but found none tempting. Instead, as he remarked near the end of his life, "Why not change sex? It was much simpler."[15] In 1920, he picked the "most awful name" he could find, Rose, and added a punning surname, Sélavy. Within her exotic name, the provocative whiff of the Orient contrasted sharply with the vulgar obviousness of *c'est la vie* and the tired cliché, even in 1920, of *la vie en rose*. But its full significance remained to be elaborated later. Meanwhile, by the end of 1920, the rude Rose had copyrighted her first work of art. She mechanically signed her name, in bold black block letters, to a somber and mysterious construction.

It was a small-scale French window, only 31 inches high, built by a carpenter in New York. Much to Duchamp's mirth, the eight glass panes were replaced by black patent leather which "would have to be shined every morning like a pair of shoes."[16] Its name, *Fresh Widow*, offers up a multiplicity of meanings even more complicated than the name of its pseudonymous author. Beyond simply describing the object, sans "n's," it also brings to mind another meaning of the French word for widow, *veuve* — the guillotine — suggested by the metallic luster and funereal black of the leather. Just like the view through this blank window, so is the outlook bleak for a widow and,

"Dust Breeding," 1920

Man Ray (in a 1924 self-portrait), and Duchamp with the "Rotary Glass Plates" that nearly decapitated him

perhaps, for the bachelor as well, since *la veuve Poignet* is French slang for masturbation. As *To be looked at with one eye* tantalizingly revealed nothing to the spectator, so this window's promise of a complete revelation is cut off by a blank and black reflection. Or is it just one more clever glass construction that conveys Duchamp's hostility and his desire for distance?

Duchamp, of course, never explicitly discussed any such speculations, but it is significant that twice before he had reacted to Suzanne's marriages with destructiveness. The whole concept of *The Bride Stripped Bare by Her Bachelors, Even* had been triggered by her first marriage to the pharmacist in Rouen. Like a concrete fulfillment of Duchamp's fantasy wish regarding this marriage, all but one of the preparatory experiments for his complex mechanical project had somehow broken or cracked. The *Unhappy Ready-made* of 1919 had given some indication of how abandoned, wind-whipped, and exposed he felt after Suzanne's second marriage. In early 1920, after suddenly fleeing Paris, Duchamp was himself whirling in circles via a motorized visual machine (which almost decapitated his best friend). Then, after a brief flirtation with total anonymity, he had chosen a clunky, vulgar, and fictional woman as a mask and shield against exposure of any kind.

A guillotine is the symbol, par excellence, of castration. And so is a woman, in the eyes of many men, a castrated man or a castrator. Behind its witty title, the *Fresh Widow* harbors a host of frightening fantasies. Among them, perhaps, is Duchamp's secret wish that Suzanne would be a widow. Conversely, by marrying again, Suzanne had perhaps made off with a vital portion of Duchamp's personality so that he resembled, in his loss of masculinity, a bereaved wife. No symbol more poignantly describes, as well, the impotence of a creative artist beset by unbearably contrary impulses, agonizingly suspended, much like the hanging female at the top of the *Large Glass*, between revealing and concealing.

Neatly as they fitted into the advanced art of the time, the readymades had done double duty for Duchamp: creating a work of art while mocking art. The prescription for "painting of precision and beauty of indifference," compounded with "irony of affirmation," which Duchamp had written for himself in 1913,[17] was a broad philosophical statement. But it was also a moving expression of Duchamp's personal dilemma. And his claim to being, not antiaesthetic, but "anaesthetic" was a cry against pain. Rose Sélavy allowed the real Marcel to avoid finishing the *Large Glass;* the *Fresh Widow* reassured him that a creative spark still flickered.

So long as *The Bride Stripped Bare by Her Bachelors, Even* remained a mass of scattered sketches and loose notes, Duchamp was able to pursue his work on it. But as the *Large Glass* began to materialize in immutable form, every step seemed to become longer and more painstaking. And the dust accumulated on its surface betokened Duchamp's wish that the entire work would disappear under anonymous grit. Small wonder that the artist drifted off into a multitude of unrelated projects — funny machines, chess, drinking, publications — while New York soot gently obliterated his troublesome chef d'oeuvre.

The concept of the glass had actually been complete when Duchamp landed in New York in 1915. Still in Paris, he had drawn a full-scale cartoon on the wall of his studio in the rue Hippolyte and had completed the technical experiments for painting on glass. It all came to him, "idea after idea," between 1913 and 1915, Duchamp recalled much later, "so that from 1915 on I was just copying."[18]

By early 1916 Duchamp had brought to life the Bride and her domain, in the upper half of the glass. Brooding as a black widow, the Bride dominates the left side, emitting a horizontal cloud which Duchamp called the "draft pistons." Her form was based largely on Duchamp's last true painting (only the confused *Tu m'* followed it), the mechanical *Bride* whose tender pink mechanism Marcel had caressed to glossy perfection with his fingertips in Munich in 1912. In 1956, he disclosed a dream he had had about this painting, upon returning to his room drunk after an evening at a beer hall. In the dream, the bride "had become an enormous beetle-like insect" that tormented him "atrociously with its *elytra*" — both the wing sheath of an insect and a medical term for vagina.[19] This Freudian displacement of Duchamp's worrisome associations with sexuality onto the safe "insect" is given an unusual sidelight in one of Duchamp's most revealing puns from several years later: "Rose Sélavy and I believe that an incesticide must sleep with his mother before he kills her; bedbugs are de rigueur."

By contrast with the careful contrivance of the bride, Duchamp allowed chance to "draw" the draft pistons. To determine the shape of the three openings, he hung a square of gauze in an open window and made three photographs as the wind ruffled through. Then he used the silhouettes as a template. From his sketches, Duchamp traced the forms onto the glass and affixed thin lead wire with varnish to establish the outline. He used oil paint to fill in the shapes before covering them with lead foil.

*An early foray as Rose Sélavy,
c. 1920*

The Bride's domain had been virtually complete when Duchamp sailed for Argentina in 1918; and the lower half of the glass, the Bachelors' domain, was also close to realization. In fact, all that remained to be done, according to his sketches, could easily have been completed in a few months, especially since it was all "just copying." But the work hardly progressed, and distractions kept popping up.

In March 1920, one of these distractions took the form of a new museum of modern art sponsored by Katherine Dreier, in the organization of which Duchamp became deeply involved, and for which he proposed a conspicuously anonymous name: Société Anonyme, Inc. ("Incorporated, Inc."). To Dreier, the Société's purpose was to further "the study in America of the Progressive in Art, based on the Fundamental Principles."[20] In pursuit of this lofty goal, the museum was "to rise above personal taste and to conduct a gallery free from prejudice."[21]

Dreier had found little support for her project among New York's usual patrons for modern art. Stieglitz refused.[22] Quinn had suspected her of pro-German sympathies during the First World War, and furiously wrote to Henri-Pierre Roché that she "is a poseur, an egotist, a cheap fakir, and tries to pose as an art patron, but is pseudo in all her art postures."[23] To Duchamp and Man Ray, however, the Société's headquarters at 19 East 47th Street

represented not so much a beachhead in the New World for fundamental principles of progressive art as a promising new source of patronage. When Dreier suggested that Ray contribute photographs to her new charity, he decided that at least he would collect for expenses and "reserve some of the cost to myself." Soon, Ray recalled in his autobiography, "I was kept busy with photography for the museum and for Miss Dreier personally."[24] Duchamp, meanwhile, was equally busy designing the decor, shiny white oilcloth glued to the walls, while Ray installed blue daylight bulbs.[25]

Marcel contributed the emblem of the high-minded new undertaking. It was identical to the design he had originally created in Buenos Aires for the knight in his rubber-stamp chess set, but printed on the letterhead of the Société Anonyme it looked suspiciously like the head of a braying donkey. This, Miss Dreier explained earnestly to a Yale University audience in 1948, was "to show that we, too, could laugh at ourselves."[26]

On April 30, 1920, the first museum in America devoted to modern art opened with a show of works by Man Ray, Picabia, Morton Schamberg, and Joseph Stella, but none by Duchamp. In contrast to its plodding motto, "Traditions are beautiful — but to create them — not to follow,"[27] it became the first showcase in America for such varied modern painters as Léger, Franz Marc, and Kandinsky, the Russian sculptor brothers Naum Gabo and Antoine Pevsner, the master of collage Kurt Schwitters, and the protominimalist Piet Mondrian. Until 1929, when the Rockefeller millions launched the New York Museum of Modern Art, the Société was the principal outpost for modern art in America.[28]

Duchamp's addiction to chess provided another distraction from work on the *Large Glass* and served as a handy escape from personal relationships as well. One night Man Ray and Duchamp were having dinner at the Pepper Pot Restaurant when "a tall black-haired girl" who had been playing the piano came over to their table and sat down. "She did not take her eyes off Duchamp," Ray recalled, "and I realized she was madly in love with him." Marcel introduced her as Hazel. She was a Bostonian who had fled to bohemian Greenwich Village; she supported herself playing the piano. Ray, who was never one to pass up a feminine glance, was puzzled when "Duchamp was noncommittal and presently rose" to play chess upstairs. Hazel, too, was perplexed. Duchamp had "responded to her advances at first," she told Ray, "but had long periods of indifference." Ray tried to explain his friend's peculiarity as "his preoccupation with artistic matters."

"Fresh Widow," 1920

A few weeks later, Ray again met Hazel and she "poured out her heart ... I told her to be calm, not to run after him." When Duchamp arrived, he barely glanced at Hazel and swept Ray upstairs.[29]

In her fictional character modeled on Duchamp, Ettie Stettheimer shrewdly described a "strange tendency ... to be neutral in relationships." She found his travels baffling: "He seemed so little related to places that it was impossible to discern what geographical change could possibly mean to him and disquieting that he nevertheless indulged in it."[30] Another friend, Gabrielle Buffet-Picabia, noted "the pitiless pessimism of his mind." Some kind of conflict was eating at his soul, she surmised, so that "the more clearly the contradiction is stated, the more impossible it becomes to do anything about it."[31]

Again and again, friends remarked on Duchamp's imperturbable facade, as smooth and as impenetrable as the *Large Glass* itself. Sometime in 1920, for example, Dreier gave Duchamp a movie camera to play with. He bought a second, cheap camera and fastened the two together for an experiment in stereoptic movies. Ray and Duchamp shot the film; then, having no darkroom, waited until dark to develop it. That night, they fumbled the film through a labyrinth of some four hundred nails pounded into plywood. They plunged this contraption into developer, using two garbage can lids as

"*Belle Haleine,*" *1920*

(opposite page)
"*Why Not Sneeze?,* " *1920*

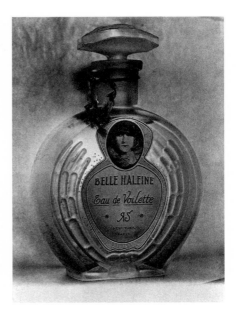

developing tanks. When they pulled the film out of the fixer, Ray recalls, it "looked like a mass of tangled seaweed." The developer had not even touched most of the film, and it was ruined. Marcel was not upset. He wanted only a few feet to verify his experiment. "I was depressed," Ray writes, but "Duchamp went to the chess club."[32]

As his imperviousness baffled friends, so the creations of his alter ego puzzled his patrons. Early in 1921, Katherine Dreier's sister Dorothea commissioned a work by Duchamp. Recalling his resentment over the specifications for *Tu m'*, perhaps, Duchamp this time insisted on carte blanche as to subject and materials. He soon produced a work as original as it was mysterious: in a small birdcage, he had arranged 152 sugarlike cubes, a cuttlebone, and a thermometer. The ensemble beckons the viewer to lift it up, but this turns out to be no easy task, since the "sugar" cubes are really marble. Underneath, in the same brazen black lettering as on *Fresh Widow,* is the title: *Why Not Sneeze Rose Sélavy?*

As with *Fountain,* Duchamp had pushed patrons of "advanced" art beyond their limits. Even the compulsively tolerant Dreier was shocked by this work — she loved birds and hated cages.[33] Her sister reluctantly paid Duchamp $300 but asked him to find another buyer. Three years later, he persuaded Arensberg to acquire it for the same price.

In addition to signing saucy works, the mischievous Rose Sélavy insisted on appearing in person. In April 1921, her portrait turned up for the first time on an empty perfume bottle, which Man Ray and Duchamp had cleverly relabeled *Belle Haleine, Eau de Voilette*. Literally translated, it reads, "Beautiful Breath, Veil Water," but it was also a pun on the French *eau de toilette*, as well as on Offenbach's popular opera *la Belle Hélène*. Like a portrait of the genie inside the bottle, the label showed an unsmiling female peering sternly at the world through haughty kohl-rimmed eyes. She wore a frumpy hat clapped over limp curls, beads, and a scarf draped around her neck and shoulders. Her initials were elegantly centered on the label, with the *R* facing backward. Like two mischievous boys, Duchamp and Man Ray extracted maximum mileage from this one image: the Schwarz catalog lists all of six versions created between 1921 and 1951.[34]

The label for *Belle Haleine* appeared as the cover of the single issue of *New York Dada*, published in April 1921 by Duchamp and Man Ray. This publication consisted of one large sheet, printed only on one side and folded to conceal the blank interior. The text included an "Authorization" from Tristan Tzara to use the word "Dada," an unsigned poem by the American artist Marsden Hartley, attempts at Dada-photos by Ray and Stieglitz, and a cartoon by Rube Goldberg satirizing professors. In assembling this confused

potpourri, it remains unclear whether Duchamp was simply lazy, or whether he was following some quirky principle of allowing chance to produce a publication. At any rate, Ray later explained that "Duchamp left the composition, aside from the cover, entirely up to me. I chose the contents at random — the first things that came to hand."[35]

A few years earlier, this kind of gesture had impressed New York's avant-garde, when the youthful Duchamp and Picabia first unleashed their "veritable genius for perturbation and polemics."[36] But what had been shockingly tonic in 1915 appeared simply tired in 1921. The rebellious display of a young man of twenty-eight now seemed, in a mature man of thirty-four, merely childish. Marsden Hartley was one of the few American artists who still considered Dada a way "to reduce the size of the 'A' in art to meet the size of the rest of the letters in one's speech."[37] But Hartley's interest in American Dada sprang largely from the fact that he had been in Europe during its first New York outbreak, and in New Mexico when Duchamp and Man Ray tried to revive it in 1921. Most of the other artists and writers who had orbited around the Stieglitz gallery and the Arensberg salon had moved on. When Stieglitz's *Camera Work* died in late 1917, it turned out to have had only thirty-six subscribers.[38]

The American victories in Europe and the isolationism that followed reverberated in the American art scene. American artists were experiencing a new confidence in native inspiration. Even the Arensbergs headed for the cultural hinterlands, moving to Southern California at the end of 1921. Unlike *The Blind Man* and *Rongwrong*, which had appealed to the mainstream of the American avant-garde, as symbolized by the Arensbergs, *New York Dada* circled aimlessly in a side eddy. One of its few loyalists was Elsa von Freytag-Loeringhoven, now over fifty, who still "dressed in rags, wore sardine cans on her head and had objects suspended from her clothes on chains."[39] To Man Ray, publishing the sheet "was as futile as trying to grow lilies in a desert."[40]

Meanwhile, to Duchamp, that other desert suggested by the dust-covered *Large Glass* remained both a challenge and a threat. His work on it became increasingly painstaking and, finally, so fussy and frustrating that he could not bear to labor over it even two hours a day. In late 1920, he had drawn the outlines of the "Oculist Witnesses"; with his uncanny ability to transform his slightest gesture into an icon, the carbon paper he used to transfer the design to the glass has itself become a museum piece and the object of learned analysis by hair-splitting scholars.

Early in 1921, Duchamp had the entire Bachelor half of the glass moved to a factory "somewhere around Long Island," where a mercury compound was applied to the right half to give it the mirror-like effect he wanted. Then, once the silvered glass was back on its trestle in Lincoln Arcade, Duchamp carried forward a "meticulous ritual of craftsmanship" that would finally and literally justify his original description of the work as "a delay in glass."[41] Crouched over it and squinting, he obsessively scraped at the mirror with a razor, removing all but a network of thin silvery lines and circles. When completed, they were to resemble the eye charts used by French opticians and called *témoins oculistes*. When Man Ray dropped by one day, Duchamp "paused, put his hand over his eyes and sighed: if he could only find a Chinaman to perform this drudgery."[42]

As Ettie Stettheimer mentioned in her novel, he had also begun "some canvases," Cubist in form, but trying to produce "those impressions so painful to the eye when several objects in a movie move simultaneously at different velocities." One's eyes become confused, he told her, and one's head dizzy.[43] Possibly these were experiments later destroyed; or perhaps Duchamp was simply developing the ideas in his head, as he had earlier in his notebooks. Certainly the description fits his slavish picking at the "Oculist Witnesses." As Duchamp was meticulously scraping the mirror into impotence, it could no longer function as a reflector, while the glass could no longer reveal all behind it. The contradiction expressed, yet again, Duchamp's abiding theme: that every plus summons a minus, that yes is canceled by no, that a win is checked by a loss.

In his notebook seven years earlier, Duchamp had agonized over "the interrogation of shop windows." The chocolate grinder he had seen in a Rouen shop window was reappearing in the *Large Glass*. Back then, in 1913, Duchamp had noted his "inevitable" response to "the demands of the shop window." His choice: "no obstinacy, ad absurdum, of hiding the coition through a glass pane with one or many objects of the shop window. The penalty consists in cutting the pane and in feeling regret as soon as possession is consummated."[44] Laboring over his glass, Duchamp may again have reflected on the Bachelor who grinds his chocolate alone.

Meanwhile, Rose Sélavy continued to develop as an outrageous and increasingly vulgar personality. While the meaning of her name seemed to be explicit — *rose, c'est la vie* (pink, that's life) — its true significance, like so many of Duchamp's elaborate conceits, was maddeningly ambiguous.

Aloof and secretive, he avoided any explanations that might help the observer out of the mirror-lined cul-de-sac inhabited by the nimble Rose — or Rrose, as he would soon style her. Many observers have noted that her first name sounds like the French verb *arroser* and have translated it as "to moisten": giving nourishing liquid to life. But *arroser* can also mean to toast in celebration, to bathe with tears, to bribe, to shell, or to bomb. Thus, the multisided lady could be dealing life either a celebration or a bomb barrage; she could benignly irrigate life with water, or bathe it with tears; or she could simply bribe it. In choosing the name, Duchamp may have been building on a popular Lumière film circulated in France during the late 1890s, the first fiction film, a farce titled *L'arroseur arrosé* — a sprinkler sprinkled. The most common interpretation, of course, is the most straightforward: *Eros, c'est la vie,* or Eros is life, a wry comment from a man who shunned intimacy like the plague.

When asked about it later, Duchamp lightly skipped over any explanation whatsoever. "I just wanted two identities, that's all,"[45] he told Calvin Tomkins in 1961. Robert Lebel believes that the woman's name, together with the photos in women's clothes, suggest "the artist's inherent androgyny, in the manner of Leonardo da Vinci, to whom Duchamp had paid homage in his own way."[46] But in addition to enabling Duchamp to straddle the masculine and feminine worlds, the identity of Rrose Sélavy also allowed him to be in two places at the same time, to obscure the artistic paralysis of Marcel Duchamp with the feminine whims of Rrose Sélavy.

◆ ◆ ◆

In the spring of 1921, the Paris Dadaists were organizing a show, to which Duchamp had agreed to send four works. The printed catalogue promised them, as did the invitations, but nothing arrived from New York. As the June 6 opening approached, four blank spaces remained on the walls of the Galerie Montaigne: slips of paper marked entry numbers 28, 29, 30, and 31.[47] It was not Duchamp, however, but the rude Rrose who on June 1 added insult to injury via a two-word cable to Jean Crotti: "Pode Bal" (*Peau de balle*: Nuts to you!). In a follow-up letter to Tzara, Duchamp confused the issue even more; no entries had been sent, he explained darkly, because "the word 'exhibit' (*exposer*) resembles the word 'marry' (*épouser*)."[48]

Several days later, Duchamp boarded the SS *France* and sailed back to Paris, where he stayed for the next six months with Suzanne and Jean Crotti

(who had apparently forgiven Rrose's cable) in their apartment at 22 rue Condamine. Suzanne's husband was Swiss, nine years older than Marcel (born April 24, 1878), and the son of a house painter. He had studied first at the Decorative Arts School in Munich and in 1901, three years before Duchamp, had trained at the Académie Julian in Paris. Locked into an interior world by his own timidity, Crotti had lived quietly on the rue Fontaine; he often saw Degas in the neighborhood, but never spoke to him. At the 1908 Salon d'Automne, Crotti had sold his first work, a faintly Cézannesque landscape, for 150 francs (about $30).[49] In New York, in 1916, he became caught up in the ironic love-hate relationship with machines triggered by Duchamp and Picabia. Using a wire coat hanger, he had constructed a witty portrait of Duchamp, now lost.[50] When it was shown at the Montross Gallery in New York, Crotti described it as a "made to measure," the very opposite of readymade.[51]

Both Suzanne and her husband had been involved in organizing the Dada show; but toward the end of 1921, in the vacuum left by the disintegration of Dada, they developed their own entry into the fray of competing art movements. Their "Tabu manifesto," published in America in the spring of 1922, bears strong traces of Duchamp. No one invents an idea, the manifesto contended; rather, the artist is only the "receiver and transmitter" of ideas. "Tabu is ours," the Crottis announced, "through a violent revelation, through an inexpressible shock." Echoing Marcel's "beauty of indifference," they asserted that Tabu was "a religion without ethics."[52]

Duchamp had been in Paris less than a month when Man Ray arrived a week after Bastille Day. Duchamp met the boat train at the Gare St. Lazare and took him to a shabby *hôtel meublé* in Passy that turned out to be that legendary bugaboo of unsuspecting tourists, a sometime whorehouse. Ray's room had just been vacated by Tristan Tzara, and Duchamp's first bit of advice to Ray was that the fastest way to learn French was to "get a French girl." Later, Marcel offered Ray a maid's room in his sister's apartment, which Ray accepted.[53]

Duchamp also introduced his friend to the Café Certà in the tiny Passage de l'Opéra, whose Basque owner proudly featured Spanish port and English ale. Here, the same writers who had sparked the explosion of Dada in Paris before Duchamp's departure were now noisily conducting its wake. The poets Paul Éluard, Louis Aragon, Philippe Soupault, the sometime essayist and dandy Jacques Rigaut, and the lordly theoretician André Breton debat-

ed and squabbled vigorously over the form Art should now take.[54] After his very first meeting with Duchamp, Breton was struck by Marcel's calm, smiling demeanor and his talent for grasping "faster than anyone else the *critical point* of ideas."[55] Breton expected much from Duchamp, "if he weren't so aloof, and, at bottom, so desperate."[56]

But Duchamp, with Man Ray in tow, remained aloof. While willing to topple art's most sacred tenets, he stuck tenaciously to opinions he had developed early in life. In this case, the rejection of *Nude Descending a Staircase* more than a decade earlier had fixated him permanently against joining artistic groups.

All summer long, Duchamp and Man Ray played in Jacques Villon's garden in Puteaux, filming the spirals obtained by threading a white rag through the spinning wheel of an inverted bicycle. Villon, who was already in his mid-forties, looked on benignly. Sometimes they all played chess, perhaps striving nostalgically to recapture the optimistic and far-ranging speculations of the prewar Puteaux group. But, along with Raymond and Apollinaire and the millions of other victims of the war, Villon's carefree creativeness had become a casualty. He had sold only a few original works in recent years and was making a modest living by producing colored etchings of works by more successful artists.[57]

As Duchamp introduced his American friend to the Paris art scene, he also cautioned Ray against overinvolvement. And even Breton, "who could be extremely intolerant, never reproached either of them for their refusal to become involved in politics."[58] Instead, Breton called Duchamp "a veritable oasis for those who are still *searching*."[59]

That same summer, Rrose Sélavy posed for another portrait by Man Ray. This time she wore a hat belonging to Germaine Everling, Picabia's mistress, who also poked her hand into the picture. Nestled inside a fur collar, Duchamp's face peeks out, his eyes brooding and black-rimmed, his mouth lipsticked into a flirtatious bow. A fringe of hair, retouched in the negative, covers the ear, and there is a peculiar ambience of revealing while yet concealing: snap the shutter a moment later, one thinks, and the figure will have pulled the fur collar entirely up over the face. Like other Duchampian poses, this one also produced many copies, five during 1921 and an unknown number of others printed from the original negative by Man Ray in 1951.[60]

At about the same time, Duchamp posed before Man Ray's camera for

another photograph. This time someone had shaved a star-shaped tonsure on the back of his head. The rest of his hair was close-cropped, and in his mouth he clamped a pipe. It seemed Duchamp was determined to veil his original identity, whether in the guise of a woman or as a mock monk. While the gesture was prompted by his own sense of personal ambiguity, such a pose fascinated the Dada diehards.

Breton recalled expecting something "marvelous" before his first meeting with Duchamp. At first glance, he wrote, the "admirable beauty" of Duchamp's face "cannot be attributed to any particularly affecting feature." In conversation, "anything one might say to the man dulls against a slab so polished that it reveals none of what is going on deep down." No close friendship was possible, Breton wrote, because of his twinkling eye, "without sarcasm or self-indulgence, which dispels the slightest shadow of concentration and evinces a concern for remaining, externally, utterly amiable." While frankly admiring Duchamp, Breton struggled then and for the rest of his life to penetrate the "polished slab" behind which the real Marcel Duchamp presumably lived. But he was never to break through Duchamp's "elegance at its most fatal." It was also Breton who first pointed to the profundity of *L.H.O.O.Q.*: in defacing the world's most revered art work and then refusing to produce art, Breton argued, Duchamp had somehow transformed his whole life into a work of art. How else to explain the "extraordinary thing" Breton had seen Duchamp perform? Tossing a coin into the air, Marcel had told Breton: "Tails I leave for America tonight, heads I stay in Paris."[61]

Breton was describing an event in January of 1922; for on the 28th, after only six months in Paris, Duchamp embarked on the SS *Aquitania* for New

York. In fact, Duchamp's gesture was not quite as impulsive as it looked. He had been planning a return to New York for more than two months. On November 15, he had written Arensberg that he was studying "the most economical route" back to the city. Completing the *Large Glass*, he assured Arensberg, was "nothing special," with only some lead wire required. "Perhaps I won't die before it's finished," he joked. However, he also took note of the Arensbergs' move to Los Angeles, next door to the Hollywood movie industry, in the fall of 1921. Telling his friend he was bringing "a bit of film" — the spirals created in Villon's garden — Duchamp wrote that he planned to find a job in the movies, "not as an actor, but as an assistant cameraman." He signed the letter, "Marsélavy."[62]

Perhaps Duchamp was fleeing the increasingly heated battle among the Dadaists, in which the faction led by Tzara was stridently flinging verbal bricks against a splinter group led by Breton. But more likely, he was trying to prepare supportive American friends for the further escapades of Rrose Sélavy. That irrepressible lady had recently scrawled her name among dozens of others on a chaotic work by Picabia, titled *L'Oeil Cacodylate*, which eventually was hung in the Montmartre artists' café Le Boeuf sur le Toit. Duchamp also left behind two "aphorisms" that were printed in March 1922 in *Le Coeur à Barbe*, a broadsheet aimed by Tzara at Breton. One of them read:

> *Question d'hygiène intime:*
> *Faut-il mettre la moelle de l'epée dans le poil de l'aimée?*
> (Question of intimate hygiene:
> Should you put the hilt of the foil in the quilt of the goil?)[63]

Also printed among literary contributions from Éluard, Soupault, and the composer Erik Satie was a photo of Duchamp's challenge to the New York avant-garde, the notorious *Fountain* of 1917.[64]

Back in New York, Duchamp ostensibly plodded forward on the *Large Glass*. With the Arensbergs gone and a new generation providing New York with its own version of youthful rebellion, Duchamp discovered the further virtues of Rrose Sélavy. Now, in addition to posing for photos and signing works of art, she also began spewing raunchy puns, later dubbed "Texticles." Playing on the French literary phrase *morceaux choisis* (selected passages), Duchamp called them *morceaux moisis* (moldy morsels) — or "wrotten writtens" for his American audience.[65] Thus, while Duchamp

remained impotently transfixed by the mounting ambiguities not only in the content of the *Large Glass* but also in its construction, Rrose Sélavy abandoned herself to the salacious ambiguities within language via puns and spoonerisms.

The previous year, while the artist Duchamp was painfully scraping out the Oculist Witnesses, the prankster Rrose Sélavy had acquired a calling card:

> Precision Oculism
> Rrose Sélavy
> New York–Paris
> Complete line of
> whiskers and kicks

The whiskers probably refer to Duchamp's desecration of the *Mona Lisa*, while the kicks fit with a pun on "oculism," as "*au cul*-ism" (in-the-ass-ism). Now, in the summer of 1922, Rrose dazzled André Breton with a blaze of verbal pyrotechnics. The puns and spoonerisms Marcel sent from New York were printed in the October 1922 issue of Breton's magazine *Littérature*. Among them was Rrose's revealing judgment on "incesticides," cited above. The others were similarly suggestive, such as:

> *Abominables fourrures abdominales.*
> (Abominable abdominal furs.)[66]

The French language easily lends itself to plays on words, a form of wit that the French savor.[67] Breton, fresh from a honeymoon pilgrimage to visit Freud in Vienna, was so entranced with the shimmering implications of these statements that he called them "the most remarkable development in poetry" and dedicated the entire fifth issue of *Littérature* to Rrose.[68]

Their author, meanwhile, was going even further to breathe reality into his/her word games. With another expatriate Frenchman, Léon Hard, as a partner and financed with 3,000 francs (less than $250) borrowed from his tolerant father, Duchamp opened a dyeing establishment in New York. He found it amusing that the French word for "to dye" is *teindre*, close in sound to the word for "to paint," *peindre*. In any event, within six months the business was bankrupt.

Increasingly, Duchamp allowed outside distractions to divert him from completing the *Large Glass*. By November 1, he wrote Picabia: "I am drink-

ing again. Do nothing. Played little chess for four months. Will get back into training ... Nothing happened here ... go to bed much earlier."[69] By early February 1923, he was aboard the SS *Noordam*, bound for Rotterdam; he settled in Brussels, where he did little but play chess. In June, he moved back to Paris, taking a room at the Hotel Istria, 29 rue Campagne Première — "a sort of commune" wrote Pierre Cabanne, "frequented by artists and models from Montparnasse ... to conduct their experiments in free love."[70] It would be Duchamp's home for the next three years.

Meanwhile, the unfinished *Large Glass* went into storage at the home of Katherine Dreier, who had acquired it when the Arensbergs moved to California. She paid all of $2,000: $500 down and the rest in monthly $100 increments. Arensberg called the *Large Glass* "perhaps the supreme monument of Marcel's genius" and said he would be "heartbroken" to see it go to anyone but Dreier.[71] In the spring of 1922, rumors raced around the New York art world that financial reverses were forcing Walter Arensberg to sell his collection. John Quinn crowed that "an auction sale would be a slaughter." He was mildly interested in viewing the *Large Glass* but never found time.[72]

That his all-forgiving patron Katherine Dreier now owned the "supreme monument" left no impression on Marcel. As he would with other works, people, and places, Duchamp coolly turned his back on the *Large Glass*. Having picked at it for more than a decade, he would never add all the motifs he had originally sketched. In fact, the only subsequent addition was the traditional artist's gesture of completion: his signature. "You know how it is to continue something after eight years," he explained much later. "It was monotonous ... You have to be very strong ... there were simply other things happening in my life then."[73]

Actually, Duchamp had spent more than eleven years trying to materialize what he first labeled the "world in yellow" or "delay in glass" on his first pencil sketches in Munich. His original *The Bride Stripped Bare by Her Bachelors* of the summer of 1912 proved, by the winter of 1923, to be ultimately unconquerable. Later, Duchamp would assert that "in my whole life ... I have done but one work, the *Large Glass*."[74] In its incompleteness, it symbolized his attitude about art: "I have forced myself to contradict myself in order to avoid conforming to my own taste."[75] But its incompleteness also marked the self-destructive conflicts immobilizing Duchamp's life. Even the way he described work on the glass as "a sort of

negligent persistence"[76] might also describe his entire life, an existence determined by the toss of a coin.

Like all great works of art, *The Bride Stripped Bare by Her Bachelors, Even* harbors a multiplicity of meanings. On the technical level, it comprises a daring experiment with modern materials: glass, lead, varnish — and even the detritus of urban life, dust. On the symbolic level, it likens humankind's most basic drive to the operations of an absurd machine. Much as Freud drew on the concrete vocabulary of physics and economics to understand buried emotional mechanisms, so Duchamp turned to machinery to reveal essentially invisible concepts. On the aesthetic level, the glass's deliberate indifference to beauty heralds the twentieth century's persistent confusion about visual pleasure. On the philosophical level, the glass represents an effort to go beyond Wittgenstein's assertion that "the limits of my language are the limits of my world." Perhaps, Duchamp suggests, beyond the limits of language dwells another world: the visual. Finally, on the personal level, the glass charts a poignant graph of Duchamp's difficulties with intimacy of any kind: its conception draws the combatants as clearly as its incompletion limns their impasse. A tour of the *Large Glass*, therefore, is a multisided experience: sometimes clear, sometimes clouded, but persistently intriguing.

In a witty parody of the earnest encyclopedia entries of his youth, articles dealing with the marvels of modern technology, Duchamp intended to depict an absurd, complicated, and utterly baffling and frustrating lovemaking machine. The Bride above is the instigator, while the Bachelors below respond to her commands. The Bride has will; the Bachelors do not. The Bride has imagination and capacity for various behaviors but not the Bachelors. The Bride can blossom in unimaginable forms, while the Bachelors follow their humdrum routine. Like a queen bee, the Bride dominates the Bachelors. According to such broad concepts, Duchamp carefully worked out the details of his fantasy machine.

His notes and sketches of 1912 to 1915 indicate that the Bride is "basically a motor," in fact, an internal combustion engine. She secretes "love gasoline," a sort of "timid power" or "automobiline." The fuel sparks a flask-shaped object called the "sex-cylinder," barely attached to the Bride's main body, the *pendu femelle* (hanging female). The sex-cylinder is the heart of the Bride's desire. Floating across the top of the glass is the "cinematic blossoming of the Bride," containing three roughly square windows called "draft pistons." They transmit the commands issued by the *pendu femelle*.

Just below the blossoming at the right are nine shots, placed by Duchamp by firing paint-tipped matches at the glass from a toy pistol nine times. Originating with the Bachelors, the shots are supposed to trigger a mechanism (called the "Boxing Match" and never executed) which, by means of electrical sparks, will bring about the Bride's "electrical undressing." Meanwhile, the sticklike shape at the lower left is the Bride's "desire magneto," which triggers the whole operation of the Bachelor Machine, at the bottom of the glass.

Thus it is the Bride who controls the far more complex, but far less autonomous, Bachelor Apparatus. "The Bride has a life center," Duchamp noted. "The Bachelors have not." At the Bride's command, the Bachelors' desire is activated by a burst of illuminating gas into the "malic molds." These nine figures at the lower left of the glass "cast" the gas into their own forms: gendarme, priest, cuirassier, and so on. The "gas castings" are reminded of their malic function by the melancholy dirge from the glider, which is driven endlessly back and forth by water falling on the wheel: "Slow life, vicious circle. Onanism. Horizontal. Round trip for the buffer. Junk of life. Cheap construction. Tin, cords, iron, wire. Eccentric wooden pulleys. Monotonous flywheel. Beer professor." To the tune of this lugubrious litany, the illuminating gas starts converging through the capillary tubes at the top of each malic mold.

As it flows through the tubes, the gas undergoes "the phenomenon of stretching in the unit of length," following a Law of Playful Physics invented by Duchamp. Invisibly, it solidifies into long needles that break up into "spangles of frosty gas." Being lighter than air, they tend to rise but get caught in the first cone, or Sieve. Now they begin to have human attributes. As they pass through all seven sieves, which are increasingly clogged with dust, they lose their "individuality," suffer "dizziness," and emerge as a "liquid elemental scattering."

The drops apparently fall into the chocolate grinder, but their fate remains unclear because Duchamp never executed the remaining machinery. Somehow, by means of a "toboggan," they were to move toward the base of the Oculist Witnesses all the while being transformed into an explosive liquid. With terrific speed, they are "dazzled" upward through the center of the Oculist Witnesses and into the Bride's domain. Three horizontal lines separate the Bride from the Bachelors, and these comprise the Bride's "clothing." When the splashes touch her clothing, then, the Bride herself deflects

them upward toward the nine shots. From here on, the *pendu femelle* commands the splashes by activating the draft pistons.[77]

Within this schematic and utterly mechanical operation, Duchamp envisioned frustrating sexual drama, an endless, self-generating cycle of lust perpetually doomed to frustration. The Bride's "blank desire (with a touch of malice)" activates the subservient Bachelors. The sparks from her desire-magneto set up the two-stroke internal combustion process that powers her magical blossoming. She accepts the Bachelors' splashes, then blossoms, entering the last state before fulfillment. But fulfillment never comes; she remains "forever lovely and unravished, eternally between desire and possession."[78]

Like every artist, Duchamp drew heavily on his own experiences and feelings in developing the *Large Glass*. Aside from his grandfather's paintings and engravings, his earliest exposure to art had been to the stylized, hackneyed representations in the church across the street from the family home in Blainville-Crevon. As usual, the centerpiece here was a crucifixion. Later, in the Rouen public library, he must have seen the many versions of this same scene as interpreted on the manuscripts laid out for display there in glass cases. Given his budding skepticism of religion in a society where religion still played a controversial role, he could well have conceived of a secular crucifixion, a highly personal crucifixion in which the central figure is a woman.

Both verbally and in the bitterly ironic painting *Sonata*, Duchamp had expressed his feelings about his mother. She was "cold and distant," and her deafness surely emphasized this trait. Just as he had already figuratively torn his youngest sisters in tatters and speared his parents, the king and queen, he could well have conceived of crucifying his mother in a sly and complicated and ultimately harmless way. Seen against this background, the hanging female in the *Large Glass* reads relatively easily as a female Christ, dominating the bachelors who scurry in fruitless activity, like the figures at the foot of the cross in painted crucifixions.

These feelings may well have crystallized, in the summer of 1912, following the marriage of the second important woman in Marcel's life: Suzanne. It was during his frenzied work in Munich that he focused on virgins and brides and what differentiated one from the other, anxiously penciling out a vision of *The Bride Stripped Bare by Her Bachelors* in his lonely cubicle.[79] The neglected son and beloved brother who had been abandoned

in favor of a father and a husband insisted on intruding himself back into the bride. Then, suddenly fearing that he might have revealed too much, Duchamp fled into a pose of distance, choosing to speak symbolically in the idiom of a machine, specifically an internal combustion engine whose two strokes evoke an obvious sexual parallel.

Duchamp insisted that he intended a "hilarious" picture, and indeed, he had developed an elaborate spoof of science and technology. But, as Freud concluded as early as 1905, jokes have a far deeper meaning, especially to those who devise them. Freud argued that a joke is a message from the unconscious. Jokes, like dreams, couch this message obliquely, characteristically using psychological processes of displacement, condensation, and indirect representation.[80] In such terms, Duchamp displaced a conscious stimulus — the development of the internal combustion engine — into a symbol for his frustrated erotic strivings. Again and again in the *Large Glass*, processes remain unfulfilled. The Bride's cylinders are "feeble," her desire contains "malice," she harbors "timid-power"; the splashes, though "dazzling," fail to reach the mark. Through multiple meanings, Duchamp tried to condense all his feelings into one statement: his disappointment in his mother, his frustration as one artist among many talented artists and as the much younger brother of two gifted artists, his vain search for personal identity, his inability to achieve intimate relationships, his "loss" of Suzanne, his inability to communicate, and his professional paralysis. For more than eight years, until late in 1920, Duchamp struggled to purge himself of these conflicts through this indirect representation — the most elaborate visual joke of the twentieth century.

The next installment of this complex joke was the birth of Rrose Sélavy. Just at the moment when, at the age of thirty-three, Marcel was blocked in completion of his crucifixion fantasy, he engineered a resurrection: as Jesus reappeared in symbolic form, so the artist Marcel had to reappear in a totally altered fashion. Now he became Rrose, a separate personality who was crude, rude, and vulgar down to her name; who blatantly expressed sexual impulses, such as the desires of the "incesticide." Her boldness contrasted harshly with Duchamp's aloofness, her vulgarity canceled his elegance, her aggressiveness paralleled the activeness of the Bride, just as Duchamp's obedience to the laws of chance matched the passivity of the Bachelors. The birth of the fresh widow, Rrose Sélavy, marked the death of the Bride Stripped Bare and heralded Duchamp's withdrawal from being an artist.

All his life, Duchamp tried to muddy and belittle the meaning of his magnum opus. His own offhand, amusing, and ultimately misleading statements to various interviewers demonstrate his own share of displacement, condensation, and indirect representation. He told Cabanne that the Bride was "a projection of a fourth-dimensional object ... a bit of sophism."[81] He told Tomkins that the *Large Glass* symbolized the wooing of the Muse, which "can never wholly succeed ... this Bride, like life itself, can never truly be possessed, nor even stripped bare ... the courtship is what matters."[82] He told Lebel that "the glass is not to be looked at for itself, but only as a function of a catalogue I never made." He told John Golding that it was "a wedding of mental and visual concepts."[83] He told Katharine Kuh that it was a technical experiment in "getting away from even the idea of painting a picture ... purely mental ideas expressed ... but not related to any literary allusions."[84] He told Schwarz: "Eroticism is a subject very dear to me and I certainly applied this liking, this love, to my glass ... It's an animal thing that ... is pleasing to use as you would use a tube of paint, to inject into your production, so to speak." On another occasion, however, he told Schwarz that he tried to "rely on phenomena and principles that could not have the slightest aesthetic value or artistic significance."[85] His most fanciful explanation came in 1955, when he told an interviewer from a Surrealist publication that the *Large Glass* was "certainly not" a revelation of his own mental life. The inspiration, he said, came from those dummies at local fairs, dressed as a bride and groom, "who offered themselves for decapitation by people throwing balls at them." Obviously, Duchamp explained further, the *Large Glass* was an expression of "an attitude toward machines, by no means admiring, but ironic."[86] Having invested almost eleven years of his life in this work, Duchamp sailed away from it forever, flippantly explaining, "It no longer interested me."[87]

Within the art world, however, the *Large Glass* has challenged, enraged, inspired, and baffled generations of critics. It is generally conceded to be "the most complex and elaborately pondered art object" produced in the twentieth century.[88] It has been described as "a great modern legend,"[89] as "the only new myth created by a painter before the advent of Surrealism,"[90] as a "light ... to guide the ships of the future through the reefs of a dying civilization."[91] Its meaning has been interpreted in endless verbosity and variety. Perhaps it expresses twentieth-century man's alienation from his powers of reason and love into a ruthless determinism, outwardly symbol-

ized by molds and inwardly propelled by the relentless rhythm of his drives, all the while "taunted from above by a woman."[92] Perhaps it is ultimately meaningless, its "unintelligible visual experience ... leaving a profound sense of spiritual and intellectual waste, corresponding to the onanism of the bachelors."[93] Perhaps it is even an occult message, including in its iconography symbols from numerology, astrology, alchemy, Tarot, Gnosticism, Tantric Buddhism, and the Kabbala.[94]

In its ambiguity and its incompleteness, the *Large Glass* defies a final interpretation. Is it even a work of art? Duchamp deliberately suppressed any aesthetic value it might harbor. He rebelled against the tyranny of the hand, of craftsmanship. Yet he spent eight years meticulously gluing on wire and lead, varnishing dust and scraping mirror glazing. Is it a unique work? Then why have four museums, failing to obtain a loan of the original, painstakingly created replicas? And why did Duchamp ostentatiously sign the copies? Is it a joke? If so, why aren't we laughing? Even black humor, while evoking an inner shudder, brings an ironic smile to our lips. Is it really a hymn to Eros? Then why does its message of frustration, incompleteness, and impotence incline in the direction of Thanatos? Ultimately it is the richness of meanings and their inherent contradictions that make this work so fascinating.

Duchamp strongly believed that each generation creates its own masterpieces. As he told a Houston audience in 1957: "In the last analysis, the artist may shout from all the rooftops that he is a genius; he will have to wait for the verdict of the spectator in order that his declaration take a social value and that, finally, posterity includes him in the primers of Art History."[95] For eleven years *The Bride Stripped Bare* was Duchamp's principal artistic preoccupation. (By comparison, the *Sistine Ceiling* occupied Michelangelo only four years, Leonardo took two years to finish *The Last Supper*, and Picasso completed *Guernica* in just over a month.) But the "verdict of the spectator" is that the "social value" of the *Large Glass* lies, not in its artistic genius, but in its far broader and deeper insights. In confronting his own passionate and bitter, and ultimately checkmated, love-hate relationship with art and with the people around him, Duchamp sought to set himself firmly apart from the artists of his time. In the process, wrote the art historian Barbara Rose, he came close to being "the outstanding esthetician and critic" of the twentieth century.[96]

◆ ◆ ◆

In his struggle to communicate, Duchamp spoke to the struggle of every modern artist and writer to explain himself within a contemporary idiom. In his experiments with materials and techniques, he was among the first to try using the resources, as well as the debris, of modern technology. In the diffuseness of his message, he symbolized the multiplicity of contradictory messages that jumble the modern world. And in the abstractness of his expression, he summarized the abstract essence of modern communication. In his refusal to repeat himself, as well as his seemingly contradictory impulse to reproduce his productions ad infinitum, Duchamp mocked the marketplace of art, where Picassos are sold in bulk and Chagalls illustrate greeting cards. And finally, in his abdication as an artist, Duchamp bitterly expressed his disgust with the modern world's insistence on the separation between art and life, in which the artist is a clown, an entertainer — or simply merchandise.

The source of Duchamp's enormous influence on modern art lies in the responsive chord his artistic and verbal statements have struck throughout the art world and over a span of more than four generations. The central puzzle of his appeal is that the importance of his work is based not on its beauty but on its denial of beauty, not on its clarity but on its ambiguity, not on its abundance but on its paucity, not on its expressiveness but on its inarticulateness, not on its sense of fulfillment but on its sense of frustration. The crowning paradox is that Duchamp's universality springs from neurotic particularity.

Many observers have noted Duchamp's dual and contradictory orientation. Jean Reboul frankly called the *Large Glass* the work of a schizophrenic; such personalities, Reboul observed, typically act as though there were a pane of glass between them and others. Lebel argues that the Bachelor Apparatus alone represents a schizoid obsession and that Duchamp finally "rejected its yoke" and identified with the Bride.[97] In a study of schizoid attitudes that sometimes surface in modern art, the psychiatrist Louis A. Sass points to the similarity of Duchamp's irony to a striking characteristic of schizoid behavior, the "famous empty smile." Such an all-encompassing irony, he writes, "is not a criticism of one thing in favor of another, but a universal mockery."[98]

In fact, Duchamp was paralyzed as an artist by the conflict between revealing and concealing his real personality. Should he create a mirror, which blankly reflects reality while hiding whatever lies behind it? Or

should he allow the glass to reveal all? For the three years from the birth of Rrose Sélavy to his abandonment of the glass, Duchamp contemplated the dilemma, scratching away a bit of mirror here, adding a snippet of lead there, revealing on one side what he concealed on the other. As early as February 8, 1921, Marcel had written to Picabia that he had decided to renounce painting.[99] One of his closest friends, Henri-Pierre Roché, noted the extremes in his personality: "He swings like a pendulum between inertia — acceptance of reality — and suicide — refusal."[100]

"It just fizzled out," was Duchamp's laconic comment in 1966 on the unfinished *Glass*.[101] But through the years, he offered a multitude of explanations and rationalizations. Back in Paris, in February 1923, he took on the prevailing protective coloration of the Dadaists, many of whom were "renouncing" art during this period. In April of 1923, for example, André Breton told an interviewer that he intended to quit creative work. "In two and one-half months we will publish a final manifesto," he said. It would be signed by himself, Paul Éluard, and Robert Desnos, "if we can all agree on the text."[102] In the *Journal du Peuple*, also in April, Breton wrote emotionally "To Rrose Sélavy":

> *J'ai quitté mes effets*
> *mes beaux effets de neige.*
> (I've abandoned my effects
> my special effects of snow.)[103]

And on September 19, Breton told Picabia: "To Rrose Sélavy — André Breton has given up writing ... melancholy distracts me from what I wish to say."[104]

But for Breton (as for Éluard), the dark cloud passed quickly; by 1924, he was deeply involved in organizing and dominating Surrealism. When Robert Desnos improvised spoonerisms that, he claimed, resulted from telepathic communication with Duchamp, via Rrose Sélavy, Breton devoted seven pages to them in *Littérature*. "What a telepath! Why doesn't he ask for Rrose's hand?" an irritated Duchamp grumbled to Breton. "She'd be thrilled."[105] In much later interviews, Duchamp went out of his way to distance himself from Surrealism and all its works. "The work of an epoch is always its mediocrity," he told Alain Jouffroy in 1954. "That which is not produced is always better than that which is." Then he rationalized: "A person can do other things than one profession from the age of twenty to his

death ... I enlarged the way to breathe."[106] In 1961, he explained that he abandoned art "partly because of laziness and partly because of lack of ideas ... painting was one means among others toward an indefinable end."[107] At about the same time, he told another interviewer that he had "always been bored with it" and that art gave him "no essential satisfaction."[108] And two years after that, there was a note of self-pity as Duchamp discussed his flight from painting: "I never do anything to please myself," he complained. Of the few works he had done, none was finished "with a feeling of satisfaction." Yet, he added defiantly, to stop painting "was never a decision. I can paint tomorrow if I wish."[109]

Many observers believe that, indeed, Duchamp never stopped doing art throughout his long life. One recent study argues that every replica of a Duchamp work and every scrap of paper he was associated with should be seen as a new work of art.[110] Arturo Schwarz, in his "complete" catalogue, lists 258 works created by Duchamp after 1923, compared with 405 before. But of the later works, so many were replicas and ephemera that new finds are still turning up. The few originals include such marginal works as a

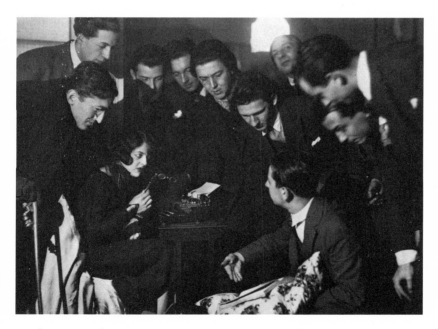

Robert Desnos, foreground, dictating his unconscious to the Surrealists. André Breton (upper center) listens as Giorgio de Chirico peers at the camera from behind.

framed chess score, a green vest bought at Lord & Taylor in New York, and an urn containing the ashes of Duchamp's cigar. It is also possible that Duchamp destroyed certain of his works in the interest of maintaining a coherent oeuvre, a gesture toward polishing the consistency of his image as the original antiartist. A number of his works were lost for so many years and turned up so casually that one wonders if more of them were not just as casually destroyed. But ultimately Duchamp's word for what he intended should be taken seriously — and he certainly announced loudly that he was quitting art, and insisted until his death that he was no longer an artist.

Of course, Duchamp was responding to the increasing commercialization of art; he was disgusted to see the originality of the Fauves and the Cubists swallowed up in the repetition required by the marketplace. But he also played out in extreme form the classic role of a younger brother, "who shows off, who is brilliant, who gambles recklessly and who, at crucial moments, disrupts the game and does not compete at all."[111]

He pleaded boredom and he pleaded principle, but behind it all lurked an overwhelming desire for distance. It drove him back and forth across the Atlantic at the toss of a coin. It rang down a glass curtain between him and anyone who desired intimacy. It even spawned a second personality, Rrose Sélavy, whose creative outbursts masked the paralysis of Marcel Duchamp. Unresolved and festering, this conflict relentlessly ate into Duchamp's personality and drove him, for relief, into a life dominated by a bizarre disease — chess poisoning.

LIKE MANY ARTISTS whose moderate success did not match their ambitions, Duchamp had grown to hate the competitive spectacle art had become: each movement arriving in a hurricane of liberating pronouncements, shrill manifestos, and revolutionary blather, only to become in a matter of months a censorious, exclusionary academy. Abetted by skilled dealers and by the obvious profits from investment in earlier revolutions, the small but growing public for modern art had an insatiable appetite for new sensations.

Kahnweiler's exclusive Cubists had driven out many competing movements, and the Futurists had rushed home to lend their energies to Italy's Fascist dictator, Benito Mussolini. Henri Matisse had developed such a loyal American following that in 1924 he sent his son, Pierre, to New York as a sales representative.[1] Since his youth, Duchamp had watched the marketers of avant-garde art deliberately stressing the difficulty and inaccessibility of what they were selling. They promised their clients membership in an exclusive club, a token of arrival at a lofty cultural plateau.[2] Indeed, the obscurity of the *Large Glass* was Duchamp's contribution to this effort. But it was unfinished and seemed to have no offspring.

From this standpoint, Duchamp's mustache on the *Mona Lisa* and its flippant title, *L.H.O.O.Q.*, were a profound commentary on the bankruptcy of the art that had been evolving since the Renaissance as well as on most artists' increasingly anxious efforts to create some stunning new thing. For Duchamp, Dada had been only a way station, as it was for many other Dadaists.

Johannes Baader, for example, flashed briefly across the Berlin Dada firmament between 1918 and 1920 as the self-styled "Dada-Prophet." Johannes Baargeld was a poet before he helped Max Ernst found Cologne Dada. He quit art in 1921 to devote himself to politics. Hugo Ball's aim in founding the Cabaret Voltaire in Zurich during the First World War had been "to remind the world that there are people of independent minds — beyond war and nationalism — who live for different ideals."[3] After the war he devoted his time to writing a biography of the Russian anarchist Bakunin.[4] Among those still involved in Dada, Duchamp was widely admired as the only one to heed Dada's destructive logic, or so the movement's biographer, Willy Verkauf, noted: "He quit painting as of no consequence."[5]

Painting, perhaps, but art was a different matter. Man Ray observed that Duchamp believed the average person could not comprehend his work and that he masked his painful sensitivity to adverse comments with "a profound contempt for others' opinion." Rather than face destructive criticism, he preferred to be "tolerant of a certain snobbism on the part of those who professed to understand him." So fearful was he of critical comment that he rarely offered his own opinions about art. When he spoke out, his remarks were totally impersonal, "as if he himself were not involved," Man Ray recalled. "Pride and humility went hand in hand."

Unable to catch up with his brothers, Marcel instead reveled in his reputation for "impishness" and "cleverness," converting his disappointment at being overtaken by other artists into overbearing mockery and humor. In that mode, he casually dismissed all the art of the previous century as "ethnographic documents," insisting that he preferred "non-art" to "anti-art." And he tried to ignore "everything that ritually constitutes and exalts the raison d'être of art: the sensitive ego, the emotional ego, the remembering ego."[6] His friend Gabrielle Buffet-Picabia could not understand his harsh self-discipline. His check on himself, she wrote, "was so stringent and ascetic it approximates that of the most rigorous mystics."[7]

What had transformed the seemingly carefree, carousing Marcel of New York in 1915 into the ascetic Duchamp who, in the late spring of 1923, moved into a humble room at the Hôtel Istria in Paris?

The SS *Zeeland* had landed him in Rotterdam in mid-February that year. After a brief dash to Paris, he had stayed for a time in Brussels, where he joined the local chess club. After his first important team tournament,

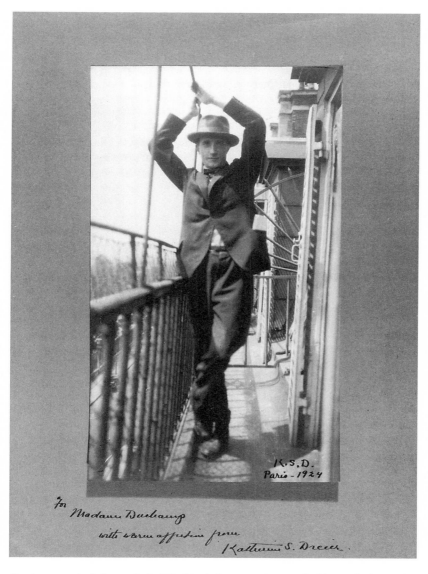

Duchamp on the balcony of the Hôtel Istria in 1924, photographed by Katherine Dreier

Duchamp reported to a Paris friend that he was "a perfectly happy man … I am doing very well."[8]

For more than a decade thereafter, chess dominated Duchamp's life, an obsession that raises questions about "a perfectly happy man." Like an athlete, he trained daily; he pored over games of the masters, often replaying a particularly challenging match out of the past on his own chessboard. By ordinary standards, Duchamp was an excellent player; four times he was a member of the French team at the annual International Chess Olympiads, which were organized in 1927. But by a striking analogy with his art, in which his fame increased proportionately as his creative output diminished, so in chess Duchamp may well have been a less skillful player in the years after he threw himself into the tournament circuit.

By a curious parallel with the world of art, chess experts see the years between 1900 and 1914 as the "period of virtuosi," while after 1920 "chess gradually stagnated"; despite many fine games, "it began to seem that there was nothing more to discover." In 1921, José Raúl Capablanca, the man whose early games Duchamp had replayed in his solitary Buenos Aires studio, had become world champion. Insiders considered the victory detrimental to chess, as no challengers arose; even Capablanca himself complained that the "game was played out."[9] Furthermore, France was in a deep and lengthy slump in producing able chess players. Ever since England's Howard Staunton had defeated Pierre Saint-Amant in 1836, not a single French player had attained an international reputation. Perhaps Duchamp hoped to fill this void. But to the end of his life, his ultimate standing in the chess world, as in the art world, was as an original and brilliant genius *manqué*. He played poorly in each of the four Olympiads in which he participated, "not so much from lack of natural ability," wrote chess expert Harold Schonberg, "as from lack of technique and will to win."[10]

The grand master Edward Lasker noted that Duchamp "would always take risks in order to play a beautiful game, rather than be cautious and brutal to win."[11] The poet Alfred Kreymborg recalled that when he first met Duchamp over the chessboard in New York, "Marcel was a diverting performer, full of surprise attacks and eccentric combinations. As he took the game more seriously, studied books, joined the Marshall Chess Club, played in tournaments and rose to the status of a first-class player, his originality vanished." Typically reacting to failure with a Dada-like upset of all the rules, Marcel briefly tried to revise the game so that only illegal moves were

tolerated; but the experiment apparently left him depressed, said Kreymborg, and his game in ruins.[12]

Duchamp traced his obsession with chess back to his 1922 stay in New York, during which he had been a member of the Marshall Chess Club's tournament team, the champions in the Metropolitan League. The youthful face of Duchamp still looks gravely down from a group photo of that championship team hanging in the club's main salon. On November 22, 1922, Capablanca had played against twenty-five of the club's members simultaneously, and had defeated twenty-one of them, including Duchamp. "After that," Marcel told an interviewer much later, "ambition set in." Not until 1940 did he comprehend that reaching the top of the world chess ladder was "hopeless, that there was no use in trying." Nevertheless, he continued to play "seriously" until 1960, and for diversion until his death.[13]

To the end, Man Ray was one of his favorite recreational chess partners, though Duchamp dismissed his friend as a "wood-pusher" and in their friendly games never was "particularly intent on winning." Duchamp also left it to his friend to design a series of handsome modern chess sets, beginning with one in 1926 made of silver, the white pieces polished, the black, oxidized.[14] For Marcel, playing with his friends was "a form of conversation," Man Ray decided. "One's character emerged as one exposed oneself to an opponent, as in an argument."[15] To his friends Duchamp surgically diagnosed his own shortcomings as a player. On rounds of clubs, "smoke-filled places where everyone drank a lot of coffee," he would predict the outcome of his matches to Roché: "I will win at the beginning. I will even make some brilliant moves. But toward the end, I may be at the mercy of an oversight or of a mistake."[16]

There is a poignant paradox in Duchamp's obsession with a game in which he was condemned to lose, while giving up a career in art that promised him success. For, despite his overt renunciation, Duchamp was still considered an extremely promising artist — if only he would produce. In the mid-1920s, Alfred Knoedler, the prominent New York art dealer, offered Duchamp an annual salary of $10,000 for only one painting per year. Marcel smiled at Man Ray, who was conveying the offer, and said he "had accomplished what he had set out to do and did not care to repeat himself."[17]

But while shunning repetition in art, Duchamp was devoting most of his energies to a game in which, by definition, "the player will repeat and repeat again ... throughout his life certain gambits and strategies." The reason,

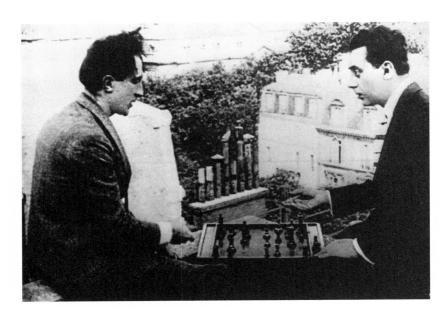

*Partners in chess: Duchamp and Man Ray at the board
in the film "Entr'acte," 1924 (above), and some forty years later*

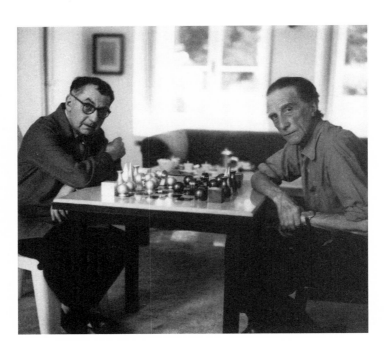

according to the psychologist and chess grand master Reuben Fine, is that "the chess pieces represent a mime of the Oedipal situation and the player is forced to confront this mime every time he looks at the board ... [He] is exiled from ordinary reality during his chess seance, yet that exile allows him to play out the dramas ... otherwise repressed ... of his early life."[18] A less Freudian observer could emphasize that playing chess provides a safe outlet for inner hostility and anger. A more recent study of the chess player's mind sees him (and it is seldom a "her") as "a man with a dedication to the game that approaches obsession, with the motivation to perform better than his competitors and with that elusive 'chess skill,' the ability to recognize the patterns on a chessboard which are the key to deciphering the meaning and potential of the position."[19]

Unlike most chess players, Duchamp did not learn the game from his father but from his surrogate fathers, his two older brothers. They began teaching him the game when he was thirteen, at exactly the same age that they began to interest him in painting.[20] A 1904 etching by Villon shows Marcel deeply absorbed in a chess game with his beloved sister Suzanne. In October 1911, during his most feverish period as an artist, Duchamp drew six pencil sketches of his brothers at the chess board, in preparation for two versions of a painting he completed by the end of the year, *The Chess Players* and *Portrait of Chess Players*.

The first sketch consists of but a few lines indicating the heads and one arm of the two antagonists, superimposed on two larger profiles drawn nose-to-nose above a single rook. The lines also form a single face seen head on, with the eyes of the two figures now forming the eyes of one, their noses forming a single nose and the hand on the rook forming the mouth. The succeeding five sketches are increasingly complex, as though Duchamp wanted to obscure the ambivalence of the first sketch. (One of these sketches, a veteran of many an exhibition, was sold at Sotheby's London in December 1999 for almost $780,000.[21])

In the first of the paintings, the two players are so close together as to form one figure: no board stands between them; indeed, they look as though they are manipulating each other, while the chess pieces seem randomly scattered around them. The sketchy face of a man looks on from the upper right. The second painting, *Portrait of Chess Players*, is more purely Cubist; the two protagonists appear to be in motion, while the expressionless face at the upper right is larger, more developed, and better integrated into the work.

In April and May of 1912, Duchamp had created further works with a chess motif, providing unconscious clues not only to their inherent double meaning, but also to how they might express his family fantasies. One sketch, *The King and Queen Traversed by Nudes at High Speed*, fuses the motif of chess pieces with the symbolism of the static, vertical mother and father sliced by their dynamic, diagonal, fast-moving offspring. In a second sketch, *The King and Queen Traversed by Swift Nudes*, the two parental figures are more vague, perhaps tottering from the swift thrusts of the nudes. In the painting based on these sketches, *The King and Queen Surrounded by Swift Nudes*, the swift nudes have decisively separated the two complex multifaceted totems representing King and Queen. In a chess game, the queen uses her versatility and mobility to protect the slow-moving, vulnerable king. The queen can be captured, while the king need only be immobilized to end the game. To shield the king, the queen requires a row of squares clear of other pieces. But in the painting, a bevy of "swift nudes" isolates the king, presumably leaving him helpless.

While Duchamp never commented on the psychological symbolism of these paintings, he often spoke about the symbolism of chess, though always in intellectualized terms. The parallels he drew between chess and art often contradicted each other. Sometimes he insisted that the game was the purest form of art; sometimes he stressed the gulf between these two kinds of play. A chess game is "very much like a pen-and-ink drawing," he told the members of the New York Chess Association in August 1952. "However, the chess player paints with black and white forms already prepared, instead of inventing forms." He compared the board to a "musical score," while the pieces resembled "a block alphabet which shapes thoughts." Though the arrangement of pieces forms a visual pattern, the thoughts they embody, Duchamp said, "express their beauty abstractly, like a poem."[22] As for the pleasures of chess, Duchamp discussed only two: "The abstract image akin to the poetic idea of writing" and the "sensuous pleasure of the ideographic execution of [that] image in the chessboard."[23]

Duchamp's discussion of chess is so rarefied and refined that the careless listener entirely forgets the aggressive, competitive, even murderous nature of the game. It originated as a war game in India, probably around 700 A.D.; its Sanskrit name, *chaturanga*, translates as "army." On its way to Europe, in Persia, the game was called *Shahmat* — checkmate — which eventually, in about the twelfth century, became the German *Schach-matt*. The Persian can

also be translated as "kill the king," highlighting the game's murderous objective. Since its introduction into Europe, chess has attracted aggressive personalities. William the Conqueror was a devoted player, as was Robespierre. Napoleon played daily at the Café de la Régence while awaiting the call from the Directory to lead France into new glory.[24]

Historically, as well as in its psychological symbolism, chess is hardly the aesthetic or purely intellectual delectation Duchamp tried to make it. The unconscious motive of the chess player, the psychoanalyst Ernest Jones writes, is not just competition, but "father-murder."[25] The American psychiatrist Karl Menninger concluded that chess players silently plot "murderous campaigns of patricide, matricide, fratricide, regicide, and mayhem."[26] And while it may be true, as Duchamp said, that "all chess players are artists,"[27] they are also participants in a kind of "psychic murder ... trying to dominate and, if necessary, to crush" their opponent.[28]

Again and again, Duchamp mildly described his addiction to chess as somehow related to his image as an artist. Playing a game of chess, he said near the end of his life, was like "constructing a mechanism ... by which you win or lose."[29] Sometimes he represented it as a nobler form of art than painting or sculpture. "Chess players are just like artists," he told one interviewer, "except they have not even the moneymaking opportunity [of the artist]."[30] To another interviewer, he described chess as being "purer socially than painting, for you can't make money out of chess, eh?"[31]

But perhaps this is more Duchamp draping his constitutional resistance to success in moral superiority. He had fled from a promising career as a painter in 1918, abandoned his major work in 1923, transferred all his creative impulses to his brash alter ego Rrose Sélavy, and rejected the central role he could have filled among various artistic movements: the Cubists, Dadaists, or Surrealists. Finally, he managed, through judicious errors and omissions, to defeat his principal stated ambition — to become a chess champion.

Writing about another chess maniac, the mercurial and eccentric American Paul Morphy, Ernest Jones points out that some men can endure success only in their imaginations; they identify every triumph with their fantasy of successfully castrating their fathers, provoking unendurable unconscious guilt. The Oedipal symbolism of chess has often been pointed out. To win at chess, a player must immobilize the opposing king. In that task, "the most potent assistance is afforded by the queen." Most players,

says Jones, hide from themselves the profound aggressiveness of the game, for the basic goal in driving for checkmate is "castration, exposure of the concealed weakness, destruction of the father."[32] Pawns are really *spawns;* their function is to destroy the king, especially if they survive the move to the opposite side of the board, where they turn into upstart queens, the pieces most lethal to the opposing king.

The novelist Vladimir Nabokov, himself an avid chess player, sensitively described the alienated, objectified, and conflict-ridden world of a chess champion in a novel published in 1930, *The Defense.* Discovering that his son is a chess prodigy, a father compulsively watches all his son's matches, "always craving a miracle — his son's defeat — and … both frightened and overjoyed when his son won."[33] The son, by contrast, projects all of his emotions onto the chessboard, eventually playing out his entire affective life on its sixty-four squares.

Chess players often have trouble communicating verbally, and many use nonsense phrases or puns during the game. Reuben Fine describes one player who, whenever he gave check, would say: "Let us go to Veracruz with four aitches." Another man would ritually intone this nonsentence: "Shminkus, krachus, typhus mit plafkes schrum schrum." Such a dissociation of words from their original meanings, he writes, "is characteristic of obsessional thinking."[34] This was the kind of thinking that Duchamp so entertainingly used to create his outrageous word games and spoonerisms. In fact, of the twenty-seven art works he produced during these years, sixteen deal directly with chess, while seven involve his other creative form at the time — verbal puns.

A cluster of Duchamp's works during this time feature his obsession with a single ominous sentence, a mantra repeated with slight variations: *"Rrose Sélavy et moi estimons les ecchymoses des Esquimaux aux mots exquis."* (Rrose Sélavy and I value the bruises of the well-spoken Eskimos.) This oblique sentence appeared in Man Ray's handwriting on the sketches for Duchamp's one substantial art project of these years, *The Rotary Demisphere,* completed in 1924. In the final version, however, Duchamp gave the sentence another twist by changing the word *estimons* (value) to *esquivons* (avoid, elude), thus canceling the original meaning one more time. So intrigued was Duchamp by this sentence that he used it again as one of the nine discs inscribed with sayings that formed part of a film with the anagrammatic and nearly palindromic title, *Anemic Cinéma.*

Another pun — *moustiques domestiques (demi-stock)* (domestic mosqui-tos [half-stock]) — endlessly repeats as the background pattern of another project from later that year, while a curious drawing illustrates still another pun: *Nous nous cajolions.* This translates as "We were petting each other," but Duchamp's drawing illustrates a homophone — *nounou cage aux lions* — by showing a nursemaid and child in front of a caged lion. Below the drawing, Duchamp pasted a photo of obscene graffiti from the public men's room in the Lincoln Arcade, thus drawing attention back to the title and its sexual overtones.

Except for chess, Rrose Sélavy was intimately involved in all Duchamp's puns and games. She was named as the author of many of them. Her name was engraved on the disc for the *Rotary Demisphere,* and her shaky signature appeared not only etched onto the camera used to shoot *Anemic Cinéma* but also above what is most likely Duchamp's thumbprint on the film's copyright. She boldly scrawled her name vertically, next to the graffiti, in the margin of *Nous nous cajolions.* All through the 1920s, she peppered the avant-garde publications of Paris with outrageously suggestive or explicit observations.

In 1921, she had produced for her Paris public another version of *Fresh Widow,* raffishly titled *Bagarre d'Austerlitz,* signing her name on one side of the fake-brick base while Duchamp signed the other (though both signatures were probably added long after the fact). Like *Fresh Widow,* this is a blind window; but instead of patent leather, the glass of this version is covered with the whitewash glaziers often daubed onto fresh panes. The offhand translation of the title is *The Brawl at Austerlitz,* but it also refers to a major Paris railroad station, the Gare d'Austerlitz. The historic "brawl" at Austerlitz, Napoleon's 1805 victory, of course resulted in quite a few fresh widows.

Rrose Sélavy also expressed herself idiomatically in English. Picabia's publication *391* printed her coarse witticism in July 1924: "Oh! do shit again! Oh! douche it again!" And for a speech on black humor by André Breton, she tried her hand at metaphysical couture: "Practical style, created by Rrose Sélavy: an oblong dress, designed exclusively for ladies afflicted by hiccups."[35]

◆ ◆ ◆

While Rrose romped through the world of avant-garde aesthetics, a hard-nosed Marcel Duchamp took care of business. Early in 1924, Duchamp

found a patron for a new version of the *Rotary Glass Plates*, the motorized optical contraption that had nearly decapitated Man Ray in 1920. At André Breton's urging, Jacques Doucet, the wealthy Paris couturier who aspired to be a patron of the arts, agreed to finance the project.

Doucet had earlier built a massive collection of eighteenth-century works, a rival to Lord Hertford's brilliant Wallace Collection, but in 1912 he and another collector of eighteenth-century works, the couturier Paul Poiret, sold everything to invest in contemporary art. In 1916, Poiret had arranged for the first public exhibition of Picasso's shocking *Demoiselles d'Avignon*. To Picasso's enduring spite, Doucet acquired the *Demoiselles*, sight unseen, for 25,000 francs — less than $5,000, and one-eighth the price the artist claimed he could have gotten for it soon afterward. The collector had bought the painting at André Breton's urging but was himself so embarrassed by it that he hung the work in his bathroom.[36]

When Duchamp entered the picture, Doucet was already in his seventies, and increasingly skeptical about buying paintings from young artists. However, he had arranged with Breton and Louis Aragon to write him two letters every month about literature, for which he paid each of them 1,000 francs.[37] Breton, who also worked for Doucet during the early 1920s as a librarian and adviser on art purchases, found him difficult and demanding. "Convincing him to buy a painting was ... an extremely laborious process," Breton later recalled. "Not only did I need to extol its virtues in person and many times over, I also had to continue doing so in several letters."[38] Thus warned by his friend, Marcel expertly toyed with Doucet's aspirations to be seen as an aristocratic patron of the arts. When the couturier sent him 6,000 francs ($279) to start work on the *Rotary Demisphere*, on February 28, 1924, Duchamp fastidiously replied that he considered it "an exchange and not a payment. I would like to make you a gift of this demisphere."[39]

Reporting on his progress, Duchamp corresponded with Doucet often and at length, sometimes daily, all through the rest of the year. Some observers have seen this carefully preserved bundle of letters as "elucidating the creative process" as profoundly as the notes for the *Large Glass*. But the tone and content of these missives embody another of Duchamp's elaborate jokes, this time a sardonic commentary on the greed and gullibility of those who collected avant-garde art.

"I have found and purchased a base today," Duchamp informed Doucet on March 7, "at Ryppaley's, a dealer in medical electrical supplies ...

Saturday I have an appointment ... with an engineer who'll give me an estimate." The very next day, Duchamp reported that the "engineer ... seemed to understand perfectly what I wanted." Less than a week later, he described how he haggled over the "engineer's" estimate, and how "I cut the discussion short by telling him in no uncertain terms that the maximum sum was 2,500 francs."

Three weeks later, Duchamp called on his patron to help him find, for the backdrop, "an English velvet, a silky velvet ... that will bring to mind the absolutely matte backdrop that you see in movie houses, 70 centimeters wide and the same length." Doucet's dressmaker's mind responded eagerly, it seems, for some weeks later, Duchamp sent a note accompanying his "final choice" among the swatches Doucet had supplied. "I prefer the blacker of the two," he wrote. "The coarser would give off a gray color compared to the other, which gives off a reddish black."

By July 3, Duchamp was encouraging Doucet with a promise of publicity: "Man Ray has made an excellent photograph of [the globe] which will appear in _391_ if you don't have any objections." More than a month later, Duchamp announced that he had found two copper and steel plates for mounting the contraption: "The entire thing won't go over 1,000 francs ($60)." A week later, he indicated that "the object will run by the end of September at the latest."

But the way of true art was strewn with setbacks. On September 15, Duchamp dejectedly reported "pitiful results ... I almost (!) finished mounting the striped globe on the first plate ... I'm sure we'll get there, but it will require your patience and mine." A week later, Duchamp was elated: "Your letters seem to have had a magic effect. The mechanic achieved in one day what it seemed would take him a week ... we can expect a rotation experiment next week." But the velvet for the backdrop still concerned Duchamp. It must be "absolutely matte and absolutely black at the same time," In a series of letters, Duchamp insisted it must be exactly "o meters 60 [centimeters] in diameter." All the swatches Doucet had sent were inadequate, so Duchamp undertook to locate velvet "which I hope will be perfect."

Finally, one Friday late in October, Duchamp excitedly reported he had "finally seen something turn," and several days later invited his patron to join him at the mechanic's workshop and "see the instrument there in its finished state." On the last day of the month, he forwarded a bill for 300 francs ($15.68) from the "engraver-geographer" who did the "remarkable

job" of inscribing the Eskimos' *mots* on the disc and promised that "next week everything will be finished."

Duchamp's obsessively elaborate joke was complete, but its humor teetered close to tragic farce. A creative artist had labored the better part of a year directing various craftsmen to bring forth a profoundly absurd object whose purpose was to set an empty phrase dizzily spinning in circles. In a wild parody of Leonardo's minute notes of his optical experiments, he had recorded, via the correspondence with Doucet, each absurd step in the construction of his zany machine. But like a child with a top (or an artist who deals with anxiety over his creative powers by obsessively repeating himself, circling around motifs of the past), Duchamp never could resist giving his creations one more ironic twist.

In a final letter to Doucet about the *Rotary Demisphere,* on October 19, 1925, Duchamp was as candid as he ever would be in expressing his pain and doubts about his work:

> A friend has asked me to exhibit the globe which you have, telling me that you've agreed to lend it to him.
>
> To tell you the truth, I'd rather not. And I'll only do it if you insist.
>
> All expositions of painting or sculpture make me ill. And I'd rather not involve myself in them.
>
> I would also regret if anyone saw in this globe anything other than "optics."[40]

By the time this was written, however, Duchamp was already deeply involved in another elaborate and marginally amusing prank. In the fall of 1924, he had designed and printed thirty *Monte Carlo Bonds.* These were shares in his own system to exploit, as the "Company Statutes" detailed on the back, "roulette in Monte Carlo" and "Trente-et-Quarante and other mines on the Côte d'Azur as may be decided by the Board of Directors." Printed on the front of each bond was a Man Ray photo of Marcel, his eyes earnestly contemplating a distant goal. The rest of his face was smothered with billows of shaving cream, which also formed his hair into a pair of devilish horns. Each bond was to sell for 500 francs (about $26), repayable with 20 percent interest over a period of three years.

The laughable price and horrendous interest rate may well have been an ironic commentary on the shrinking value of the franc versus the dollar. The effort to stabilize the franc began soon after the end of the First World

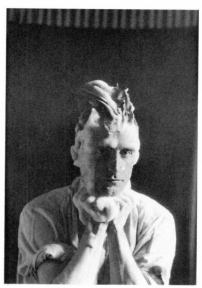

*"Monte Carlo Bond," 1924, and
Duchamp in shaving cream "costume"*

War and preoccupied one short-lived government after another.[41] The value of Duchamp's father's property (hence his own inheritance) was no doubt severely impacted by the successive devaluations of the franc.

In Duchamp's parody bonds, the return of capital and interest was to derive from "a cumulative system which is experimentally based on one hundred thousand rolls of the ball; the system is the exclusive property of the board of directors." But while the company statutes in their mock legalisms set forth the rights of shareholders and a board of directors, the names and titles at the bottom of the bonds clearly indicated who was in charge: Marcel Duchamp's modest signature appears at the lower right, as "an administrator"; at the lower left, as President of the Administrative Council, is the bold, broad-nibbed scrawl of Rrose Sélavy.

In the United States, the avant-garde *Little Review* promoted the bonds as not only "very amusing" but also, for anyone "in the business of buying art curiosities as an investment," as "a chance to invest in a perfect masterpiece," since "Marcel's signature alone is worth much more than the 500 francs asked for the share."

Duchamp had spent some time in Monte Carlo during 1924, ostensibly

researching and testing his system. During one five-day test, he wrote Picabia, "I have won steadily — small sums — in an hour or two"; but he was "still polishing the system ... it's delicious monotony without the least emotion."[42] In a letter to Doucet, he retracted his well-advertised "retirement" from painting: "You see I haven't quit being a painter, now I'm drawing on chance."[43]

Despite Duchamp's outward optimism and overt efforts to promote the bonds, most were unsold and are now lost. Among the few subscribers were the painter Marie Laurencin and the faithful Doucet. Undaunted, Duchamp dutifully departed for Monte Carlo after assuring Doucet, on January 16, 1925, that he had "studied the system a great deal ... This time I think I have eliminated the word chance. I would like to force the roulette to become a game of chess. A claim and its consequences: but I would like so much to pay my dividends."[44]

Two weeks later, however, on January 29, Duchamp's plans were interrupted by the death of his mother from cancer, followed almost immediately by the death of his father on February 3. In his last years, Eugène Duchamp had been a vice president of the Agricultural Bank of Haute-Normandie, a volunteer member of the Administrative Commission on Public Shelters in Rouen, a commissioner of public education, and a member of the Family Council for children receiving public assistance. The ribbon of a chevalier of the Legion of Honor in his lapel, he was buried in the Cimetière Monumentale of Rouen three days after his wife.[45] Duchamp returned to Rouen to wind up his parents' estates and collect a small inheritance. As he had promised, Duchamp's father had carefully recorded all the advances he had paid to his children and deducted accordingly in his will. Unlike the death of Raymond, which he mentioned briefly in letters, Duchamp did not refer to his parents' death or his inheritance of about $10,000 in any correspondence.[46]

It wasn't until that December that Duchamp was able to pay Doucet the first and only dividend on the *Monte Carlo Bond* — 50 francs, or less than $2. (Ultimately, just as the *Little Review* had predicted, those who bought bonds were well repaid in their investments; during the 1950s, Man Ray was offered $200 for his bond and exulted, "One thousand percent profit! Only the most improbable luck at roulette could match this."[47] He would have been even more euphoric had he lived and kept the bond into 1995: on June 28, Sotheby's in London auctioned one of them for $98,200.)[48] For Duchamp, the project was a complete success; he ended up "neither winning nor los-

ing." He had proven what he had set out to prove: that "one could win the equivalent of a clerk's wages" if one worked exactly as long at the roulette table as a clerk worked at his desk.[49]

During this same period, Duchamp participated in occasional forays into the world of entertainment. In November 1924, he played a small role in the film *Entr'acte*, conceived by Picabia and directed by René Clair, who went on to make *Sous les toits de Paris* and *A Nous la liberté*. For a brief scene, Duchamp appears to be losing a chess match to Man Ray while perched on the roof parapet of the Théâtre des Champs-Élysées. Then Picabia enters with a hose nozzle and washes the whole scene away. The film was shown during the intermission of Picabia's ballet *Relâche*, with music by Eric Satie, that December — the first time a movie was combined with a live performance.[50]

A few days later, in a farce entitled *Ciné-Sketch* directed by Clair that was performed on New Year's Eve, Duchamp (made up with a beard) coyly posed on stage in the nude as Adam. His equally nude Eve was the Polish artists' model Bronia Perlmutter, who would marry René Clair a year or so later. The two figures were revealed only by the light of a few momentary flashes; but, with characteristic care for the cultivation of his image,

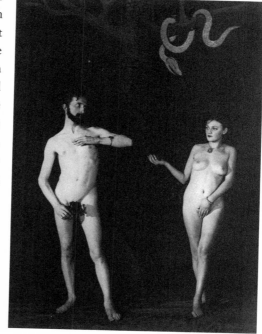

Duchamp had arranged for Man Ray to photograph the scene at a rehearsal. "It was a strip tease in the most literal sense," Man Ray wrote. "One would have liked to see a more prolonged vision of the tableau."[51] Once again, Duchamp had managed to bare all while revealing practically nothing.

"Ciné-Sketch," 1924: Duchamp and Bronia Perlmutter as Adam and Eve

Probably his most blatant exercise of this ambiguous art, however, was *Anemic Cinéma*, which resulted, after two years' collaboration with Man Ray and the would-be Surrealist Marc Allégret, in a seven-minute enigma on celluloid. The film consisted of a sequence of ten spiral-design discs, alternating with nine discs on which words were arranged in a circular pattern. As they revolved, the discs formed various oscillating designs; and such was their contradictory nature that at least one viewer noted that the film's "ambiguity ... is total — spatial, visual, verbal, and conceptual."[52] Like a child's magic incantation, the play sentence about the Eskimos from the *Rotary Demisphere* reappeared in the film, while the mosquitos from the *Monte Carlo Bond* likewise swarmed in a slightly altered version on one of the discs. The use of puns to create abstract patterns may have been a fresh idea, but by 1926, when *Anemic Cinéma* was completed, many others had experimented with cinematic abstraction: *Symphonie Diagonal*, for example, a five-minute effort by Viking Eggeling, had been released five years earlier.

In a way, Duchamp's complex puns were analogous to a chess game. They required long, patient, and concentrated effort for an essentially meaningless purpose. Their brittle cleverness and sly suggestiveness leave the reader intrigued but unsatisfied, with a sense of cosmic frustration. Like the *Large Glass*, they are also elaborate exercises in revealing and concealing, in meaning and nonsense; a hall of mirrors into which the viewer (or reader) inexorably enters only to stumble and fall, while somewhere behind the glare he senses Duchamp smiling — polite and sardonic, cool as ice, hard as glass, brilliant as crystal: a masked magician whose virtuosity leaves us with a tragic sense that life is just an optical illusion.

For in the film, the spinning discs turn the words into an illegible blur: "*Bains de gros thé pour grains de beauté sans trop de Bengué*": Baths in tea for beauty marks without too much Ben-Gay; *Inceste ou passion de famille, à coups trop tirés*": Incest or family passion ... Is the rest to be translated as though it read *à couteaux tirés* (at daggers drawn)? Or does it refer to *tirer un coup* (to have a lay)? As the words dizzily spin, does it matter? Is it worth analyzing these fragments for themes and significance, or is that effort itself a capitulation to Duchamp, an inexorable self-parody, much like the deadpan correspondence with Doucet or the loving display of a snow shovel in a dignified art museum?

To his loyal patron Doucet, Duchamp wrote in August 1926 that the film was ready at last; the only remaining job was to assemble it. Between this

matter-of-fact business correspondence and the wildly absurd content of *Anemic Cinéma*,[13] one senses a summing up of Duchamp's bitter conflicts about art. Like the last of the bathwater circling down the drain, the film's endless spirals symbolized the alarming thinning — the anemia — of his creative blood. While absurd humor tempered his psychic despair, chess enabled him to confront, in ritual form, the worst nightmare of the creative personality: checkmate.

The French word for chess, *échecs*, is the plural of *échec*, which can mean failure. Just as the *Large Glass* may be seen as an elaborate allegory of sexual impotence, so Duchamp's chess career presents an exquisitely wrought pun; his inability to become a grand master meant that he even failed at his self-proclaimed career goal of failure itself. It is hardly accidental that all three of the principal works of these years — the *Rotary Demisphere*, the *Monte Carlo Bonds*, and *Anemic Cinéma* — express profoundly similar themes, as though Duchamp were repeating endlessly an inner, compulsive litany. All of them combined a variety of media: fabric and film, metal and glass, photos and print. They all asked, without answering, whether they were works of literature, cinema, or fine art, intimately blending mental, verbal, and visual concepts. All three included some kind of machinery — motors, or movie cameras, or a roulette wheel. In fact, they dealt basically with circles, like mills mindlessly grinding out sensory data in a repetitious, mechanical fashion, as monotonous as the litany of the bachelors in the *Large Glass.*

From a practical standpoint, all three projects intimately involved other people's money and the time and effort of collaborators, as though Duchamp's doubts required the approval of patrons and coconspirators. In fact, his correspondence indicates, as we have seen, that these works were part of an elaborate scheme to parody and devalue the business world, that realm of negotiation, contracts, francs, and sous that had occupied the life of the *notaire* Duchamp, his father. In this light, the work and correspondence on the *Rotary Demisphere* ironically resembles the intricacy of a real estate transaction; the issue of the *Monte Carlo Bonds* crazily reflects the stereotyped legal workings of a corporation; while the drawn-out shooting of *Anemic Cinéma* coolly parodies the piecemeal repayment of an installment loan. With the guarantee that none of these elaborate, long-term projects would turn a profit, Duchamp mocked his father's daily concerns, while trying to console himself for failure in traditional art with cynicism, irony, and detachment.

In all of these works, Duchamp danced between extreme opposites. The pure, smooth white of the disc in the *Rotary Demisphere* twirled against the matte and mysterious black of the background velvet. The system to be exploited in the *Monte Carlo Bonds* depended on the opposition between red and black: win and lose. So terrifying was any decision that chance was made the arbiter, and Duchamp could speak of "delicious monotony without the least emotion." *Anemic Cinéma* presents sentences that are not sentences in stark black and white. Stripped of their meaning by an absurd juxtaposition, they circle in a blur. In motion, the words become indistinguishable from designs so that the viewer is drawn into dizzily confusing patterns of letter forms.

Duchamp's final, hopeless goal in these works was to solve an impossible problem: literally squaring the circle. In the *Rotary Demisphere*, as in *Anemic Cinéma*, the central patterns move eccentrically, as though trying to break out of their circular prison. In a letter to Doucet from Monte Carlo, he described an analogous task he had set for himself: "I would like to force the roulette to become a game of chess." The thirty-seven numbers of the roulette wheel, and the dancing and leaping ball that chose the winner, were somehow to be forced to perform as their opposite: a square board of sixty-four squares that harbored infinite possibilities for driving the king into a corner.

◆　　　　◆　　　　◆

In 1927, following another brief stay in New York, Duchamp created another work that illustrated even more explicitly the impossible goal he had set for himself. In his studio at 11 rue Larrey, he installed a remarkable door. Swinging on a single set of hinges between two openings, it closed the entrance either to the bedroom or the bath, leaving the other doorway always open. Duchamp lightheartedly explained this conceit as a refutation of the Cartesian proverb "A door must be either open or shut." He also pointed out that the arrangement was eminently practical, since it saved space in a cramped apartment. But in the context of Duchamp's life, it portends a far deeper and more poignant paradox.

For in June 1927, at the age of forty, Duchamp suddenly married. The bride was Jeanne Lydie Marie Louise Irène Sarazin-Levassor, the twenty-five-year-old daughter of a wealthy automobile manufacturer. Marcel's friends were dumbfounded when they learned of his plan shortly before the wedding — all except Picabia, who may have introduced the couple.[14]

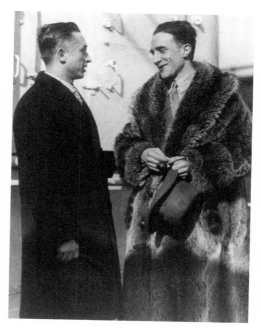

With Leon Hartl at the end of another New York visit, 1927

No one was more surprised by the news than Mary Reynolds, an American war widow who had settled in Paris in 1920. Duchamp had been seeing her for four years. He often stayed at her house on the rue Hallé, which had become a meeting place for modern artists, including Villon and Rouault.[55] According to some friends, Reynolds "obviously adored [Duchamp] but just as obviously was his equal in the relationship."[56] Man Ray recalled that the "charming young widow" (indeed, a fresh widow) "worshiped" Duchamp and "with his usual sangfroid and amiability he accepted the homage."[57]

Mary was four years younger than Marcel, a native of Minneapolis and a Vassar graduate. She had met and married Matthew Givens Reynolds in 1916 and moved with him to New York, where he took a job with an English insurance company. When the United States entered the First World War in 1917, Matthew enlisted and commanded a battery of field artillery in France. He survived the war but died in the great flu epidemic in January 1919. Near the end of 1920, the young widow had moved permanently to Paris. Her apartment on the rue Hallé soon became an avant-garde salon where modern artists mingled with American expatriates and Surrealist writers. Friends assumed that she was engaged to Laurence Vail, a raffish American artist

who was dubbed (perhaps by himself) the "King of Montparnasse." In 1922, however, Vail had married the twenty-four-year-old heiress Peggy Guggenheim, a stormy match that dissolved in 1930.

Marcel had met Mary in 1923, while socializing at the Boeuf sur le Toit and other artists' cafés. After they became lovers, he insisted they keep their relationship secret and not even acknowledge each other if they met in public. He also insisted that they continue to see others. Mary was intensely pained by these requirements and became convinced, so writes her biographer, that Duchamp was "incapable of loving." Nevertheless their relationship survived, in one form or another, for more than twenty-five years.[58]

Duchamp's companion from New York, Henri-Pierre Roché, who had shared with him the favors of Beatrice Wood, was puzzled by Marcel's attitude toward women. Though "he could have had his choice of heiresses," Roché wrote, "he preferred to play chess."[59] To the end of his life, Roché hoped that a "romantic essay" would be written, titled "Marcel Duchamp and Women." Perhaps it could explain why, though Duchamp dwelled so intensely on women in his fantasies, "he lets none into his confidence ... The desire ... to remain apart seems to preclude real love."[60]

Roché, to whom Duchamp introduced Mary in the spring of 1924, was immediately taken by her blond hair, slender figure, and calm demeanor. He also noted that "she seems to have something like a desire to die," drinking herself into oblivion every night. Yet, as Roché noted in his journal, she lost "neither her charm nor her nobility." Perhaps regretfully, he resisted her charm: "We see to it that our fingers do not touch, even by chance, in handling books and objects."[61]

No mean womanizer himself, Roché recorded Duchamp's athletic sexual exploits, including a "bouquet of three flowers," a sexual marathon with three naked women. He reacted admiringly to Marcel's reports of picking up "unworthy" women in cafés and bars,[62] but these tales have never been otherwise documented. Only Beatrice Wood of this female multitude has ever told her story. Nor did Duchamp share reports of his conquests with anyone but Roché.

In his various letters to friends, perhaps Duchamp had written a more accurate, though far from romantic, essay about his relationships with women. Two weeks before his wedding, he announced to Katherine Dreier "an important news: I am going to be married ... I don't know how to tell you this, it has been so sudden, it is hard to explain." He described his pro-

spective bride as "not especially beautiful nor attractive — but seems to have rather a mind which might understand how I can stand marriage." As the daughter of one of the partners in the Panhard-Levassor automobile company, Lydie was an heiress, but, as Marcel's halting English explained it to Dreier, "her money is for the present hardly enough to make her live." Nevertheless, he planned to "have two apartments and ... keep several hours or days for myself," an arrangement much like what he had managed in Buenos Aires and what he contrived with Mary Reynolds. With the practicality of a *notaire*, Marcel explained that he was marrying because "I am a bit tired of this vagabonding life and want to try a partly resting one."[63] Less than three weeks after the wedding, Duchamp further assured Dreier that "my life won't be changed essentially ... I don't intend to feel too responsible for the upkeep of a household." Then, as though he were discussing an object — a twirling spiral machine, perhaps, or a snow shovel — he informed his American friend that "Man Ray is going to make a picture of the wife."[64]

Possibly Duchamp met Lydie at the Théâtre de la Cigale, where he and Man Ray often saw ballet performances. The stage activities, according to Ray, provided "an excellent backdrop" for picking up women in the theatre's

Man Ray's picture of "the wife": Lydie Sarazin-Levassor in 1927

bar, "a most attractive spot both on account of the quality of its drinks and the charm of the sophisticated girls who frequented it."[65] Or perhaps, as Duchamp told an interviewer in 1967, Lydie was an acquaintance of Picabia's.[66]

The road to the wedding was swift and generally downhill. On May 12, barely two months after they met, Marcel and Lydie's engagement was announced at an afternoon tea at her parents' home, 80 avenue du Bois de Boulogne. The Sarazins deemed the engagement ring Marcel gave her too plain, so it was exchanged for a more striking pearl ring. On May 21, a fortnight before the event, Lydie, her father, and his mistress dropped by at Duchamp's flat to see whether it was a suitable abode for the couple after the wedding (though the mission was sidetracked by the excitement of Charles Lindbergh's landing at Le Bourget after his historic nonstop flight from Long Island). On June 4, just four days before the wedding, Duchamp was stunned to learn, from the marriage contract before him, that Lydie's life annuity would amount to only 2,500 francs (about $100) per month. After the signing, he took his betrothed to the Luxembourg Gardens, where she was told, for the first time and to her horror, that her husband-to-be had no steady income.[67]

Marcel and Lydie were married, first in a civil ceremony at the *mairie* of the 16th Arrondissement on June 7, and the following day in a lavish church wedding. Man Ray, who was hired to take the wedding photos (as well as studio portraits of Lydie), recalled "a buxom girl with pink and white skin." At the church portal, Ray snapped the shutter as "a voluminous form in white veils, like a cloud, stepped out, followed by Duchamp in striped trousers and cutaway." To his friend, Marcel "looked spare and gaunt beside her." After a week's honeymoon in the south of France, the newlyweds were back in Paris, and Man Ray was surprised to notice no change whatsoever in Duchamp's lifestyle. He still slept in his studio while Lydie stayed with her family, ostensibly until they found an apartment. Gradually, however, some of the disastrous events of the couple's single week of married life emerged. Every evening during the honeymoon, Picabia told Man Ray, Marcel caught the bus to Nice. After many hours in the chess club there, Duchamp would return late to Lydie, "lying awake waiting for him." Then he would spend the rest of the night alone poring over chess problems. His wife was so distraught, according to Picabia, that early one morning she arose, while Duchamp slept in exhaustion, and glued the chess pieces to the board.[68]

Meanwhile, Duchamp's American friends were still reacting to the news of his wedding. More than two months after the event, Dreier gravely announced to Alfred Stieglitz the "great news that Duchamp has taken unto himself a wife. Judging from her picture she is a powerful and fine-looking woman."[69] Carrie Stettheimer wrote to her sister Florine that "Duche" had married "a fat girl." And Florine "was sufficiently stirred to dream about the news: First ... that 'Duche' was getting bald and that the fine top of his head was made of smoky-hued milk glass; she then asked him about his wife and he replied that she looked about eight or nine years old."[70]

Barely six months after the wedding, Lydie filed for divorce; and on January 27, 1928, her petition was granted. Even before the divorce was final, Duchamp sardonically wrote to Stieglitz that he was "going south for two months to recover ... So I am afraid you will never see me married."[71] To Alice Roullier, an acquaintance in Chicago, he wrote that he was "happy to announce" his divorce and that he looked forward to seeing her again in Paris "this summer or even spring."[72] And to Dreier, on March 12, he described his "bachelorly" life in Nice, enjoying "every minute of my old self again ... The 'wife' is also down here ... we see each other every other week." He had realized, he wrote, that "chess is my drug," and he signed the letter: "Affectionately, Dee(vorced)."[73] Some forty years later, Duchamp laconically explained that the marriage "didn't take because I saw that [it] was as boring as anything."[74]

♦ ♦ ♦

After his brief foray into the beau monde, Duchamp returned to his studio at 11 rue Larrey, where he worked and slept "in an atmosphere of austerity like a monk." No accessory indicated the "penchants of an artist," Man Ray noted. The principal piece of furniture was the chess table.[75] Although he had written to Picabia as early as February 8, 1921, that he renounced painting to dedicate himself to chess — "My ambition is to be a professional chess player"[76] — and although the *Little Review* had announced in the fall of 1924 that "Marcel has given up painting entirely and has devoted most of his time to chess,"[77] Duchamp had, in fact, still given considerable time to art projects. Now, toward the summer of 1928, the bold, creative swath carved by Rrose Sélavy faded, and Marcel settled down to what he had threatened to do all along: quit art.

Perhaps justifying his decision to himself, he kept explaining it to friends.

"I have arranged my studio here to live so perfectly," he wrote Dreier in July of 1928, "that I don't see why I should ever make any effort toward 'more money' as it costs me very little to live this way."[78] In November, apparently responding to her suggestion that he return to painting, he replied:

> I have lost so much interest in the question [of painting] that I don't suffer from it ... The more I live among artists, the more I am convinced that they are fakes from the minute they get to be successful in the smallest way. This means also that all the dogs around the artist are crooks ... Don't name a few exceptions to justify a milder opinion about the whole "art game." In the end, a painting is declared good only if it is worth "so much." It may even be accepted by the "holy" museums — so much for posterity ... If you like some paintings, some painters, look at their work, but don't try to change a crook into an honest man or a fake into a fakir.[79]

Almost a year later, in September 1929, Duchamp was still vigorously asserting that "it can be no more a question of my life as an artist's life — I gave it up ten years ago. This period is long enough to prove that my intention to remain outside of any art manifestation is permanent."[80]

For the next five years, Duchamp produced nothing that would fit into the category of art, but rather concentrated entirely on chess. He regularly spent the winter "in training" in Nice while traveling all over Europe to compete in chess tournaments. In June 1928, he played to a draw in the International Paris Tournament against Saviely Tartakower, one of the Russian exiles who tried to pull France out of its sorry competitive position in international chess. In July and August, he was on the French team that competed in the Second International Chess Olympiad at the Hague; among seventeen teams, the French placed twelfth. In September, at the French Championship Tournament in Marseilles, Duchamp finished seventh.

The following year, he again competed in the Paris International Tournament, defeating George Koltanowski, the Belgian champion and holder of the world blindfold chess record, but failing to place among the tournament winners. And at the Third International Chess Olympiad in July 1930, in Hamburg, Duchamp again displayed his penchant for neither winning nor losing when he played against the American champion, Frank Marshall, who had the look of a florid Shakespearean actor and who, according to *Life* magazine, "always [took] a pocket chessboard to bed with him."[81] Duchamp battled Marshall to a draw, which gave the French team the half

point needed to draw the match. In the overall tournament results, however, the French team placed twelfth out of eighteen.

By August of 1932, Duchamp had reached the zenith of his chess career: he defeated his archrival, Eugene Znosko-Borovsky, to win the Paris Tournament. The following June, he played his last Olympiad at Folkestone. The French were eighth among fifteen.

Meanwhile, Duchamp was also active in chess organizations and participated in some of the more arcane activities of the chess world. In 1931, he became a member of the executive committee of the French Chess Federation and, until 1937, served as its delegate to the International Chess Federation (F.I.D.E.). Perhaps disturbed by the realities presented by an actual chessboard, Duchamp enthusiastically took up chess by correspondence. In 1935, he became captain of the French team of the First International Chess by Correspondence Olympiad. In a monumental tournament that lasted four years, he remained undefeated and was declared champion. Another four-year correspondence marathon concluded in 1939, with Duchamp again the undefeated champion.[82]

One of his opponents described his chess style as totally devoid of Dada or anarchist elements. "Duchamp applied absolutely classic principles," said one of his tournament opponents. "He had studied chess theory in books. He was very conformist."[83] Raymond Keene, an astute student of chess, disagrees, arguing that Duchamp's style was shaped by Aron Nimzowitsch, a grand master born a year before Marcel, who died in 1935. Echoing Duchamp's view of chess as "a violent sport," Nimzowitsch asserted that it was "a mirror of the life struggle itself ... exhausting and full of pain."[84]

Looking at the careers of men who were gifted chess players in their youth, the chess master Adriaan de Groot found that their future success depended on how well they integrated perception, memory, and creative speculation. If the young player was unable to bring these qualities together as "experience" (i.e., willingness to repeat), he would become "an adventurously artistic character without much goal-directedness in life ... the victim of his divergent talents." The climb to the very summit of the chess ladder, he found, requires "constancy and concentration ... a more bourgeois way of life."[85]

Such an observation, at first glance, would help explain Duchamp's perpetual hoverings on the slopes toward the chess summit. But it throws little light on his persistence. There is a clue, however, in a peculiar affinity

between chess and the legal profession. Since the beginning of world championship chess in the nineteenth century, several world grand masters, and many top players, have been lawyers or the sons of lawyers. Most notable was the New Orleans prodigy Paul Morphy, whose bizarre streak across the world chess firmament in the mid-1800s has intrigued psychiatrists as well as novelists.[86] Many observers have noted the analogy between "the cut and thrust of legal argument and the interplay of ideas on the chessboard, the opportunism of a cross-examining counsel, the common element of victory or defeat."[87] I would suggest that Duchamp's lifelong involvement with chess was not only an obsessive replaying of a son's negative psychological conflict with his father but also an effort to identify positively with him.

For the figure of the man Duchamp had painted so earnestly, so ambiguously, in the 1910 portrait inevitably remained a powerful model throughout his life. Later, in Paris, the conciliatory talents he had learned from the Rouen *notaire* were in demand; the poster of a 1938 Surrealist exhibition listed his official title as "General Arbiter." And among the petty feuds and shrill squabblings of the Surrealists in New York, Duchamp's fairness as a mediator would earn him universal respect. Robert Motherwell describes one occasion in the 1940s when André Breton and Max Ernst stood "mouth-to-mouth, in that curious French fashion, arguing with rage about ... something which raised the question of their professional indebtedness toward each other. At such moments ... only Duchamp, with his detachment, his fairness ... and his innate sensitivity could try to bring calm."[88]

Though he had summarily, at times even angrily, rejected the materialistic matters that occupied his father, there clung to Duchamp much of the father's manners, the calm exterior and the pragmatism of the successful provincial politician and lawyer. It must have impressed Marcel's friends: two of them chose him as executor of their estates.

In losing himself in the chess world, Duchamp entered a ritualized abstract realm whose parallels with art have often been pointed out. As the Russian champion Mikhail Botvinnik explained it, "There is a science which studies the world of sound — acoustics. But there is also an art operating within the ocean of sound — music. Clearly it is the same with thought. Logic studies the laws of thinking, but chess, in the form of artistic images, reflects as an art, the logical side of thought." So stirring is a chess attack in its logic and clarity, according to the English grand master C. H. O'D. Alexander, that it "excites the same kind of feeling as a great work of art."[89] Stefan Zweig

called it "Art without works; architecture without substance."[90]

Still, in viewing Duchamp's fascination with chess, it may be more significant to remember the important *differences* between chess and art. For while both are varieties of play, chess follows strict rules; while art, especially in the twentieth century, invites the artist's highly personal, individual freedom of action. Chess requires a partner, while art frequently demands solitude. Chess is a mental, cerebral occupation, while art — sculpture or painting — insists on a measure of physical or manual input. In chess, a game can end in a draw. But in art, something must be produced; one cannot, much as Duchamp tried, fight the creative muse to a standoff. Finally, once entered into the realm of chess, the player passively attends tournaments and meets opponents in a determined place at a set time; the game itself has a time limit. By contrast, the artist must be active, search out materials, sketch, develop concepts, and choose his own time and place in which to work.

In a sense, Duchamp tried to leap this chasm between chess and art with a project he completed in 1932. In collaboration with a chess colleague, Vitaly Halberstadt, he produced a book about chess so esoteric that, by his own description, "only three or four people in the world are interested in it."[91] Nevertheless, it was loaded with typically Duchampian multiple meanings and ambiguities. (Not the least of them is that the manuscript was sold for $40,000 in 1976. Since then, the scuffed department-store box containing the manuscript, corrected page proofs, diagrams, and a copy of the single issue of *New York Dada* has gradually evolved into a work of art. Shown at important museums in several Duchamp retrospectives, this "work" is now on loan to the Philadelphia Museum.[92])

The book's title alone, *L'Opposition et les cases conjuguées sont reconciliées* (Opposition and Sister Squares Are Reconciled), brings to the cold and rational world of chess a whiff of intense, emotional drama. The book's subject is an endgame situation so rare that even chess champions encounter it perhaps once in a lifetime. As Roché explained it, the book deals with a way to end the game when almost no pieces remain on the board. The king, in choosing two moves, "may act in such a way as to suggest he has completely lost interest in winning the game. Then the other king, if he is a true sovereign, can give the appearance of being even less interested." Until one of them provokes the other into a blunder, "the two monarchs can waltz carelessly across the board as though they weren't at all engaged in mortal combat."[93]

This particular problem had occupied the more rarefied fringes of the chess world for some twenty years before Duchamp and Halberstadt provided the solution. But Duchamp denied every suggestion that the book was a classic exercise in futility. His purpose, he said, was "to remove its pseudo-esoteric appearance from the problem," though he finally acknowledged that following his system "leads inevitably to drawn games."[94]

Man Ray noted that the book was hardly relevant to chess players, who generally resign before the bitter end. Duchamp did all the work himself, Ray recalled, patiently accumulating photos, diagrams, and text in individual sheets until the work was ready for publication. "He knew that no publisher would risk his capital in the production of such esoteric works and he made little effort to secure backing. His object through the years was not to get money for his projects but to spend as little as possible."[95] Nevertheless, friends and admirers subscribed and the book was printed in Brussels with parallel texts in German and English on the left-hand pages. Duchamp created the cover by clamping sign-painters' zinc stencil letters between glass plates and exposing them to the sun. He captured the light coming through on photographic paper, complete with distortions caused by the angle at which the letters were exposed.[96] The first edition was printed in one thousand copies in 1932. As though it were a work of high literature, the coauthors had thirty numbered hardbound copies printed on Montgolfier Annonay handmade paper, which they signed in blue ink.

While the art community considers Duchamp to be the book's principal author, the chess community confers that distinction on Halberstadt, "in conjunction with Marcel Duchamp, who is perhaps better known as an avantgarde painter."[97] Such a judgment is probably too harsh. The chess grand master Edward Lasker described Marcel as "a marvelous opponent" and would have rated him in the 1920s and 1930s among the twenty-five best American players. In fact, Duchamp struck Lasker as "a good deal more serious about chess than he ever was about art," partly because he claimed, in that era before Bobby Fischer, that chess "is in no danger of being corrupted by money."[98] This ascetic side of chess may have been what appealed most to Duchamp, although one suspects that the game's artistic side attracted him more. On its highest level, Lasker writes, "chess is as much a search for perfection as mathematics, art, or any other undertaking of the creative mind."[99]

But there is another side of chess that is frighteningly repetitious, a kind of poisoning whose victim, as Stefan Zweig describes him, lives in a world

shrunken to "a narrow, black-and-white one-way street; who seeks ultimate triumphs in the to-and-fro ... movement of thirty-two pieces; a being who, by a new opening in which the knight is preferred to the pawn, apprehends greatness and the immortality that goes with casual mention in a chess handbook — of a man of spirit who, escaping madness, can unremittingly devote all of his mental energy during ten, twenty, thirty or forty years to the ludicrous effort to corner a wooden king on a wooden board."[100]

The sufferings of obsessive chess players have been graphically described. Luzhin, Nabokov's hero in *The Defense,* can finally cope with the crumbling of his own defenses only with an ignominious leap from a fifth-story bathroom window. The hero of Zweig's *The Royal Game* turns to chess as an escape from Nazi tortures only to find himself trapped by his own fascination with the game. Psychological studies of obsessive chess players describe them as "willing to wound, yet afraid to strike," finding a haven in "the restricted world of chess from the complications of human relationships."[101]

Duchamp described himself in such terms when he wrote to Dreier, in October 1929, that he was going through "a hardening process ... a 42-years-of-age summing up." Physically, he wrote, "I am a little sick ... my bladder is beginning to speak ... so I have to take care of myself." As for his plans, "anything one does is all right and I refuse to fight for this or that opinion or their contrary." Anticipating his missionary friend's rejoinder, he added: "Don't see any pessimism in my decisions — they are only a way toward beatitude." She was in no position, he felt, to "approve of my choice between a snake and a butterfly for a disguise ... I am trying for a minimum of action, gradually."[102]

The paradox of chess is that tucked within its drab fabric of repetitious, even ritualized, moves gleam brilliant thrusts of creativity. From this standpoint, one can perceive the seamless web enveloping Duchamp's chess, his art, and his life itself. Duchamp's contribution to chess of a book devoted to a state of perpetual check shades into his contribution to art of machines that twirl elliptical phrases in eccentric circles. At times, it seems as if he willingly tried to hook the meaning of his own life onto this hellish circle. But in fact, the deed was done so lightheartedly and gaily — and with so many derisive side jabs at the pompous world of art critics and connoisseurs — that one is tempted to agree with Duchamp that, just as in chess the king is never captured, so in life "there is no solution because there is no problem."

Many years later, Duchamp suggested that the artist's most critical moment came around the age of forty: "It is then that he should change himself completely or be resigned to copying himself."[103] In 1932, when his chess book was published, Marcel was already forty-five. It was time to get moving.

A𝙽𝙰ÏS 𝙽𝙸𝙽'𝚂 𝚃𝙰𝙺𝙴 on Marcel Duchamp in 1935 was grim. In her journal, she noted that he "looks like a man who died long ago. He plays chess instead of painting because that is the nearest to complete immobility, the most natural pose to a man who died. His skin seems made of parchment and his eyes of glass."[1] In a more optimistic vein, but scarcely less puzzled, the art dealer and friend of the Surrealists, Julien Levy, wondered in 1936 whether Duchamp's "present activities" were "indicative of a new advance." Searching for a category in those years of confusion between ideological and aesthetic theories, Levy thought that perhaps Duchamp was a "sur-Surrealist." Or was he merely "writing his memoirs?"[2] And in still another effort to pierce the mystery, the German art historian Wieland Schmied has suggested that the artist endlessly recapitulated his own early work because he wanted always to remain "a youth, whom the gods favor." Furthermore, posited Schmied, Duchamp's "skeptical intelligence" was larger than his "animal creative drive," resulting in "a genius painter killed off by a genius skeptic."[3]

Like a snapshot, each of these descriptions contains an element of truth but, as a group, they also obscure the full dimensions of Marcel Duchamp. For, even as the Surrealist poet Georges Hugnet described Marcel as "armed against reality,"[4] Duchamp perhaps coped more successfully with the dreary realities of the European art world of the 1930s than most of his contemporaries. During those tempestuous years, the icy detachment that prevented him from entering into intimacy with others and that expressed itself artistically in the *Large Glass* served as a survival shelter. Imperturbably,

9 · VACATION IN PAST TIME

he sailed among the shrill ideological battles that sapped the creative vigor of the Surrealists and drove them into obscure, doctrinaire aesthetic corners. If the reality consisted of "small bands of intellectual marines, landing in little magazines," as T. S. Eliot described it, Duchamp was well defended against it; he had "this bulletproof system," as his friend the painter Matta phrased it. "He doesn't live anything. He makes beautiful gestures."[5]

In the avant-garde intellectual world of Paris in the 1930s, much as in the political realm, it was almost impossible not to be caught in the crossfire of a multitude of strident splinter groups. The most prominent of these, Surrealism, had from the start gathered daily (as Louis Aragon put it) "in a spirit of lassitude, idleness, or boredom," in which the fiery young poets, writers, and painters who comprised it "assembled hastily in the throes of one of those violent crises which convulsed [the group] when an accusation of moderatism was leveled against one of its members."[6] "Psychic automatism" is how Breton had capsulized Surrealism's basic goal in 1924. Poetry, prose, and painting, he wrote, were to be "dictated by thought in the absence of any control exercised by reason, exempt from any aesthetic or moral concern."[7]

Breton, who had been trained as a physician, insisted he was harnessing the cart of art to Sigmund Freud's discovery of the unconscious and of its expression through free association. However, despite Breton's honeymoon pilgrimage to Vienna and an outpouring of published affection for Freud, the founder of psychoanalysis remained stubbornly unresponsive to Surrealism or any other kind of modern art. Undeterred by such rejection, Breton and his followers continued to wave the banner of Freudianism as they spewed forth profuse examples of automatic writing and painting. The "125 Proverbs" published in 1925 by the Surrealists Paul Éluard and Benjamin Péret, ostensibly without the interference of conscious thought, closely resemble Duchamp's puns: "Elephants are contagious ... Grasp the eye by the monocle," and "Breaking two stones with one mosquito."[8] So do the collectively generated sentences of the game Exquisite Corpse, which was developed at around the same time: a group would create a sentence or drawing by writing on papers folded and passed around so that no contributor could see what had been written or drawn previously. In 1927, some results were published in the group's magazine *La Révolution surréaliste*, among them: "The winged vapor seduced the locked bird" and "The strike of the stars corrects the house without sugar."[9]

Breton summed up his reliance on unconscious forces in his 1923 essay "The Disdainful Confession": "Every night I would leave the door to my hotel room wide open, in hopes of finally waking beside a companion I hadn't chosen."[10] During these pioneering years, he was casting about for all possible allies, and Duchamp looked like a good prospect — superficially, at least. As early as 1923, Breton had courted Duchamp through Picabia, and the prankish Cuban assured him, "I'll do my best to meet him [Duchamp] and bring him along to you."[11] Breton dramatically recorded the meeting in the *Manifesto* itself: "Last week, in the hall of mirrors, we received a certain Marcel Duchamp, whom we had not hitherto known."[12] Duchamp's reaction to the Surrealists goes unrecorded, but he was not likely to participate in a group sitting in a circle and playing a game called Exquisite Corpse. Perhaps he quietly registered his dismay at Breton's statement that "The artist is nothing but a recording apparatus; his role in the mechanism of inspiration is entirely passive."[13] We do know that Duchamp disappeared into chess and his own oblique, humorous, and hostile comments: the correspondence with Doucet and the *Monte Carlo Bonds* are typical examples. Though he expressed "a certain esteem" for the Surrealists, Man Ray recalled, Duchamp "never took part in their activities nor frequented the cafés where they met."[14]

Within a few years, the effete parlor games of the early Surrealists were to be racked by the same bitter dissensions that were troubling French political life. As early as 1925, an ugly shrillness overtook the intellectual debate. The third issue of *La Révolution surréaliste* was provocatively dated "1925: End of the Christian Era."[15] In June, the Catholic poet Paul Claudel dismissed Surrealism in the conservative daily *Le Figaro* as "pederast literature." In September, a "Declaration of Young Intellectuals" published in the Communist Party newspaper *l'Humanité* called for "War on French thought! War on Western civilization!"[16] Aragon had perhaps set the tone the previous year when he denounced all journalists as "scum ... morons, creeps, bastards, swine ... without exception ... Death to all you who live off the lives of others ... death to those whose hand is pierced by a pen!"[17]

So fierce were the tensions that a few years later, stung by the rude rejection of his application for Communist Party membership,[18] Breton would no longer see Surrealism as passive, "indifferent to all the world's ballets."[19] Rather, in his *Second Manifesto* (1929), he described "the simplest Surrealist act" as "dashing down into the street, pistol in hand, and firing blindly, as fast as you can pull the trigger, into the crowd." On many of the compan-

ions who had until recently shared so much wine and talk at the daily café meetings, he now poured bitter venom: "that slut of ideas" (Roger Vitrac); "a rat running in circles around his rat cage" (Philippe Soupault); that victim of "congenital imbecility" (Francis Gérard). His opponents responded in kind, declaring (in the words of one) that "the final vanity of this ghost will be to stink eternally among the foul smells of paradise," while another confided to the world that "no one ever took Breton's ideas seriously except a handful of schoolboys, somewhat overaged, and a few women pregnant with monsters."

Long afterward, Breton himself was appalled at "the broadsides which the Surrealists unleashed with fire and brimstone against one another." These diatribes reveal, he noted in a cooler moment in 1946, "how impossible it was for them to carry on the debate on any lesser level." He blamed "the violence of expression ... squarely upon the period itself and also upon the formal influence of a good portion of revolutionary literature."[20]

In 1924, Duchamp may well have seriously considered the outrageous question posed in the first issue of *La Révolution surréaliste*: "Is Suicide a Solution?"[21] Ten years later, in the firestorm of words and events, such a question was comparatively tame. Artistic issues had been swallowed up in the political whirlpool that was soon to suck all Europe into its abyss. From Duchamp's standpoint, it must have seemed eminently sane and sensible to stay aloof from the fray and, above all, to keep one's sense of humor. It suited not only his personality but the character of the times to refer to the past for guidance in dealing with the present — perhaps even to return to the traditional Norman values of "strict rationalism, economy, fondness for dialectical disciplines which makes good lawyers and good merchants."[22]

In a manner that surely would have pleased that notable Norman lawyer and businessman, his father, Duchamp had maintained contact all through the 1920s and early 1930s with his American friends. He corresponded regularly with Walter Arensberg in Hollywood; with Katherine Dreier in New York; with Alice Roullier, secretary of the adventurous Arts Club of Chicago. While these and many other correspondents faithfully preserved his letters, Duchamp ruthlessly destroyed theirs. In sharp contrast to his lifelong hoarding of every scrap of his own notes, he kept other people's letters only until he had answered them. Then, as though ripping up the relationship, he tore them to bits and threw them away.[23]

More than mere letters, Marcel had established a web of favors done:

giving tips on up-and-coming artists, making arrangements for the Americans to partake of the Paris art world during summer visits, and lending his own elegant presence to dinner parties when he visited America. Through his friendship with Mary Reynolds, Duchamp also became a friend of her brother, Frank Brookes Hubachek, a lawyer and a powerful trustee of the Chicago Art Institute.

Until the Second World War separated them, Duchamp and Reynolds lived casually together, yet apart. As Duchamp described it much later, "We weren't glued together, in the 'married' sense of the word."[24] Indeed, their tenuous relationship survived Duchamp's short-lived marriage in 1927 and endured until Reynolds died in 1952. While Duchamp lived at his studio at 11 rue Larrey, he often joined Mary as she "kept open house" on the rue Hallé, and many times in the summer he visited her in Villefranche in the south of France, where Mary would take a villa. While Duchamp never actually moved in, he mingled his few books with hers and invented some imaginative decorations for her flat. In one room, as Man Ray noted, he papered all the walls with maps and created curtains composed of closely hung string "in his usual meticulous manner without regard for the amount of work involved."[25]

Reynolds fused her interests in art and literature by creating exotic bookbindings. She studied with a Parisian master, Pierre Legrain, but soon developed an individualistic style. Some of her bindings employ such unusual materials as toad skin, perforated copper, wrapping twine, a china teacup handle, a real kid glove, and pink sponge rubber. In one known instance, a binding of Jarry's *Ubu Roi*, Duchamp designed the cover and Reynolds executed it in an edition of two. By her choice of books and her "very original bindings," she demonstrated what Duchamp called her "decidedly surrealistic approach and ... unpredictable fantasy."[26]

Among the books bound by Reynolds are first editions of twenty-four works by Jean Cocteau and the Shakespeare & Co. edition of James Joyce's *Ulysses*, Henry Miller's *Tropic of Cancer* and *Tropic of Capricorn*, six works by Alfred Jarry, three volumes of Stendhal, and a thin volume by Duchamp — a collection of puns published as a pamphlet in a tiny edition in 1939. Reynolds's lovingly crafted binding includes a book with a spine covered in Nigerian goatskin and with grayboard covers edged with tan morocco leather, die-stamped with the title *de ou par Marcel Duchamp ou Rose Sélavy*.[27]

Amid such exquisite gestures, with smiling disengagement, Duchamp

Brancusi, Duchamp, and Mary Reynolds (in chair), Villefranche, 1929

sheltered himself against the responsibilities of an ordinary life. Having a family, he was convinced, "forces you to abandon your real ideas, to swap them for things it believes in, society and all that paraphernalia!" Because Mary was "a very independent woman," Duchamp found his relationship with her "a very agreeable liaison indeed."[28] He appreciated her "modest way."[29] But under the sweet personality lay a stern will reminiscent of the pioneer women of her native Minnesota and an unsuspected resourcefulness that eventually saved her life.

Like Duchamp, Mary had stayed outside the political wars among Paris intellectuals during these years. Among her friends, the communist Louis Aragon mingled with the right extremist Louis-Ferdinand Céline and the talented, anarchic madman Antonin Artaud. She enjoyed that model of French "engaged" man of letters, Breton, as well as the playful and practical American sculptor Alexander Calder. (Duchamp, in 1932, suggested the felicitous name by which Calder's works are known: mobiles.) Paul Éluard, who had joined the Communist Party, warmly dedicated volumes of his work to "sweet and beautiful" Mary and so, "affectionately," did the utterly apolitical American hedonist Man Ray.[30] Clearly, Mary Reynolds had developed a sturdy network of friends among the Parisian avant-garde, an array of contacts shared by Duchamp.

♦ ♦ ♦

In the sense of making new works of art — at least in a traditional form — by the 1930s Duchamp had stopped being an artist. But in another sense, a sense that paralleled the double statement of the readymades, he carried on a creative effort that was perhaps more pervasive than simply executing individual works. Just as the snow shovel had been both a concrete work and a critical statement, so Duchamp's activities within the art world for the remainder of his life had both a concrete and a conceptual edge. As early as 1920, when he helped found the Société Anonyme, Duchamp had demonstrated his penchant for propaganda. Indeed, the statement defending his submission of *Fountain* to the Independents Show in 1917, though not written by him, reflected his iconoclastic anger.

In such efforts, he found more than an ally in Katherine Dreier. A dynamo of earnest activity and a juggernaut in imposing her will, the spinsterish Dreier saw Modern Art as a cause spiked with germanically capitalized virtues. The Société's aim, she wrote in 1928, had been to found "a Modern Museum where the Art which expresses the Vitality and Vision of our Times is seen without fatigue and shown with joy. A Living-Vital-Manifestation of an Educational Project which stimulates Creative Thoughts."[31]

While Dreier energetically corresponded, traveled, conferred, lectured, and crusaded on behalf of Modern Art, Duchamp muted his own sardonic views of the contemporary art scene while gradually converting his patron. As such, the Société's collection differed sharply from the great aggregations of increasingly valuable works, the good investments on which most museums and private collectors focused. "We never took into consideration ... technique, taste, good or bad, or temporary popularity," Dreier later wrote, but "tried always to discover the pioneers."[32]

Unlike the Museum of Modern Art, which was founded in 1929 with quite a different point of view and far more substantial funding, the Société Anonyme performed without a net. Its exhibits and acquisitions rigorously followed Dreier's notion that "the best painting by an 'unknown master' has often more of art in it than a lesser painting carrying a well-known name." Over a period of twenty-one years, until 1941, the Société sponsored eighty-three exhibitions, showing more than seventy-three artists for the first time in the United States. And while the catalogue of its holdings contains such aesthetically, and financially, appreciated artists as Kurt Schwitters, Paul Klee, Kasimir Malevich, Joan Miró, Alexander Archipenko, Wassily Kandinsky,

Fernand Léger, and Jacques Villon, it also included such all but forgotten figures as Otto Cartsund, Friedebald Dzubas, Werner Drewes, and Harry Holtzman. Dreier also made a point of searching out women artists; militantly, as she tackled everything, she bought works by more than twenty women for the collection. Above all, she wanted to demonstrate "that art is an uplifting and moral force in society,"[33] a conviction that collided head on with Duchamp's nihilism.

Despite Duchamp's evident resistance to missionary endeavors, Dreier enthusiastically supported him, both financially and morally. He even contradicted his own views that the readymades harbored no aesthetic message and went along with Dreier's defense of *In Advance of the Broken Arm* by not disputing her claim that he had examined some sixty snow shovels to choose "the one good design," something that "the average eye was too untrained to notice."[34] Reviewing a series of lectures she gave in 1933, the *New York Times* called Dreier "the most ardent espouser of modernism that America has yet produced."[35]

Probably the Société's biggest triumph was its exhibition at the Brooklyn Museum from December 1926 to January 1927, the most comprehensive show of avant-garde art in America since the Armory Show of 1913. Katherine Dreier was the main organizer and enlisted Duchamp's help in collecting modern works in Paris for the show. Among these works the most significant, from Dreier's viewpoint, was the *Large Glass*, which would be exhibited publicly in America for the first time; as Dreier wrote Alfred Stieglitz, she expected it would "create quite a sensation."[36] Dreier's predictions were correct: before it closed on January 9, fifty-two thousand people had seen it.[37]

As it happened, they were the first and the last to see Duchamp's magnum opus in its intact, though unfinished, state. The truckers who transported the glass after the show had laid the heavy panes on top of each other inside a crate, "without knowing," as Duchamp later put it, "if there were glass or marmalade inside." After the forty-mile trip back to Dreier's house in Connecticut, "it was marmalade."[38]

When Dreier finally told Duchamp of the accident, over lunch one summer afternoon in the early 1930s, his reaction was revealing. "She was so much moved by the fact that she had to announce it to me," he related to an interviewer much later, "that my reaction was really a cold reaction. I wanted to help her and I had a reaction of charity, instead of despair."[39] In his

cool and humorous way, Duchamp made much of the irony of the breakage. As early as the days of the Arensbergs' New York salon, he had said that "a stained glass window that has fallen out and lay more or less together on the ground was of far greater interest than the thing conventionally composed *in situ*."[40] Later, he was able to maintain the same ironic detachment toward his own wrecked masterpiece. In 1956, he told Lawrence Steefel that the cracks "brought the glass back into this world." Asked where it had been before, Duchamp threw up his hands and laughed.[41] And in 1966, he remarked to Cabanne, "It's a lot better with the breaks, a hundred times better. It's the destiny of things."[42]

Still, despite his show of unconcern, the bad news about the *Large Glass* may well have contributed to Duchamp's next project. It was to be a new box, far more ambitious than the three copies of the *Box of 1914*. In 1934, Éditions Rrose Sélavy, its address given as 18 rue de la Paix (apparently the address of an American bank), announced an edition of three hundred copies of a work titled *The Bride Stripped Bare by Her Bachelors, Even*. The title did not stick to this project any more than it had to the *Large Glass*; its final name would be simply *The Green Box*. It consisted of ninety-three exact reproductions of Duchamp's scribbled preparatory notes and sketches for the *Large Glass*, plus a copy of Man Ray's photo of *Dust Breeding*. In form and illustration, it followed Leonardo da Vinci's format for his *Notebooks*, an assemblage of loose papers.

While moving among his many domiciles, Duchamp had not only carefully retained every scribbled scrap related to the *Large Glass*, he had also developed jaunty — and puzzling — statements about this project. He told one questioner that his box was "a very incomplete realization of what I intended"; he had conceived of a final form "somewhat like a Sears, Roebuck catalog."[43]

To produce his box, Duchamp spent months scouring Paris for paper exactly matching the original notes, and carefully made zinc dies to cut the reproductions into perfect replicas of the haphazardly torn and crumpled originals. The ink also was precisely matched. All these pieces Duchamp packed inside an elegant green suede-covered box, punched in little white circles with the title: *La Mariée Mise à Nu par ses Célibataires Même*.

By February, Marcel was marketing the box among his American friends. "Since an edition in *phototypie* is very expensive," he wrote to Arensberg. "I have thought of asking 10 real friends if they would pay $50 each for a de

luxe copy." There were to be twenty deluxe copies "as beautiful as possible" and five hundred (later reduced to three hundred) ordinary editions.[44] To another longtime acquaintance in America, Alfred Stieglitz, Duchamp described the box as "my last secretion. Old papers respected (?) and framed in their original shape only ... The 'essential' of one's life amounts probably to a few hours."[45]

As silently and capriciously as an oil slick spreading on the sea, Duchamp's peculiar project reached other potential consumers. On June 30, 1935, the *New York Times* dramatically described one of the very few copies then in the United States. An anonymous reviewer on the art page called it "quite the strangest book of the season." He reported intense delight upon first opening the suede-covered box containing the loose scraps of paper upon which the "incorrigible and quite unpredictable Marcel Duchamp has scribbled." The total effect was of "profound detritus."[46] Despite the Great Depression, Duchamp could report by the end of the year that he had already sold ten deluxe and thirty-five ordinary boxes, "without much advertising," and had gotten "almost [his] publishing money back."[47] So would canny subscribers: anyone who picked up a *Green Box* in those depression years owned a rarity that would fetch more than $8,000 near the end of the century.[48]

Duchamp soon began work on a far more ambitious retrospective. In March 1935, he wrote to Dreier about a new idea for a new box, a complete museum of his own works, on which he was beginning. He cautioned her not to speak of it, "as simple ideas are easily stolen." To finance the project, he intended to sell an edition of ten color reproductions "of my better things."[49]

In that year, even as unpolitical a person as Duchamp could hardly avoid hearing the strident voices emanating from European radios or seeing the first wave of refugees from Hitler's Germany, many of them artists and writers, who were arriving in Paris. In the following year, when German troops goose-stepped into the Rhineland, wary French intellectuals began to inventory their portable possessions, just in case. Thus, Duchamp's irresistible and long-standing personal urge to gather in his own oeuvre was reinforced by the very real, practical, and immediate problem of creating liquid, portable assets. He called this new work a *Boîte en Valise*. Its English translation — *Box in a Valise* — obscures the playful double meaning of the French. *Boîte* also means "can," so that, just as the *Standard Stoppages* "canned" chance, the *Boîte* "canned" all of Duchamp's major works. Again,

Duchamp planned a regular edition of three hundred and an additional twenty deluxe, signed versions.

Duchamp was to labor on the *Valise* for almost six years with spiderlike patience and ingenuity. He ordered miniature replicas of three readymades: a china *Fountain*, a fabric *Traveler's Folding Item*, and a glass flask of *Paris Air*. He searched Paris for the best color printer to run off reproductions of his paintings by the complex *pochoir* process, applying color to monochrome images by means of metal stencils. He included a tiny wooden model of the *Standard Stoppages*. *The Large Glass* was actually printed on cellophane, a "terribly long job," he wrote to Dreier. "The black ink ... had to dry for two months."[50] For four of the boxes, Duchamp had one of the components of the *Large Glass*, the *Glider Containing a Water Mill in Neighboring Elements*, printed on a semicircle of celluloid. The whole project was designed so that when the box is opened, the contents slide and pivot on tiny grooves and hinges to blossom into a tabletop museum of seventy-one works — illuminating another play on words hidden in its name: *boîte à malice*, or bag of tricks.

◆ ◆ ◆

Man Ray observed that "Duchamp was concerned with the permanence of his ideas," much like old masters worried about preserving their individual works.[51] Certainly, assemblages such as the *Green Box* and the *Box in a Valise* were a way for Duchamp to ensure the survival of his ideas. But he also spent the greater part of his life seeing to it that his original works were gathered up in safe places. As a young man, he had observed how his father helped clients put their business affairs in order. With similar care and devotion, Duchamp guided one important work after another safely into the Arensberg collection.

As early as 1926, when the John Quinn collection was auctioned in Paris, Duchamp had used a portion of his inheritance to buy back a study for the *Nude Descending a Staircase* and the *Portrait of Chess Players*. Both were profitably resold to Arensberg.[52] Over the span of their thirty-five-year friendship, Duchamp arranged for Arensberg to acquire not only most of his own works but also some thirty-five works by major moderns.[53] For each of nine early Picassos and eight Braques, thirteen Klees, five Grises, four Légers, a Chagall, "many" Mirós, a Rousseau, and "a fine Matisse," Duchamp received a commission of $200 to $300.[54]

Unlike a traditional art dealer, Duchamp operated in ways that reflected the mystifications he liked to drape around his works. The New York dealer Julien Levy described one such transaction. During the depression in the 1930s, Levy was having trouble raising $2,000 in gallery rent. Some four months earlier, he had acquired *The Bride*. "I don't know how Marcel's wireless operated," Levy recalled, "but he called me up just about that time — probably in 1936 — and said ... he'd arranged for Arensberg to buy the painting for $2,000." "I would like him to have it now," Duchamp told Levy.[55]

Duchamp's first foray into the official art market came in 1926, when he organized an auction of eighty Picabias in Paris. It was Rrose Sélavy who signed the flyer advertising the sale as well as the statement in the catalogue that described Picabia's "desire to unfrock himself, to remain an unbeliever in those divinities too lightly created for social needs." But it was very much the *notaire's* son, Marcel Duchamp, who penciled into the catalogue beforehand the sum he anticipated for each work, and who presided over Room 10 of the Hôtel Drouot on March 8, keeping a running total of the proceeds in the marked catalogue. The sale brought in 96,990 francs (about $3,500), just a few hundred francs less than Duchamp expected.[56]

Two years later, Duchamp sent Stieglitz a carefully calculated price list, $200 to $600 for the eleven Picabias to be exhibited at the Intimate Gallery in New York. Stieglitz deposited the proceeds in Duchamp's Fifth Avenue Bank account and shipped the remaining pictures to Chicago, where they were to be shown at the Arts Club.[57] Picabia was "one of the few today who are not 'a sure investment,'" Duchamp wrote to Stieglitz. The Paris market was "disgusting"; unlike twenty years earlier, "painters and paintings go up and down like Wall Street stock."[58]

It had not been abnormal greed so much as fear driving the Paris art market's volatility at the time. From the end of the First World War, the franc had gyrated wildly and generally downward in relation to the dollar. In just three months between the March 1926 Picabia sale in Paris and July, it had plunged from 27.7 to 49.2 to the dollar. By 1928, when Duchamp was writing to Stieglitz, drastic government measures had stabilized the franc at around 25 to the dollar, one-fifth of its value on the eve of the First World War.[59] Under such uncertain circumstances, French art collectors were wary of unproven investments.

Nor did the situation change for the better during the 1930s. The last Allied occupation troops had withdrawn from the Rhineland in 1930, leav-

ing France without a buffer against the increasing threat from its neighbor. In 1933, Hitler became chancellor, and two years later Germany demonstrated that it had violated the Versailles Treaty's disarmament clause: its troops marched into the Rhineland and a new *Luftwaffe* was formed. Victory in the First World War had cost France a generation of young men. Now, the old enemy threatened once again.

In his art dealings at this time and to the end of his life, Duchamp was inhabited by a hopeless conflict that reflected his self-canceling views of art: he consistently claimed to dislike the business side of art, while consistently dealing in art. To a newspaper interviewer in 1963, he even blamed his abdication as an artist back in 1923 on "too much commercialism." He did not care to mix money and art, he told the *New York Times*'s Harold Schonberg over a chess game. "I like a pure thing. I don't like water in wine. And so I have made my life. I don't need much. Chess, a cup of coffee — 24 hours is taken care of."[60]

But the reality was not nearly so simple. For the Marcel nurtured at the notarial dinner table in Blainville never disappeared. All his life, Duchamp fought a strange interior battle to keep the "water" of commercialism from adulterating the "wine" of art. By perpetuating this conflict, Duchamp perhaps felt he was paying for having rejected the secure and measured world of contracts, investments, and wills that his father had offered him. And so it was the rebellious son, the artist sometimes sheltering behind Rrose Sélavy, who had befriended Brancusi and appreciated the genuine creative genius of the solitary Romanian. But it was very much the son of Eugène Duchamp who borrowed money to buy fifteen Brancusis auctioned from the Quinn collection in October 1926. It was the businessman, too, who promptly arranged to bring these works to the Brummer Gallery in New York for a show and sale toward the end of that year. And when the U.S. Customs refused to admit them duty-free because they were "not art," both the businessman and the artist in Duchamp were outraged. He brought the photographer Edward Steichen and the art critic Henry McBride to the customs shed to vouch for the sculptures' artistic qualities. "To say that the sculpture of Brancusi is not art," Duchamp angrily told reporters, "is like saying that an egg is not an egg."[61] The matter was settled when the customs officials admitted the Brancusis on bond and would levy the 40 percent duty only on those works remaining permanently in the United States.[62]

(It is tempting to suggest that the whole customs flap was cooked up by

Duchamp to publicize the sale. In 1916, John Quinn himself had brought in without customs duty several large Brancusis bearing "certificates of originality" or "consular invoices." This astute, well-connected lawyer had personally lobbied around Washington to persuade Congress to lift all tariffs on imported art. In 1921, Quinn had added four more Brancusis to his sizable collection and informed the artist that they had "passed through the customs satisfactorily."[63])

Duchamp's art dealings have been explained in terms of his aesthetic theories: "The works of art he sold were, for him, readymades," Robert Lebel wrote, "which he disdained to sign because they had already been signed by others."[64] In fact, Duchamp invested much of his time during the late 1920s and 1930s, when not playing chess, in the delicate palaver and correspondence required of a trader in art. He kept up to the minute on prices. In 1930, for example, Arensberg inquired about Brancusis, "especially if you have a [Mademoiselle] Pogany." (Brancusi had executed seventeen versions of this sleek and sexually suggestive sculpture between 1913 and 1933, nine of them during 1913 alone.) When Duchamp quoted the current valuation, the collector complained mildly that he "hadn't realized that his prices had gone up quite so high."[65]

Arensberg also sought more Duchamps. Having bought *The Chess Players* and suffering regrets over selling the *Large Glass*, he begged Marcel to let him know "if you have been doing any more painting or work on glass. If so, for auld lang syne, please give us the opportunity to purchase whatever is best among your recent works."[66] There were none, but between March and October of 1932 alone, Duchamp sold Arensberg three Picassos, a Léger, a Roger de la Fresnaye, and an early de Chirico, receiving a commission on each.[67] Many years later, when Arensberg needed a summary of his purchases for tax reasons, Duchamp provided a carefully itemized list.[68]

Arensberg's sometimes indiscriminate mania to collect made Duchamp uneasy. For years, Arensberg had gone almost daily to visit a dealer in pre-Columbian art who lived next door, and often the urge to buy was irresistible. Soon Arensberg's collection of pre-Columbian art rivaled his hoard of modern European paintings. Wandering among this plethora of aesthetic goods while on a visit in the early 1950s, Duchamp was heard to mutter, "*Dangereux, dangereux.*"[69]

The curious division between Duchamp's creative side and his shrewd business head seemed to surface and recede whenever he crossed the Atlantic.

Seen "occasionally in Paris in what used to be called the High Bohemian society," one prewar visitor recalled, Duchamp "would be reticent about his activities to the point of mystification."[70] But once on the other side of the Atlantic, he cheerfully gave interviews that were bound to make headlines. In 1927, he had traveled to Chicago for the opening of a Brancusi exhibition at the Chicago Arts Club. "Tout Chicago came on the opening day," he reported to Dreier. "I am treated like a male Cecile Sorel — opera every night — dinners — teas ... hope to sell one or two things."[71] And in 1936, during another sojourn in the United States, he blithely told the reporter from the *Literary Digest*, the most widely circulated American periodical, "For me, painting is out of date ... a waste of energy, not good engineering, not practical. We have photography, the cinema, so many other ways of expressing life now."[72]

The Parisian Duchamp, on the other hand, studiously avoided contributing to any of the swarm of little magazines, including those published by the Surrealists. The only exceptions were promotions of his own work: some sample pages from his chess book in the group's new periodical, *Le Surréalisme au Service de la Révolution*, in 1930 and a one-page excerpt from what was to become *The Green Box*, published in the same magazine in 1933. Even when he did publish and exhibit, Duchamp kept careful watch on every word and on every work. When Katherine Dreier wanted to lend a print of *Anemic Cinéma* to a museum, Duchamp strongly suggested she ask for a rental fee of $10, "not so much for the amount, but for the principle — and also because of the precedents."[73]

Writing from Paris in 1934, he told Dreier that he had begged Julien Levy and Walter Pach not to lend their Duchamp paintings to the Museum of Modern Art for an exhibition of Dada art and regretted that Dreier had lent hers. He did not like the "arrogance" of the show's organizers, he told her, "and you know my only attitude is silence. But please," he went on with a sudden rush of interest, "write what you know of the show." Then, reversing again (as he had on previous occasions), he added, "It is all unimportant."[74]

The following year, Duchamp sat for a month in the Paris Concours Lépine, a large trade fair for inventions, making the seemingly futile gesture of trying to sell his *Rotoreliefs*. These consisted of a set of six printed discs to be "played" for visual effect on a phonograph turntable. His friend Roché found him minding his booth and serenely smoking his pipe, "between the

garbage compressor on the left and the instant vegetable chopper on the right." The dizzy discs were spinning at various angles, "a regular carnival."[75] The Surrealists, in typically perverse fashion, saw his gesture as a cosmic rejection of art, much like Rimbaud's abandonment of written poetry and disappearance to Africa a half century before.[76] But perhaps a psychic's study of Duchamp's palms, published in the Surrealist magazine *Minotaure* in 1935, was closer to the mark: it pointed to his superior gifts as a "born strategist."[77]

For to his American friends, Duchamp showed a far from indifferent attitude toward the *Rotoreliefs*. Before the Concours Lépine opened, Marcel sounded euphoric about his prospects: "I am very busy arranging my counter," he wrote Dreier.[78] The works themselves, he told her, had gotten scientists interested in optics: "They say it is a new form, unknown before, of producing the illusion of volume or relief." He planned to show them to a professor of optics and "maybe have a scientific account written by him for the Academy of Sciences."[79] He also sent a set of *Rotoreliefs* along with a promotional letter to Henry McBride, who was by then a critic for the *New York Times* and contributor to *Art News*.[80]

While the French Surrealists marveled at the fact that Marcel had "not a single sale"[81] at the Lépine fair, Katherine Dreier was told that since the show opened, he had sold two sets — but only two. "This is a complete failure commercially," Duchamp glumly confessed, but he nevertheless planned to have the *Rotoreliefs* copyrighted in the United States.[82] Again torn between the desire to look like a successful businessman and the wish to make a noble aesthetic gesture, Duchamp insisted that the spiral discs be sold in America for $1.25. "If people find it too cheap," he wrote Dreier, "too bad, but the cost of making it does not allow me more profit. They were only typographical prints on cardboard and have no value as originals." On the one hand, Duchamp was clearly enchanted with the absurd project of selling a work of art at a ridiculous price — and even then failing. But on the other, and in the same letter, he was delighted that Macy's department store had bought one set on approval. "If they took them," he crowed, "they would sell them for $3."[83] In recent years, these flimsy cardboard traces have brought up to $7,500 at auction.[84]

To the few French who were interested in 1935, Duchamp studiously presented his profile as the cerebral genius, the dandy in the tradition of Baudelaire who scorned commerce as the antithesis of art. Holed up in the

barren studio at 11 rue Larrey, he purportedly emerged only for chess. Meanwhile, his American friends saw an elegant, debonair French art connoisseur as well as an able businessman. Duchamp's studio door, which opened and closed at the same time, could stand as an artistic and psychological symbol as well.

◆ ◆ ◆

In 1936, Duchamp spent three months in America, two of them at Katherine Dreier's house in Connecticut, where he painstakingly worked at repairing the *Large Glass*. Then he visited the Arensbergs in California. Sailing to France in September, Duchamp described his trip to see Dreier as "a wonderful vacation in my past life" and said he did not "feel like the people who don't dare touch a past for fear of regretting." The experience was "very objective," he said; "vacation in past time instead of a new area."[85] Back in Paris, Duchamp remarked on the "curious" contrast between his two existences, wondering "why I could be so energetic in America and the minute I land in Europe, my muscles refuse to function?"[86]

Like a visual echo of these feelings, Duchamp, during the same year, produced a characteristically ambiguous cover for the art magazine *Cahiers d'art*, a piece usually called *Fluttering Hearts (Coeurs Volants)* because its superimposed blue and red hearts create an optical illusion of faintly sexual vibration. The name also served as the title of an article inside the magazine by Gabrielle Buffet-Picabia about Duchamp's optical works. In addition, the title parodied the popular Catholic children's magazine, *Coeurs Vaillants*, even as it puns: in French, *volant* can also mean loose, flying, stealing, or traveling.

This last proved especially significant, for even the detached Duchamp could not ignore the rumblings of approaching war. On the eve of his American trip, he had confided to Dreier how glad he was "to leave my political shores."[87] A year earlier, he had conceived the *Box in a Valise*, an almost clairvoyantly sensitive formula for the fast getaway. Now, back from America, even the solitary Duchamp felt the need to huddle closer to the only kindred spirits in reach, the Surrealists. In 1937, he designed a glass door for André Breton's Gradiva gallery at 31 rue de Seine. And the following year, Breton asked Duchamp to design a huge international Exposition of Surrealism. When it opened on January 17, 1938, at the Galerie Beaux-Arts, its frantic mood of artistic high jinks and aesthetic

American visits, 1936: with the Arensbergs in Hollywood (top) and with Katherine Dreier in her Connecticut home, framed by his works

send-ups barely concealed a realization that this could well be the final gathering of Surrealist spirits.

Breton and Paul Éluard were the show's organizers, while Duchamp's official title was General Arbiter. Man Ray was Master of the Lights, the painter Wolfgang Paalen was in charge of water and brushwood, and Salvador Dalí and Max Ernst were technical advisers. While the show included 229 works by sixty artists from fourteen countries, its greatest impact did not come from the individual objects but from its overall effect. In this respect it prefigured the Happenings of the 1960s; indeed, many works on display "happened" accidentally as the exhibit was being prepared.[88]

As developed by Duchamp, the ceiling was completely swathed with coal sacks — probably twelve hundred but estimated at twelve thousand by some observers — and the gallery was divided into a courtyard with streets radiating outward, surrealistically named Street of All the Devils (rue de Tous les Diables), Weak Street (rue Faible), Blood Transfusion Street (rue de la Transfusion de Sang), and so on. Just outside the entrance, a perpetual artificial storm poured inside Dalí's Rainy Taxi, a cab direct from the Paris streets in which a slatternly female dummy grinned while live snails crept around her. Under the coal sacks in the central hall, the floor was strewn with dead leaves and moss; ferns and reeds ringed a lily pond, in which, at Dalí's suggestion, a dancer named Hélène Vanel periodically improvised a choreographic spectacle titled "The Unconsummated Act." One of the show's multisensual features was poignantly relevant: the music blaring through a loudspeaker hooked to an echo chamber was an ugly parody of German marches and soldiers' songs.

In keeping with this hyperactive summing up of what the organizers saw as the last days of European civilization, Man Ray's idea of lighting was to have none at all. Instead, each visitor to the opening received a flashlight, a reminder that this was a serious art opening, not just a social gathering. However, after the first day, lights had to be installed because the opening-night visitors had taken all the flashlights as souvenirs. Duchamp had wanted to play a different game: he suggested an electric eye hooked up to each painting, so that its spotlight would flash on only when someone was looking at it.[89]

Though the Surrealists would have bitterly denied it, their exhibit reflected a mood pervading much of Europe. The winter of 1938 was bleak, cold, and unpromising for any moderate, reasonable European. It seemed

that the 1930s had revealed a fatal thirst for sensation among surprisingly varied layers of society. And so, such seemingly different spectacles as the Nazis' Nuremberg rallies and the Surrealists' Paris exhibit yield, beneath the surface, an array of shocking parallels.

Both the Nazis and the Surrealists stretched the boundaries of theatricality, blending the media spawned by technology — sound, light, environment — to enhance their message. Both expressed themselves stridently, in terms of absolutes, screaming for total revolution. Both plucked at the passions of the spectator, manipulating the individual's emotional core by every sensory avenue: sight and hearing, smell and touch. The object was to drown rational beings in waves of irrationality. The spectacle in Paris no less than the Nuremberg pageant assaulted all moderation as though it were an enemy fortress. Many observers have noted that the Nazi spectacles of the 1930s exuded the atmosphere of mass orgies, but perhaps their assault was part of a widespread disease. As early as 1929, Breton had urged that "every means must be worth trying in order to lay waste to the ideas of family, country, religion." True Surrealists, he wrote, "maintain that reality is by definition ugly; beauty exists only in that which is not real."[90] In their 1938 show, the Surrealists celebrated unreason in a form shockingly similar to the witches' sabbath sweeping Nazi Germany.

One final feature of their show, so typical of the self-consciousness that was part of the Surrealists' credo, was a street devoted to sixteen mannequins representing major artists, each dressed in his own symbolic image. While some created elaborately startling self-portraits involving bird cages, kitchen utensils, and spangled G-strings, Duchamp's was characteristically simple. Marcel "simply took off his coat and hat, putting them on his figure as if it were a coat rack," Man Ray recalled.[91] What Ray failed to mention was that the lower half of the female dummy was unclothed, while in the breast pocket of the coat Duchamp had placed a small glowing red electric lamp, the kind used in red-light districts. Thus, the upper half of the figure showed a male Duchamp subtly toying with prostitution, while the naked, lower half of the dummy flaunted the feminine charms of Rrose Sélavy.

The figure's symbolism was probably unconscious, but Duchamp's behavior on the eve of the opening was conscious and typical. When all was ready and "the rainstorm raged inexorably inside Dalí's taxi," Duchamp stood at the entrance of the hall, Marcel Jean recalled, "casting a final eye over his creation. We exchanged a few words and he soon went. He did not

Two Duchamp contributions to the 1938 Surrealist exhibition: twelve hundred coal sacks and a cross-dressed mannequin for the "Street of Lips"

appear at the official opening. Afterwards it was learned that on leaving the gallery, he had taken the train for England."[92]

As Duchamp's train swayed northward across the chill Norman night, history was catching up with the sad young man. Now the same impulsive departures that had looked so mysterious and puzzling in his youth seemed, in the light of current events, like the rational behavior of a sensible, prudent man. In that winter of 1938, it would take more than the Surrealists' echo chamber to drain the horror from the sound of German soldiers on the march. In every country in Europe, thoughtful people were packing their bags, preparing their personal box in a valise. The German intellectuals were already in flight. The French watched wearily as the Spanish Civil War ground toward its tragic end. Every heroic gesture, perhaps, had already been made; every passionate word said. Now all one could do was to pack one's bags.

After the Surrealist show closed in March, Breton went off to Mexico on a "cultural mission" sponsored by the French Ministry of Foreign Affairs. He had long conversations with Leon Trotsky, trying to arrive at a theory of revolutionary art that would counter Stalinist repression. So persuasive was the Frenchman that the final communiqué from their meeting announced that the exiled Russian revolutionary had accepted "the doctrine so dear to the Surrealists: that at heart poets are anarchists."[93] Duchamp, expecting Breton to pass through America on his return, had asked Katherine Dreier to invite the Surrealist to tea in her Connecticut home, where the rebuilt *Large Glass* now dominated the library.[94] Breton, however, hurried directly home to France and would not visit the United States until 1941.[95]

In 1934, Breton had written a glowing review of the "magnificent" *Green Box* titled "The Lighthouse of the Bride." Surveying some thirty-five "interventions" that Duchamp himself considered significant, Breton had written that "no profounder originality has ever been seen to flow more evidently from any being more obviously committed to a policy of absolute negation." *The Large Glass* and the *Green Box* were works of "absolute originality," Breton wrote. He did not believe that any previous work of art had made such a telling statement "of the relationship between the rational and irrational."

Ironically, though, while Breton had not seen a picture of the *Large Glass* until that spring of 1938, the spring of the Nazi *Anschluss* of Austria, he had, years earlier and sight unseen, invested the *Large Glass* with an impossibly

heroic mission: "It is imperative," he had written at the end of 1934, when the glass lay smashed to shards in its crate, "that it should be kept luminously erect, its light there to guide the ships of the future through the reefs of a dying civilization."[96]

Now, as the summer of Munich was about to sweep the dregs of European optimism down the drain, such aesthetic master judgments looked as meaningful and effective as Neville Chamberlain's furled umbrella. Far from bickering about the meaning of Art, one cultivated distant contacts; one wrote practical letters to foreign friends — until, in September of 1939, one wrote the inevitable: "Well, it had to come," Duchamp scribbled to Dreier. "How long will it last? is my first question. How will we come out of it, if we come out of it?" Now fifty-two, Marcel was "not actively in the war." But, in contrast with his attitude twenty-five years earlier, or perhaps to please Dreier's activist nature, he wanted to "do something to help. What?? ... I am in Paris, waiting for the first bomb to leave [for] somewhere in the country."[97]

When France fell nine months later, there began a drama to rescue Duchamp that typified thousands of strenuous and well-meaning efforts by Americans to rescue European friends. Duchamp surely appreciated its ironic blend of accident and design, of cool rationality and passionate feeling, of loftiest altruism and base crassness, of the precision of a razor set against the dumbness of chance. As it unfolded, this drama paralleled with peculiar fidelity the absurd notions he had expressed in the *Large Glass*.

◆ ◆ ◆

At 10:00 A.M. on June 20, 1940, Walter Arensberg cabled $125 to Poste Restante in Arcachon, plus a message: "DO YOU NEED HELP?"[98] Only six weeks earlier, Arensberg had written Duchamp a long, chatty letter asking for aid in augmenting his collection (would Marcel do a colored reproduction of the *Sad Young Man on a Train*, as he had long ago done with the *Nude Descending the Staircase?* and did he think Raymond's widow might part with the *Coffee Mill?*). He also offered Duchamp a job in California, painting murals in the projected building for the Arensberg Foundation.[99]

Duchamp had been noncommittal about the California proposal, and now, in mid-July, still in Arcachon, where he and Mary Reynolds were sharing a villa with the Crottis, he reassured Arensberg that "the organization of the country" was "not as bad as I had feared ... I can even work — I have

a good printer — and my album moves ahead." But money was a problem. Arensberg could have the *Tzanck Check* of 1919 for $50, and did he "think that $100 would be too much" for the *Mona Lisa with the Mustache?*[100] (A later replica of the *Tzanck Check* recently sold for more than $313,000, while replicas of *L.H.O.O.Q.* have reached $550,000.[101] But such long-term profits were not on anyone's mind in 1940.)

On August 22, Arensberg officially invited Duchamp to America, the first step required to obtain a visitor's visa. He had already sent a lawyer to Washington, he wrote, "to personally take up the case with the Federal Authorities."[102] A month later Duchamp indicated he wanted such a visitor's visa, and asked Arensberg to have the papers sent to the American consulate in Marseilles.[103]

Meanwhile, the lawyer Arensberg had dispatched to Washington soon hired another, an immigration specialist,[104] to join the throng hammering at the gates of the State Department. By November, Arensberg was able to suggest that an affidavit for immigration was more advantageous than a visitor's visa good for only six months. (None of this kept Arensberg from reminding Duchamp to inquire about the *Coffee Mill*.)[105]

By the end of 1940, Duchamp had returned to Paris. In his resourceful fashion, he equipped himself for survival. From his old friend and erstwhile neighbor, Gustave Candel, whose portrait he had drawn in 1909, and who had since become the well-to-do owner of a chain of Paris dairies, he obtained a travel permit as a cheese buyer. Then, as methodically as France's disrupted trains permitted, he began a series of trips between Paris and unoccupied France. In the battered suitcases that became a symbol of those times, he carried, so to speak, a symbol within a symbol: the makings for the *Box in a Valise* that comprised his worldly goods.

By the end of November 1940, Duchamp had his affidavit but, through Kafkaesque bureaucratic quirks, no visa. Curiously, he kept dithering about applying for it at the American Consulate in Marseilles. Possibly he did not care to leave Mary Reynolds, who was "stubborn as a horse," as he wrote to Alice Roullier; she "did not want to leave her house and her cat."[106] But more likely, he wavered because he craved the ambiguity that left his options open, much like the door at 11 rue Larrey.

It wasn't until six months later, on July 3, 1941, that Duchamp finally presented himself for a visa at the Marseilles American Consulate, which was now besieged with frantic refugees. He was told that he was two days too late:

as of July 1, the rules had changed and affidavits now required two guarantors. Arensberg would have to start all over again.[107] The absurd reality was an uncanny echo of an imaginary scenario Duchamp had written in 1939:

Let's Be Serious

First of all, I will say that I

...... that he is the first in the world, and notably

We authorize beforehand

............... That he orders we are convinced that

..........................

reasoning.

Therefore, we willingly act in concert

..

................. Unfortunately

inspired by the most lofty

who is, of course, absolutely innocent:

time, our joy and our despair I

which is, at one and the same

...

must spread butter on his countenance daily

...

...

.............. it was a feat of strength

...

Comrades of Phynance, as Père Ubu used to say

...

...............

...

Now, attention![108]

While the bureaucrats tried their best to live up to this parody, Duchamp settled at Sanary, a tiny village between Toulon and Marseilles. Nearby, at the Château Air Bel, a group of Surrealists huddled around Breton and waited for the hastily organized American Committee for Aid to Intellectuals to rescue them. To pass the time, they played cards with a deck collectively designed by Jacqueline Lamba Breton, André Masson, Victor Brauner, Wifredo Lam, Jacques Hérold, and Oscar Dominguez and printed by

Frédéric Delanglade. Supposedly a graphic summary of Surrealist philosophy, the suits and their symbols were Love, a flame; Dream, a black star; Revolution, a bloody wheel; and Knowledge, a keyhole. On the face cards, which were called Ace, Genius, Siren, and Magus, were portraits of the Surrealists' heroes: Hegel, Sade, Baudelaire, Novalis, Lautréamont, and Freud, appropriately labeled the Magus of Dreams.[109]

Set against the tragic scenario of these exhausted remnants of the Surrealist movement desultorily fingering these cards, one can imagine the frantic rescue activity of their American friends. On Duchamp's behalf, Arensberg and, quite independently, Dreier were poking at every imaginable strand of the bureaucratic web to provide Marcel with his essential piece of paper, as well as money to survive.[110] On July 11, Arensberg tried to get Alfred H. Barr, Jr., director of the Museum of Modern Art, to intervene. But Barr was away for the summer and his assistant, swamped with the "refugee problem," wrote that "our contacts with the State Department do not seem to be good enough" to get Duchamp "a cabled visa authorization."[111] On July 24, Arensberg wrote to George Biddle, whom he had met at a dinner party, to ask him to use his influence with his brother, Francis, who was attorney general.[112] And on August 5, he fired off a scolding to his intended beneficiary: "The delay on your part to avail yourself of our affidavit has landed you in the present difficulty." He wondered why Duchamp had created the "additional difficulty" of failing to get a French passport. Then, perhaps abashed by his tone, he asked, "Do you need financial assistance?"[113]

To Frank Hubachek, Mary Reynolds's brother in Chicago, Arensberg confided his annoyance with Duchamp: "I feel a little put out that Marcel delayed so long ... I sometimes wonder, especially on the strength of certain statements from friends of his in Paris, just how much he actually wants to come."[114] And in the midst of the peril, there were still aesthetic considerations. As late as March 2, 1942, Alfred Barr doubted whether George Biddle would intervene in Duchamp's favor, "for George has come out against artists of Marcel's type with almost hysterical fury."[115]

With the United States in the war, Arensberg was haunted by the fear that America would break diplomatic relations with Vichy France, or even declare war, which would strand the refugees for the duration. His new affidavit application, with Louise Arensberg as the second sponsor, slowly made its way through the in and out baskets at State. Finally, on March 21, Arensberg was able to send a triumphant wire to Alfred Barr: the visa was

approved. In response, Barr immediately demanded the Arensbergs pay $400 to the Hebrew Immigrant Aid Society for Duchamp's fare.[116] On April 2, an exasperated Arensberg suggested Hubachek pay for Marcel's passage: now that it looked as though Marcel would have to stay in America, at least until the war was over, Arensberg had reconsidered his previous job offer. It was "inadvisable for Duchamp to come to California," he wrote Hubachek, "in view of financial changes and general uncertainty."[117] Hubachek, also vexed, replied that he hoped Marcel would arrive in America soon so that "I can straighten out some of the embarrassing situations into which his impetuous disregard of my instructions has plunged me."[118] To add to the men's annoyance, they discovered that during all the months they had been laboring to extricate Duchamp, Katherine Dreier had been pursuing her own efforts to bring him to America.[119]

Their testiness was partly understandable: they had witnessed a flood of refugee artists and intellectuals arriving in America. Breton had embarked for Martinique (and eventually New York) in March of 1941. Most of the other Surrealists had also betaken themselves and their deck of symbolic playing cards to New York. Yet not until mid-May of 1942 did Duchamp finally set sail for Casablanca. From there, he hopped a plane to Lisbon. The sample *Box in a Valise* was virtually his only baggage as he finally crossed the submarine-infested Atlantic aboard the safely neutral Portuguese *Serpa Pinta*.

He arrived in New York on June 25, a day that had started with drizzle, then bloomed into perfect early summer weather, with a high temperature of seventy-six degrees. It was twenty-seven years and ten days since that other June day when he had so smilingly parried the questions of reporters in New York Harbor. Now a letter from Arensberg awaited him: "The plans for working in California have to be indefinitely postponed," his old friend wrote. Furthermore, even a visit in the West was inadvisable: "California is the first line of defense and the authorities have publicly stated that it is entirely inevitable that we are to be bombed."[120]

By 1942, Walter Arensberg was no longer the carefree bohemian who had welcomed Duchamp into his house in 1915. Unwise investments during the 1920s and the 1930s depression had eroded much of his fortune; he worried about permanently supporting an impecunious fifty-five-year-old artist who considered joblessness a point of pride. As for Duchamp, the prospect of establishing himself in Los Angeles was hardly attractive; his contacts were all in New York, and now included not only Dreier, but also an array

of French exiles, among them the Surrealists. He made no known reply to Arensberg's discouraging letter, but later described the crossing, his thirteenth, in typically detached terms: "It was perfectly delicious. All the lights were on and we had dancing on deck every night."[121] As so many times before, Duchamp responded to dire prospects with flippant humor.

THE IMMIGRANTS STREAMING INTO the United States in the years before the Second World War were an unprecedented class. Many of them were not the penniless, uneducated masses that had earlier flocked in, but instead were equipped to step directly from an immigrant ship to the center of American cultural life. In the world of art, as in the sciences and the humanities, the newcomers helped to shift Americans' intellectual orientation away from its pattern of deference toward the Old World.[1] The large cities, like universities and museums in more provincial settings, welcomed these newcomers as reinforcements in a cultural battle that had been waged since at least 1913: to bring European refinement to the brash, moneygrubbing heathen of America. In New York, the avant-garde had formed a small and cohesive, perhaps incestuous, cultural upper crust. Katherine Dreier, for example, had frequented the famous Paris salon of Gertrude Stein,[2] who chose as the designer for her opera *Four Saints in Three Acts* Florine Stettheimer, who often entertained the critic Carl Van Vechten, who was a friend of the opera's composer, Virgil Thomson, who was acquainted with the art critic and early mentor of Duchamp, Henry McBride, and so on.

When Duchamp arrived in 1942, he was, as *Time* magazine pertly put it, "comfortably installed in Patroness Peggy Guggenheim's apartment" at 440 East 41st Street.[3] Throughout the previous decade, the bohemian heiress had relied substantially on Duchamp's advice in assembling an extraordinary collection of modern art. In 1941, Guggenheim arrived in New York, having extricated from Nazi-occupied Europe the ingredients for Marcel's *Box*, along with

her art holdings, her current lover, Max Ernst, and her ex-husband, Lawrence Vail. Soon, the copper heiress married Ernst and started preparing a gallery to show her collection in the very heart of New York's art market, at 30 West 57th Street. The designer of the gallery was Frederick Kiesler, an architect whose Seventh Avenue apartment Duchamp shared toward the end of 1942. Five years earlier, Kiesler had written a glowing article about Duchamp's *Large Glass* in *Architectural Record*.[4] It had, Dreier wrote Marcel, "cost him his job,"[5] though it remains unclear whether Kiesler was fired because of his radical views or maddeningly turgid writing.

Kiesler's design for Guggenheim's Art of This Century gallery exuded a faint aroma of Surrealism's coy suggestiveness, but at least the lighting was bright and on the walls hung works by both outstanding European modernists and promising young Americans. In a prominent spot was a wheel with a peephole behind it: as the viewer turned the wheel, the peephole revealed the various components of Duchamp's *Box in a Valise*. The twenty limited deluxe editions were on sale at the gallery for $200 each.[6]

This jaunty display put a brave face on the dismal economic facts confronting Duchamp. The small inheritance that had supported his ascetic life over the previous decades was now out of reach, in Europe. Arensberg, the patron who had bought virtually all of his older works and had labored to get him out of France, was in California and had invoked Japanese bombing threats to keep Marcel from collecting the earlier promise of a job. Mary Reynolds, whose generosity could always be counted on, had remained in France and become active in the Resistance. American connoisseurs of modern art had always been a tiny group; now they were faced with aiding a veritable army of needy foreign artists.

While a few pioneers like Arthur Dove and Stuart Davis had tried to man the crumbling barricades of modernism first raised through the Armory Show in 1913, the mainstream of American art had abandoned abstraction for a return to interpretations of the American scene. Many of the young artists inspired by the antics of Duchamp and Picabia in 1915 had died or moved on to other things. Meanwhile, potential sources of aid such as the Works Progress Administration (WPA) tended to commission more traditional artists, rather than those whose style was abstract or "international." In this, the government's taste mirrored the prevailing taste of the art-buying public at the time. In 1942, a survey by the Grand Central Galleries, one of New York's most successful, revealed that almost all of the $6 million

worth of pictures sold during the previous twenty years were traditional genre scenes and landscapes. Erwin S. Barrie, the director of this artists' cooperative gallery, reported that fewer than 10 percent of his customers were interested in "so-called modern art, and 90 percent despise it."[7]

At the same time, the Museum of Modern Art had for a dozen years displayed the work of leading European abstract artists, not only in its New York setting but also in many exhibitions that traveled to other museums, to women's clubs, and even to department stores. As many of the American artists supported by the WPA were able for the first time to devote themselves primarily to art, a more adventuresome spirit seeped into their work. Many warmly greeted the iconoclasm of newly arrived European artists and art teachers, of whom Duchamp was one.

More symbolic than even its symbol-ridden organizers dreamed was the title of the first major show organized by exiled European artists: "First Papers of Surrealism." The setting of the show, which ran from October 14 to November 7, 1942, was a faux-Florentine palazzo, the Whitelaw Reid mansion, built in the 1880s at 451 Madison Avenue. Amid the gilt and curlicues of its cavernous rooms would hang the works of an unprecedented array of modern, mostly French, masters. The admission fee, $1.10 for the preview and 50 cents thereafter, benefited the Coordinating Council of French Relief Societies, which had its headquarters elsewhere in the same building.

The show's setting was created by Duchamp, whose design for the 1938 Paris Surrealist Exhibition raised expectations of another succès de scandale. Asked to economize by the show's sponsor, the couturier Elsa Schiaparelli, he created huge "spider webs" out of string that intentionally obstructed visitors' access to the works André Breton had carefully selected. When the artists complained, Duchamp suggested they show their works in the corners. To compound the confusion, he also invited the dealer Sidney Janis's young children to romp through the crowd at the opening. As usual, Duchamp himself did not attend.

The preview was "a piquant and gay and wittily alarming experience,"[8] the New York Times critic wrote, later adding that Duchamp's web comprised "the most paradoxically clarifying barrier imaginable."[9] A few agile viewers would be able to study the pictures through "strategically placed" openings. But such acrobatics were not essential, he assured readers of a full-page Sunday review, since a Surrealist picture's "impact may even seem enhanced" through the twine.[10]

The *Times* man was clearly impressed by the roster of the show's sponsors; it included Peggy Guggenheim, the art dealers Pierre Matisse and Sidney Janis, the Arensbergs, Dreier, Elsa Schiaparelli, and the art historian James Johnson Sweeney, who would later become director of the Guggenheim Museum. Equally impressive was the list of exhibitors, not all Surrealists. Such diverse talents as Alexander Calder, Piet Mondrian, and Marc Chagall joined such Surrealist veterans as Jean Arp, Hans Bellmer, Max Ernst, Victor Brauner, René Magritte, Wifredo Lam, Joan Miró, André Masson, Kurt Seligmann, and Yves Tanguy. In addition, the exhibit launched several important Americans: Robert Motherwell, David Hare, William Baziotes, and Jimmy Ernst.

One critic poetically raved over Duchamp's design as "an Ariadne's thread, beyond which the pictures hung like secrets at the heart of a labyrinth."[11] Another called the setting "an immense spider's web ... crisscrossing at every angle and ironically covering the old-fashioned decor and the modern painting equally with its tangled cords."[12] The catalog, also designed by Duchamp, reinforced the decor's playful hostility. The front cover was a photo of a crumbling wall, pocked by five bullets, while the back

Sixteen miles of twine: installation for the "First Papers" exhibition, 1942

cover showed a close-up of a slab of Swiss cheese and a quotation from Apollinaire: "Here, then, for my fast, is a piece of Gruyère."

Somewhat like the mannequins representing exhibitors in the 1938 show, the 1942 catalogue contained a series of "compensation portraits" of exhibitors, photos intended to convey their spiritual visage rather than their likeness. Duchamp's was a photo of a haggard woman, supposedly taken by Ben Shahn. Like the design of the show, the catalogue was intended to shock and perhaps anger the public, which made the critics' wide-eyed and friendly reception of it all the more disappointing. The docile admiration in New York contrasted sharply with the critical reaction in Paris to the 1938 Surrealist show. That event and its organizers had attracted such comments as *"Les vieux enfants terribles,"* *"les cochons compliqués,"* and a sardonic obituary: *"Surréalisme mort, éxposition suit"* ("Aging brats," "complicated pigs," and "Surrealism dead, exhibition to follow").[13] Some years later, Duchamp bitterly compared the Americans' attitude toward art during the Second World War with what he had experienced during his first stay in 1915. "The younger artists," he said, "are following along in the paths beaten out by their predecessors ... During that other war, life among artists in New York was ... much more congenial ... The art was laboratory work; now it is diluted for public consumption."[14]

Though three decades had passed since his *Nude Descending a Staircase* first scandalized New York, Marcel's most casual gesture still seemed to attract admirers. The *Times* found even the way he unrolled a ball of twine "spell-binding."[15] Yet the very tortuousness of his drooping labyrinth appeared to reflect his persistent ambivalence toward art and artists. The show "seems to be quite a success," he wrote to Dreier. "I was not there (this is one of my habits) but reports indicate that the children played with great gusto."[16] Indeed, the presence in America of so many important artists was a two-edged sword: on the one hand, it hastened the acceptance of modern art by Americans; but on the other, it scattered the loyalties of a limited group of collectors, critics, and curators among a throng of diverse talents.

Financially, the consequences for Duchamp were grim. On November 4, he wrote Dreier to thank her for a gift of ten dollars, hoping "I can wait until your arrival in New York [from Connecticut] for more, if I need it." The Swiss cheese on the show's catalogue may have been a wishful totem. "I am dumbfounded," he wrote, "at my position as a kind of *'vedette'* [star] in this town and not to be able to at least make an ordinary living out of it."[17]

Though the stock market crash in 1929 had greatly reduced Katherine Dreier's fortune, she continued to help Marcel with small gifts or commissions. All through a relationship that had endured for more than thirty years, she had affectionately addressed him as "Dee." And while he addressed his letters to "Dear Katherine," to others he always referred to her formally as "Miss Dreier."

By the early 1940s the collection of the Société Anonyme, which Duchamp and Man Ray had sanctioned so cavalierly in 1923, had grown, under Dreier's earnest management, to include 169 artists from twenty-three countries.[18] In addition to the works Dreier bought, she had applied her relentless will to getting contributions from the artists themselves, an eclectic array of bright stars and nobodies.

In 1940, Duchamp, who was still a trustee of the Société, had agreed to Dreier's plan to donate the collection to a nonprofit "Country Museum" that was to be established in her home at Redding, Connecticut.[19] By the following year, however, those plans had fallen through and on October 11, 1941, Dreier officially deeded the collection and all its papers to Yale University.

Richard Huelsenbeck, the former Dadaist, recalled visiting Dreier's Connecticut home not long before she died. Katherine and her sister, Dorothea, were "like characters in *Arsenic and Old Lace,*" he wrote. "In the stable, which smelled of horses and coaches, there were two strange-looking cars; and the house and gardens exhaled lavender and the odor of old Christmas trees and linen closets."[20] Katherine Kuh also described her impressions when she accompanied Duchamp on a visit to Dreier. "Mesmerized by Marcel," Kuh wrote, the elderly Katherine listened raptly as Marcel wondered aloud whether the possessions of collectors were not a form of readymade.[21]

Near the end of her life, Dreier praised Duchamp's "perseverance and constancy" as secretary of the Société.[22] Indeed, as executor of her will, Duchamp's interest persisted long after she was gone. As late as 1960, he urged the Yale Museum's curator, George Heard Hamilton, to seek funds from Dreier's heirs to pay for restoring some of the works in the Société Anonyme collection.[23]

◆ ◆ ◆

In 1942, such a correspondence between Duchamp and an eminent art historian would have been hard to foresee. Just finding a place to live was prob-

Katherine Dreier at home in Connecticut, in an elevator painted by Duchamp to match her wallpaper, 1946

lem enough. Finally, early the following year, he located the right spot, a fourth-floor walkup at 210 West 14th Street. Located on the top floor of an aging brownstone between Seventh and Eighth avenues, the apartment was flooded by the north light that mythology requires for an artist, through a skylight that ran the width of the building. The neighborhood was Spanish, including among its residents many refugees from the recently concluded Civil War; and the rent was right — $25 per month. For almost the next quarter century, fact and fiction about this setting and its occupant would interweave into a tapestry of legend.

There was no telephone in Duchamp's studio, as the gallery owner Sidney Janis marveled soon after the artist moved in. Furthermore, "no one had the slightest idea what [Duchamp] did in these spartan surroundings." Was he giving French lessons? Was he studying chess problems? Was he, perhaps, "working in secret on a new masterpiece?"[24] The place was incredibly dusty, recalled the artist Jeanne Raynal, who met Duchamp at around this time through André Breton. "The dust lay two inches thick on the floor, with a narrow path from the front door and another leading to the bathroom, and always a table at the ready for chess."[25] An art scholar, it was said, once

came to the studio and found Duchamp playing chess with a nude woman. When the game was over, the woman dressed and left, while Duchamp, without a word of explanation, turned to his visitor. While the story is wholly imaginary, its retailer, Calvin Tomkins, suggests it is "perhaps spiritually true."[26] The poet William Carlos Williams, possibly still rankled by an insult he sensed in 1915, described Duchamp during the 1940s as "idling in a telephoneless 14th Street garret."[27] Marcel's longtime friend Beatrice Wood visited him in 1944 only to find "the same unmade bed [as in 1917], chocolates on the windowsill and more readymades." Wood confessed that she didn't understand Duchamp's work, except for the *Nude Descending a Staircase*, but that "the man meant more to me than his art."[28]

As late as 1956, a *New York Times* reporter described interviewing Duchamp in "littered, dusty rooms,"[29] and Huelsenbeck reported visiting Duchamp's studio and finding a chess table he had built complete with clocks, electric bells, hand rests, and even foot rests. It "resembled … an electric computer, a machine without human aid."[30]

As for Duchamp's spartan eating habits, Motherwell describes lunching with Duchamp "at a little downstairs Italian restaurant, where he invariably ordered a small plate of plain spaghetti with a pat of butter and grated Parmesan cheese over it, a small glass of red wine and espresso afterwards."[31] John Cage, for his part, described "two or three peas and one bit of meat" on Duchamp's plate,[32] implying an ethereal preciousness altogether remote from Duchamp's real existence. In fact, the owners of two long-established Spanish bistros in the neighborhood remembered frequent visits from Duchamp. Amado Prada of La Coruna recalled that Duchamp "always" drank martinis.[33] And Alfonso Ojen, who owned the Oviedo Restaurant, even pointed to the corner barstool next to the window where Duchamp often sat, quietly sipping a double martini.[34]

These details illustrate how, on the way to canonization, the humanity of an individual often gets rubbed out. Especially when the individual is as intensely private and deliberately distant as Duchamp, a banal and modish — even tawdry — mythology befogs the authentic and far more interesting personality.

Duchamp himself contributed to the air of tatty bohemianism and mystery surrounding him. "I am chessing, lessoning, starting a few boxes; my usual life," he wrote to Dreier in 1944.[35] And to *Life* magazine the following decade, he said, "My capital is time, not money." At tax time, he revealed,

he sent the government a few dollars, more than enough to cover what he owed. "I feel I should send them something," he explained, chain-smoking a pipe filled with Cuban tobacco.[36]

The cavalier remark of 1952 belies the fact that during much of this time, and especially during the war years, money was a continual concern. The art dealer David Mann recalled that Duchamp was so poor that he traveled all the way to Brooklyn for some dental work at a free clinic. The dentist pulled a whole group of teeth, and on the way home Duchamp collapsed on a street curb; he rested a while and then quietly went home. Mann once had a drink with Duchamp in a Bowery bar and was struck by Duchamp's bland gaze at the derelicts around them, and his remark: "I envy these people because worldly things mean nothing to them."[37]

Some concluded from this attitude, as well as from Duchamp's so-called abdication from art, that his life itself comprised a work of art. The Surrealists subscribed to this notion: that "each individual, whether consciously or otherwise, is in the process of acting out ... life-as-a-work-of art."[38] But they also recognized that this idea, in fact, is much older and more widespread. Oscar Wilde had said that he had put his talent into his art, but his genius into his life.[39] A similar concept was in Berthold Brecht's mind when, in 1918, he concluded a memorial essay for the playwright Frank Wedekind with: "His greatest work was his personality."[40]

Considerable evidence indicates that Duchamp, in his diffident, passive way, deliberately projected a certain image of himself. And who, after all the readymades, could argue that it was not a work of art? In the years between 1942 and 1954, he was frequently interviewed for articles in popular magazines, and the reporters almost invariably came away with an impression of an urbane, engaging, and cerebral personality, a man who had unlocked the secrets of art as a young man and thereafter, in a noble gesture, had repudiated the creative act. As early as 1937, in fact, he had arrived at a shrewd judgment on the value of publicity. "Criticism for or against is of equal value," he had written to Dreier. "The amount of publicity is proportional to the number of lines written for as well as against."[41] Only three months after arriving in New York in 1942, he obligingly posed for *Time* magazine's photographer with the *Box in a Valise*. Artists in Nazi-occupied France, he told the reporter, were "flourishing"; his brother Villon had "sold thirteen paintings in one show." Furthermore, his own narrow escape had been a glamorous adventure; the trip across the wartime

Atlantic aboard a ship crammed with refugees "was perfectly darling."[42]

He teased interviewers by pointing to his famous abdication from art, yet in filling out his U.S. immigration biography in 1941, Duchamp gave his profession as "artist, painter."[43] The *Nude Descending a Staircase* had been notorious enough, wrote one reporter, "to satisfy him with fame for the rest of his life." Since then, "he has spent as much energy in trying to be obscure as other men spend in the effort to be conspicuous."[44] In his own profile in the catalogue of the Société Anonyme, in 1949, he wrote that he had "joined the Surrealists" but remained "aloof and free."[45]

But there were those who sensed premeditation in Duchamp's attitude. One former Surrealist, Pierre de Massot, thought Duchamp had been "preparing his pedestal" since 1920; "he always knew exactly what he was doing." The painter Arshile Gorky agreed, telling Sidney Janis that "Duchamp planned everything ... counting on others to fight his battles for him." Huelsenbeck, on the other hand, insisted, "He never wanted to be anybody."[46]

Duchamp's behavior confused even his friend Robert Lebel. In the first major book about Duchamp, Lebel marveled at Marcel's "secret preoccupations" and professed "amazement and admiration for his way of life" and "irresistible charm" without "intentional seduction." The "illumination which radiated from him ... of the interior freedom which he at last possessed" was canceled by his avoidance of "indiscriminate familiarity."[47] Thus Lebel saw deliberate mystification, charm without seduction, permitting admiration without familiarity. The paradoxes in Duchamp's personality bring to mind the very same paradoxes he tried to express — to the point of incompletion — in the *Large Glass*. Three decades after abandoning his masterpiece in a tangle of ambivalences, Duchamp was still wavering between revealing (as through a glass) and concealing (as with a mirror). On the one hand, as the artist William Copley noted, he "could talk about anything ... you felt you'd known him all his life." And on the other hand, "you also felt there was always something back there, a reserve to break through."[48]

In 1951, Villon painted a remarkable likeness of Marcel that conveyed graphically the deep clefts he perceived in his brother's personality. The head and right arm are painted in brilliant reds while the rest of the figure carries Villon's characteristically cool greens, blues, and violets.

The subject himself seemed to be at loose ends during this time. With his

Surrealist friends, he participated in several movies filmed by Hans Richter in Connecticut. *Dreams That Money Can Buy,* completed in 1947, was a bitter tirade against the commercialized dream-factory of Hollywood, "starring" Max Ernst, Fernand Léger, Richard Huelsenbeck, and Man Ray. Duchamp's section, making its own statements about the moneymaking potentials of art, showed a nude woman descending a staircase. Two other short films deal with chess: *8 x 8* is a heavy allegory of the game's relationship to life, while *Passionate Pastime* is a documentary in which Duchamp and the chess champion Larry Evans demonstrate its history.[49]

But even chess was not without its moneymaking potential. Trying to eke out an income, Duchamp spent a good deal of time in 1943 and 1944 revising the design for a pocket chess set he had already created in the 1920s.[50] The game indeed continued to be a passionate pastime, even as Duchamp realized he would never become a champion. His studio was directly across the street from a neighborhood chess club, in whose smoky depths silent men huddled around the checkered board. Mild and thoughtful and politely amused as he was so often described, Duchamp expressed quite a different personality over the chessboard. As Man Ray once explained it to Janet Flanner, the *New Yorker*'s Paris correspondent who signed her work "Genêt," chess to Marcel was "rather like an argument except that in chess the argument reaches a decision."[51]

One evening in the mid-1940s, the grand master Edward Lasker received an anxious telephone call from an acquaintance he had not seen in ten years. It was Frederick Kiesler, saying that two of his friends, Max Ernst and Julien Levy, were being abused at chess by Duchamp "most ignominiously." Kiesler begged Lasker to come over immediately and subject Marcel to revenge. "We would love to see him checkmated," cried Kiesler. Lasker obliged.[52]

◆ ◆ ◆

In the years after settling in the United States, Marcel watched in calm detachment as successive flurries of interest in both his works and his theories rippled over the surface of the art world. In 1943, *Vogue* magazine commissioned him to do a cover for its Independence Day issue. But the editors balked when they saw his witty double portrait of George Washington and Abraham Lincoln, concocted out of white gauze soaked in a vaguely striped pattern of blood-red ink and dotted with gold stationers' stars: they felt it

looked too much like a used sanitary napkin. He was paid $40, but the cover was never used, and Duchamp soon sold the original design to André Breton for $300.[53] (In 1986, the Musée National d'Art Moderne in Paris acquired the gauze collage from the Breton estate for a reported $500,000.[54])

In 1945, the New York avant-garde magazine *View* devoted an entire issue to Duchamp. It was an unusual tribute, considering that for more than twenty years Duchamp had produced few tangible works. To many American art experts, he was an enigma. Ten years earlier, Alfred H. Barr, Jr., had described him as "an aloof and intensely independent spirit." The astute director of the Museum of Modern Art noted that Marcel was "an important influence upon both Dada and Surrealism, but he does not seem to have committed himself in any formal sense."[55]

Duchamp often talked contemptuously about repetition. As early as 1923, he had answered Naum Gabo's question as to why he stopped painting with, "But what do you want? I have no more ideas."[56] By 1949, the "keen old knife-blade of a man," as *Time* magazine described him, had extended this attitude to all of modern art. It was all over, he said. "Unless a picture shocks, it is nothing, a calendar painting." Matisse and Picasso, he added, had run out of ideas long ago. As for himself, "If I have an idea tomorrow, I will do it."[57]

Despite his protests, however, Duchamp was inevitably as caught up with repetition as any other artist. In his early years, he had painted the various versions of the *Nude Descending a Staircase* and of the chess players, as well as numerous virgins and brides. His final painting, *Tu m'*, was a recapitulation of the readymades, as the *Rotary Demisphere* summarized his ideas on moving machines. The *Large Glass* again repeated many of his earlier concepts: the chocolate grinder, the bachelors, and, once more, the bride. Furthermore, Duchamp perpetually acted out his obsession with repeating his own work, in multiple copies. His notes on the *Large Glass* were reproduced in facsimile on several occasions, including 320 exemplars of the *Green Box* in 1934. During the very period that Duchamp was inveighing against repetition, he was also trying to market more than three hundred copies, in eight versions, of the 1938 *Box in a Valise*. However, the "original" of *L.H.O.O.Q.*, with its connection to Leonardo, still carried a special meaning. It had been created on the four hundredth anniversary of Leonardo's death. And in 1944, Duchamp went so far as to have his signature on it certified by a New York notary.[58]

For years, Duchamp had been performing the most repetitive job imaginable, painstakingly assembling the pieces for the *Box in a Valise*. He was so bored with the work that in late 1942 he persuaded Joseph Cornell, then an artistic fringe figure, to help him assemble the complicated works.[19]

At the time, the Surrealists in New York were hardly aware of the eccentric American who was interpreting many of their concerns with dreams and chance by means of boxes filled with suggestive combinations of objects and collage. Rather, the circle of European exiles around Peggy Guggenheim encouraged her to give the first one-person shows at Art of This Century, during the 1940s, to Pollock, de Kooning, Motherwell, Baziotes, Mark

Portrait of Duchamp "at the age of eighty-five" for View magazine, 1945

Rothko, Clyfford Still, Adolph Gottlieb, and David Hare. Guggenheim and her adviser, Howard Putzel, agreed that these artists' blend of abstraction and dreamlike Surrealism expressed a new, homegrown style.

However, mainstream America still viewed their difficult, often sexual imagery as a poison fouling the pure and wholesome body of American art. The influential designer of furniture and interiors T. H. Robsjohn-Gibbings, for example, in 1947 saw abstract art as "an attempt to reverse scientific progress and rational thought." Modern art was so pernicious, he noted, that "in 1914 Kandinsky arrived in Russia and three years later came the Revolution." But the worst example of "pseudo-lunacy," wrote

Robsjohn-Gibbings, was "a painting [*sic*] by Marcel Duchamp in which the *Mona Lisa* has a mustache."[60]

By contrast, Duchamp deplored the lack of shock in the paintings of the late 1940s and early 1950s. The works of the Abstract Expressionists, as the New York group had been christened, were in his opinion just "acrobatics," not a new direction in art. "I think people should be shocked," he told an interviewer. "If you want to get out of the basket of crabs, it's only through shock that you can do it."[61] There are two kinds of artists, he told a friend in 1956: "the artist that deals with society, is integrated into society; and the other artist, the completely freelance artist, who has no obligations." And he seemed perfectly content with his own marginal place: "The danger is in

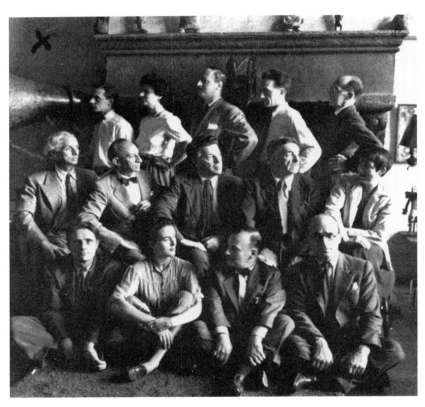

Artists in exile, c. 1942, from left to right: in front, Stanley William Hayter, Leonora Carrington, Frederick Kiesler, Kurt Seligmann; in the middle, Max Ernst, Amédée Ozenfant, Breton, Frenand Léger, Berenice Abbott; in back, Jimmy Ernst, Peggy Guggenheim, John Ferren, Duchamp, Piet Mondrian

pleasing an immediate public," he said. "Instead, you should wait for fifty or one hundred years for your true public."[62] That same day, he told a French interviewer, "I am not essentially a painter. Painting was a means, not an end. There are many other ways to explain oneself … The idea of repetition strikes me as terrible — always making the same picture for the same dealer."[63]

Duchamp obviously had thought a great deal about the nature of creativity, and a year before he died he offered some final thoughts on that subject. "A painting that doesn't shock isn't worth painting," he told Pierre Cabanne. Any artist had only three or four "good things" in him, he went on; the rest was just "everyday filler."[64]

Yet, despite the sharp tone of his comments about other artists and his own patent repetition in works like the *Box in a Valise*, Duchamp's reservations about artists repeating themselves were genuine and profound. He was trying to deal with a basic conflict experienced by all artists: the persistent, and ultimately insoluble, confrontation between exploring basic creative themes and the drive for originality. What made Duchamp so impatient with repetition among his contemporaries, however, was a peculiarly twentieth-century phenomenon: the pressures of the art market. He resented the commercial system that caused every preliminary sketch and scribble by a famous artist to acquire a substantial monetary value, and the fact that some artists succumbed to the pressures of that market by cynically repeating themselves. Furthermore, the overthrow of stuffy academic art standards early in the century, though much needed, had not led to new and broader aesthetic standards. Instead, with all aesthetic judgment of art suspended, the only criterion left was novelty. But countering this paltry criterion is the artist's perennial need to explore what André Malraux called "the eternal" in art, "the realm of sex and the realm of blood."[65] Thus, an art based purely on originality is likely to fail, much as the chess player who insists on making only unique moves will fail. The problem of expressing "the eternal" by new means continues to bedevil postmodernist art.

◆ ◆ ◆

All of New York, and especially the exiled artists, greeted the end of the Second World War in Europe with relief and joy. But Duchamp's reaction even to this happy event was cool and measured. Man Ray recalled celebrating V-E Day in May 1945 with Duchamp and André Breton. "Everything

was jammed" with people celebrating, he wrote, and the party ended up at Lüchow's German restaurant, which was also crowded — but with Germans, "subdued and weeping." Amid these emotional extremes, Man Ray was startled to see Duchamp's "noncommittal" attitude.[66]

After the war, Breton lingered in the United States for a quickie divorce and remarriage, then lectured in Haiti and visited the Dominican Republic before returning to New York. He sailed for France in April 1946; Duchamp followed in May.[67]

Upon arriving in Paris, Breton was eager to reestablish Surrealism under his leadership at the center of French intellectual life. Hoping to re-create the shock waves that had followed the 1938 exhibition, he invited Duchamp to design another Paris Surrealist show for the following year. Duchamp suggested a hall of superstitions, a white grotto made of yards of fabric stretched on wooden frames. There was also to be a labyrinth and a "rain hall" featuring a billiard table. Some eighty-seven artists from twenty-four countries contributed works, but, despite the passage of time, the stars were much the same group as in 1938: Ernst, Tanguy, Brauner, Miró, Bellmer, Arp. The organizers hoped to root themselves firmly in the past by display-ing the works of artists they considered spiritual ancestors — Giuseppe Arcimboldo, William Blake, Hieronymus Bosch, and Henri Rousseau — but were unable to arrange the necessary loans. The catalogue, which Duchamp also designed, likewise strove to shock; on the cover of each was glued a hand-colored replica of a breast with the stenciled legend: "Please Touch."[68] Marcel conscientiously worked with the young Italian artist Enrico Donati in gluing 999 foam-rubber falsies onto the cover of the deluxe edition of the catalogue; but in December, months before the vernissage, he left Paris for New York.

When the show opened the following July at the Galeries Maeght, Paris was still dealing with coal and food shortages, political instability, and financial collapse. After eight years of hardship, war, hunger, and death, the Surrealists' relentless prankishness struck many as frivolous and in poor taste. Moreover, many Parisians resented the fact that the organizers had spent the war safely in New York. The common reaction was summed up by Janet Flanner as she described "the first psychopathic aesthetic exhibition since the war." She declared that "the show's japeries were stale *derniers cris*" and angrily flashed that "in the midst of the crisis in civilization, the intelli-gentsia Surrealists are still raking in cash through the inspiration of their pri-

vate, patented muse — a composite of the Marquis de Sade, Machiavelli, Maldoror, Narcissus, Mammon and Moscow."[69]

In the United States during the early 1950s, meanwhile, a new group of artists had caught the fancy of critics and other sensitive fingers testing the winds of art. The young abstractionists who had been kept alive through the 1930s by the WPA were finally coming to prominence. Painters like Jackson Pollock, Lee Krasner, Willem de Kooning, and the sculptor David Smith had held but one major exhibition, at the Whitney in 1935, and then were refused another museum show later on in the thirties. In 1940, they had even picketed the Museum of Modern Art demanding that it show more American art.[70]

But ten years later, these and other innovative American artists were attracting widespread attention. In August 1949, *Life* magazine had printed a multipage picture spread on Pollock, asking, "Is He America's Greatest Painter?"[71] The following May, eighteen avant-garde painters and ten sculptors signed an open letter protesting the Metropolitan Museum of Art's juries as "notoriously hostile to advanced art"; the *New York Times* printed it on the front page. In January 1951, *Life* published a full-page formal photo of these protesters, titled "The Irascibles."[72] Such publicity in a magazine with more than five million subscribers confirmed a fresh turn in American visual art.

◆ ◆ ◆

While he traveled among artists with cool aplomb, Marcel could make himself agreeable to just about anyone. His landlord, who was also an art supply dealer in the neighborhood, used to drop in on Duchamp once a month to collect the rent. "He was a real artist, to look at him," Joseph Torch recalled, "a good thinker and talker." Duchamp asked Torch to import, when it was possible, a special mastic varnish from France. "Twenty-four bottles at a crack," Torch marveled, "and the most expensive kind."[73] And yet, Duchamp appeared to be producing virtually nothing new, while seemingly living on air.

The artist William Copley described Duchamp at around this time as having "no respect or use for money. All he had was a bed, a bathtub, and a roll of string." But the studio also contained, he remembered, a chess table flanked by one chair and one orange crate.[74] The second time Copley saw Duchamp, they were to meet at the Hotel Biltmore, a cavernous place with many lobbies. After a frantic hour searching for Marcel, Copley greeted his

friend, "groveling with apologies," but Duchamp was serene and told Copley, "I often come here just to ride the elevators."[75]

Such uncanny calm balanced the pleasure Duchamp took in playing devil's advocate. Lunching in a New York restaurant one day, Copley remarked on the terrible quality of a mural behind Marcel; Duchamp spent the entire rest of the meal "enumerating all its virtues ... That was the most important aspect of his personality," Copley noted. "He said 'yes' to everything."[76] In fact, Duchamp could be equally adamant about saying "no," especially when he suspected he was being commercially used. In the late 1940s, for example, he agreed to design and install a show for Jeanne Raynal at a prominent midtown gallery, but only on condition that no one know he was involved. When the news slipped out, Duchamp insisted that Raynal cancel the show.[77]

For a brief time in the late 1940s, Duchamp appeared to be forming an intense romantic relationship. His letters to Maria Martins, the wife of the Brazilian ambassador to the United States, provide a one-sided account of what may have been the great love affair of his life. Martins entertained lavishly among Washington diplomats but also kept a duplex apartment in New York, where she was trying to develop a career as a sculptor. She may have met Duchamp at the Valentine Gallery in 1943, when her work was shown with paintings by Piet Mondrian. Their friendship blossomed secretly, and by 1946 they had become intimate, as indicated by at least one original work Marcel included in a *Boîte en Valise* that he gave Maria in 1946. The work was titled *Paysage fautif* (Defective Landscape), and consisted of a pale splash upon a celluloid rectangle, backed in black satin. Only in 1989, at the request of a scholar, did an FBI analysis of the splash reveal that it was created with ejaculated seminal fluid.[78]

While their relationship became more public in 1947, it would also falter the following year, when Maria's husband became Brazil's ambassador to Paris. Maria herself apparently never took Marcel's affections seriously but kept his ardent letters and passed them on to her daughter, Nora Martins Lobo. As a thirteen-year-old, Nora frequently encountered Marcel in her mother's apartment and felt that their relationship was less sexual than intellectual. Unfortunately, Duchamp destroyed Maria's letters, just as he did all the letters other he received.[79] We do know that while he was involved with Maria, he also embarked, in the summer of 1946, on a five-week vacation in Switzerland with Mary Reynolds.[80]

(top)
Kay Sage, Yves Tanguy,
Maria Martins, Duchamp,
and Kiesler at the Tanguy
house in Connecticut,
May 1948

(bottom)
"The Illuminating Gas and
the Waterfall," 1948–49,
one of the earliest studies
of Duchamp's last major
work; on the back the artist
inscribed, "This lady
belongs to Maria Martins
with all my affection"

In several of his closest friendships, Duchamp also seemed to be seeking reminders of his roots. The Stettheimer sisters introduced him to their lawyer, Joseph Solomon, who specialized in trusts, wills, and estates, precisely the areas of the law handled in France by a *notaire*. After Florine Stettheimer died in May 1944, Solomon asked Marcel to help persuade a major museum to sponsor a show of her fantasy paintings. These charming pictures could not have been more "retinal" or ephemeral. Yet, in 1946, Duchamp was guest curator of the Museum of Modern Art show of her works.

Alert to the archival importance of many of his acquaintances and clients, among them Carl Van Vechten, Virgil Thomson, and Alexander Archipenko, Solomon began collecting clippings, catalogues and books about Duchamp in the late 1940s. He stacked them in folders and manila envelopes in a closet of his Fifth Avenue apartment, across the street from the Metropolitan Museum of Art. "Marcel would drop by quite often," he recalled, "and we would chat about mutual friends; never about art." As they talked, Duchamp would sign his name, seemingly absentmindedly, to all the memorabilia Solomon set before him.[81]

Through Reynolds, Duchamp had become acquainted with her brother, Frank Brookes Hubachek, a prominent Chicago lawyer who also specialized in wills, trusts, and estates. Although the two men had actually met in the early 1920s, it was only during the Second World War, when Hubachek acted to help Duchamp flee France, that their friendship blossomed. In the late 1940s, Duchamp gave "Hub" one of his earliest paintings, the 1904 *Garden and Chapel at Blainville*, simply because, as Hubachek wrote later, he "admired" the work and was "intrigued by the youth of the artist (17)." On the canvas stretcher, Duchamp wrote "With affection, to Brookes."[82]

Despite her family's urgings, Mary Reynolds had elected to stay in Paris after the fall of France in June 1940, and had become deeply enmeshed in a Resistance network; her code name was "Gentle Mary."[83] More than two years later, she was still in Paris, one of scarcely a dozen "American diehards, all women" who had chosen to remain under the Nazi Occupation. Then, on September 1, 1942, warned that the Gestapo was about to arrest her, she fled. Moving "as rapidly, which in the end meant as illegally as possible," she finally arrived in New York some eight months later, in mid-April 1943. She had had innumerable close escapes and finally trekked on foot over the Pyrenees into Spain. So excitement-laden was her odyssey that, during

May and June, *The New Yorker* ran three articles on "The Escape of Mrs. Jeffries." Janet Flanner described Reynolds as forty-five years old and "statuesque, unmelodramatic ... a seasoned traveler."[84] Duchamp had seen Reynolds off at the pier when she returned to Paris in 1948.

Then, in the summer of 1950, Duchamp learned that Reynolds was seriously ill. He told Hubachek that he had "various personal reasons" for returning to his native country, but had "insufficient funds — a somewhat common condition for artists." In the fall of that year, Hubachek sent Duchamp to Paris where a trained nurse (his former secretary) was already caring for his sister. Weak and wasted, Mary was beset by an inoperable uterine tumor, discovered too late. Duchamp remained with her for the last ten days and stayed to settle her modest estate. Such was his relationship with Hubachek that the Chicago millionaire "asked him for no accounting of the rather considerable amount of money ... I had provided."[85] After her death, Marcel spent weeks sorting through the memorabilia of a lifetime. To the biographer's chagrin, he also sifted her correspondence and discreetly destroyed all personal data. The rest he shipped back to her family in Chicago, where her unusual collection of Surrealist literature forms one of the treasures of the Art Institute's Ryerson Library.[86] Having organized and censored her rich assemblage of papers, he wrote a sober tribute for the catalogue: "A great figure in her modest ways."[87]

The following year, Hubachek set up a trust for Duchamp; payments ran around $6,000 a year, he said, "a sort of minimum living for him." At Duchamp's death, the $250,000 principal reverted to Hubachek's son and daughter.[88] This arrangement strikingly repeats Duchamp's financial relationship with his father, who had supported him in his youth with advances on his inheritance. "I can't tell you, dear Brookes," Duchamp wrote the following decade, "how grateful I am to you to allow me to live in my free way, although not quite orthodox, yet consistent."[89] In return, Duchamp presented his patron with occasional small works.[90]

Despite his generosity toward the artist, Hubachek had his own clear notions of what constituted Duchamp's genius, and what did not. When the Art Institute was offered a set of replicas of the readymades in 1965, the lawyer, who was also a museum trustee, tactfully wrote to John Maxon, the museum's director, that the institute's atmosphere "would not be hospitable, I fear, to items like a coathanger or a garden rake or a snow shovel."[91] Perhaps Hubachek had heard about what happened in 1945 at a Minnesota

museum during an exhibition of works by the Duchamp brothers. One snowy morning, as the show was being readied, a janitor (who had obviously not been exposed to modern aesthetics) grabbed the replica of the snow shovel readymade and used it to clear the sidewalk in front of the museum.[92]

Duchamp surely sensed Hubachek's essential conservatism. In his will, he remembered his friend and patron with an early painting, *Nude in a Tub* — the only bequest made outside Duchamp's family.[93] It was from 1910, the same year as the portrait of Marcel's father. Sensitively, Hubachek accepted the fatherly role into which Duchamp had cast him. "I know that this was his 'final payment' on our arrangement, which had been so important to him for so many years,"[94] Hubachek wrote years later.

In his friendship with Arensberg, too, Duchamp continued to play the complex role of creative artist, business adviser, and friend — despite Walter's slightly panicky letter urging Marcel to stay away from California; his anger that Marcel had "concealed" Dreier's efforts to get him out of Europe; his testy scolding over the delays in leaving France; and even his tactless suggestion that, in exchange for his rescue, Duchamp contribute "a painting for it, if you care to do so." A copy of the *Sad Young Man on a Train*, he suggested, hand colored and signed by Duchamp, would do.[95]

A series of letters scooped out of wastebaskets and forgotten bureau drawers by Arensberg's conscientious secretary, Elizabeth Wrigley, chronicles the close relationship between the two men. In November 1942, for example, Arensberg found a lawyer for Duchamp to consult regarding naturalization as an American.[96] Six months later, he furiously demanded data from Marcel about a new set of papers required to obtain citizenship. "Explain it to us in person," he growled petulantly, "not by letters of an unknown lawyer coming out of the blue." At the same time, the compulsive collector wondered whether Duchamp had had any news about the *Coffee Mill* or the *Sad Young Man*. Rereading it, and perhaps abashed by its testy tone, Arensberg never sent the letter.[97]

Like an investment counselor with a valued client, Duchamp continued to scout for additions to his friend's collection. In 1943, he located a 1914 Picasso for $9,000, a price he thought "not too high." He also offered Arensberg a painting by the Surrealist Wifredo Lam for $100. It was a good buy, he suggested: "[Pierre] Matisse sells them for $350."[98] In 1950, Duchamp learned that Walter Pach was willing to sell his own early work *The Chess*

Players; the artist-dealer suggested $3,500 as a possible price, though Arensberg eventually paid $4,000 (on which Duchamp earned a $500 commission).[99]

Through the years, the Arensbergs had been able to set off Walter's bad investments and unrepaid loans with Louise's prudent management of her fortune; they lived in upper middle-class comfort.[100] Though their art collection threatened to engulf the house, Arensberg's acquisitive urge carried him relentlessly into more and varied purchases, ranging from modern masterpieces to ancient Mexican artifacts. "The house was packed with works of art," wrote one visitor. "Every inch of wall space was covered with paintings, even the bathrooms, and the sculpture overflowed on the windowsills, the furniture, and the floor."[101]

Anyone who was interested could visit the collection just by phoning Arensberg, William Copley recalled, "but he wasn't bothered an awful lot."[102] Among museum directors, however, interest in the collection was definitely perking up. As early as 1943, Albert E. Gallatin, the pioneer collector of American art, had asked Duchamp to suggest to Arensberg that he donate the collection to the Philadelphia Museum of Art.[103] Over the next decade, there would be a mad scramble among museums to acquire such collections. With as much dignity as Keystone Kops and as much cunning as Hitchcock killers, directors of the most respected institutions in America courted the very same people who thirty years earlier had been called insane or depraved for their support of modern art.

Later, it was realized that during the early 1940s the fulcrum of Western art had already shifted to the United States. But to conservative art investors, collectors no less than curators, the works of European painters of the previous two generations were suddenly the most in demand. Relatively few Americans had invested in modern art, and even fewer of them lacked heirs. But a new provision in the tax laws had created a lively incentive for collectors to leave works of art to museums. It allowed a donor an immediate deduction for the (often swollen) value of a work if he signed an agreement to bequeath it to a public institution. The work or collection could stay in the donor's possession until his death. At about the same time, European nations, alarmed at the art outflow to America, not only passed strict laws against art exports but also established substantial budgets for acquiring threatened works.

The story of the Arensberg collection illustrates American museums'

diligent courtship of collectors, an artful blend of connoisseurship and greed. Ultimately, it left Arensberg convinced that "the idea of fair exchange doesn't exist in the breasts of museum directors accepting gifts,"[104] while Katharine Kuh, curator of modern painting and sculpture at the Art Institute of Chicago, complained that the collector was "leading [his] victims on unmercifully." During her negotiations, she noted, hardly a day went by in which no importuning museum trustee, director, or university representative appeared; Walter "charmed them with his courtly manner, but left them dangling."[105]

Henry Clifford, assistant curator of paintings at the Philadelphia Museum, described an evening in the mid-1940s when he dined with the Arensbergs for the first time: having asked Walter "point-blank" for his collection, he watched the man rise silently from the table, fold his napkin, and go upstairs. Clifford chatted quietly with Louise, as they heard Walter pacing overhead. "At last, she went upstairs and brought him down," Clifford recalled, "and the meal continued, though he never made any reference to my suggestion."[106]

In 1947, Fiske Kimball, the director of the Philadelphia Museum, approached Arensberg even though Walter had promised his collection to the University of California in 1944. The Philadelphian's hopes rose as Arensberg greeted him at the door with: "The University is trying to get out of [our agreement] ... The conservative trustees hate the stuff." And then a coy hint: "I am thinking of using you as a wastebasket."[107]

In succeeding months, a parade of suitors soft-soaped their way through the Arensberg household. Katharine Kuh came on behalf of Daniel Catton Rich, director of the Art Institute. And, as Kimball reported in some panic, she was already "measuring all the paintings" so that their final home in Chicago could be designed.[108] Kuh recorded her own tribulations. As they lunched on cheese, dates, and nuts, she wrote, Arensberg was "suspicious, ambivalent, acquisitive, inquisitive, urbane, scholarly, alternately drunk with delight or opaque with doubt."[109]

By February, Kimball jubilantly reported that the Arensbergs had ruled out UCLA or Berkeley, and had rejected the Metropolitan Museum and the Modern in New York, the Museum of Fine Arts, Boston, the Los Angeles County Museum, and the Modern Institute of Beverly Hills. Since the elusive collector was an alumnus, Harvard was still a threat, but Kimball reported breathlessly that "We were here just in time ... John Coolidge of the

Fogg is on his way out [to California] right now." Also pursuing the Arensbergs was the National Gallery of Art, while the University of Minnesota, San Francisco's Legion of Honor, and Stanford University were prepared to build special buildings for the collection.

In April 1949, Duchamp visited the Arensbergs for several days, passing through Hollywood on his way home from a conference in San Francisco. Kuh marveled how his "impeccably good manners" got him through "the ups and downs of that mercurial ménage." He studied his own works on the Arensbergs' walls and, pointing to the *King and Queen Surrounded by Swift Nudes,* remarked, "This one still holds up." Every day he went to visit Man Ray, who lived nearby but had been banished from the Arensberg house following an obscure quarrel; at night, Marcel munched Hershey bars from a seemingly endless hoard.[110]

About two weeks after this visit, Duchamp sent his friend his own set of detailed drawings for the proposed exhibit rooms in Philadelphia and commented that, "all in all, there is a good air of permanency in the building."[111] But by August of 1949, Arensberg was still undecided. Duchamp wrote again, urging his friend to choose Philadelphia,[112] but Arensberg dithered for more than a full year longer.

Finally, at the end of 1950, Kimball, the legal agreement discreetly in his pocket, and his wife, Marie, had Christmas dinner with the Arensbergs. Two days later, Arensberg was willing to sign.[113] He gave the Philadelphia Museum of Art twenty Brancusis — a group larger than any outside the sculptor's studio[114] — as well as important works by Picasso, Léger, Braque, Cézanne, Matisse, Renoir, and Modigliani. There were more than two hundred paintings in a total of one thousand items. Pre-Columbian works aside, Duchamp's taste dominated the selection, as it was to dominate the plan for its display. His own works, of course, were also its centerpiece, including virtually every major painting, most of the readymades, and a number of important sketches and notes, forty-three items in all. The value of the collection was estimated in 1954 at $2 million. And the museum had agreed that it would display all of it as a unit for at least twenty-five years.[115] Somberly signing the agreement on December 27, 1950, Arensberg told Kimball, "I feel as if I were kissing my children good-bye." Louise tremulously asked Mrs. Kimball to undo the construction work on the new galleries every night, so that "like Penelope's web" it would never be done.[116] Over a ten-year period, the Arensbergs had negotiated with more than thirty institutions, and now

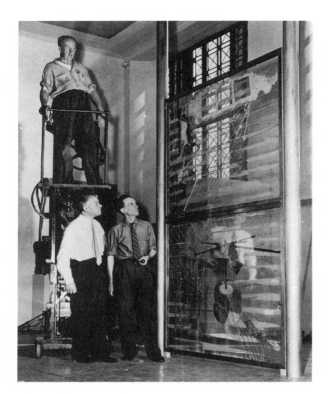

that this was done it took almost another four years to prepare the galleries that would house their precious children.[117] Duchamp supervised every step of the construction, the lighting, and the installation of the exhibits.

Meanwhile, in March 1952, Katherine Dreier died, and as executor of her estate Duchamp was in the ticklish position of controlling the fate of his own works in her collection. With a lawyer's sense of justness-cum-rationality — and more than a touch of Cartesian hairsplitting, one imagines — he had persuaded her that *Tu m'*, his last painting and a work of more historical than aesthetic interest, belonged at Yale with the collection of the Société Anonyme. But the *Large Glass* went to the Philadelphia Museum of Art as the capstone of the Arensberg Collection,[118] despite Duchamp's suspicion, as he confided to Arensberg, that "a broken glass is difficult to swallow for a 'museum.'"[119] In the event, the museum people quaked as the huge and fragile panel was moved into place. But Duchamp puffed his pipe calmly, murmuring, "We must be careful not to drop it; it might break someone's foot."[120] He also helped to prepare the museum's detailed catalogue of the

collection, though Arensberg, who had sheltered all his life behind a dense screen of privacy, stubbornly insisted that "nothing personal" appear.[121]

Despite optimistic plans, the Arensberg were never to see their collection installed in Philadelphia. Louise died on November 25, 1953; Walter followed her on January 29, 1954, just before the unveiling. But Marcel was there; it was the first time in his life he was actually present at a major opening. Ironically, the party was a soggy failure. Not only were the Arensbergs gone, but a severe windstorm buffeted the city during dinner. The elegant awning at the museum's west entrance had to be hurriedly removed to keep it from blowing into the Delaware River, and the guests were too busy talking about the weather to look at the pictures.[122]

◆ ◆ ◆

Just a few days before Arensberg's death, Duchamp had written him to describe the "dignified publicity" he was arranging for the show's opening. *Art News Annual* was planning coverage for its November issue and *Life* magazine would do an article; but, wrote Marcel, "this kind of show ... does not need heavy advertising." At the very end of this six-page letter, Duchamp had hurriedly scribbled, "Another mere piece of news is that I married last Saturday."[123] Equally laconic was Duchamp's note to Yale Art Gallery director George Heard Hamilton explaining his recent "silence":

1 – got married
2 – operated on for appendix
3 – pneumonia
4 – operated on for prostate.[124]

The bride was Alexina Sattler, a daughter of one of Cincinnati's most prominent families. Her father, Robert, was "a medical prodigy" who had received his degree at the age of twenty. Fluent in German, French, and Italian, he had studied with leading eye specialists in Vienna, Berlin, Holland, and England. At the age of twenty-seven, he had been named professor and head of the attending staff at Cincinnati Hospital. From 1890 until his death in 1939 at the age of eighty-four, he was chief of the Cincinnati Ophthalmic Hospital. After the death of his first wife, Robert had married Alexina's mother, Agnes, a talented violinist, who bore him three daughters. Alexina grew up surrounded by the leading figures of Cincinnati society and was often singled out in newspaper columns.[125]

In the early 1920s, the teenage Alexina, who would be called Teeny most of her life, was sent to Paris to study with Brancusi (according to one account), or to learn French while living with a wealthy French family (according to another). It was there that she first encountered Marcel Duchamp, who set off "a sudden rise in the level of excitement" when he arrived at a party. His companion, the expatriate writer Robert McAlmon, created a sensation by peeing over the banister of his hosts' circular stairway.[126]

Teeny married Pierre Matisse, son of the painter, in 1929, and they lived mostly in New York, where Pierre would establish himself as the city's leading dealer in works by his father and other European modernists. By the time she met Duchamp in person, she had spent several decades in the center of the New York art crowd. Teeny entertained the Matisse gallery's clients and even took over its management when Pierre had legal problems before and after the Second World War. At Pierre's side, she absorbed the low-key salesmanship and high-profile elegance of a successful art dealer. She was a veteran of many of the sensations and bafflements, the feuds and liaisons, the masks and affectations within that besieged village outpost that constituted the world of the avant-garde.

Pierre and Teeny had had three children before their marriage crumbled in a Surrealist dance of musical beds. Late in 1948, over the intense opposition of his parents, the forty-eight-year-old Pierre was determined to divorce Teeny and marry Patricia, the twenty-five-year-old ex-wife of the Surrealist artist Matta. In the divorce settlement, Teeny retained ownership of a 55-acre estate near Oldwick, New Jersey, and received a large stock of paintings, some of which she gradually sold to support herself and the children.[127]

Although Marcel and Teeny had occasionally crossed paths, they did not really get acquainted until the fall of 1951, when Max Ernst and his new wife, the painter Dorothea Tanning, brought Duchamp along for a weekend at Teeny's New Jersey farm. After that, they saw a good deal of each other, a sixty-three-year-old bachelor and a forty-five-year-old mother of three just emerging from a bitter divorce.

Marcel and Teeny had been close friends for about two years when, at a Christmas celebration in 1953, her daughter Jacqueline toasted them with, "Here's to a happy marriage." The quiet family wedding took place the following January 16, the feast day of St. Marcel. For Duchamp, it was a point of some pride that he "married a woman who, because of her age, couldn't have children. I personally never wanted to have any," he told Cabanne in

1967, "simply to keep expenses down."[128] He liked to call his stepchildren his "readymade family."[129]

Duchamp's wedding gift to Teeny, unsentimentally enough, was the last of a series of three charmingly erotic objects he had made during a period when, ostensibly, he had given up art and was deeply involved with Maria Martins. It consists of two suggestively interlocking chunks: one of galvanized plaster, the other of flesh-colored dental plastic. Its title, *Coin de Chasteté* (Wedge of Chastity), seems particularly ironic, since the work was created for another lover. Duchamp joked about the piece in 1967: "We still have it on our table," he told Cabanne. "We usually take it with us, like a wedding ring, no?"

The earlier works in this series were the *Feuille de Vigne Femelle* (Female Fig Leaf) of 1950, a richly painted plaster cast of external female sex organs; and a sinuously phallic shape, also in galvanized plaster, done in 1951 and titled *Objet-Dard*. The latter presented a typically Duchampian pun, in which the meanings jostle other meanings. The subject is a penis, artfully arranged and cast in plaster. The title is an art object, which is also a "dart object": *dard*, which means "stinger" and "the forked tongue of a snake," is also a slang term for "penis."

In a deadpan parody of much overblown art talk, Duchamp patiently explained to Cabanne in 1967 that these works grew out of "a sort of erotic climate. Everything can be based on an erotic climate without too much trouble." And then, as the tape relentlessly immortalized his words, the French *notaire's* son who had grown up among the earthy peasants of Normandy added: "I believe in eroticism a lot because it's truly a rather widespread thing around the world ... It replaces, if you wish, what other schools call Symbolism, Romanticism. It could be another 'ism,' so to speak." Duchamp solemnly granted that eroticism had remained "disguised for a long time" in his work, but insisted this was not "out of shame." "No, hidden," suggested Cabanne. "That's it," agreed Duchamp. "Let's say underlying," said Cabanne; and Duchamp replied, "Underlying, yes."[130] But also underlying these erotic works is the association of sex and pain, a penis that stings.

To all appearances, Duchamp's second marriage was harmonious. One old friend said that Teeny "adored" Marcel "and took great care of him."[131] Lebel recalled watching Teeny climbing a narrow circular stairway as Marcel, close behind, poked her backside with an umbrella all the way to the top. Far from being annoyed, Teeny appeared delighted.[132]

Teeny and Marcel Duchamp, Palm Beach, 1962

The newlyweds moved into a fourth-floor walkup apartment at 327 East 58th Street. It was a fashionable location, near Beekman Place and within easy walking distance of New York's art galleries. The previous occupants had been Ernst and Tanning. But Duchamp also kept the studio on Fourteenth Street and, according to one friend, "as a person, he didn't change."[133] Materially, however, it was "only from the time he got married that he had a comfortable house, a telephone, a comfortable life," as another friend recalled. Marriage "was his form of retirement."[134]

When Duchamp turned sixty-five in 1952, he was not eligible for Social Security, as he had not worked enough in the United States. Nor would he be eligible for any pension in France. Teeny shared her considerable property with him, finally enabling the affluent lifestyle to which he had previously been only an observer. Eighteen months after their marriage, they sold

all but 7½ acres of the 55-acre estate in New Jersey, near the Pennsylvania border.[135]

Duchamp taught Teeny how to play chess and took her along every Wednesday night to the London Terrace Chess Club. He would often play against William Slater, the club's manager, while Teeny took on his wife, Kathryn. Marcel never talked about art, Mrs. Slater recalled, but he did discuss events of the day — and "very entertainingly."

After the Duchamps moved in 1959, to a spacious high-ceilinged apartment at 28 West 10th Street, they would need only to cross the quiet tree-lined street to reach the Marshall Chess Club, one of New York's oldest. This they did about twice a week. Located on the second floor of a brownstone, the club's paneled interior exuded the tobacco smoke and tension of a million long-pondered moves. Behind locked glass doors, dusty and tarnished trophies testified to past glories; the monthly newssheet was called *The Marshall Swindle.* Twenty or so tables had a chessboard inlaid right into their tops, while, in a quiet corner, one could consult a modest library of chess literature. The Slaters managed this club as well during the last years the Duchamps played there. Toward the end, said Mrs. Slater, "it was a problem to keep the celebrity hunters away from Marcel."[136]

Whether Duchamp really wanted them kept away is another matter. "I adore being loved," he once told Lebel. And to Cabanne he confessed, "I suppose each generation needs a prototype. I certainly play the role. I'm enchanted by it."[137]

In the fall of 1954, the Duchamps boarded the *Flandre* for Le Havre. They would stay in Paris until January, in an apartment at 99 Boulevard Arago lent them by Henri-Pierre Roché. Five days after arriving, Marcel was already being interviewed by a Paris arts magazine. With an intelligent, experienced art promoter at his side, he was finally emerging from the shadows.

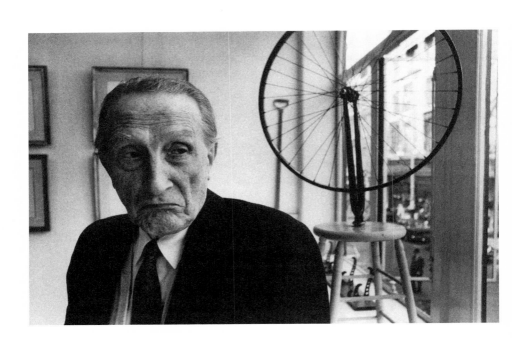

In 1961, the Pop artist Claes Oldenburg wrote:

> The artist disappears
>
> No one knows where he went
>
> He leaves his signs here and there
>
> He is seen in this part of town and, the next moment, miraculously,
>
> On the other side of town.
>
> One senses him rather than sees him —
>
> A lounger, a drunkard, a tennis-player, a bicycle rider,
>
> Always violently denying that he did it.
>
> Everyone gives a different description of the criminal.[1]

While this lachrymose portrait scarcely applies to Claes Oldenburg, poised as he was on the cusp of worldwide fame, it strikes a vibrant chord on the reclusive persona so carefully crafted over half a century by Marcel Duchamp. But at the dawn of the sixties, this facade was crumbling. As Duchamp wryly observed in 1963, "When you are trying to shock and you're not shocking anyone, it's a shock."[2] Even mainstream *Newsweek* had no problem printing his scandalous put-down of the religion of art as "not even as good as God."[3]

History was catching up with Duchamp. An energetic wife steeped in the ways of helping art history along augmented his own considerable talent for *le mot juste*. Teeny had been intimately involved with Pierre Matisse's notable success in selling the works of his father and other School of Paris artists to American collectors. She had often entertained clients at their New York apartment and at their spacious country estate in New Jersey. And now, having

11 · ANTI-FAME

been abruptly cast aside for a younger woman, she may well have been eager to show her ex-husband her own prowess in promoting an artist.

History lent support, for artists in the 1960s were reveling in just the sort of aesthetic hijinks Marcel had pioneered. "Shocking, scandalizing, startling, mystifying, and confounding," wrote the critic Clement Greenberg, "had become ends in themselves."[4] And so, artists like Claes Oldenburg began to call their self-styled alienation from society an art in itself. In this view, works were merely incidental to the artist's life. Style, the word traditionally associated with the form of painted or sculpted works, became embedded in language with a new meaning: lifestyle. In this view, Baudelaire's central cultural contribution was not his writing, but his alienated and tragic existence. Rimbaud's most fruitful contribution to art was not his early poetry, but his later silence and flight to Harrar, Ethiopia. The true hero was not James Joyce, who fought desperately to publish his pioneering works, but his fictional alter ego Stephen Daedalus, whose aesthetic passwords were "silence, exile, and cunning."

The German aesthetician Alfred Neumeyer noted that in visual art this new viewpoint replaced "the statement 'It is' of a five-hundred-year-old naturalism with the new art of 'I am.'"[5] In the midst of the most affluent, wasteful, and raucous society in the history of the world, this new art now seemed to focus on the slightest eye twitch of a single individual, to raise to the loftiest summit the most trivial of gestures. "Is a truck in a music school more musical than a truck passing by in the street?" the composer John Cage had asked in 1954. Are rusty nails, rags, bits of rope, and feathers more beautiful when glued on a canvas than when mingled in the gutter? echoed Robert Rauschenberg in his "combines" of that period. In 1953, Rauschenberg had flamboyantly erased a drawing by de Kooning — after which even the remaining smudged paper became a valuable commodity. "It was an act," the critic Barbara Rose later wrote, "reminiscent of Duchamp's painting a mustache on the *Mona Lisa*."[6]

Paradoxically, every revolutionary art movement of the twentieth century has pointed to its roots in the past, while vigorously proclaiming itself unique. The structure of Cubist painting has often been likened to the precise, classical organization in the paintings of Poussin or Vermeer. The Surrealists persistently proclaimed their debt to such artists as Arcimboldo, Bosch, and Matthias Grünewald. The Abstract Expressionists saw their sources not only in the glaring emotionalism and richly daubed canvases of

the German Expressionists but also in the bold spontaneity of Oriental calligraphy.

Time and again, the new avant-garde accused its predecessor of having turned art into a commodity. As had happened since the late nineteenth century, the dealers in the current avant-garde hastened to create historical ancestors, a reassurance for skeptical clients that their purchases were a good investment.[7] A raft of new galleries in New York amplified the critique by this latest generation against its fathers.

The group around Cage and Rauschenberg looked back further, to the rebellious generation of artists emerging after the First World War, the Dadaists, and found a warm affinity with those earlier masters of aesthetic rudeness. The problem was that most of the Dadaists themselves — Arp, Ernst, Schwitters — had matured into respectable (and sometimes wealthy) gentlemen. Schwitters may have defined art as "anything the artist spits out,"[8] but even this defiant statement still implied some kind of art product. By the early 1960s, however, even more radical definitions of art were launched, and they centered not on works but on the artist's life. The French art critic Alain Jouffroy wrote: "Finally, what is an artist, if not precisely a man who spends his time defying good sense, dealers, reactionaries, and the public?"[9]

In this context, it is not surprising that the spotlight now swiveled to an artist who was the master of the cynical gesture; whose whole life, in fact, could be read as a mélange of alienation and humorous detachment, all served up with an elegant Gallic sauce. Holed up in a dusty walk-up studio on Fourteenth Street, so the legend went, was a flesh-and-blood Stephen Daedalus who for thirty years had practiced his own brand of "silence, exile and cunning."

The catalogue Duchamp had designed for the "Dada 1916–23" show at the Sidney Janis Gallery in 1953 articulated his attitude about art: it consisted of single two-by-three-foot sheets of tissue paper, crumpled into a ball and handed out to visitors from a wastebasket. The public might have expected the ball to explode, Duchamp chortled to a *Time* magazine interviewer, but "none has so far." The magazine called the exhibit of three hundred works "the ghost of an almost forgotten art movement," but Duchamp, who had sailed away from the Dada artists in the 1920s, now insisted that Dada was not *"passé*. The Dada Spirit is eternal."[10] Above the entrance to the exhibit hung a replica of *Fountain*, now filled with geraniums and flanked

by mistletoe. "Everyone had to pass under it," wrote the filmmaker Hans Richter, shocked, perhaps, by the realization that "no trace of the initial shock remained."[11] Another Dada veteran, Richard Huelsenbeck, noted that "the American press, intimidated by Duchamp's authority, adopted Dada like a naughty but beloved child."[12]

These two were not the only observers impressed with Duchamp's life-long ability to convey his ideas about art with quiet authority, seemingly without ever producing any art, and to get his views before the public while insisting, like Greta Garbo, that he wanted to be left alone. "He seemed never to seek an occasion to exercise his influence," wrote the art critic Dore Ashton, "but the occasion always sought him out."[13] Throughout his career, Duchamp exercised a keen talent for the practical side of the art business, whether in advising his patrons or promoting the interests of the artists in his family.

The calm veneer behind which he did this may have been another family trait: Duchamp *père* raised no objection to all three sons avoiding sound bourgeois careers and continued Marcel's stipend long after it became clear that he enjoyed scandalizing the art public. Marcel himself rarely raised his voice. The artist Arman, who saw Duchamp at least once a week during the 1960s, visualized him as King Arthur presiding over the Round Table, "above all the fights ... nobody ever had the smallest chance to have a fight with Marcel."[14] Even within his family, no one could recall Marcel ever losing his temper.[15] His stepson believed that Duchamp's equanimity was a psychic defense: "Agreement was the way he kept his freedom," wrote Teeny's son, Paul Matisse. "He felt arguing was just falling into a trap" set by an opponent.[16]

While Duchamp spoke softly, his words often carried bitterly sarcastic baggage. "I never lived as a painter-artisan who makes so many pictures a year at such a price," Marcel caustically told an interviewer from *L'Express* in 1964. "In general painters arrive at a formula ... It all reduced itself to a work of repetition: Renoir painted a series of nudes all alike. Why? To furnish one to each of the two thousand museums in existence? That little job of repetition is nothing but masturbation."[17]

When Denis de Rougemont asked him why he decided to quit painting, Duchamp shot back, "I decided nothing at all; I am simply waiting for ideas. I've had thirty-three ideas; I've made thirty-three paintings. I don't want to copy myself, like all the others ... They no longer make pictures; they make

checks."[18] Earlier, he had told the *New York Times Magazine*'s A. L. Chanin, "All good painters have only about five masterpieces to their name — [works that] have the force of shock."[19]

Such statements, and many others along similar lines, indicated that Duchamp had some sort of consistent position about art: that each work must be totally and absolutely original. An artist who tried to explore the subtleties of painting by executing a series of works, or who devoted himself to expressing a particular subject from a variety of viewpoints, was guilty, in Duchamp's view, of repetition, for which he chose the worst epithet he could find: "masturbation." That was certainly not his vice, Duchamp carefully pointed out to de Rougemont, and to a swelling parade of interviewers.

Those who caught Duchamp before fame rode the subway down to Fourteenth Street and Eighth Avenue often came away with fresh, spontaneous, and eminently printable Duchamp-isms, comments that revealed a human being out of whom media exposure had not yet squeezed all the contradictions and discontinuities. Museums, Duchamp had tartly told an *Art Digest* reporter in 1952, "are mausoleums of art history ... don't look for aesthetics there." He admitted his "decided antipathy for aestheticians ... I'm anti-artistic," he said. "I'm anti-nothing. I'm revolting against formulating."[20] But when he was sought out by a budding aesthetician a few years later, he memorably described his artistic goal: "To grasp things with the mind the way the penis is grasped by the vagina."[21]

In a television interview that same year, Duchamp told another aesthetician, James Johnson Sweeney, director of the Guggenheim Museum, that art is the "only human activity in which man as man shows himself to be a true individual. Only in art is he capable of going beyond the animal state because art is an outlet toward regions which are not ruled by time and space."[22] Yet, even as he deplored the fact that "artists are so integrated into society that they are merchandised like wheat, steel, or this mineral water I'm drinking,"[23] he mingled convivially with the likes of Sweeney, Alfred H. Barr, Jr., and James Thrall Soby, director of the Yale University Art Museum — men who had vehemently stoked the fires of the burgeoning market for modern art and had, in fact, provoked the very repetition that Duchamp denounced in such lively fashion.

It is no accident that a collection of Duchamp's writings published in France, *Marchand du sel*, was translated into English as *Salt Seller*, both titles

highlighting Duchamp's glaring contradictions (even as the original provides an apt spoonerism on the author's name). His every posture and statement must, in a pun that also translates into French, be taken with a grain of salt. He was the elegant and debonair French artist, traveling in the loftiest social circles of pre-First World War New York. He was the son of the Norman *notaire*, and the possessor of impeccable taste that shaped some of the major collections of modern art in America. He was, too, the lanky figure in tails who married Lydie Sarazin-Levassoir in a Paris society wedding in 1927, and also the brilliantly cerebral artist who conceived a hauntingly frustrating image of unconsummated desire, the *Large Glass*.

This is the side that saw the sublime qualities of art as the source of man's sole claim to individuality. It is the side that patiently assisted the Philadelphia Museum in mounting the Arensberg Collection; that (as executor of the Katherine Dreier estate) saw that the *Large Glass* also went to Philadelphia; that in 1957 arranged for a major exhibition of the three Duchamp brothers' work at the Guggenheim Museum. And this figure mingled socially with the most prominent members of the aesthetic establishment.

And inside the same body also lived a quixotically creative personality, a forceful genie who knew how to destroy in the most creative ways. This was the figure who saw as the key quality of a work of art its ability to shock; who resented the chronological presentation of René Magritte's works at a Museum of Modern Art retrospective;[24] who, even while agreeing to serve on a jury at the Hudson Museum in 1961, impatiently answered a fellow juror's question, "Do you like this?" with "Do you like it? Well, give him a prize!"[25] And it was this figure, too, who exclaimed with some despair to a friend, "I'm nothing else but an artist ... I couldn't be very much more iconoclastic any more."[26] Observer after observer was struck by the duality within Duchamp. Olga Popovich, director of the Rouen Fine Arts Museum, for example, found him "awfully well-mannered ... completely a *notaire*... but then suddenly, he would say, 'Now that's enough,' and leave ... It seemed to me he always wanted to be someone else."[27]

As the interviewers arrived ever more frequently during the 1960s, Duchamp offered each one a quotable tidbit or two. For James Johnson Sweeney, he undercut the Futurists, a movement that plainly had exerted a strong influence on his own *Nude Descending a Staircase* and related works. "Futurism was an impression of the mechanical world," he said. "It was strictly a continuation of the Impressionist movement."[28] For Calvin

Tomkins, he recalled an old French expression, "*la patte*, meaning the artist's touch, his personal style, his 'paw.' I wanted to get away from *la patte* and from all that retinal painting."[29] He faintly praised the Surrealists for "reducing the role of the retina to that of an open window to the brain."[30] For the art dealer Sidney Janis he described artists like Monet as "just house painters who painted for the pleasure of splashing greens and reds together." This process was not cerebral, he asserted, "it's just purely retinal."[31]

As he had done retrospectively with the Futurists, Duchamp fired mercilessly upon whatever movement was dominating the art scene. Even though the Op, Pop, and Kinetic artists frequently cited him as their forefather, Duchamp found their work lacking in "scope for future development." He told Pierre Cabanne that as a prototype, "I have a life which doesn't depend on what people say about me ... I owe nothing to anyone and no one owes anything to me." (To Cabanne, however, "it was obvious he did not believe it."[32])

Duchamp's presumed offspring, Jasper Johns and Robert Rauschenberg, conceded Duchamp's influence on their work, but they didn't bother to seek him out until 1960, even though they lived a Manhattan mile or two from his apartment. Perhaps alerted by their dealer, Leo Castelli, to Duchamp's godfather role in their own work, Johns acquired a *Green Box* for Marcel to sign. Rauschenberg bought a replica of the *Bottlerack*, which Duchamp also signed, after inscribing on the bottom rim: "It is impossible to remember the original title." Rauschenberg then dedicated a large combine painting, *Trophy II*, to Teeny and Marcel Duchamp.[33]

Robert Lebel, who wrote the first major monograph and catalogue of Duchamp in 1959, found that "he piles contradiction upon contradiction, for his mechanistic materialism scarcely conceals his complete distrust of matter." The French art critic Jean Reboul found the split so deep that he was convinced Duchamp was a schizophrenic; he pointed out that victims of this mental disease often feel "as if there were a pane of glass between themselves and their fellow men." Characteristically, Duchamp deflected such learned analysis with a joke. He had passed entirely through the *Large Glass*, he told Lebel sarcastically, behind which he had then spent a good part of his life "entirely ignorant of the gravity of my condition."[34]

With similar adroitness, Duchamp turned aside a densely argued study, Michel Carrouges's *The Bachelor Machines*, which found that the *Large Glass* and a mythical apparatus described by Franz Kafka in *The Penal Colony* can

be "perfectly and exactly superimposed."[35] Besides being totally useless machines, Carrouges noted, both mechanisms also had strong connotations of sexual frustration.[36] To André Breton, Duchamp mockingly wrote that Carrouges had revealed the underlying mental concept of the *Large Glass* "with all the minuteness of a brain dissection." It was therefore no use adding that these discoveries were never conscious as he worked, because "my unconscious is mute like all unconsciouses." Duchamp explained that he felt a need to "introduce 'hilarity' or at least humor into such a 'serious' subject."[37]

Over and over again, Duchamp played ambiguous word games. In April 1957, at a meeting of the American Federation of the Arts, he had delivered a lecture titled "The Creative Act" about "the two poles of the creation of art: the artist on the one hand and on the other the spectator who later becomes the posterity." Duchamp asserted that while "the artist may shout from all the rooftops that he is a genius, he will have to wait for the verdict of the spectator." To describe the "gap" between the "inability of the artist to express fully his intention" and the message received by the spectator, Duchamp turned to a vaguely mathematical concept, a "personal 'art co-efficient,'" representing "an arithmetical relation between the unexpressed but intended and the unintentionally expressed." In his view, it was entirely up to the spectator "to determine the weight of the work on the esthetic scale."[38]

On that occasion, Duchamp seemed perfectly resigned to letting the spectator have the last word. But he could also be deeply resentful of that situation. Talking about the *Nude Descending a Staircase* in 1966, he expressed annoyance that "that painting ... was known and I was not. I spent my life hidden behind it. I was obliterated by the painting and only lately have I stepped out of it."[39]

As with every relationship in his life, Duchamp acted out intense ambivalence toward fame and the acceptance it bred. In March 1968, five months before his death, he was invited to a gala dinner celebrating the opening of the Museum of Modern Art's exhibition "Dada, Surrealism and their Heritage." As they arrived, the two hundred and fifty distinguished guests had to run a gauntlet of three hundred or so protesters outside, noisily demonstrating, in that year of demonstrations, against what they saw as the museum's regressive influence. In placards and to a *New York Times* reporter, they denounced the museum with the very epithet Duchamp had

used for museums in 1952, as a "mausoleum of modern art." A Princeton University art history instructor acting as their spokesman asserted that "Dada and Surrealism are art that's really happening in life, not in museums." Later, inside the elegantly decorated penthouse dining room, Duchamp gave his opinion of the demonstration: "Certainly I approve," he told *Times* art critic Grace Glueck, "as long as they are not violent." Then he sat down with the rest of the company to chicken à la Ritz.

During the fourteen years following the opening of the Arensberg Collection at the Philadelphia Museum of Art, Duchamp had moved from noble and impecunious obscurity to inclusion among the two hundred and fifty select guests, all in formal evening dress, at the Museum of Modern Art. And it was far from the last irony in his life that he alone fitted into all the categories Glueck used to describe those invited: "artists, collectors, lenders, and critics."[40]

◆ ◆ ◆

All his life, Duchamp had sheltered himself from loving too much. He almost always signed his letters with the stereotyped and lukewarm word *affectueusement*; he had nimbly put an ocean between himself and close attachments, whether to friends or family; he had married once for a week and once late in his life, both times choosing women who were eager to marry and appeared tolerant of his evident shortcomings as a warm, flesh-and-blood husband. Duchamp treated those who reconciled themselves to his aversion to closeness with neglect, if not disdain. It took Frank Hubachek's subsidy of a trip to Paris to persuade Duchamp to spend a few last days with his longtime lover Mary Reynolds.

Teeny, who had been a familiar figure in the art world through her years as Mrs. Pierre Matisse, now enthusiastically contributed to Marcel's increasing celebrity. Socially adept and physically attractive, Mme. Duchamp relished calling on her art contacts on her husband's behalf. She had certainly encouraged him to create more art in the fourteen years since their marriage, and would continue to be a fierce guardian of his oeuvre and reputation to the day she died.

Teeny also initiated contacts with the daughter born of Duchamp's youthful affair with Jeanne Serre. On June 23, 1966, the Duchamps attended the opening of a Paris exhibition of a new, larger version of his brother Raymond's sculpture *Great Horse*. One of the guests was Jeanne Serre,

whom Marcel had not seen since a chance encounter in the metro in 1919. He had told Teeny about his affair with Jeanne, and also about seeing her in the metro, holding a little girl by the hand. Asking after the child at the opening, Teeny learned that she was married to an engineer, Jacques Savy, and had become an artist.[41]

A few days later, Teeny and Marcel called on the Savys, bearing a *Boîte en Valise*. No one ever talked about Duchamp as the father of Yo Sermayer (as she signed her paintings), even as the two couples visited each other during the next two years. The Duchamps arranged for her to have a show at the Bodley Gallery, in New York, in 1967. For the catalog Marcel created a cryptic epigraph:

> *après: Musique d'ameublement d'Éric SATie*
> *voici: Peinture d'ameublement de YO SAVY*
> *(Alias Yo Sermayer)*
> Rrose Sélavy (alias Marcel Duchamp)[42]

Sermayer's career as an artist never took off. What painting she did was signed by an alias, following at some distance in Marcel Duchamp's elusive footsteps. Ironically, she is the only offspring of the six Duchamp siblings. Even then, she remained at best on the periphery of her father's thoughts; despite Teeny's efforts to locate her, he did not remember her in his will.

◆ ◆ ◆

Perceptions of Duchamp's critical influence upon new art are an obvious source of the honors and recognition that came his way during the 1960s. Nor has Teeny's contribution of contacts and enthusiasm been overlooked. But only recently has Duchamp's own ingenious role in promoting himself begun to be recognized. His outsider pose fed the image of a man who had been a painter during the years before the First World War, created the notorious *Nude Descending a Staircase,* then fecklessly abandoned art for chess in 1923. The *New York Times* art critic John Russell recalled Duchamp in his eighties: "Erect, steady, and precise in all his movements, debonair in his bearing, he measured his every word, yet let it slip all but noiselessly … he seemed to displace no air and demand no attention."[43] But like many others, Russell was reviewing the life rather than the art. In recent years, Duchamp's "exercise in strategic invisibility" has been unearthed, as the art historian Sheldon Nodelman noted, as "part of a systematic campaign,

unparalleled in the history of art."[44] Such was the appeal of this image that, as the 1960s wore on, not only was Duchamp invited to an increasing number of art events, discussions, speeches, roundtables, and happenings, but there was a brisk, worldwide wave of interest in his works.

Furthermore, by some marvel of aesthetic prestidigitation, the number of works credited to him began to proliferate. When Robert Lebel, in 1959, had finished combing through every cranny of Duchamp's artistic past, and assigned a number to even a three-word spoonerism and a postcard in which every "the" was replaced by a star, he came up with 208 items.[45] Less than ten years later, from the same lode, Arturo Schwarz managed to mine 421 items.[46] Schwarz's 1997 revision, now in two volumes, lists 663.[47] Thus multiplied the posthumous oeuvre of an artist who had ostensibly abandoned art in 1923; whose greatest masterpiece, indeed, was hailed again and again as being not any of his works, but his life.

While admiration mounted for Duchamp's life as a lonely but steadfast exile from the compromises and commercialism of the art world, the stack of invitations to artistic doings and of writings about him mounted even faster. On March 17, 1960, he was among the exclusive guests in the garden of the Museum of Modern Art who witnessed Jean Tinguely's *Homage to New York,* a madly inspired and complicated machine whose only useful task was to destroy itself. On May 13, he participated in a Hofstra College symposium: "Should the Artist Go to College?" On May 25, he was elected to the National Institute of Arts and Letters. On March 20, 1961, he was on a panel, "Where Do We Go from Here?" at the Philadelphia Museum College of Art. Nine days later, he was interviewed by Katharine Kuh for BBC television's *Monitor* (and again for the same program on September 27). On November 28, he lectured at the Detroit Institute of Arts and on the next day received an honorary degree of Doctor of Humanities at Wayne State University. Further proof that academe smiled on him was the completion, at the end of 1961, of a Ph.D. thesis by Lawrence D. Steefel, Jr., at Princeton University. An impressive example of the aesthetician's approach to art, the title was *The Position of "La Mariée mise à nu par ses célibataires, même (1915–1923)" in the Stylistic and Iconographic Development of the Art of Marcel Duchamp.* And in February 1963, when the Munson-Williams-Proctor Institute at Utica, New York, held a fiftieth anniversary exhibition for the Armory Show, Duchamp designed its poster and gave a lecture. "This is circus week for me," he gleefully wrote to Hubachek when the

show arrived in New York that April. "TV for breakfast, TV for lunch and radio for dinner."[48]

The following October, Walter Hopps, the young director of the Pasadena Art Museum, organized the first major retrospective exhibition: a group of 114 items "by or of Marcel Duchamp or Rrose Sélavy." For this event, Duchamp not only designed the poster and catalog cover, spent "four days 'hamming' on French television,"[49] and journeyed to California for the opening, but he also sat for an intriguing publicity photo which, of course, was hailed as yet another ineffable Duchampian gesture. It showed Marcel imperturbably smoking a cigar while seated at a chessboard, the gallery of his works in the background, and barely aware of his opponent: a naked model. Fifty years after the fantasy, perhaps, the nude had finally reached the foot of the staircase — only to be ignored in favor of the chessboard.

Eve Babitz, daughter of a Los Angeles Philharmonic violinist, was only twenty when *Time* photographer Julian Wasser, a friend of her sister, persuaded her to pose for the photo. Hopps had told Eve that Picasso and Matisse were *passé*, while Mondrian and Duchamp were the century's true giants. She concluded that "a urinal could also say, 'I look like a urinal, but Marcel says I'm art.'" Still "practically speechless" over the event thirty years later, she recalled "having to play chess with someone who hardly spoke English and was so polite he pretended that the reason he'd come was to play chess. *Well!*"[50]

One visitor called him the *"ancien terrible"* of modern art" and the show a model of "dandified historicism," fulfilling Baudelaire's paradoxical aim: "the pleasure of provoking astonishment [while] never being astonished." A Los Angeles critic marveled at Duchamp's sangfroid, "playing chess while a hushed crowd files past," and quoted a visitor's awe that "everything he touched became important ... famous."[51]

Because of its fragile state, the *Large Glass* never traveled to this or any other exhibition. However, as early as 1961, a Swedish museum director, Ulf Linde, had commissioned a painstaking replica of it, and Duchamp had traveled to Stockholm to sign it. No less than with the long-lost bottle rack or the snow shovel — or even the cliché phrase *c'est la vie*, in which he had found his pseudonym — Duchamp treated this replica of his masterpiece as just another readymade.

Duchamp had been "discovered" by a new generation of the avant-garde. In 1955, he could still be described as the last of the Surrealists, "the

one man who is always in parentheses,"[52] as one of them wrote. But after the 1963 Pasadena show, Duchamp could do no wrong. "Like a radar [*sic*]," burbled one critic, "he pointed the way to the mechanized psychical and philosophical expressions of today, the dynamic flow and movement of time and speed, the Freudian overtones in our culture."[53]

On the heels of that exhibition, critics and scholars busily combed through every statement Duchamp had ever made and suddenly discovered profundity therein. "I can't tell you how an artist gets along," he had remarked to a *New Yorker* interviewer in 1957. Sipping vermouth in a room tastefully decked with Brancusis, Matisses, and Mirós, Duchamp philosophically added, "You live and you don't know how you live. You just don't die. I've never had more than $200 or $300 ahead of me." The fact that the most prestigious cultural magazine in America had sent an interviewer raised such modesty to the level of fine art. "When I painted, no one talked about it," he told the interviewer. "When painting becomes so low that laymen talk about it, it doesn't interest me."[54] But in 1963, he told Harold Schonberg of the *New York Times* that he had found the scandal over the *Nude Descending a Staircase* "very pleasant." Though he did not intend to please the general public, "the scandal was exactly in my program."[55] By 1973, William Copley could even find some sort of aesthetic satisfaction in recalling Duchamp's flip description of his life: "I developed parasitism to a fine art."[56]

Some saw such exquisitely constructed oppositions as the essence of Duchamp's art; they saw his ability to refrain from art altogether as the core of his genius. A respected art historian, for example, was thrilled that "into the construction of himself as the perfect nonartist ... has gone all the subtlety, the conscious awareness, the esthetic distance, the balance of part against part ... that go into the making of a classic work of art." In that way, he suggested, conjuring up another native of Normandy, Duchamp "might be called the Poussin of Dada."[57]

Others saw in his "continual ambiguity and contradictions" proof that one could both "be an artist dedicated to antiart, or an anti-artist dedicated to art."[58] As a *Time* magazine chronology simplistically set it out, while Picasso was almost every painter's "ghostly father" during the 1940s and Hans Hofmann played a similar role in the 1950s, Duchamp was the "grandada" of the 1960s. The key, as *Time* saw it, was that forty-two years after he abandoned art, the "enigmatic, impudent, possibly lewd messages" that Duchamp had tied to balloons "have come back to earth."[59]

The *Time* critic was, of course, describing the sudden success of Pop Art during the early 1960s. And he noted, quite correctly, the philosophic thread that connected the bronze beer cans and encaustic flags of Jasper Johns, the Campbell's soup cans of Andy Warhol, the comic-book blowups of Roy Lichtenstein, and the "Soft Toilet" of Claes Oldenburg with the readymades of Duchamp. Many critics were shocked by how readily such aggressively ugly japeries were sweeping Abstract Expressionism from gallery walls no less than from the wish lists of collectors. The pressure to remain avant-garde drove them to jettison all traditional art standards and cling tenaciously to one critical spar: novelty. Though the Pop artists themselves claimed no forebears — most of them, indeed, were largely innocent of any art history whatsoever — the critics and art historians, not to mention the dealers, desperately needed to find order, some shred of historical development, in this brashly successful new movement. What meaningful aesthetic statement, indeed, could one make about a billboard-size blowup of a comic panel, or a 3-foot-tall painted plaster *Hamburger with Pickle and Tomato Attached?*

The flamboyant spirit of this American art reflected the surge of new galleries in New York. While there were fewer than fifty galleries in the city in 1940, the numbers grew to 115 by 1954 and to about 275 by 1960. Gallery prices and auction sales had tripled as more collectors entered the field. Most of these, however, fixated upon the artists sanctioned by the Museum of Modern Art: Picasso, Matisse, Mondrian.⁶⁰ Fashionable dealers in avant-garde art, like Leo Castelli, needed some kind of historical precedent to market the Pop artists' flags, targets, and soft hamburgers, and Marcel Duchamp was the obvious precursor of it all. Castelli said as much to an interviewer whom he told that his criterion for selecting artists to show in his gallery was, quite simply, "Marcel Duchamp."⁶¹

Duchamp resisted furiously. "This Neo-Dada, which they call New Realism, Pop Art, Assemblage, etc., is an easy way out," he fumed. "When I discovered readymades, I thought to discourage aesthetics. In Neo-Dada, they have taken my readymades and found aesthetic beauty in them. I threw the bottle rack and the urinal into their faces as a challenge and now they admire them for their ... beauty."⁶²

He summed up the difference between Pop and Dada: "Dada never made a penny in its day." In his own day, he mused, with the selective nostalgia of a seventy-eight-year-old, artists sought to be "outcasts, pariahs."

But Pop artists aspired to be part of society. "They have country houses, two cars, three divorces, and five children," he asserted. "An artist has to turn out lots of paintings to pay for all that, hmmm?"[63] And he gloated to Cabanne, "I made the fewest possible things," in contrast to "the current spirit, where, on the contrary, people make the most, in order to get the most money."[64] As for dealers, he dismissed them with a tart epigram: "They have a trade, like grocers."[65]

Still, those who sought consistency in Duchamp searched in vain. John Cage found Duchamp "extremely interested in money; he resented being thought a poor businessman ... He couldn't understand why Rauschenberg and Johns should make so much money and he should not."[66] Attacking that problem with an astuteness worthy of his father, in 1963 Duchamp began allowing a whole series of "new" Duchamps to be marketed through the Galleria Schwarz in Milan. The first of these works — and few who know Duchamp would consider it accidental — was an impersonal line drawing of that impudent urinal, *Fountain*, which became the cover of a book created and published by Schwarz, *Marcel Duchamp: Readymades, etc. (1913–1964)*. On the dust jacket, also designed by Duchamp, appeared a memento of another old joke, the *Monte Carlo Bond*. Included with the one hundred special black-leather bound, autographed copies of the book was a reproduction of a blurry 1914 photo of a window, seen through a dotted veil, ostensibly one of the shapes used to outline one of the three "Draft Pistons" in the *Large Glass*. These Duchamp ostentatiously signed — and Schwarz industriously marketed.

As a young man intoxicated with Surrealism, Arturo Schwarz had left his native Egypt for Paris in 1939 to seek out the magus of that movement, André Breton. When his family was driven out of Egypt in 1955, he settled in Milan to write poetry and exhibit Surrealists in a small gallery. As he tells it, Schwarz contacted a New York art publisher after dreaming about Duchamp and was given his address. Schwarz's fascination with the artist converged with the revival of American interest in Duchamp, as well as with Teeny's marketing savvy.

A nervous magpie of a man, Schwarz embarked on compiling his magnum opus, a massive tome called *The Complete Works of Marcel Duchamp*, on which this and every other writer on Duchamp has heavily relied. But much to the dismay of Duchamp's family and many scholars, Schwarz also advanced certain theories about Duchamp's inner life — probably the most

Duchamp and Arturo Schwarz, Milan, late 1960s

controversial being that the *Nude Descending a Staircase* was based on Marcel's incestuous fantasy about his sister, Suzanne. Despite his impassioned explanations that he was referring to a Jungian concept of incest as an unconscious fantasy, not a reality, his critics, including Teeny, have regularly pummeled him in conversation and in print. Schwarz's further notions that many of Duchamp's works contain alchemical signs and symbols have also been widely, sometimes angrily, dismissed. Nor have many scholars credited his insistence (in a curious echo of the Surrealist poet Robert Desnos) that he had a kind of psychic relationship with Marcel. His "evidence" involves Duchamp misplacing some of his early drawings and Schwarz dreaming of seeing them rolled up behind a buffet; he cabled Duchamp and quickly received a return cable: "*Trouvé. Merci*"[67] (though whether they were in fact located behind the buffet remains unknown).

While at work on his catalog, Schwarz met with Duchamp at least twice a year for a biographical review that Duchamp supposedly described as "better than psychoanalytic treatment." The artist also told Schwarz that he especially appreciated the writer's "psycho-surgical analysis" of his relationship with Suzanne.[68] There is no way to know whether this secondhand report conveyed Duchamp's real feelings or was just another example of his

tendency to tell people what they wanted to hear, but there is no doubt that Duchamp continued to maintain a close relationship with Schwarz to the very end. Nor is there much doubt that Schwarz continues to occupy a formidable perch as an expert on Duchamp.

Duchamp was quite aware of the implications of all the commercialism represented by Schwarz and may well have viewed the parade of pricey multiples as a way of mocking the runaway market in art while cashing in on it. During the course of 1964, another raft of Duchamp "originals" appeared, among them four scrawls vaguely representing four readymades that Schwarz used to illustrate (along with ten "original" Man Ray lithographs) a collection of his own Surrealist-style poems. The next new Duchamp was another scribble, this time on a cotton napkin, executed, Schwarz earnestly wrote, "on June 5, 1964, at a dinner given on the occasion of the preview of the exhibition, 'Homage to Marcel Duchamp,' Galleria Schwarz, Milan, June–September 1964." As item number 369, *Roberto Crippa Smoking*, it occupied one-quarter of a glossy oversize page in Schwarz's 1969 "complete" Duchamp catalogue and is item number 599 in his 1997 "complete" catalog. The original napkin, the catalogue adds with a straight face, was formerly in the Roberto Crippa Collection, Milan, but now resides with Rosangela Baggini in Milan.[69]

Duchamp's inspiration for the next work in the catalogue came once again from the urinal. The copperplate and the 115 examples printed from it on expensive paper were grandly titled *Mirrorical Return*. But the bland sketch of the urinal now had some descriptive sentences that perhaps expressed Duchamp's disdain for the ostentatious sides of the art business. At the top, the message read, "An original, revolutionary faucet/mirror return?" Below was the phrase: "A faucet which stops running when no one listens." In a parody of art marketing methods, this small etching (only 6 by 8 inches) was sold in three forms: five sets of three, printed on various kinds of paper; 115 "proofs"; and 100 sheets printed in red and black. This topped the repetition Duchamp detested in other artists and drew another generous draft on the increasing value of Duchamp's trademark images. The 230 virtually identical images have enjoyed a brisk market, selling recently at major auction houses for up to $5,500.[70] These and other such ephemera were dutifully catalogued by Schwarz, who was soundly scolded by one reviewer for omitting several "important" works: a hunk of sheet metal signed with a welding torch during a visit to a Minneapolis art school; Duchamp's name

scratched into a lump of wet clay; a broken chair signed for a man in Cadaquès; and a notepad page headed "Don't forget," inscribed Marcel Duchamp.[71]

Publication of the Lebel catalog and Arturo Schwarz's encouragement set off a veritable signing frenzy. Much to the dismay of Teeny, her husband endorsed with a signature just about any scrap placed before him: not only the items mentioned above but also, among others, an industrial draftsman's working drawings for replicas of readymades, three broken mirror collages by a Milan artist (with the comment, "I am signing readymade future portraits"), paper with a postage stamp showing the *Mona Lisa*, and one hundred copies of a suite of serigraphs illustrating an Octavio Paz book about him.[72]

It is difficult to avoid the conclusion that more than mere mockery motivated Duchamp to sign his name so freely. Revenge was sweet against an art world that had marginalized him for so many decades while lionizing artists like Matisse and Picasso, whom he saw as endlessly repeating a few themes. So why not repeat? In 1964, Duchamp incised his name on the back of a lead sink stopper he had made in Cadaquès and soon allowed the International Collectors Society to market three series of one hundred casts: in bronze, for $395; in stainless steel, for $425; and in sterling silver, for $495. The original sales brought in more than $131,500.[73] A number of these discs, only 2⅜ inches in diameter, sold in recent years for around $3,500, and in December 1999 one bronze version sold for almost $20,000 at Sotheby's, London.[74]

The following May, Rrose Sélavy made a "final" appearance, when she signed an ornate black clay urn of classical proportions and over seven inches high, containing the ashes of the cigar Marcel Duchamp was smoking at a dinner organized by the Paris Association for the Study of the Dada Movement. Along with these ashes, the urn also contains the ashes of the minutes of that particular meeting.

This, and the other late works that suddenly appeared in such great numbers, have all acquired considerable value. Furthermore, they were frequently discussed in art publications with all the arcane scholasticism and refined appreciation that in Marcel's youth was reserved for Leonardo. The French art historian Pierre Restany, for example, called Duchamp "the incarnation of the modernity of our epoch." Pierre Cabanne determined that "Duchamp is not a man of the avant-garde; he *is* the avant-garde."[75] And Cleve Gray called him "a wizard ... a modern Merlin," waving a "wand of perpetual youth." He gushed over Duchamp's "force and grace of

presence," and "mercurial playfulness of conversation," and added, suddenly at a loss for superlatives, that "that's only half of it."[76]

Duchamp maintained his contrarian facade in the face of such pretentious cant. Jimmy Ernst, the son of Max Ernst, dined with him one evening in 1967 at "a swank New York restaurant." He asked Marcel, "as a connoisseur who had dined all over the world," to pick the wine. While the wine steward waited patiently, Duchamp perused each item on the extensive wine list, occasionally asking details about a particular year or *cru*. Then he ordered "a little white and a little red." Somehow, this incident found its way into a popular newspaper column. He was also deliberately unpretentious in his choice of favorite foods: pastrami and French fries.[77]

However, Duchamp's annoyance with aesthetic chic did not interfere with his grasp of economic realities. Teeny, who was almost twenty years younger than he, was likely to survive him for some time. And so Duchamp supervised the marketing of his artistic patrimony. He searched through attics and old trunks for the least scribble to be turned over to Schwarz. Toward the end of 1963, just after he had agreed to a limited edition of eight re-creations of the readymades, he developed a slide-illustrated lecture, "A propos of Myself," which he delivered at several museums the following year. And when the Mary Sisler Collection of Duchamp ephemera went on display, a lengthy *New Yorker* review in February 1965 opened what can only be described as a media frenzy over an artist the art world had ignored for decades. It has since scarcely abated.[78]

It seemed as though, in his late seventies, Duchamp settled the ambivalence about business dealings — and perhaps his father — that had dogged him through most of his life. Earlier, he had supported his penurious lifestyle by occasionally selling works of art, while also mocking the real business world, as in his parody correspondence with Jacques Doucet or his attempt to sell sets of *Rotoreliefs* at a gadget show for one dollar. But now he relied on the *notaire*'s legacy not only for himself but also to benefit others, and sometimes in the smallest ways. One day in 1964, Duchamp brought a *Box in a Valise* to David Mann at the Bodley Gallery on Madison Avenue, on behalf of the *Box*'s owner, the writer Kay Boyle, who needed cash. "Give her $500," the artist told the dealer, "and hold onto the box until I tell you to sell it." A few months later, when the Cordier and Ekstrom show opened, Duchamp reappeared at the Bodley Gallery and told Mann, "Now sell the box to Mary Sisler." Mann refused to disclose the profit, but smiled content-

edly when he told the story.[79] Recent sales of such boxes have ranged around $37,000.[80]

For Duchamp, life had become an updated version of the bourgeois idyll his father had created for his family. Winters, Marcel and Teeny enjoyed their comfortable Tenth Street apartment, across from the chess club and tastefully decorated with works of Matisse, Giacometti, Brancusi, Miró, and, of course, Duchamp. In the summer, they would head for Cadaqués, Spain, a village on the Catalan coast that has attracted artists since the 1930s and become famous as the home of Salvador Dalí.

Duchamp often visited Dalí when in Cadaqués. Although the Spanish Surrealist was some twenty years his junior, Duchamp, as John Cage noticed with some surprise, "took a listening attitude ... It almost appeared as if a younger man were visiting an older man, instead of the other way 'round."[81] Sometimes Man Ray would visit, and the two old cronies would sit at a cafe, drinking manzanilla or Pernod, Ray recalled, "while we watch and comment on the young women, bronzed and almost nude in their bikinis, on their way to the beach."[82]

Toward the end of summer each year, the Duchamps would head for Paris, where they spent a month or two in Neuilly. They stayed in the apartment at 5 rue Parmentier where Suzanne and Crotti had lived almost since Marcel, in 1919, had instructed her to make the *Unhappy Ready-made*. When Suzanne died on September 11, 1963, Duchamp buried his feelings in his diffident way, perhaps even from himself. Tacked onto the end of a long letter to Hubachek mostly devoted to details about certain works being shipped to Chicago, Marcel wrote, "A few days ago, my sister Suzanne Crotti-Duchamp died after a very short illness ... We were in Paris for the funeral the day before yesterday and came back to leave again for good the day after tomorrow."[83] Later Duchamp busied himself with settling her estate. As with Mary Reynolds and Katherine Dreier, this *notaire*'s endeavor was, perhaps, his only way of grieving.

He seems to have engaged more with the death, only three months earlier, of Jacques Villon. The news reached the Duchamps in Sicily on June 9: they immediately changed their plans to linger in Rome and flew straight to Paris, where they joined Marcel's sisters, Villon's dealer, and a sprinkling of others for a vigil around the deathbed. Duchamp approached the body for a long look before touching the shoulder and, turning to the others, said: "He is like Father without the beard."[84] Two days later, Duchamp was the princi-

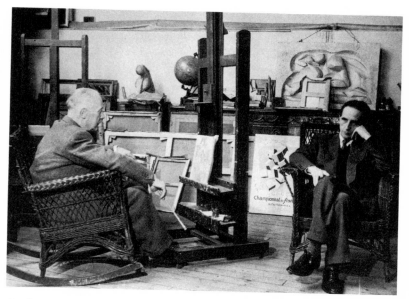

Duchamp and Villon in the latter's studio, ca. 1950s

pal mourner at a string of obsequies marking Villon's death. The coffin, banked with flowers and with the Legion of Honor and Croix de Guerre on cushions at its foot, was the center of religious services at 11 A.M. The service ended with a distant drumroll and a military bugler playing the last post. The rites then moved to the town hall of Puteaux, where the mayor, the director of the Musée Nationale de l'Art Moderne, and a representative sent by Minister of Culture André Malraux eulogized Villon. Later that afternoon, Villon was interred in the family plot in Rouen.[85]

By contrast with Marcel, Villon had patiently applied himself to art over a span of sixty-five years, methodically exploring and developing a small number of basic themes in a large number of works. Indeed, Marcel's outspoken censure of modern artists' repetitiousness seemed to target Villon. As for Villon, his younger brother's lifestyle was as foreign to him as the objects with which Marcel mesmerized the American avant-garde. Still, even though their art — and their views about art — had diverged so drastically, the two had maintained a friendly, if distant, relationship.

As Lebel had noted in 1959, Duchamp's "obsession, if indeed he had one, would be the distance, the separateness which exists between individuals.

This separateness is simultaneously necessary and intolerable."[86] Within a very few years, however, even this peculiarity would be admired in aesthetic terms. Shortly before Duchamp's death, the *London Times* art critic John Russell described him as "one of the great poets of disengagement."[87]

◆ ◆ ◆

As his fame grew, Duchamp seemed to pad through his existence easily yet mechanically. In a way, he had arranged matters so that the interested spectator, the audience to which he had assigned an equal role with the artist in creating a work of art, now formed the background chorus for his life. Even the commercial arrangement with Arturo Schwarz was seen as an artistic gesture. By allowing the dealer to produce and sell replicas, said Alain Jouffroy, "He destroyed the fetish quality that the single readymades were acquiring."[88] For their part, the art-buying public pounced eagerly upon these replicas, and over the past forty years their sale prices have predictably skyrocketed. A signed, poster-size 1960 version of *L.H.O.O.Q.* sold at Christie's, New York, in 1999 for $550,000. A smaller, signed version, one of thirty-five printed in 1964, went that same year for $105,553.[89]

As Duchamp approached his eightieth year, his slightest gesture — the way he puffed on a cigar, his shrug, his chuckle, even his occasional forgetfulness — came to be seen as deeply meaningful. One friend discovered profundity in Duchamp's remark that "any man can fall in love with a beautiful woman, but you don't know what love is until you're madly in love with an ugly woman."[90] Another friend found deep meaning in Duchamp's explanation of why he had become an American citizen: "Because it was easier to get my favorite cigars through customs."[91] The dancer Merce Cunningham was struck by watching Duchamp sitting on Venice's Piazza San Marco, smoking a cigar, while Teeny went upstairs to a museum: "Every once in a while, she would lean out the window and describe what she was seeing." No detail of his life seemed negligible, whether it was the fact that he seemed to fill up on a few peas, that he "drank quite moderately," or that he liked to sit in a large armchair that had once belonged to Max Ernst.[92]

The anecdotes tucked into the memories of friends may often reveal an individual's character. But in the case of Duchamp, these stories, intertwined as they are with his artistic legend, often are freighted with such heavy meaning that their thin legs collapse like those of an overloaded donkey. Rather than being seen as an artist who used humor not only as an inspira-

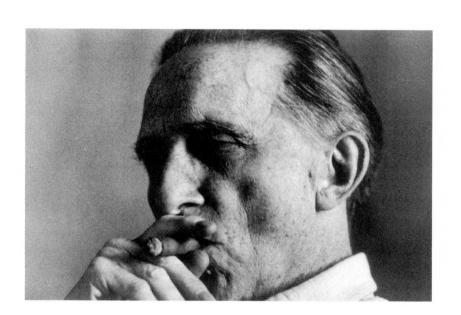

tion but as a tough, reflective shield against self-revelation, Duchamp was often taken as an entertainer. Thus George Heard Hamilton happily quotes Marcel's remark about a new Dalmatian puppy: "So you have the positive. What do you suppose the negative looks like?"[93] To Francis Steegmuller, Duchamp's "'Hmmmmmm?' and then a chuckle on a similarly rising note, when he invited us to share something funny," seemed both lovable and significant. "That laughter of Marcel's," Steegmuller wrote, "echoes down from the very early years of this century."[94]

Duchamp's laughter, however, echoed on several levels. The kind of humor he favored was the pun, a shimmering hall of mirrors that diffused meaning so ambiguously that the truth could be lost in a myriad of reflections. As he told Alain Jouffroy in 1961, humor "is indispensable ... because the serious is something very dangerous."[95]

To anyone who sincerely wanted to know him, Duchamp could present a blank wall. In June of 1965, Cleve Gray suggested he talk to a tape recorder, "perhaps for a few hours a week for a month or so," with the resulting "autobiography" to be published by Macmillan.[96] Duchamp replied: "I flatly refuse to write an autobiography. It has always been a hobby of mine to object to the written I I I's on the part of the artist."[97] Yet he had not objected in 1958, when Michel Sanouillet had gathered his writings for *Marchand du sel*. Nor did he seem to resist, during the later 1960s, participating in a flowering array of interviews and appearances, including a BBC film called *Rebel Readymade* (shown on June 23, 1966), an extended series of interviews on French radio, and a book-length taped "dialogue" with Pierre Cabanne. There were so many Duchamp happenings, in fact, that one critic testily described him as "a master of ceremonies at a cabaret performed by his own early self ... a man whose gifts lie in his past, which he inhabits, dusts, and catalogues, keeping pretty busy — a kind of Duke of Windsor of art."[98]

Duchamp was aware of and reveled in contradictions. He told Schwarz, "I don't want to be pinned down to any position. My position is the lack of a position, but of course, you can't even talk about it; the minute you talk, you spoil the whole game."[99] He told Tomkins that he distrusted language as "no damn good ... Only the fact directly perceived by the senses has any meaning."[100] His friend and patron Hubachek would conclude, on the basis of "many hours and days" with Marcel, that Duchamp "will be known as a greater philosopher than an artist."[101]

To the end, and despite all the publicity, adulation, and even financial

success — his estate ultimately amounted to more than $250,000[102] — Duchamp pursued contradiction and courted uncertainty. Just as the fifteen-year-old Marcel willingly accepted guidance from Jacques Villon and Raymond Duchamp-Villon, so the seventy-nine-year-old Grandada still sought outside approval of his aims and accomplishments. He had always intended his works to be shocking, he reiterated to Schwarz in 1966. But he poignantly added, "I've been all my life in that attitude. I never do anything to please myself. None of the few things I have done in my life ever were finished with a feeling of satisfaction."[103] Sometimes, he even masked such feelings of uncertainty with grandiose bombast, such as his claim that "when the vision of the *Nude Descending a Staircase* flashed upon me, I knew that it would break forever the enslaving chains of naturalism."[104] And at other times, he professed puzzlement over the attention this painting still attracted. "It's a mystery still, forty-six years later," Duchamp told a *Newsweek* reporter, while sipping at a dry vermouth. Discounting the notion of a joke, Duchamp insisted he was serious when he painted it, but "had no idea that in 1959 we would still speak of it."[105]

Indeed, more people would speak, not only of the *Nude* but of Duchamp's far more radical works. In 1966, London's Tate Gallery mounted the largest exhibition yet, 242 items, comprising "The Almost Complete Works of Marcel Duchamp." The show included even a second exact replica of the *Large Glass*, lovingly constructed by Richard Hamilton and smilingly signed by Duchamp. To coincide with the show, there was a round of television programs, interviews and an entire issue of *Art and Artists* magazine devoted to him. At a gala preview on June 16, Duchamp told the assembled crowd, "I have some advice for you young artists — Beware of Wet Paint,"[106] a flip remark that also reached a widely read New York columnist. Again and again, Duchamp was asked about his paternal relationship with the Pop artists who were just then cresting in popularity, and whose works, in fact, did much to provoke interest in Duchamp as their forerunner. "The difference," he told one interviewer, "is that I never had to sell my work, so I never repeated myself ... poor dears, they have to make a living."[107]

While the reviews of the Tate show were generally friendly, if not eulogistic, at least one critic noted that the "early paintings were poor" and served mainly as "pointers to the historic moment when Duchamp realized he was never going to make it as a traditional artist."[108] Perhaps Duchamp agreed. Certainly, he had little patience for abstruse, complex explanations

of his work. After one such two and one-half hour session of "high pressure hypothesizing" by Schwarz, Duchamp was heard to remark: "Capital! I couldn't hear a word, but I enjoyed it very much."[109]

<center>◆ ◆ ◆</center>

By the time of the Tate retrospective, the international art establishment had recognized a winner. That same year, Time-Life Books devoted one of the twenty-eight volumes in its history of Western art since Giotto to *The World of Marcel Duchamp*, written by Calvin Tomkins. Over the next two years, exhibitions focusing on Duchamp were held as far away as Australia and New Zealand. The artist who had devoted himself so single-mindedly to producing shock must have been amused to learn that — in Christchurch, New Zealand, at least — his works still had the desired effect. Two items in the exhibit there, *Fountain* and *Please Touch* (the 1948 Surrealist exhibition catalogue with the foam-rubber breast), had been "labeled offensive and withdrawn from public display." Duchamp surely felt a thrill of success in reading the comment of Christchurch City Parks and Reserves Committee chairman P. J. Skellerup: "I don't mind a bit of good clean fun in the art world — but you have to draw the line somewhere."[110]

Of the many exhibits, probably the most gratifying to Marcel was a show of eighty-two works by "The Duchamps: Jacques Villon, Raymond Duchamp-Villon, Marcel Duchamp, Suzanne Duchamp-Crotti" at the Rouen Beaux-Arts Museum from April 15 to June 1, 1967. During his visit to Rouen for the opening, Duchamp also ceremoniously pulled back the curtain over a brass plaque installed by the city on the wall of the house at 71 rue Jeanne d'Arc. It was in this substantial brick town house that his father posed for the portrait in 1910 and that his mother and sisters had sat for *Sonata*. The sad young man had walked through this door after getting off the train in 1911. Not far away, in the rue des Carmes, which now was a pedestrian shopping mall, there was still a confectioner's shop, though no chocolate grinder was issuing its challenge from the window. On the eve of the exhibition, the only survivor of the four artists spent two hours being interviewed by a reporter. Afterward, museum director Olga Popovich asked Duchamp why he had delivered so many outrageous offhand statements during the interview. "What does it matter?" he replied. "It's what he wanted me to say."[111]

Perhaps for relief from the solemnity of so many formal occasions, the

Duchamps traveled to Toronto, early in 1968, to take part in *Reunion,* a musical performance organized by John Cage. Those who gathered in the Ryerson Polytechnic High School auditorium at 8:30 of a frosty February evening saw a bare and darkened stage. Spotlighted was a plain wood table. On it was a chessboard with a tangle of wires connecting each square to banks of eight amplifiers and speakers. The performers were the Duchamps and Cage. The musical work produced that evening, recorded by Columbia, consisted of the sounds randomly issuing from the speakers as the chess game progressed. The recorded performances consisted of one and one-half games. In the first, Duchamp beat Cage. The second game, which pitted Marcel against Teeny, was suspended at midnight when the house lights went up and the chess players saw that the "audience [had] silently abandoned the hall in the course of the evening."

Cage reported later with some satisfaction that the match continued the following morning and Teeny defeated Marcel. For him, it might have been a small consolation for his repeated chess humiliations at Duchamp's hands. Cage invariably lost when playing against his friend, and in fact the only time he had ever seen Duchamp "really angry" was one afternoon when he had burst out: "Don't you ever want to win?" and then left the room.[112]

For Teeny, the notion of beating her husband across the chessboard, even after the audience's departure, must have been gratifying. If not an art widow, she had been a chess widow on so many occasions, not only when Duchamp fled from social responsibilities to his chess club but also, since 1959, as he carried out official duties as a director of the American Chess Foundation.[113]

For Duchamp, finally, it may have been yet another assertion that there was, indeed, a profound relationship between chess and art. A few months later, while visiting a chess match in Milan with Arturo Schwarz, he studied the players and predicted the outcomes of various games. Then he turned to Schwarz and said, "with a faint note of regret in his voice, 'You see, chess has become a science now, it is no longer an art.'"[114] And the artist Arman was perhaps offering more than just a casual remark about chess when he told an interviewer: "He had one of the strongest endgames I have ever seen."[115] Duchamp could, after all, look back with satisfaction, and perhaps with secret chuckles, on a life devoted mostly to a noncareer as an anaesthetic artist that had turned out to be inordinately successful — a strong endgame indeed.

A month after the chess games in Toronto, Duchamp was fêted at the premiere performance of Merce Cunningham's ballet *Walkaround Time*; David Behrman's music, ...*for nearly an hour*..., was based on Duchamp's 1918 glass piece, and the decor, created by Jasper Johns, was inspired by the *Large Glass*. A few weeks later came the opening of the show "Dada, Surrealism and their Heritage" at the New York Museum of Modern Art, with Duchamp the guest of honor; thirteen of his works were on exhibit. During that spring, he completed a series of nine slyly erotic, derivative etchings, *The Lovers*, based on works by such classical French artists as Ingres and Courbet. While at Cadaqués as usual that summer, Duchamp worked on *Anaglyphic Chimney*, the model for 110 replicas he intended to make by hand for the deluxe French edition of Schwarz's *Complete Works of Marcel Duchamp*, which was about to be published. The model was of an optical game, he wrote to Schwarz, "apropos of a Spanish chimney of which I have made a sketch in three dimensions for the mason who is executing it in our new summer home ... [It] should produce a three-dimensional effect when viewed through a pair of spectacles with red and green filters."[116]

In early September, the Duchamps postponed their usual trek to Paris by more than a week to allow Marcel to recover from a bad cold and back pains. From Paris on September 22, he wrote to Frank Hubachek about plans for a visit to Chicago, suggesting that since he had recently been unwell, a quiet evening would be welcome.[117] In fact, he was more than just unwell: Teeny had not told Marcel that he had prostate cancer, a disease that advances slowly in a man of his age. In 1962, he had undergone a second prostate operation, after which surgeons gave Teeny the diagnosis.

On the evening of October 1, 1968, the Duchamps entertained the Man Rays and the Lebels at a pheasant dinner in their Neuilly apartment.[118] Lebel noted that Marcel looked "abnormally pale," resembling a nineteenth-century representation of great men, perhaps Leonardo.[119] After the guests departed, Teeny was looking for her glasses when Marcel called from the next room to tell her about something funny he was reading. He laughed. A moment later, when she entered the room, he was dead.[120]

Duchamp's will specified that there be no funeral, so his ashes were placed in the family plot at the Cimetière Monumentale in Rouen, where, from beneath a gnarled pine tree, one can overlook the Seine and the city where it all began. Among the imposing funerary fantasies erected by the city's commercial elite, three simple stones, cracking and mossy, mark the

last resting place of Émile Nicolle, "Painter-Engraver-Etcher," of Lucie and Eugène Duchamp, of Jacques Villon and Raymond Duchamp-Villon, of Suzanne Duchamp-Crotti, and of Marcel Duchamp.

Along with his mortal remains, Duchamp had arranged to confront the citizens of Rouen with one final provocation. A special dispensation had to be extracted from the cemetery authorities to permit the grave to be inscribed with Marcel's chosen epitaph: *"D'ailleurs, c'est toujours les autres qui meurent"* (Besides, it is always other people who die).[121] The quotation, attributed to Montaigne, continues: "one's own grave is empty, to be inhabited only by the recollections of future generations."[122] Duchamp could not have chosen a more apt philosopher to quote than Montaigne; his *Essays* were part of the curriculum at Duchamp's lycée, and in them one could read: "My trade and my art is living."

THE OBITUARIES PUBLISHED after Duchamp's death provide a poignant insight into his checkered reputation in the western world. Even though he had died in a Paris suburb, a highly recognized figure in the art world, the city's *Le Figaro* printed news of his passing in its chess column.[1] Rome's *Corriere della Sera*, in its lengthy obituary, omitted mention of perhaps his most original contribution, the readymade.[2] A *Chicago Daily News* editorial praised him for rejecting "everything that shackled art to the visually factual but the spiritually empty."[3] *Life* magazine called him "one of the century's most influential artists,"[4] while John Canaday in the *New York Times* said he was possibly "the most destructive artist in history."[5] When Picasso learned of Duchamp's death, he was heard to mutter simply, "He was wrong."[6]

All these observers and many others were sure that they had witnessed the transit of a unique — and uniquely disturbing — comet, though no one seemed to know exactly why. But by the turn of the millennium, more and more observers believed that, for good or ill, Duchamp had been not only right, but had become the lodestar for artists who followed.

Those who wrote the obituaries and the assessments of Duchamp's life and work dwelled at length on his iconoclasm, destructive for some, cleansing for others. Duchamp had "spent a lifetime constructing traps for the rational mind," Lawrence Steefel had noted with some awe in 1960.[7] But few anticipated that the avant-garde, marching to his beat, would blindly march over a cliff during subsequent decades.

In 1969, almost a year after his death, Duchamp's final trap for the rational mind was sprung. Far from simply breathing, waiting, or nodding over chess, Duchamp had been secretly laboring during the last two decades of his life on a massive work of art. The work had proceeded so secretly that not even close friends knew of it. The only person who had been told of the project, apart from Teeny, was William Copley; Duchamp had met with him that spring, before his final summer in Cadaqués, and given instructions for disposition of the work.

On July 7, 1969, in a small room adjoining the Arensberg Collection in the Philadelphia Museum of Art, the public got its first glimpse of this mysterious opus. Its title was, as might be expected, both cryptic and provocative: *Étant donnés: 1° la chute d'eau, 2° le gaz d'éclairage* — known in English as *Given: 1. the waterfall, 2. the illuminating gas.* Into the body of received truth about art, and especially Duchamp's art, this work ate like an unidentifiable virus. Even the artist's instructions for its display were mysterious. In a notebook, he had minutely described its construction and the details of how it was to be transported and set up; but, unlike his notes for the *Large Glass,* there was not one word as to his intention and no clue as to its meaning.[8] Furthermore, in stark contrast to his positive delight in creating replicas and multiples of earlier work, Duchamp forbade any photographs whatsoever of this one. This ban was quickly broken by Arturo Schwarz, whose massive Duchamp catalog was on the verge of publication. Schwarz added a hasty photo and a six-page analysis to his 631-page tome.[9]

The curious viewer thus goaded into making the journey to Philadelphia found himself finally — after passing the spacious gallery containing the portrait of Duchamp's father, the *Nude Descending a Staircase,* the readymades, and the *Large Glass* — in a small, dark chamber, confronting an ancient, splintered, and massive pair of wooden doors. There was no latch or handle. In the silence and the dark, and in bafflement, the visitor would discover in those doors, at eye level, two small peepholes. Peering through, he would face a brick wall with just enough of the bricks missing to allow a glimpse of the startling scene beyond: sprawled in pale, ghostly reality upon a bed of twigs was a life-size nude figure, its left hand raising high a torch and its face forever concealed by the brick wall. The background was composed of a lush and realistic landscape, animated by a mechanically lighted waterfall.

But having scanned the total effect, the observer's eye was drawn inexorably back to the figure in the foreground. Yes, it was a woman, her skin

matte and smooth in the relentless, shadow-free light. Her legs were flung apart, as though in the aftermath of a violent act, and the pubic area, in its clinical, hairless exposure, was shocking indeed.

What could one make of all this? Was it one of the most profound works of art to come out of the twentieth century, or just a spoof? Was it an aesthetic statement, or a deeply anti-aesthetic one? Did Duchamp, in his old age, mean to reveal all, or nothing?

One fact was immediately apparent: this disquieting work possessed an aura engaging virtually every viewer; neither the casual museum stroller nor the knowledgeable specialist seemed able to remain aloof from it. According to a longtime docent at Philadelphia, visitors who flocked to the museum in a "great rush," when the work was first installed, generally asked to see "the peephole picture." Some would whisper when asking for it, she said. As they turned away, many looked puzzled and "all were shocked."[10] The scene likewise puzzled two experienced art scholars: Walter Hopps, the organizer of

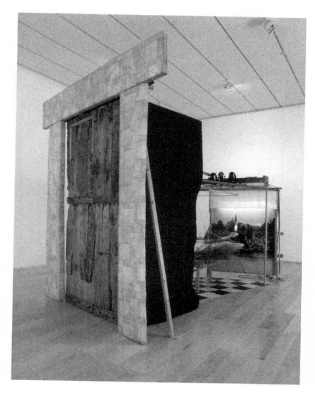

*Richard Baquié,
"Sans titre. Étant
donnés: 1. La chute
d'eau, 2. Le gaz
d'éclairage," 1991*

the 1963 Duchamp show in Pasadena, and Anne d'Harnoncourt, then curator of modern painting at Philadelphia and now the museum's director. "What one actually sees can be reduced to words," they wrote, "but the initial impact is one of the most crucial aspects of the work, and one which cannot be rendered second-hand."[11]

Apart from shocking, which admittedly had always been one of his primary goals, Duchamp's intentions will forever remain frustratingly unclear. His thirty-five-page handwritten notebook, illustrated with 116 photographs, contains only extremely detailed instructions for installing the work, down to the wattage of light bulbs, and nothing more. Duchamp never discussed *Given* with anyone except Teeny, who helped him gather twigs for it, and Copley, who arranged, through the Cassandra Foundation, to give the work to the Philadelphia Museum.

To expect a simple, verbal explanation of this piece from Duchamp would be entirely unrealistic. As we know, he took intense delight in deliberately contradicting himself and in misleading and mocking interviewers with pseudo-serious pontifications. But one of the notions he held consistently all his life was that language was unequal to the task of describing art. As he told Schwarz in 1966, no doubt in irritated response to being goaded for verbal answers, "The content ... of a painting cannot be evaluated in words ... Painting is a language of its own ... To say the least, you will distort the original message, whatever you say about it."[12]

And yet, as he had perpetually confronted the king on the chessboard, who can never be captured but only held in check, so Duchamp had also pursued paradox even as it shattered in its own reflection. Even in this work, there was, of course, one important verbal message: its suggestive title.

Like the concept for the *Large Glass*, the title of *Given* comes from Duchamp's notes of 1912–14. This was a period when Duchamp still tried to use words for art, but the impenetrable prose indicates how lost he was already getting in that realm. The full note reads:

> *Preface:*
> Given 1° the waterfall
> 2° the illuminating gas
> *we shall determine* the conditions for the instantaneous state of Rest (or allegorical appearance) of a *succession* (of a group) of *various facts* seeming to necessitate each other under certain laws, *in order to isolate the sign*

of the accordance between, on the one hand, this *state of Rest (capable* of all the *innumerable* eccentricities) and, on the other, a *choice of Possibilities* authorized by these laws and also *determining them.*[13]

Adrift in the shifting glitter of such obscurity, one steps with relief onto the hard ground of historical facts. One fact is that Duchamp included this note among the facsimiles he so meticulously reproduced in the *Green Box* of 1934. Another fact is that gas and water still formed part of Marcel's fantasy firmament in 1959 when, for the cover of the deluxe edition of Lebel's monograph, he chose a replica of a blue enamel plaque displayed on the facades of countless Paris apartment houses, *"Eau et gaz à tous les étages"* (water and gas on every floor); such a sign, in fact, was still affixed to the apartment house directly across the street from Duchamp's first lodgings in Paris, at 73 rue Caulaincourt.

Building onto the immediate scatological reference to body functions that might strike a young man freshly arrived in Paris from a rural background, one can associate the mythological significance (quite apparent to a graduate from a lycée's classical education) as two basic elements recognized by the Greeks: water and air. It seems significant that Duchamp avoided the other two: fire and earth. For just as, in 1962, he had described the *Large Glass* as "a little game between 'I' and 'me,'" so the "I" in *Given* may be Marcel Duchamp, symbolized by the water and gas of the title, while the implied elements — earth and fire — were the work of "me," Rrose Sélavy. A man as alert to symbolic overtones as Duchamp would have chuckled over such an ironically apt allocation. Wasn't Marcel Duchamp elusive as air, cool as water (or glass)? And didn't Rrose Sélavy dwell, like the women of myth, in the realms of earth and passionate fire?

That Rrose relished shocking people, we know. From her birth as the creator of *Fresh Widow,* with its overtones of eroticism and castration, to the puns about incest, to her ubiquity in the titles of Duchamp's major exhibitions, her presence reeks of dark, unspeakable desires and eternal lack of fulfillment. To the viewer peering through the peephole in that Beaux Arts museum in Philadelphia, she provides a double shock. First, a gasp at witnessing so aggressively erotic a tableau. For the figure sprawled on the twigs is depicted crudely, as crudely as Duchamp could sometimes talk about women; as, for example, he could tell the prim Rouen art museum director Olga Popovich, about some mutual acquaintance: "She's a nice woman, but

no good in bed."[14] And then, while studying the details of the Philadelphia tableau, the viewer gets a second shock: alone with this work, devouring it with his eyes, the viewer is now the voyeur.

Nor are these the only shocks. Stylistically, *Given* is a brazen challenge to the dominant art modes of its time. Just as the *Nude Descending a Staircase* was a slap at notions of Cubism formulated by his brother's friends in 1912, so *Given* totally defied contemporary notions of artistic style — not only during the late 1940s, when it was begun, but up to and beyond the death of Marcel Duchamp in 1968. This was the period when the most successful avant-garde artists were, first, the Abstract Expressionists and, later, the practitioners of Pop, Op, and Minimalism. Not the least of *Given*'s functions was to baffle, confound, and defy the contemporary art establishment. A hint of disarray comes through the smoothly diplomatic preface written by Evan H. Turner, then director of the Philadelphia Museum, for its *Bulletin* in September 1969. While expressing the museum's "great satisfaction" that Duchamp wanted his new work to "quietly join the museum's collection," Turner remarked that "the affection that the Board of Trustees felt for the man himself enriched its recognition that in this new work the artist had achieved yet another startling step in a remarkable career."[15]

Behind Turner's bland, almost militantly nonjudgmental adjectives lay the quite obvious challenge to current received artistic truths emanating from *Given*. During a period when the most admired avant-garde artists were indulging in drips and slashes, this work was provocatively naturalistic. And while spontaneity — the creative work flowing out with minimal rational intervention — was the goal of the most successful artists, this work was painstakingly conceived and meticulously constructed, as well as being accompanied by the most specific installation instructions the museum had ever seen. The fluorescent lamps, for example, were to be "very white (General Electric) or pinkish," while the Brevel motor which activated the waterfall was to be set for "three turns per minute." Every brick was numbered. Short circuits could be avoided, Duchamp advised, by staggering the wires to the fuses. The nude figure was to be lifted with utmost caution: "better to have two people do it."[16] All fifteen steps for assembling the work were so minutely detailed and illustrated, in fact, that anyone acquainted with Duchamp's sense of humor could almost discern a parody of craftsmanship.

As for the work itself, in its parts and in its totality, *Given* embodies a profusion of significant moments in the artist's life. The old-fashioned Bec

Auer lamp that the figure brandishes in its left hand is a readymade and evokes echoes of Blainville-Crevon's first street illumination in 1895 as well as a drawing the fifteen-year-old Marcel had done while a student at the Lycée Corneille. The lamp further recalls Duchamp's many arrivals and departures through New York Harbor, where a gigantic woman, a gift from the French, holds aloft the torch of liberty. The waterfall in its verdant landscape echoes the little stream, the Crevon, which wound through the swale east of the Duchamp house and which had been the subject of Marcel's very first painting. The bricks, which Duchamp had ordered especially handmade in Cadaqués, echo the warm bricks of the *mairie* in Blainville-Crevon and of the house where the nude, in a fantasy that time had nudged into a reality, descended the staircase.

In its concept, *Given* suggested the second leaf of a diptych, embodying the two great biblical themes that Duchamp had encountered first in the church at Blainville-Crevon — the subject of his second oil painting — and later in the chapel at the Lycée Corneille, as well as in the glass cases of the library nearby. Where, in one of its aspects, the *Large Glass* represents a crucifixion, the central theme of the New Testament, so *Given* represents the Fall of Man, the central theme of the Old Testament — the word *Chute* in the title refers not only to a waterfall but to a fall in general. The display's sylvan setting suggests a perverted Eden. And just as, in the *Large Glass*, the central figure is a woman, so it is in *Given*.

And again, this woman is maddeningly ambiguous. Apart from her brazen genitals, the rest of her conformation is sexually vague. She is muscular yet effete; her feminine characteristics remind us of Michelangelo's robustly muscled women with their breasts seemingly pasted on or, even more suggestively, of the Louvre's treasure that hangs near the *Mona Lisa* — the mysterious, ambiguous, smoky, and perhaps leering *St. John the Baptist*, also painted by Da Vinci.

The hairless, woundlike gash of her sex, the figure's most shocking aspect, suggests castration, especially when we take in the phallic lamp it so triumphantly brandishes. Are we seeing another version of the *Mona Lisa*, which Duchamp first supplied with a mustache and later shaved (in a 1965 version called *L.H.O.O.Q. rasée*)? Was this the final act of "the widow," the figurative guillotine Rrose Sélavy had so impishly constructed? Or was this the final fate of *la belle Hélène*, whose portrait Duchamp humorously posed for and signed with the name of Rrose Sélavy? No, the bed of twigs, no less

than the disturbing wound, suggests rather the final fate of Rrose Sélavy — the same fate that befell the central figure in the history of Rouen, a woman following the métier of a man; a girl, in fact, who donned armor and chose to give up her life rather than wear the clothes of a woman. For that, Joan of Arc was burned on May 30, 1431, in the city's Old Market. This was the fate prepared by the imaginative "I," Marcel Duchamp, for the nettlesome "me," Rrose Sélavy.

But the twigs remain unlit under the figure behind the peephole in Philadelphia. Instead, she thrusts aloft, like a beacon, the cool yet fiery flame of Marcel Duchamp's spirit. Ironic, perhaps; paradoxical, of course, that he finally chose a lamp, symbol of enlightenment. And, indeed, that lamp attracted a swarm of artistic moths, so many that, as the twentieth century passed into history, the very word "Duchamp" represented an ironic, paradoxical, and often irritating brand of art.

◆ ◆ ◆

In recent years, Duchamp has frequently been described as the pioneer iconoclast, the man who smashed the fusty religion of art, the worship of beautiful objects. In the early twentieth century, it was said, such a cleansing opened the door to new media and new concepts of what constitutes art. Duchamp's *Fountain* came to be admired as an emblem of artistic freedom. Yet when the first full-size replica of *Fountain* was exhibited at the Sidney Janis gallery in 1953, Duchamp deplored "the dangers of delectation" lurking in readymades. "You can make people swallow anything," he said. "That's what happened with *Fountain*."[17] By the late 1980s, many editions of replicas, sketches, and engravings had multiplied the urinal bought in a plumbing supply store into 687 exemplars.[18]

Further evidence that Duchamp could "make people swallow anything" is that every scrap of paper that he so much as sneezed upon is now publicly displayed and sold at increasing prices. In 1987, the Philadelphia Museum of Art exhibition marking Duchamp's one hundredth birthday included not only its extensive holdings of his works, but also photos, catalogs, magazines, objects, and posters. In the museum's store, visitors could purchase a plastic shower curtain version of the *Large Glass* for $75.[19] The museum also published Duchamp's instructions for displaying *Given*. In the fall of 1998, it opened "Joseph Cornell/Marcel Duchamp ... in resonance." The display occupied a single small gallery, but its catalog filled 344 pages. Central to the

show was Cornell's "Duchamp Dossier," featuring more than one hundred ephemeral items that Cornell had rescued from Duchamp's wastebasket: crumpled dry-cleaning bills, a coaster for Trommer's malt beer, receipts from Bloomingdale's.[20]

The Philadelphia Museum was building on a rash of exhibitions that mingled replicas and trivia with original works. Of about four hundred items shown in a 1991 Duchamp "Retrospective" at the Ronny Van De Velde Gallery in Antwerp, only 230 had been created by Duchamp himself; the rest were ephemera.[21] A New York gallery in the fall of 1999 exhibited 158 Duchamp-related items, among them twenty-three etchings by his grandfather, and three nineteenth-century rebus plates by an unknown artist. The show's curator had written copiously on Duchamp while also amassing a valuable collection of Duchampiana, portions of which were for sale in the show.[22] Gallery owner Achim Moeller pronounced the show "a great success" but also quoted an observation by a fellow dealer, Virginia Zabriskie, that while there were lots of Duchamp scholars, there were not as many Duchamp buyers.[23]

The Duchamp effect on art has been summed up as total freedom, the artist's absolute right to decide what is art. Belief in this freedom has persuaded most art schools and college art departments to abandon much of the curriculum traditional for artists over more than two thousand years — instruction in drawing, color, composition, and painting or sculpture techniques. Indeed, so entrenched was Duchampian Dada, wrote the artist Philip Pearlstein, that it had become "the academic art of the late twentieth century."[24]

This academy and its dogma of freedom have immobilized art critics and scholars in terror that any real art criticism would brand them either as philistines or traitors to that absolute doctrine of absolute freedom. It has also led dispensers of public funding for the arts to confuse the exercise of judgment with attacking the artist's First Amendment rights.

Nowhere have Duchampian ironies played so intensely as at the Philadelphia Museum, where most of his oeuvre resides. From its exterior, it would seem a most unlikely resting place for such rebellious art. The approach is a monumental stairway to a vast, shadeless plaza. The central entrance is a massive Greek temple with eight elephantine Corinthian columns.

Incongruously planted in the right patio is a flagrantly orange Calder stabile looming over a Beaux Arts fountain dedicated to a nineteenth-century

parks commissioner. To the left of the entrance, a wing stretches out in Ionic motif, six columns. On the right wing, a pediment features a row of scantily draped figures representing a mythological theme, colorfully painted. Perhaps they represent legends of Philadelphia, an ancient Hellenistic city of that name situated where Amman, Jordan, is today.

At the foot of the final stairs before the entrance stands *Prometheus Strangling the Vulture*, a Jacques Lipschitz bronze acquired in 1952. How harshly the Duchampian revolution has dealt with artists attempting such a classical subject! As the millennium was ending, no noble theme — religious, mythological, literary, or metaphysical — was welcome in galleries or museums of contemporary art.

The reaction to the saccharine promises of Victorian artists and their patrons is complete. Modernism undermined all that — a bracing draft, at first, sweeping out stale notions of art as it swept in simplicity of means, honesty of materials, and belief in the imagination of the artist. It took only a few decades for modernism to be toppled by a kind of rambunctious anarchy that has been unable to invent a more touching name for itself than postmodernism. Unlike modernism, this movement has built little and destroyed much, and it reveres Marcel Duchamp as its Pied Piper, its exemplar, and sometimes even its saint. To many of his followers in the art world, his message has been distilled to: "Talk softly and carry a big shtick."

In a more serious mode, the cultural historian Jacques Barzun has identified *L.H.O.O.Q.* as the central symbol of the decadence that has overtaken culture in our time. The mustache on the *Mona Lisa*, he notes, "disposed of the Renaissance and its sequels." It "opened a door, gave a password, flashed a permanent green light" for "the collective aim of anti-art." What followed — "Found Art (jetsam from the beach), Junk Art (the discarded refrigerator door), Disposable Art (objects magnified or made of flimsy materials; bridges and buildings draped in cloth) — all these told the world that art as an institution with a moral or social purpose was dead."[25]

Postmodernism can't get enough of the readymades Duchamp tossed off as a fleeting joke and somehow strives to achieve an art that is not "retinal." One can hardly accuse a can of an artist's excrement of being retinal, but does it really put art, "once again," as Duchamp demanded, "at the service of the mind"? The postmodern offshoots, re-creations, and blatant replicas of Duchamp's inventions do not convey wit or humor. The smile evoked by the weighty birdcage titled *Why Not Sneeze?* has been dragged down into a

sneer, and the lighthearted *Fountain* transformed into a sermon on artistic freedom.

After the 1970s hoopla, the Philadelphia Museum clearly became uneasy about *Given* and would prefer that casual visitors pass it by. No sign points out the peepholes, or warns of the horrific panorama within. Scholars may skate merrily over this work, dissecting every possible meaning, but the museum takes a (literally) dim view. The half-lit alcove is easy to overlook. The two peepholes are virtually invisible. Most visitors give a quick glance at the label and the wooden doors, make a puzzled shrug, and move on. Those who do look appear to be stunned. Indeed, a typical reaction is a shocked withdrawal from the scene, followed by, "Oh, my God!" For the silent observer, the work's capacity to shock is, to build on Duchamp's locution, still a shock.

The wider art public, the great mass of museum-goers, knows what it likes, swarming into galleries filled with yet another Impressionist or Postimpressionist show. It is willing to deal with Picasso, Matisse, and their early twentieth-century colleagues. But this crowd cannot figure out how to react to Marcel Duchamp. He seems to call for a whole new vocabulary that such visitors do not care to master. The note cards featuring a urinal cannot awaken the affection of those who cannot get enough of Monet's water lilies. The *Large Glass* is too puzzling, and nobody in the United States has yet dared to present *Given* as a postcard or calendar.

And, far from the crowd seeking an uplifting — or at least entertaining — few hours at the museum, the scholars known as Duchampians tickle theories and issue intimidating jargon. Many pages of dense prose seek to tease out the ultimate meaning of this or that fragment he left behind. And legions of artists struggle to pry open the wall space of galleries and the pocketbooks of collectors with yet another "readymade" or another take on a stripped bride. Marcel Duchamp's shadow continues to lengthen, but its clarity is diffused. That playful spirit in a dark century is by now all but smothered by sober sifters of scraps and wan imitators.

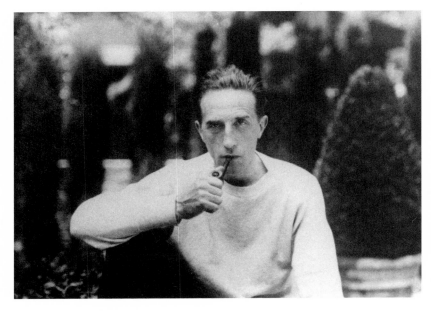

Duchamp in Hollywood, as captured by Beatrice Wood

I can write about Marcel Duchamp only in a personal way, because my interest was in the man, not the artist. I met him when I was very young, while calling on Edgard Varèse, the composer, who was in a hospital with a broken leg. The three of us enjoyed a swift understanding of art — or rather what was not art. Marcel was under thirty and handsome with a finely chiseled face. He had a penetrating gaze that saw all but held no judgment. Though already famous, he in no way wore fame's coat but maintained a simplicity of being that endeared him to everyone he met.

From the first minute, we had an accord together and *tutoi*-ed each other. When he heard I was bored with acting on the stage (I was with a French repertory company), he asked why I did not paint, and learning that I was unhappy at home, suggested that I come to his studio to do so. His room was in the same apartment house as his good friends, the Walter Arensbergs. It was a square space, overlooking a court, sparsely furnished, with a bed coming out from the wall, usually unmade, and little bits of chocolate and crackers were invariably on the window sill. Readymades and canvases which I did not understand were against the wall. After the overwhelming luxury of my family's home, I found it an oasis of enchantment.

Like friends who understand each other we had the privilege of enjoying long silences together. I spent afternoons sketching little horrors, which Marcel carefully examined. A few he praised; many he threw away. He had me do two posters for an artist's ball; I did not understand his choice from among my sketches. What he chose I did not care about.

I only cared about being in his presence. For I was in love with him, in the way of everybody who knew him. He had a captivating personality, a keen intelligence with a sensitive approach to life and a compassion for the frivolous mistakes of others that enthralled me more than his paintings. Sometimes we had dinner together in dark restaurants on Sixth Avenue and he would talk to me like a *vieux papa*, while the El trains roared overhead. He thought it necessary to educate me in matters of the world, for I was on Cloud Nine in relation to the realities of life.

It was he who introduced me to the Arensbergs. He had a great deal to do with the assembling of their collection; his taste was true pitch, and not only they but many art dealers in New York, holding high his opinion, consulted him continually. With his good friend Henri-Pierre Roché, with whom I was also in love, but in a different manner, he wanted to publish *The Blind Man*, a magazine with the same freedom of choice as the Independents held from juries. It was their child, and I endured endless discussions about its birth, while longing for conversation of a more romantic nature. Patiently I went to printers with them and because they were foreigners, subject to the French government, they decided to make me editor. Marcel and Roché were close friends, and were among the first to buy Picassos and collect Brancusi's then-baffling sculptures. Later, Marcel arranged Brancusi's first exhibition in New York.

He was the moving spirit behind the Independents, underground as well as above, and his *Fountain*, signed R. Mutt, was created to test the freedom of the group's by-laws and establish the purpose of the movement. I was walking with him in the gallery when he stopped at an Eilshemius and, of the many paintings on the wall, that was the one that attracted his attention. He wanted me to send two paintings to the show and helped me glue a piece of soap on one. It was his suggestion I use real soap in the composition instead of painting it in, with the result that the painting attracted a great deal of attention.

Free from greed, he had little desire for money. When he showed me a miniature chess set he designed, I told him to put it on the market. It was characteristic of his point of view that he replied, "What would I do with money? I teach French to care for my needs. I do not want to be bothered with money. If I had it, I would have to give time to thinking about it. Now I am free."

Although he has become a legend, he was already one when I met him sixty-three years ago. Many consider him the most important painter of the twentieth century, the most truly inventive.

Beatrice Wood
Happy Valley, Ojai, California
April 1979

This book includes facts, insights, suggestions and critiques accumulated for more than two decades, as it evolved from a Ph.D. thesis in 1978, to publication in 1980 (under the title *Marcel Duchamp: Eros, c'est la vie*), and then on to this completely rewritten and updated version. I owe a great deal to those who searched their memories as well as their files for materials contributing to this work. Equally important were the willing eyes and ears of colleagues and friends.

Many individuals helped as I retraced the path of Marcel Duchamp: Dorothy Baker, Mike Bidlo, Arthur Cohen, William Copley, Reuben Fine, Winifred Higgins, F. B. Hubachek, Marge Klein, Lydia Kahn Malbin, David Mann, Vivianne Miguet, Jacqueline Matisse Monnier, Olga Popovich, Jeanne Raynal, Moira Roth, Dr. Alan Saven, Arturo Schwarz, Theda Shapiro, Joseph Solomon, Dickran Tashjian, Beatrice Wood, and Elizabeth Wrigley. Ariss Treat punctiliously read an earlier version of this work, while many other friends listened patiently and advised thoughtfully: Liliane and David Burge, Ann Elwood, Anne Ewing, Joanne Ferraro, Jane Ford, Reva and Gerson Greenburg, Aline Hornaday, Gerry and Bob Horwitz, Nancy and Larry Jarvik, Sue and Larry Keller, Luisa and Paul Larson, Ann Lowenthal, Gerry and Larry McGilvery, Charlotte and Martin Stern, and Sue Whitman.

In New York, Marilyn Kim has been a gracious hostess, while the Cytryn clan and Freda and James Polak shared many a delightful evening with me. In Cincinnati, Eleanor Adams and Ward and Claudia Bushee generously shared the resources of the *Cincinnati Enquirer*; the Cincinnati Historical Society and Cassandra Collins, librarian at the Cincinnati Medical School, provided important information.

The University of California at San Diego has been my congenial home for many years, first as a graduate student and later as a visiting scholar in the Department of History. Above all, I wish to acknowledge here the vital contributions to this work of the late H. Stuart Hughes, who launched me into this project more than two decades ago. The reference staff of the Geisel Library is always

eager to help, as are Susan Jurist and Leslie E. Abrams and their colleagues at the Art and Architecture Libraries.

This work owes its rebirth to the MFA's publisher, Mark Polizzotti, who commissioned it and whose wise advice and editing skill guided its transformation into the present book. Its final form owes a great deal to Mark, as well as to the meticulous copy editing of Robert Hemenway and proofreading of Marlowe Bergendoff, and the diligent photo research of Greg Albers.

La Jolla, California
April 2002

AAA = Archives of American Art

BL-Yale = Beinecke Library of Rare Books and Manuscripts, Yale University, New Haven, CT.

Cabanne 1971 = Pierre Cabanne, *Dialogues with Marcel Duchamp*, trans. Ron Padgett (New York: Viking, 1971).

Cabanne 1997 = Pierre Cabanne, *Duchamp & Company* (Paris: Terrail, 1997).

FBL = Francis Bacon Library, Claremont, CA.

Gough-Cooper and Caumont 1977 = Jennifer Gough-Cooper and Jacques Caumont, *Marcel Duchamp: Chronologie* (Paris: Centre National d'Art et Culture Georges Pompidou, 1977).

Gough-Cooper and Caumont 1993 = Jennifer Gough-Cooper and Jacques Caumont, "Ephemerides on and about Marcel Duchamp and Rrose Sélavy," in Pontus Hulten, ed., *Marcel Duchamp* (Cambridge, MA: MIT Press, 1993); entries referred to by date.

HA = F. B. Hubachek files, Art Institute of Chicago Collection, Ryerson Library, Chicago.

Jean = Marcel Jean, *The History of Surrealist Painting*, trans. Simon Watson Taylor (New York: Grove Press, 1960).

Lebel = Robert Lebel, *Marcel Duchamp*, trans. George Heard Hamilton (London: Trianon, 1959).

Masheck = Joseph Masheck, ed., *Marcel Duchamp in Perspective* (Englewood Cliffs, NJ: Prentice-Hall, 1975).

MD, *Notes and Projects* = Marcel Duchamp, *Notes and Projects for the Large Glass*, ed. Arturo Schwarz (New York: Abrams, 1969).

MD, *Salt Seller* = Marcel Duchamp, *Salt Seller: The Writings of Marcel Duchamp (Marchand du sel)*, ed. Michel Sanouillet and Elmer Peterson (New York: Oxford University Press, 1973).

NYPL = New York Public Library

NYT = New York Times

Quinn-NYPL = John Quinn Memorial Collection, New York Public Library

Ray = Man Ray, *Self-Portrait* (Boston: Atlantic Monthly Press, 1963)

Schwarz 1969 = Arturo Schwarz, *The Complete Works of Marcel Duchamp* (New York: Abrams, 1969).

Schwarz 1997 = Arturo Schwarz, *The Complete Works of Marcel Duchamp*, rev. ed. (London: Thames & Hudson, 1997).

NOTES

1. See Tony Judt, *Past Imperfect: French Intellectuals, 1944–1956* (Berkeley: University of California, 1992).
2. Calvin Tomkins, *The Bride and the Bachelors: Five Masters of the Avant-Garde* (New York: Viking, 1965), 18–19.
3. Alexander Keneas, "Marcel Duchamp Is Dead at 81; Enigmatic Giant of Modern Art," *NYT*, Oct. 3, 1968.
4. Mike Bidlo, interview by author, New York City, Sept. 10, 1999; Carol Vogel, "More Records in Contemporary Art," *NYT*, Nov. 19, 1999.
5. Francis M. Naumann, "Arturo's Marcel," *Art in America*, Jan. 1998, 35–39; Arturo Schwarz, "Errors, c'est la vie," *Artforum*, Dec. 1998, 12–14.
6. Sidney Tillim, "Mythical History of Modern Art," *Arts*, March 1965, 48
7. William Rubin, in Masheck, 41.
8. Thomas Hess, quoted in William Varley, "Beyond Irony," *Stand VIII*, no. 2, 1966, 36.
9. Irving Sandler, *The New York School* (New York: Harper & Row, 1978), 164; Calvin Tomkins, *Off the Wall* (New York: Penguin, 1980), 170.
10. *New York Tribune*, Sept. 12, 1915.
11. "A Complete Reversal of Art Opinions by Marcel Duchamp, Iconoclast," *Arts and Decoration*, Sept. 1915.
12. For an insightful description of this mechanism, see Robert Jensen, "The Avant-Garde and the Trade in Art," *Art Journal*, winter 1998, 360–67.
13. Francis M. Naumann, "Minneapolis: The Legacy of Marcel Duchamp," *Burlington Magazine*, Feb. 1995, 137.
14. Georges Charbonnier, *Entretiens avec Marcel Duchamp* (Marseille: André Dimanche, 1994), 15.
15. Cabanne 1971, 43.
16. Robert Hughes, in Gregory Battcock, ed., *Idea Art* (New York: Dutton, 1973), 194.
17. *The Almost Complete Works of Marcel Duchamp*, exh. cat., Tate Gallery, June 18–July 31, 1966 (London: Arts Council of Great Britain, 1966), 5.
18. Anthony Hill, "Aimez-vous Duchamp," in Hill, ed., *Duchamp: passim* (n.p.: Gordon & Breach Arts International, 1994), 11.
19. Hilton Kramer, "Duchamp and His Legacy," *New Criterion*, Oct. 1955, 6.
20. MD talk at the Tate Gallery, London, June 16, 1966, quoted in Leonard Lyons, "The Lyons Den," *New York Post*, Nov. 3, 1967.
21. Matthew Mirapaul, "New Award to Honor Internet's Leonardos," *NYT*, Jan. 20, 2000.

CHAPTER 2: BEGINNINGS

1. Société d'études culturelles de Balinville-Crevon, "Le Chateau de Blainville," *Études normandes* 83, 2e trimèstre, 1972, 2–9.
2. Gough-Cooper and Caumont 1977, 35–37.
3. Theodore Zeldin, *France 1848–1945*, vol. 1 (London: Oxford University Press, 1973), 43–51.
4. Gough-Cooper and Caumont 1977, 36.
5. MD, *Salt Seller*, 155–56.
6. Eugène Lassale, *Jacques Villon* (Paris: Éditions des Musées Nationaux, 1975), 67; William C. Agee, *Raymond Duchamp-Villon, 1876–1918* (New York: Walker and Company, 1967), 33.
7. Société des artistes Rouennais, *Exposition Retrospective du Peintregraveur Emile Nicolle 1830–1894* (Rouen: Musée de Peinture de Rouen, 1908), 6.

8. Nicole Laquerrière, secretary to Maître LeBertre, mayor of Blainville-Crevon, interview by author, Oct. 28, 1977.

9. Zeldin, *France 1848–1945*, 43–51.

10. Minutes of Conseil Municipal, Blainville-Crevon.

11. Olga Popovich, interview by author, Sept. 22, 1977.

12. Lebel, 3.

13. Robert Lebel, "Marcel Duchamp: Liens et ruptures, premiers essais, le cubisme, le nu descendant un escalier," *Le Surréalisme, même* (fall 1957), 20.

14. Cabanne 1971, 20.

15. Gough-Cooper and Caumont 1977, 42.

16. République française, *Le Centenaire de 1789 dans la Seine-Inférieure* (Rouen: Imprimerie Espérance Cagniard, 1890), 39–40.

17. Minutes of Conseil Municipal, Blainville-Crevon.

18. T. de Croissy, *La Session de Mai: Traité théorétique et pratique des questions relatives à la rédaction des budgets communaux* (Paris: Société d'Imprimerie et Librairie Administratives des Chemins de Fer, 1880), 25.

19. N. Capperon, *Morale et Instruction Civique* (Paris: Librairie Classique Internationale, 1893), 12, 22, 95, 98.

20. de Croissy, 303, 13–14.

21. Minutes of Conseil Municipal, Blainville-Crevon.

22. Anne d'Harnoncourt and Kynaston McShine, eds., *Marcel Duchamp* (Greenwich, Conn.: New York Graphic Society, 1973), 48.

23. Gough-Cooper and Caumont 1977, 38.

24. Olga Popovich, interview.

25. Gough-Cooper and Caumont 1977, 43.

26. Records of Lycée Corneille, Archives départementales, Seine-Maritime, Rouen.

27. Capperon, 86–90, 102–3.

28. Henri Berdalle Lapommeraie, ed., *Rouen en 1886* (Rouen: Emile Deshays, 1887), iii-vii, 50-53.

29. Ibid., 51.

30. M. S. Frère, *Rapport sur le mouvement artistique* (Rouen: Léon Gy, 1908), 36–37 and 21.

31. Ibid., 40.

32. Ibid., 19.

33. Gabriel Reuillard, "L'Extraordinaire famille Duchamp-Villon," *Paris-Normandie*, Jan. 26, 1964.

34. Francis Steegmuller, "Paris Celebrates: A New Art Center and the Brothers Duchamp," *Atlantic Monthly*, June 1977, 88.

35. Pierre Larousse, *Grand dictionnaire universel du XIXe siècle* (Paris: Administration du Grand Dictionnaire Universel, 1866), vol. 15, 1065.

36. Cabanne 1971, 90.

37. Gough-Cooper and Caumont 1977, 38.

38. Cabanne 1971, 27.

39. Olga Popovich, interview.

40. Correspondence in the files of F. B. Hubachek, Chicago (HA); Olga Popovich, interview.

41. Gough-Cooper and Caumont 1977, 38.

42. The dates and sequence of all the early works by Duchamp were not established until the 1960s. In his first catalogue, Arturo Schwarz worked out a chronology, which was approved by Duchamp shortly before he died (see Schwarz 1969).

43. F. B. Hubachek to author, April 13, 1976.

44. Records of Lycée Corneille.

45. Schwarz 1969, 376–78.

46. Gough-Cooper and Caumont 1977, 39.

47. Ibid., 14.

48. Olga Popovich, interview.

49. "Duchamp 50 Years Later," *Show*, Feb. 1963, 28–29, 65.

50. Agee, *Raymond Duchamp-Villon*, 45.

51. Solomon R. Guggenheim Museum, *Frantisek Kupka: 1871–1957* (New York: Solomon R. Guggenheim Foundation, 1975), 59.

52. Olga Popovich, interview.

53. Lassale, *Jacques Villon*, 9.

54. Cabanne 1971, 20.

55. Theda Shapiro, *Painters and Politics* (New York: Elsevier, 1976), 232, 276.

56. Records of Lycée Corneille.

CHAPTER 3: AN EXTRAORDINARY CURIOSITY

1. "Duchamp 50 Years Later," *Show*, Feb. 1963, 28–29.

2. Theda Shapiro, *Painters and Politics* (New York: Elsevier, 1976), 73.

3. Ludmila Vachtovà, *Frank Kupka: Pioneer of Abstract Art* (London: Thames & Hudson, 1968), 38.

4. Peter Murray and Linda Murray, A *Dictionary of Art and Artists* (Baltimore: Penguin, 1968), 61.

5. Anne d'Harnoncourt and Kynaston McShine, eds., *Marcel Duchamp* (Greenwich, CT: New York Graphic Society, 1973), 12.

6. B. Krasne, "Profile of Marcel Duchamp," *Art Digest*, Jan. 15, 1952, 11.

7. Schwarz 1969, 402.

8. F. B. Hubachek to Anne d'Harnoncourt, Dec. 21, 1972.

9. "Duchamp 50 Years Later," 28–29.

10. Dawn Ades, Neil Cox, and David Hopkins, *Marcel Duchamp* (London: Thames & Hudson, 1999), 14.

11. Gough-Cooper and Caumont 1977, 46–47 and 14.

12. Gelett Burgess, "The Wild Men of Paris," *Architectural Record*, May 1910, 401.

13. Liliane Brion-Guerry, ed., *L'Année 1913: Les formes esthétiques de l'oeuvre d'art à la veille de la Première Guerre mondiale*, vol. 1 (Paris: Klincksieck, 1971), 278, 277, 282.

14. Ambroise Vollard, *Recollections of a Picture Dealer*, trans. Violet M. MacDonald (London: Constable, 1936), 47.

15. Ibid., 21–25.

16. Harrison C. White and Cynthia White, *Canvases and Careers: Institutional Change in the French Painting World* (New York: Wiley, 1965); Francis Haskell, *Patrons and Painters* (New York: Harper & Row, 1971); Alice Goldfarb Marquis, *The Art Biz: The Covert World of Collectors, Dealers, Auction Houses, Museums, and Critics* (New York: Contemporary, 1991).

17. Robert Jensen, "The Avant-Garde and the Trade in Art," *Art Journal*, winter 1988, 361.

18. Miklavz Prosenc, *Die Dadaisten in Zürich* (Bonn: H. Bouvier, 1967), 28 ff.

19. John Berger, *Success and Failure of Picasso* (Baltimore: Penguin, 1965), 73.

20. John Golding, *Cubism: A History and Analysis, 1907–1914* (New York: Harper & Row, 1968), 47.

21. Douglas Cooper, *The Cubist Epoch* (New York: Dutton, 1970), 21–22.

22. Daniel-Henri Kahnweiler, *The Rise of Cubism*, trans. Henry Aronson (New York: Wittenborn, Schulz, 1949), 5–6.

23. See Cooper, *Cubist Epoch*; also Daniel-Henri Kahnweiler and Francis Cremieux, *My Galleries and Painters*, trans. Helen Weaver (New York: Viking, 1971); Bernard Dorival, *Robert Delaunay* (Paris: Jacques Damase, 1975); and Golding, *Cubism*.

24. Kahnweiler and Cremieux, *My Galleries and Painters*, 40–43, 63 and 56–58.

25. Cooper, *Cubist Epoch*, 11.

26. Gough-Cooper and Caumont 1977, 49.

27. William Seitz, "What's Happened to Art," *Vogue*, Feb. 15, 1963, 129.

28. Yale University Art Gallery, *Collection of the Société Anonyme: Museum of Modern Art 1920* (New Haven, CT: Associates in Fine Arts at Yale University, 1950), 33–34.

29. Berger, *Success and Failure of Picasso*, 3–4. This work contains a penetrating analysis of this phenomenon.

30. Malcolm Gee, *Dealers, Critics, and Collectors of Modern Painting: Aspects of the Parisian Art Market between 1910 and 1930* (New York: Garland, 1981), 13–14.

31. Gough-Cooper and Caumont 1977, 51.

32. F. T. Marinetti, "The Founding and Manifesto of Futurism," in Umbro Apollonio, ed., *Futurist Manifestos*, trans. Robert Brain et al. (Boston: MFA Publications ["artWorks"], 2001), 19–24.

33. Bernard S. and Shirley D. Myers, *Dictionary of 20th Century Art* (New York: McGraw-Hill, 1974), 364.

34. Peter Selz, *German Expressionist Painting* (Berkeley: University of California Press, 1974), 78–79.

35. Brion-Guerry, *L'Année 1913*, vol. 1, 305.

36. George Heard Hamilton, *Painting and Sculpture in Europe: 1880–1940* (Baltimore: Penguin, 1974), 206.

37. Selz, *German Expressionist Painting*, 324–25.

38. Solomon R. Guggenheim Museum, *Frantisek Kupka: 1871–1957* (New York: Solomon R. Guggenheim Foundation, 1975), 307–8.

39. Vachtovà, *Frank Kupka*, 21.

40. Guggenheim Museum, *Frantisek Kupka*, 15.

41. Vachtovà, *Frank Kupka*, 18.

42. Ibid., 41.

43. Georges Charbonnier, *Entretiens avec Marcel Duchamp* (Marseille: André Dimanche, 1994), 19.

44. Harriet, Sidney, and Carroll Janis, interview by anonymous, New York City, 1953, unpublished, Carroll Janis Collection.

45. Guggenheim Museum, *Frantisek Kupka*, 74.

46. Vachtovà, *Frank Kupka*, 252.

47. Ibid., 288 and 101.

48. Liliane Brion-Guerry, ed., *L'année 1913: manifestes et témoignages*, vol. 3 (Paris: Klincksieck, 1973), 160–61.

49. Vachtovà, *Frank Kupka*, 206.

50. Guggenheim Museum, *Frantisek Kupka*, 49.

51. Vachtovà, *Frank Kupka*, 26 and 74.

52. Margit Rowell, "Kupka, Duchamp and Marey," *Studio International*, Jan.–Feb. 1975, 48–51.

53. Guggenheim Museum, *Frantisek Kupka*, 62 and 52.

54. Ibid., 184.

55. Ibid., 29–37, 184.

56. Gough-Cooper and Caumont 1977, 62.

57. Schwarz 1997.

58. Cabanne 1971, 15 and 25.

59. Ibid., 25.

60. Ibid., 22–27.

61. Patrick Waldberg, *Eros in La Belle Epoque*, trans. Helen R. Lane (New York: Grove, 1969), 94–95.

62. Roger Shattuck, *The Banquet Years* (New York: Vintage, 1968), 25.

63. Waldberg, *Eros in La Belle Epoque*, 77.

64. Quoted in d'Harnoncourt and McShine, *Marcel Duchamp*, 249.

65. George Sarton, *The Life of Science: Essays in the History of Civilization* (Bloomington: Indiana University Press, 1948), 55–56.

66. Ibid., 25.

67. Brion-Guerry, *L'Année 1913*, vol. 1., 392.

68. Dickran Tashjian, "Henry Adams and Marcel Duchamp: Liminal Views of the Dynamo and the Virgin," lecture at the Whitney Museum of American Art, New York, April 26, 1976.

69. Peter C. Marzio, *Rube Goldberg: His Life and Work* (New York: Harper & Row, 1973), 145.

70. Ibid., 176–204.

71. Henri Bergson, *Creative Evolution*, trans. Arthur Mitchel (New York: Modern Library, 1944), 252.

72. Ibid., xvi.

73. Linda Dalrymple Henderson, *Duchamp in Context: Science and Technology in the* Large Glass *and Related Works* (Princeton: Princeton University Press, 1998).

74. Schwarz 1997, 528.

75. MD to Mary Ann Adler, n.d. [1951], Arensberg Archive, Philadelphia Museum of Art. On MD and his daughter, see André Gervais, "Du BYOgraphique," *Les Cahiers du Musée National d'Art Moderne*, summer 1995, 102, 108.

76. Schwarz 1969, 89–102.

77. William C. Agee, *Raymond Duchamp-Villon, 1876–1918* (New York: Walker and Company, 1967), 111.

78. Gabrielle Picabia, quoted in Lawrence D. Steefel, Jr., "Art of Marcel Duchamp," *Art Journal*, winter 1962–63, 78 ff.

CHAPTER 4: THE JOY OF SHOCKING

1. Francis M. Naumann, "Affectueusement, Marcel," *Archives of American Art Journal*, 1982, no. 4, 4.

2. Katherine S. Dreier, drafts on an entry for Suzanne (Duchamp) Crotti, catalogue for Société Anonyme (BL-Yale).

3. Lebel, 13.

4. Liliane Brion-Guerry, ed., *L'année 1913: manifestes et témoignages*, vol. 3 (Paris: Klincksieck, 1973), 161.

5. Quoted in John Golding, *Cubism: A History and Analysis, 1907–1914* (New York: Harper & Row, 1968), 31.

6. Jean, 31.

7. Francis Roberts, "I Propose to Strain the Laws of Physics," *Art News*, Dec. 1968, 64.

8. Masheck, 43.

9. Robert M. Coates, "Art News," *New Yorker*, Jan. 30, 1965, 94.

10. MD, *Salt Seller*, 23.

11. MD, "A Propos of Myself," lecture at City Art Museum, St. Louis, Nov. 24, 1964.

12. Ronald Johnson, "Poetic Pathways to Dada: Marcel Duchamp and Jules Laforgue," *Arts Magazine*, May 1976, 86–87.

13. Lawrence D. Steefel, Jr., *The Position of Duchamp's* Glass *in the Development of His Art* (New York: Garland, 1977), 87.

14. Anne d'Harnoncourt and Kynaston McShine, eds., *Marcel Duchamp* (Greenwich, CT: New York Graphic Society, 1973), 252.

15. Ernest Jones, "The Problem of Paul Morphy: A Contribution to the Psychoanalysis of Chess," *Essays in Applied Psychoanalysis*, vol. 1 (London: Hogarth Press, 1951), 165–96; see also Reuben Fine, *The Psychology of the Chess Player* (New York: Dover, 1967).

16. d'Harnoncourt and McShine, *Marcel Duchamp*, 254.

17. Cabanne 1971, 29.

18. Masheck, 5.

19. Schwarz 1997, 560.

20. Daniel MacMorris, "Marcel Duchamp's Frankenstein," *Art Digest*, Jan. 1, 1938, 22.

21. Cabanne 1971, 30.

22. Robert Coates, "Art News," *New Yorker*, Nov. 11, 1968, 170–72.

23. James Hall, "The Pre-Fab Primitive," *Times Literary Supplement*, Oct. 25, 1996, 21.

24. Calvin Tomkins, *The Bride and the Bachelors: Five Masters of the Avant-Garde* (New York: Viking, 1968), 21.

25. Jean, 34.

26. Dawn Ades, Neil Cox, and David Hopkins, *Marcel Duchamp* (New York: Thames & Hudson, 1999), 48–49.

27. Quoted in Milton W. Brown, *The Story of the Armory Show* (New York: Joseph H. Hirshhorn Foundation, 1963), 110.

28. George Heard Hamilton, *Painting and Sculpture in Europe: 1880–1940* (Baltimore: Penguin, 1974), 260.

29. Robert L. Herbert, *Neo-Impressionism*, exh. cat. (New York: Solomon R. Guggenheim Museum, 1968), 18.

30. Roger Shattuck, "Confidence Man," *New York Review of Books*, March 27, 1997, 24.

31. Stefan Kanfer, "Variations on an Enigma," *Time*, Sept. 24, 1973, 102.

32. Lebel, 9.

33. Francis M. Naumann, *Marcel Duchamp: The Art of Making Art in the Age of Mechanical Reproduction* (Ghent: Ludion, 1999), 42.

34. Jindrich Chalupecky, "Nothing But an Artist," *Studio International*, Jan.–Feb. 1975, 32.

35. Alexander Keneas, "Marcel Duchamp Is Dead at 81; Enigmatic Giant of Modern Art," *NYT*, Oct. 3, 1968, 1.

36. Lebel, 30.

37. Cleve Gray, ed., "Marcel Duchamp 1887–1968: A Symposium," *Art in America*, July 1969, 21.

38. John Golding, *Marcel Duchamp: The Bride Stripped Bare by Her Bachelors, Even* (London: Allen Lane, 1973), 33, 35.

39. Katharine Kuh, *The Artist's Voice: Talks with Seventeen Artists* (New York: Harper & Row, 1962), 88.

40. Masheck, 46.

41. Ludmila Vachtovà, *Frank Kupka: Pioneer of Abstract Art* (London: Thames & Hudson, 1968), 258–59.

42. Golding, *Marcel Duchamp*, 18–19.

43. Umberto Boccioni, "Technical Manifesto of Futurist Sculpture," in Umbro Apollonio, ed., *Futurist Manifestos* (Boston: MFA Publications ["artWorks"], 2001), 64.

44. Ibid., 65.

45. Masheck, 44; see also Lawrence Alloway, "Art As Words As Art," *The Nation*, Sept. 7, 1970, 188–89.

46. Jack Burnham, "Unveiling the Consort," *Artforum*, March 1971, 59.

47. John Russell, "Exile at Large," *Sunday Times* (London), June 8, 1968.

48. Francis M. Naumann, "The Bachelor's Quest," *Art in America*, Sept. 1993, 75.

49. Russell, "Exile at Large."

50. Ibid.

51. Wassily Kandinsky, *Concerning the Spiritual in Art and Painting in Particular*, trans. M. T. H. Sadler (New York: Wittenborn, Schultz, 1947); see esp. 10 and 17.

52. Ibid., 26.

53. Calvin Tomkins, *Duchamp: A Biography* (New York: Holt, 1996), 94.

54. Lebel, 85.

55. Jensen, "Avant-Garde and the Trade in Art," 364.

56. Tomkins, *Duchamp*, 99.

57. Lebel, 15.

58. Masheck, 90–106; see also Lawrence D. Steefel, Jr., "Art of Marcel Duchamp," *Art Journal*, winter 1962–63, 73.

59. Tomkins, *Duchamp*, 101.

60. Lawrence Steefel, "The Machine in Relation to the Work of Marcel Duchamp," speech given at the Museum of Modern Art, New York, Jan. 1969.

61. Golding, *Marcel Duchamp*, 43.

62. Kuh, *Artist's Voice*, 88.

63. Masheck, 95.

64. Phillip Sarazin, "Wie populär – and wie Amerikanisch – war Populärkultur? Der Fall der Populärwissenschaft," paper given at the Colloquium on Popular Culture, Centro Stefano Frascini, Ascona, Switzerland, Nov. 12, 1999.

65. William C. Agee, *Raymond Duchamp-Villon, 1876–1918* (New York: Walker and Co., 1967), 11–12.

66. Tomkins, *Bride and the Bachelors*, 33.

67. Schwarz 1969, 17.

68. Ibid., 438.

69. MD, *Notes and Projects*, 202.

70. Golding, *Marcel Duchamp*, 62.

71. Tomkins, *Bride and the Bachelors*, 29.

72. MD, *Salt Seller*, 74–82 and 22–27.

73. MD, *Notes and Projects*, 44, 58, 60, 82.

74. Cabanne 1971, 46–47.

75. Masheck, 16–17.

76. Kuh, *Artist's Voice*, 81; See also *The Almost Complete Works of Marcel Duchamp*, exh. cat., Tate Gallery, June 18–July 31, 1966 (London: Arts Council of Great Britain, 1966), 5.

77. Philip Larson, "Urinals of the World Unite: Duchamp's Leg Will Stand Up for You," *Print Collectors Newsletter*, Jan. 1995, 212.

78. Robert M. Coates, "Duchamp Brothers' Exhibition at Guggenheim," *New Yorker*, March 2, 1957, 98.

79. Alfred H. Barr, Jr., *Cubism and Abstract Art* (New York: Museum of Modern Art, 1936), 104.

80. George Heard Hamilton, introduction to Agee, *Raymond Duchamp-Villon*, n.p.

81. Robert Rosenblum, "The Duchamp Family," *Arts*, April 1957, 21.

82. Cabanne 1971, 23; see also Masheck, 3.

83. Masheck, 34.

84. Golding, *Marcel Duchamp*, 60–61.

85. Cabanne 1971, 32.

86. Cabanne 1997, 80.

87. Golding, *Marcel Duchamp*, 46.

88. Gabrielle Buffet-Picabia, "Some Memories of Pre-Dada: Picabia and Duchamp," in Robert Motherwell, ed., *The Dada Painters and Poets* (New York: Wittenborn, Schultz, 1951), 255.

89. Jean, 29–30.

90. Cabanne 1971, 37.

91. Richard Huelsenbeck, "En Avant Dada: A History of Dadaism," in Motherwell, *Dada Painters and Poets*, 35.

92. Guillaume Apollinaire, *Calligrammes: Poems of War and Peace*, trans. Anne Hyde Greet (Berkeley: University of California Press, 1980), 45.

93. Alfred H. Barr, Jr., ed., *Fantastic Art, Dada, Surrealism* (New York: Museum of Modern Art, 1936), 25.

94. Guillaume Apollinaire, *The Cubist Painters: Aesthetic Meditations*, trans. Lionel Abel (New York: Wittenborn, Schultz, 1949), 48.

95. Cabanne 1971, 24.

96. Ibid., 33–4.

97. Golding, *Marcel Duchamp*, 47–48.

98. Lebel, 25; see also Gabrielle Buffet-Picabia, *Aires Abstraites* (Geneva: Pierre Cailler, 1957), 59.

99. MD, *Salt Seller*, 26.

100. Golding, *Marcel Duchamp*, 47.

101. Lebel, 27.

102. Cabanne 1971, 17.

103. "Marcel Duchamp," *New Yorker*, April 6, 1957, 25–27; Buffet-Picabia, *Aires Abstraites*, 17.

104. Lebel, 84.

105. Cabanne 1971, 41.

106. Ibid., 15.

107. Buffet-Picabia, "Some Memories of Pre-Dada," 257.

CHAPTER 5: A MODERN LEONARDO

1. Milton W. Brown, *The Story of the Armory Show* (New York: Joseph H. Hirschhorn Foundation, 1963), 26–27.

2. Ibid., 114–15.

3. Joseph Masheck, "Teddy's Taste: Theodore Roosevelt and the Armory Show," *Artforum*, Nov. 1970, 70–73.

4. Brown, *Armory Show*, 136–44.

5. Ibid., 134.

6. Ibid., 99, 240; see also Francis Herbert Hoover, "Frederick C. Torrey and the Famous Nude," *Southwest Art*, April 1974, 57–59.

7. Brown, *Armory Show*, 122–23.

8. Ibid., 156, 118–19.

9. Anne d'Harnoncourt and Kynaston McShine, eds., *Marcel Duchamp* (Greenwich, CT: New York Graphic Society, 1973), 59.

10. Masheck, 103.

11. Schwarz 1969, 30.

12. Cabanne 1971, 72.

13. André Breton, *Surrealism and Painting*, trans. Simon Watson Taylor (Boston: MFA Publications ["artWorks"], 2002), 91.

14. Calvin Tomkins, *The Bride and the Bachelors: Five Masters of the Avant-Garde* (New York: Viking, 1968), 27.

15. Linda Dalrymple Henderson, *The Artist, "The Fourth Dimension," and non-Euclidian Geometry 1900–1930: A Romance of Many Dimensions* (Ph.D. diss., Yale University, 1975), 180, 196–97, and 144–45. Henderson elaborated on these speculations in *Duchamp in Context: Science and Technology in the* Large Glass *and Related Works* (Princeton: Princeton University Press, 1998).

16. MD, *Notes and Projects*, 36–42.

17. MD, *Salt Seller*, 86; Henderson, *The Artist, "The Fourth Dimension,"* 257.

18. Robert M. Crunden, *American Salons* (New York: Oxford University Press, 1993), 392.

19. Trevor Winkfield, "Duchamp's Fan," *Modern Painters*, spring 1999, 105.

20. Lawrence D. Steefel, Jr., *The Position of Duchamp's* Glass *in the Development of His Art* (New York: Garland, 1977), 36.

21. MD, *Salt Seller*, 27–28.

22. André Berthélot, *La Grande Encyclopédie inventaire raisonné des sciences, des lettres et des arts*, vol. 18 (Paris: H. Lamirault et Cie, 1882–1902), 651–53.

23. Henderson, *The Artist, "The Fourth Dimension,"* 258.

24. Kenneth Clark, *Civilisation: A Personal View* (New York: Harper & Row, 1969), 135.

25. Leonardo da Vinci, *The Notebooks of Leonardo da Vinci*, ed. Jean Paul Richter, vols. 1 and 2 (New York: Dover, 1970).

26. Larousse, vol. 15, 1990.

27. Paul Valéry, *Leonardo, Poe, Mallarmé*, trans. Malcolm Cowley and James Lawler, in *Collected Works*, vol. 8 (Princeton: Princeton University Press, 1972), 81.

28. Max Weber, From *Max Weber: Essays in Sociology*, ed. and trans. H. H. Gerth and C. Wright Mills (New York: Oxford University Press, 1946), 142.

29. Cabanne 1997, 45.

30. Francis Roberts, "I Propose to Strain the Laws of Physics," *Art News*, Dec. 1968 [interview from 1963], 46–47, 62–64.

31. MD, *Notes and Projects*, 40.

32. da Vinci, *Notebooks*, vol. 1, 53.

33. Pamela Taylor, ed., *The Notebooks of Leonardo da Vinci* (New York: New American Library, 1960), 26.

34. da Vinci, *Notebooks*, vol. 2, 280–81.

35. MD, *Salt Seller*, 70.

36. da Vinci, *Notebooks*, vol. 2, 116.

37. MD, *Salt Seller*, 71.

38. Sigmund Freud, *Leonardo da Vinci: A Study in Psychosexuality*, trans. A. A. Brill (New York: Random House, 1947), 80–81.

39. See Theodore Reff, "Duchamp & Leonardo: L.H.O.O.Q.-Alikes," *Art in America*, Jan.–Feb. 1977, 89.

40. K. R. Eissler, *Leonardo da Vinci: Psychoanalytic Notes on the Enigma* (New York: International Universities, 1961), 283.

41. Lebel, 87.

42. Eleanor S. Greenhill, *Dictionary of* Art (New York: Dell, 1974), 304.

43. André Breton, "Marcel Duchamp," in *The Lost Steps*, trans. Mark Polizzotti (Lincoln: University of Nebraska Press, 1996), 85.

44. Taylor, ed., *Notebooks of Leonardo da Vinci*, 73–74.

45. Masheck, 50.

46. Roberts, "I Propose to Strain the Laws of Physics," 63–64.

47. "Pop's Dada," *Time*, Feb. 5, 1965, 85.

48. Lebel, 85.

49. Shattuck, *Banquet Years*, 247.

50. Guillaume Apollinaire, *The Cubist Painters: Aesthetic Meditations*, trans. Lionel Abel (New York: Wittenborn, Schultz, 1949), 48.

51. Patrick Padget, *Studio International*, Jan.–Feb. 1975, 52.

52. Dore Ashton, "An Interview with Marcel Duchamp," *Studio International*, June 1966, 244–45.

53. Jacqueline Matisse Monnier, interview by author, San Diego, CA, April 24, 2000.

54. d'Harnoncourt and McShine, *Marcel Duchamp*, 127–28.

55. Robert Motherwell, ed., *The Dada Painters and Poets*, 7; Douglas Davis, *Art and the Future: A Historical Prophecy of the Collaboration Between Science, Technology and Art* (New York: Praeger, 1973), 15; John Gage, "Marcel Duchamp or the Castle of Purity," *Burlington Magazine*, March 1972, 51; Manuel L. Grossman, *Dada: Paradox, Mystification and Ambiguity in European Literature* (New York: Pegasus, 1971), 26.

56. Lebel, 37.

57. Quoted in Schwarz 1997, 603.

58. "Portrait of Marcel Duchamp," *Literary Digest*, Nov. 27, 1915, 1225.

59. Lebel, 37.

60. Cabanne 1971, 44.

61. Walter Pach to John Quinn, April 15, 1915, Quinn-NYPL.

62. "Art Was a Dream," *Newsweek*, Nov. 9, 1959, 118.

CHAPTER 6: A READYMADE GENIUS

1. Calvin Tomkins, *Duchamp: A Biography* (New York: Holt, 1996), 143; *NYT*, June 16, 1915.

2. Calvin Tomkins, *The Bride and the Bachelors: Five Masters of the Avant-Garde* (New York: Viking, 1968), 36. Some thirty years later, Tomkins revised his earlier account; in *Duchamp: A Biography*, he notes that Duchamp was not interviewed until October 1915. Both bits of information came from Duchamp, whose recollections were frequently unreliable. Is it likely that a man as famous as Napoleon or Sarah Bernhardt would not be met by reporters upon arrival?

3. William C. Agee, *Raymond Duchamp-Villon, 1876–1918* (New York: Walker and Company, 1967), 121.

4. Jean, 57.

5. Association of American Painters and Sculptors, *The Armory Show: International Exhibition of Modern Art, 1913*, vol. 3 (New York: Arno, 1973), 236–37.

6. Burgess, 405–8.

7. Aline B. Saarinen, *The Proud Possessors* (New York: Vintage, 1968), 206.

8. Farrand, bill to John Quinn, Nov. 15, 1917, Reel 9, Quinn-NYPL.

9. For prices paid at the Armory Show, see Milton W. Brown, *The Story of the Armory Show* (New York: Joseph H. Hirschhorn Foundation, 1963), 240–41, 295–96.

10. Robert M. Crunden, *American Salons* (New York: Oxford University Press, 1993), 361.

11. Ibid., 426.

12. Cabanne 1971, 60–61.

13. Frederick Macmonnies, "French Artists Spur on an American Art," *New York Tribune*, Oct. 24, 1915, 203.

14. Unidentified newspaper clipping, dated 1915, in the papers of Henry McBride (AAA).

15. Tomkins, *Bride and the Bachelors*, 36.

16. Beatrice Wood, interview by author, Ojai, CA, Oct. 3, 1976; Jean, 57.

17. Cabanne 1971, 51.

18. Elizabeth Wrigley, chief librarian, Francis Bacon Library, Claremont, CA, former private secretary to Walter Arensberg, interview by author, Aug. 1976; Crunden, *American Salons*, 410.

19. Anne d'Harnoncourt, "A. E. Gallatin and the Arensbergs: Pioneer Collectors of 20th Century Art," *Apollo*, July 1974, 52.

20. Crunden, *American Salons*, 410.

21. Lebel, 38.

22. Thomas B. Hess and John Ashberg, eds., *Avant-Garde Art* (London: Collier-Macmillan, 1967), 135; see also Lebel, 39.

23. Dickran Tashjian, "Marcel Duchamp and Transgender Coupling," in Whitney Chadwick, ed., *Mirror Images: Women, Surrealism, & Self-Representation* (Cambridge, MA: MIT Press, 1998), 46–47.

24. Ray, 70; Beatrice Wood, interview by author, Ojai, CA, Oct. 3, 1976; Cabanne 1971, 53.

25. Maurice Aisen, "The Latest Evolution in Art and Picabia," *Camera Work*, June 1913, 17.

26. Robert Motherwell, ed., *The Dada Painters and Poets: An Anthology* (New York: Wittenborn, Schultz, 1951), xxvii.

27. Cabanne 1971, 58–59.

28. Walter Pach to John Quinn, April 15 and May 29, 1915, Reel 27, Quinn-NYPL.

29. Pach to Quinn, Sept. 27, 1915, Reel 27, Quinn-NYPL.

30. Quinn to MD, Oct. 15, 1915, Reel 9, Quinn-NYPL.

31. Quinn to Pach, Aug. 20, 1915, Reel 23, Quinn-NYPL.

32. Quinn to Duchamp, Aug. 24, 1915, Reel 9; Quinn to Pach, Aug. 30, 1915, Quinn-NYPL; Schwarz 1997, 634.

33. Pach to Quinn, Oct. 10, 1915, Reel 23, Quinn-NYPL.

34. MD to Quinn, Nov. 5 and 12, 1915, Reel 9, Quinn-NYPL.

35. Pach to Quinn, July 17 and 23, 1916, Reel 27; July 23, 1916, Reel 23; July 27 and Aug. 19, 1916, Reel 9, Quinn-NYPL.

36. Anne d'Harnoncourt and Kynaston McShine, eds., *Marcel Duchamp* (Greenwich, CT: New York Graphic Society, 1973), 224.

37. "Marcel Duchamp," *New Yorker*, April 6, 1957, 27.

38. Lebel, 41.

39. Anthony Tommasini, *Virgil Thomson: Composer on the Aisle* (New York: Norton, 1997), 228.

40. Parker Tyler, *Florine Stettheimer: A Life in* Art (New York: Farrar, Straus, 1963), 10–12.

41. Alfred H. Barr, Jr., Henry McBride, and Andrew C. Ritchie, *Three American Romantic Painters* (New York: Museum of Modern Art, 1969), 12, 14–15 and 27.

42. Tyler, *Florine Stettheimer*, 127.

43. Tommasini, *Virgil Thomson*, 228–29.

44. Tyler, *Florine Stettheimer*, 85–86.

45. Edward Alden Jewell, "Stettheimer Art in Memorial Show," *NYT*, Oct. 6, 1946.

46. Steven Watson, "Three Sisters," *Art & Antiques*, May 1992, 63–64.

47. Untitled article on the Carrie Stettheimer doll house, *Bulletin of the Museum of the City of New York*, fall 1974, 2–3.

48. Ettie Stettheimer obituary, *NYT*, June 3, 1955, 23.

49. Carl Van Vechten, unpublished manuscript for an article about Florine Stettheimer, undated, Van Vechten Archive (BL-Yale).
50. Tyler, *Florine Stettheimer*, 93.
51. Ettie Stettheimer [Henrie Waste, pseud.], *Love Days* (New York: Knopf, 1923), 106–10.
52. MD to Louise Arensberg, Aug. 1917 (FBL).
53. Lebel, 80.
54. d'Harnoncourt and McShine, *Marcel Duchamp*, 224–25.
55. Lebel, 80.
56. MD to Quinn, undated, but received Jan. 27, 1916, Quinn-NYPL.
57. Ray, 81–82.
58. Ibid., 59.
59. Beatrice Wood, interview.
60. Roberta Smith, "Beatrice Wood, 105, Potter and Mama of Dada Is Dead," *NYT*, March 14, 1998.
61. Beatrice Wood, interview.
62. Jean, 57.
63. Dickran Tashjian, *Skyscraper Primitives: Dada and the American Avant-Garde, 1910–1925* (Middletown, CT: Wesleyan University Press, 1975), 37.
64. Motherwell, *Dada Painters and Poets*, 15.
65. Tashjian, *Skyscraper Primitives*, 48, 73, 78–79 and 144.
66. William Carlos Williams, *Autobiography* (New York: Random House, 1948), 137–38.
67. Tashjian, *Skyscraper Primitives*, 72 and 52.
68. Quoted in Michael Klein, "John Covert's Time: Cubism, Duchamp, Einstein," *Art Journal*, summer 1974, 317.
69. Lebel, 86 and 41.
70. Sidney Tillim, "Mythical History of Modern Art," *Arts Magazine*, March 1965, 48.
71. Stettheimer, *Love Days*, 109.
72. Beatrice Wood, interview.
73. Schwarz 1969, 442.
74. MD, *Notes and Projects*, 88; see Masheck, 76.
75. MD, *Salt Seller*, 141.
76. Motherwell, *Dada Painters and Poets*, xvii.
77. Schwarz 1997, 588–89.
78. William Copley, interview by author, New York City, March 30, 1976.
79. Tashjian, *Skyscraper Primitives*, 64.
80. Schwarz 1969, 46 and 462.
81. MD, *Notes and Projects*, 90.
82. Ibid., 92.
83. Schwarz 1969, 461.
84. MD, interview by James Johnson Sweeney taped in 1955 and shown on NBC television in the series "Elder Wise Men," in Jan. 1956.
85. Tomkins, *Bride and the Bachelors*, 39.
86. Schwarz 1969, 463.
87. Lebel, 40.
88. Francis Herbert Hoover, "Frederick C. Torrey and the Famous Nude," *Southwest Art*, April 1974, 58.
89. Carla Gottlieb, *Beyond Modern Art* (New York: Dutton, 1976), 55–56.
90. Hoover, "Frederick C. Torrey and the Famous Nude," 58.
91. d'Harnoncourt and McShine, *Marcel Duchamp*, 283–84.

92. Michael Klein, "John Covert's Time: Cubism, Duchamp, Einstein," 320 ff.

93. Pach to Quinn, April 18, 1917, Quinn-NYPL.

94. Ray, 70–71.

95. Schwarz 1969, 466.

96. Tashjian, *Skyscraper Primitives*, 55.

97. Schwarz 1969, 586.

98. Beatrice Wood, interview.

99. Kermit Champa, "Charlie Was Like That," *Artforum*, March 1974, 58.

100. Quinn to Pach, Jan. 31, 1917, Quinn-NYPL.

101. Quinn to Jacques Villon, May 30, 1917, Quinn-NYPL.

102. Leon Trotsky, *My Life* (New York: Grosset and Dunlap, 1960), 268–69.

103. Tashjian, *Skyscraper Primitives*, 80.

104. Arturo Schwarz, *New York Dada* (Munich: Städtische Galerie im Lenbachhaus, 1973), 90.

105. Krasne, 51; Motherwell, *Dada Painters and Poets*, 16; Hess and Ashberg, *Avant-Garde Art*, 137; and Winthrop Sargeant, "Dada's Daddy," *Life*, April 28, 1952, 106.

106. Aisen, "Latest Evolution in Art and Picabia," 17.

107. Aline B. Saarinen, *The Proud Possessors* (New York: Vintage, 1968), 239–40.

108. Alice Goldfarb Marquis, *Alfred H. Barr, Jr.: Missionary for the Modern* (New York: Contemporary, 1989), 257.

109. *New York Tribune*, Oct. 15, 1915, clipping file at NYPL.

110. Katherine Dreier obituary, *NYT*, March 30, 1952, 92.

111. Saarinen, *Proud Possessors*, 238–43.

112. Lebel, 43.

113. Schwarz 1969, 471.

114. Cabanne 1971, 59.

115. Lebel, 42.

116. Ibid., 43–45.

117. MD to Arensbergs, Aug. 24, 1918 (FBL).

118. Katherine S. Dreier, *Five Months in Argentine from a Woman's Point of View* (New York: Frederick Fairchild Sherman, 1920), 23 and 4–5.

119. MD to Arensbergs, Nov. 8, 1918 (FBL).

120. Dreier, *Five Months in Argentine*, 15.

121. MD to Arensbergs, Nov., 18, 1918 (FBL).

122. Reff, "Duchamp & Leonardo," 92.

123. Cabanne 1971, 59.

124. Gabriel Reuillard, "L'Extraordinaire famille Duchamp-Villon," *Paris-Normandie*, Jan. 26, 1964.

125. MD to Arensbergs, Nov. 8, 1918 (FBL).

126. MD to Florine, Carrie, and Ettie Stettheimer, Nov. 14, 1918 (BL-Yale).

127. MD to Jean Crotti, Oct. 26, 1918 (AAA).

128. Stettheimer, *Love Days*, 219.

129. MD to Arensbergs, Jan. 7, 1919 (FBL).

130. Schwarz 1969, 474.

131. Saarinen, *Proud Possessors*, 249.

132. Cabanne 1971, 111–112.

133. Schwarz 1969, 475.

134. Ibid., 58.

135. MD to Arensbergs, June 15, 1919 (FBL).

136. Cabanne 1971, 62.

137. Ibid., 63.
138. For a sensitive psychological interpretation of Dada, see Willy Verkauf, ed., *Dada: Monograph of a Movement* (New York: St. Martin's, 1975), 46–52.
139. Cabanne 1971, 62.
140. Masheck, 64–65.
141. Motherwell, *Dada Painters and Poets*, 108.
142. Verkauf, *Dada: Monograph of a Movement*, 47.
143. Lebel, 40.
144. MD to Stettheimer sisters, July 7 [?], 1921 (BL-Yale).
145. Krasne, 24.
146. See François Brunet and Declan McCavana, *Bilingual Dictionary of Today's Slang* (New York: Pocket Books, 1996), p. 437.
147. Jean, 82.
148. Hans Belting, "The Fetish of Art in the Twentieth Century," *Diogenes*, fall 1998, 83.
149. Schwarz 1969, 477.

CHAPTER 7: THE PUN IS MIGHTIER THAN THE SWORD

1. Dreier to Gertrude Stein, Nov. 25, 1919 (BL-Yale).
2. James Mellow, *Charmed Circle: Gertrude Stein & Co.* (New York: Avon, 1975), 311.
3. Pach to Quinn, Jan. 18 and 28, 1920, Quinn-NYPL.
4. Pach to Quinn, April 29 and May 18, 1920, Quinn-NYPL.
5. Nancy Milford, *Zelda* (New York: Avon, 1970), 92–93.
6. Anne d'Harnoncourt and Kynaston McShine, eds., *Marcel Duchamp* (Greenwich, CT: New York Graphic Society, 1973), 213–14.
7. Roland Penrose, *Man Ray* (Boston: New York Graphic Society, 1975), 58; also Ray, 91.
8. Jean, 101.
9. Lebel, 38.
10. Calvin Tomkins, *The Bride and the Bachelors: Five Masters of the Avant-Garde* (New York: Viking, 1968) 38.
11. Lebel, 47.
12. Cabanne 1971, 64.
13. Tomkins, *Bride and the Bachelors*, 47.
14. Cabanne 1971, 63.
15. Ibid., 64.
16. Ibid., 64–66.
17. MD, *Notes and Projects*, 78.
18. Tomkins, *Bride and the Bachelors*, 35.
19. Lebel, 73.
20. Aline B. Saarinen, *The Proud Possessors* (New York: Vintage, 1968), 244.
21. Dickran Tashjian, *Skyscraper Primitives: Dada and the American Avant-Garde, 1910–1925* (Middletown, CT: Wesleyan University Press, 1975), *Skyscraper Primitives*, 60–61.
22. Dreier to Stieglitz, April 5, 1920 (BL-Yale).
23. Quinn to Roché, Dec. 8. 1920, Quinn-NYPL.
24. Ray, 90–92.
25. Penrose, *Man Ray*, 63.
26. Katherine S. Dreier, James Johnson Sweeney, and Naum Gabo, *Three Lectures on Modern Art* (New York: Philosophical Library, 1949), 6.

27. Tashjian, *Skyscraper Primitives*, 61.

28. Saarinen, *Proud Possessors*, 246.

29. Ray, 81–85.

30. Ettie Stettheimer [Henrie Waste, pseud.], *Love Days* (New York: Knopf, 1923), 114–16.

31. Andrew Forge, "The Silence of Marcel Duchamp," *The Listener*, Nov. 5, 1959, 775–76.

32. Ray, 100; see also Barbara Rose, "Kinetic Solutions to Pictorial Problems," *Artforum*, Sept. 1971, 70.

33. *The Almost Complete Works of Marcel Duchamp*, exh. cat., Tate Gallery, June 18–July 31, 1966 (London: Arts Council of Great Britain, 1966), 64.

34. Schwarz 1997, 686–89.

35. Schwarz 1969, 587.

36. Robert Motherwell, ed., *The Dada Painters and Poets: An Anthology* (New York: Wittenborn, Schultz, 1951), 13.

37. Tashjian, *Skyscraper Primitives*, 62.

38. Barbara Rose, *American Art Since 1900: A Critical History* (New York: Praeger, 1967), 113.

39. Ibid., 98.

40. Ray, 101.

41. Tashjian, *Skyscraper Primitives*, 57.

42. Ray, 82–83.

43. Stettheimer, *Love Days*, 108–09.

44. MD, *Salt Seller*, 74.

45. Tomkins, *Bride and the Bachelors*, 47.

46. Lebel, 46.

47. William S. Rubin, *Dada, Surrealism and Their Heritage* (New York: Museum of Modern Art, 1968), 203.

48. Michel Sanouillet, *Dada à Paris* (Paris: Jean Jacques Pauvert, 1965), 280.

49. René Heron de Villefosse, *Jean Crotti*, exh. cat. (Paris: Musée Galliera, Dec. 11, 1959–Jan. 11, 1960).

50. George Heard Hamilton, "John Covert: Early American Modern," *College Art Journal* 1 (1952), 38–39.

51. William A. Camfield and Jean-Hubert Martin, eds., *Tabu Dada: Jean Crotti and Suzanne Duchamp* (Bern: Kunsthalle, 1983), 14.

52. Jean Crotti, "Tabu," *Little Review*, spring 1922, 44–45.

53. Ray, 107–8, 112 and 115.

54. Penrose, *Man Ray*, 67–69.

55. André Breton, "Marcel Duchamp," in *The Lost Steps*, trans. Mark Polizzotti (Lincoln: University of Nebraska, 1996), 85–86.

56. Mark Polizzotti, *Revolution of the Mind: The Life of André Breton* (New York: Farrar, Straus & Giroux, 1995), 165.

57. Ray, 117.

58. Penrose, *Man Ray*, 84.

59. Breton, *The Lost Steps*, 85.

60. Schwarz 1997, 692–94.

61. Breton, *The Lost Steps*, 85, 87.

62. MD to Arensbergs, Nov. 15, 1921 (FBL).

63. MD, *Salt Seller*, 106; a more literal, and cruder, translation would be: "Must one stick the marrow of the sword into the beloved's pelt?"

64. Matthew Josephson, *Life Among the Surrealists: A Memoir* (New York: Holt, Rinehart and Winston, 1962), 150.

65. MD, *Salt Seller*, vii.

66. Ibid., 105–8.

67. Aline Hornaday, interview by author, La Jolla, CA, June 22, 1999.

68. Michel Sanouillet, *Dada à Paris*, 356–57.

69. Ibid., 356–57 and 552.

70. Cabanne 1997, 144.

71. Arensberg to Dreier, Aug. 16, 1923 (BL-Yale).

72. Quinn to Roché, May 1, June 9, and June 25, 1922, Quinn-NYPL.

73. Cabanne 1971, 67.

74. Schwarz 1969, 140.

75. Tashjian, *Skyscraper Primitives*, 50.

76. Jean, 100.

77. For MD's notes, see MD, *Notes and Projects*, 103–216; for a brief guide to the *Large Glass*, see Calvin Tomkins and the editors of *Life* magazine, *The World of Marcel Duchamp* (New York: Time Inc., 1966), 89–93; for an expanded explanation of the *Large Glass*, see John Golding, *Marcel Duchamp: The Bride Stripped Bare by Her Bachelors, Even* (London: Allen Lane, 1973).

78. Tomkins, *World of Marcel Duchamp*, 93.

79. Masheck, 168.

80. Sigmund Freud, *Jokes and Their Relation to the Unconscious*, ed. and trans. James Strachey (New York: Norton, 1963), 159–80.

81. Cabanne 1971, 39–40.

82. Tomkins, *Bride and the Bachelors*, 7.

83. Golding, *Marcel Duchamp*, 12.

84. Katharine Kuh, *The Artist's Voice: Talks with Seventeen Artists* (New York: Harper & Row, 1962), 81.

85. Schwarz 1969, 80 and 162.

86. Jean Schuster, "Marcel Duchamp vite," *Le Surréalisme, même*, spring 1957, 143–44.

87. Alexander Keneas, "Marcel Duchamp Is Dead at 81; Enigmatic Giant of Modern Art," *NYT*, Oct. 3, 1968, 1.

88. Golding, *Marcel Duchamp*, 11.

89. Breton, *Surrealism and Painting*, trans. Simon Watson Taylor (Boston: MFA Publications ["artWorks"], 2002), 94.

90. Alain Jouffroy, *Une Révolution du regard: à propos de quelques peintres et sculpteurs contemporains* (Paris: Gallimard, 1964), 108.

91. Breton, *Surrealism and Painting*, 99.

92. William. A. Camfield, "The Machinist Style of Francis Picabia," *Art Bulletin*, Sept.–Dec. 1966, 312.

93. Tashjian, *Skyscraper Primitives*, 57.

94. Jack Burnham, "Duchamp's Bride Stripped Bare," *Arts Magazine*, part 1, March 1972, 28–32; part 2, April 1972, 41–45; part 3, May 1972, 58–61.

95. MD, "The Creative Act," Session on the Creative Act, Convention of the American Federation of Arts, Houston, TX, April 1957.

96. Barbara Rose, "Big Art Breakout: The Master of the Game, Duchamp," *Vogue*, Feb. 1974, 126–27, 169.

97. Lebel, 71.

98. Louis A. Sass, *Madness and Modernism: Insanity in the Light of Modern Art, Literature, and Thought* (New York: Basic Books, 1992), 112–13.

99. Sanouillet, *Dada à Paris*, 279.

100. Lebel, 86.

101. Cabanne 1971, 65.

102. Herbert S. Gershman, *The Surrealist Revolution in France* (Ann Arbor: University of Michigan, 1974), 213.

103. André Breton, "To Rrose Sélavy," in *Earthlight,* trans. Bill Zavatsky and Zack Rogow (Los Angeles: Sun & Moon, 1993), 80.

104. Sanouillet, *Dada à Paris,* 533–34.

105. Polizzotti, *Revolution of the Mind,* 183.

106. Jouffroy, *Une Révolution du regard,* 109–11.

107. Ibid., 117.

108. Tomkins, *Bride and the Bachelors,* 24.

109. William Seitz, "What's Happened to Art," *Vogue,* Feb. 15, 1963, 110–13, 129–31.

110. Francis Naumann, *The Art of Making Art in the Age of Mechanical Reproduction* (Ghent: Ludion, 1999).

111. Forge, "Silence of Marcel Duchamp," 775.

CHAPTER 8: CHECKMATE

1. John Russell, *Matisse: Father & Son* (New York: Abrams, 1999), 27–33.

2. Richard A. Brettell, *Modern Art 1851–1929* (New York: Oxford University Press, 1999), 58.

3. Willy Verkauf, ed., *Dada: Monograph of a Movement* (New York: St. Martin's, 1975), 83–84.

4. José Pierre, *Le Futurisme et le Dadaisme* (Lausanne: Éditions Rencontre, 1967), 149–50.

5. C. J. Bulliet, *The Significant Moderns and Their Pictures* (London: Allen & Unwin, 1936), 131–32.

6. Ray, 234–35.

7. Gabrielle Buffet-Picabia, *Aires Abstraites* (Geneva: Pierre Cailler, 1957), 82–86.

8. Schwarz 1969, 59.

9. C. H. O'D. Alexander, *A Book of Chess* (London: Hutchinson, 1973), 52.

10. Harold C. Schonberg, *Grandmasters of Chess* (New York: Lippincott, 1973), 60.

11. Anne d'Harnoncourt and Kynaston McShine, eds., *Marcel Duchamp* (Greenwich, CT: New York Graphic Society, 1973), 131.

12. Alfred Kreymborg, *Troubadour: An Autobiography* (New York: Liveright, 1925), 365–66.

13. Schwarz 1969, 59.

14. Roland Penrose, *Man Ray* (Boston: New York Graphic Society, 1975), 171–73.

15. Robert Coates, "Art News," *New Yorker,* Nov. 11, 1968, 170–72.

16. Lebel, 83.

17. Ray, 234.

18. Alexander Cockburn, *Idle Passion: Chess and the Dance of Death* (New York: Simon & Schuster, 1975), 32.

19. W. R. Hartston and P. C. Wason, *The Psychology of Chess* (London: Batsford, 1983), 123.

20. Edward Lasker, *The Adventure of Chess* (New York: Dover, 1959), 184.

21. Sotheby's London, Dec. 7, 1999, artprice.com.

22. Alexander, *A Book of Chess,* 136.

23. Schwarz 1969, 68.

24. Anne Sunnucks, *The Encyclopedia of Chess* (New York: St. Martin's, 1970), 58–59.

25. Ernest Jones, "The Problem of Paul Morphy: A Contribution to the Psychoanalysis of Chess," *Essays in Applied Psychoanalysis,* vol. 1 (London: Hogarth Press, 1951), 168.

26. Schonberg, *Grandmasters of Chess,* 22.

27. Alexander, *A Book of Chess*, 137.
28. Schonberg, *Grandmasters of Chess*, 23.
29. Carla Gottlieb, *Beyond Modern Art* (New York: Dutton, 1976), 26.
30. B. Krasne, "Profile of Marcel Duchamp," *Art Digest*, Jan. 15, 1952, 24.
31. A. L. Chanin, "Then and Now," *NYT Magazine*, Jan. 22, 1956, 25.
32. Jones, "Problem of Paul Morphy," 191 and 139.
33. Vladimir Nabokov, *The Defense*, trans. Michael Scammel (New York: Putnam's, 1964), 68.
34. Fine, *Psychology of the Chess Player*, 17.
35. MD, *Salt Seller*, 111, 115 and 106–7.
36. John Richardson, *A Life of Picasso*, vol. 2 (New York: Random House, 1996), 305; Mark Polizzotti, *Revolution of the Mind: The Life of André Breton* (New York: Farrar, Straus & Giroux, 1995), 223–24.
37. Anna Balakian, *André Breton: Magus of Surrealism* (New York: Oxford University Press, 1971), 261–62.
38. André Breton, *Conversations: The Autobiography of Surrealism*, trans. Mark Polizzotti (New York: Paragon House, 1993), 76–77.
39. Schwarz 1969, 52.
40. MD, *Salt Seller*, 181–85.
41. See Eleanor Lansing Dulles, *The French Franc 1914–1928: The Facts and Their Interpretation* (New York: Macmillan, 1929). All franc-dollar conversions are based on this book.
42. MD, *Salt Seller*, 185–87.
43. Schwarz 1969, 491.
44. MD, *Salt Seller*, 187–88.
45. Lucie Duchamp obituary, *Journal de Rouen*, Jan. 31, 1925, 5–6; Eugène Duchamp obituary, *Journal de Rouen*, Feb. 5, 1925, 4.
46. Late in his life, Duchamp told an interviewer the amount: Calvin Tomkins, *Duchamp: A Biography* (New York: Holt, 1996), 229.
47. Ray, 236.
48. Sotheby's London, June 28, 1995, artprice.com.
49. Lebel, 50.
50. Jean, 91.
51. Ray, 238.
52. Schonberg, *Grandmasters of Chess*, 65.
53 Schwarz 1969, 491–96.
54. Cabanne 1997, 147.
55. F. B. Hubachek to author, April 13, 1976.
56. Calvin Tomkins, *The Bride and the Bachelors: Five Masters of the Avant-Garde* (New York: Viking, 1968), 53.
57. Ray, 236.
58. Susan Glover Godlewski, "Warm Ashes: The Life and Career of Mary Reynolds," *Museum Studies*, no. 2, 1996, 103–4.
59. Lebel, 79.
60. Cleve Gray, ed., "Marcel Duchamp, 1887–1968: A Symposium," *Art in America*, July 1969, 20–43.
61. Henri-Pierre Roché journals, May 19 and June 9, 1924, Harry Ransom Humanities Research Center, University of Texas, Austin.
62. Tomkins, *Duchamp*, 258–59.
63. MD to Dreier, May 25, 1927 (BL-Yale).
64. MD to Dreier, June 27, 1927 (BL-Yale).

65. Jean, 90.

66. Cabanne 1971, 76.

67. Gough-Cooper and Caumont 1993, unpaged, entries for May 12, May 27, and June 4, 1927.

68. Ray, 237.

69. Dreier to Stieglitz, Aug. 16, 1927 (BL-Yale).

70. Parker Tyler, *Florine Stettheimer: A Life in Art* (New York: Farrar, Straus, 1963), 173.

71. MD to Stieglitz, Jan. 15, 1928 (BL-Yale).

72. MD to Alice Roullier, Feb. 15, 1928 (Newberry Library, Chicago).

73. MD to Dreier, March 12, 1928 (BL-Yale).

74. Cabanne 1971, 76.

75. Ray, 236.

76. Michel Sanouillet, *Dada à Paris* (Paris: Jean Jacques Pauvert, 1965), 279.

77. Schwarz 1969, 491.

78. MD to Dreier, July 2, 1928 (BL-Yale).

79. MD to Dreier, Nov. 5, 1928 (BL-Yale).

80. MD to Dreier, Sept. 11, 1929 (BL-Yale).

81. Sunnucks, *Encyclopedia of Chess*, 331, 262–63, 4–5 and 302.

82. Schwarz 1969, 61–64.

83. François Le Lionnais interviewed by Ralph Rumney, "Marcel Duchamp as a Chess Player and One or Two Related Matters," *Studio International,* Jan.–Feb. 1975, 24.

84. Raymond Keene, "Marcel Duchamp: The Chess Mind," in Anthony Hill, ed., *Duchamp: passim* (n.p.: Gordon & Breach Arts International, 1994), 122–23.

85. Adriaan Dingeman de Groot, *Thought and Choice in Chess* (New York: Pegasus, 1971), 341–42 and 370.

86. Jones, "Problem of Paul Morphy," pass. See also: Fine, *Psychology of the Chess Player,* 31–38; Frances Parkinson Keyes, *The Chess Players* (New York: Farrar, Straus & Cudahy, 1960).

87. Alexander, *A Book of Chess,* 15.

88. Cabanne 1971, 9–10.

89. Alexander, *A Book of Chess,* 12–13.

90. Stefan Zweig, *The Royal Game* (New York: Viking, 1944), 18.

91. Schwarz 1969, 63.

92. Xavier Fourcade, interview by author, New York, March 30, 1976; Schwarz 1997, 721.

93. Schwarz 1969, 63–64.

94. Jean, 229.

95. Ray, 239.

96. Schwarz 1969, 589.

97. Sunnucks, *Encyclopedia of Chess,* 159.

98. Tomkins, *Bride and the Bachelors,* 51.

99. Schonberg, *Grandmasters of Chess,* 23.

100. Zweig, *The Royal Game,* 18–19.

101. Alexander, *A Book of Chess,* 14.

102. MD to Dreier, Oct. 1929 (BL-Yale).

103. MD's remark to Denis de Rougemont, cited in Gough-Cooper and Caumont 1993, unpaged, entry for Aug. 3, 1945.

1. Anaïs Nin, *The Diary of Anaïs Nin*, vol. 2 (Chicago: Swallow, 1957), 56.
2. Julien Levy, *Surrealism* (New York: Black Sun, 1936), 17.
3. Wolfgang Schmied, introduction to *Marcel Duchamp même* (Hanover: Kestner-Gesell-schaft, 1965), 6.
4. Levy, *Surrealism*, 16.
5. Tomkins, *The Bride and the Bachelors: Five Masters of the Avant-Garde* (New York: Viking, 1968) 49–50.
6. Louis Aragon, *Paris Peasant*, trans. Simon Watson Taylor (London: Jonathan Cape, 1971), 87–93.
7. André Breton, *Manifestoes of Surrealism*, trans. Richard Seaver and Helen R. Lane (Ann Arbor: University of Michigan Press, 1972), 26.
8. Levy, *Surrealism*, 89.
9. André Breton, ed., *La Révolution surréaliste*, nos. *1–12 (1924–1929)* (reprint, New York: Arno, 1968), no. 9–10 (Oct. 1927), 11.
10. André Breton, "The Disdainful Confession," in *The Lost Steps*, trans. Mark Polizzotti (Lincoln: University of Nebraska Press, 1996), 4.
11. Michel Sanouillet, *Dada à Paris* (Paris: Jean Jacques Pauvert, 1965), 531.
12. Breton, *Manifestoes of Surrealism*, 17.
13. Werner Haftmann, *Painting in the Twentieth Century: An Analysis of the Artists and Their Works*, vol. 1 (New York: Praeger, 1965), 188–89.
14. Ray, 232.
15. Breton, *La Révolution surréaliste*, no. 3 (April 1925), 1
16. Georges Ribemont-Dessaignes, *Manifestes, Poèmes, Articles, Projets Dada 1915–1930*, ed. Jean-Pierre Begot (Paris: Champ Libre, 1974), unpaged.
17. Aragon, *Paris Peasant*, 89.
18. André Breton, *Manifestoes of Surrealism*, 142.
19. Ibid., 46.
20. Ibid, 125, 133–34, 192–93, and 115.
21. Breton, *La Révolution surréaliste*, no. 1 (Dec. 1924), 2.
22. Balakian, *André Breton: Magus of Surrealism* (New York: Oxford University Press, 1971), 7.
23. Jacqueline Matisse Monnier, interview by author, San Diego, CA, April 24, 2000.
24. Cabanne 1971, 68.
25. Ray, 363–64.
26. Art Institute of Chicago, *Surrealism and Its Affinities: The Mary Reynolds Collection* (Chicago, 1956), 6.
27. Art Institute of Chicago, *Surrealism and Its Affinities*, 2d. ed. (Chicago, 1973), 83–103.
28. Cabanne 1971, 76 and 68.
29. Art Institute of Chicago, *Surrealism and Its Affinities*, 2d. ed., 6.
30. Ibid., 42 and 71.
31. Brochure (1928) in Archives of the Société Anonyme, Sterling Library, Yale University, xiii–xiv.
32. Katherine Dreier, "Art and the Physical Eye," letter to the editor, *NYT*, Nov. 24, 1936.
33. Susan Grace Galassi, "Crusader for Modernism," *Art News*, Sept. 1984, 93; see also: Société Anonyme brochure (1928).
34. Ibid., 95.
35. Clippings from *NYT*, Nov. 3 and 11, 1933 (NYPL).
36. Dreier to Stieglitz, July 30 and Sept. 2, 1926 (BL-Yale).

37. Dreier to Stieglitz, Dec. 16 and 28, 1926 and Jan. 15, 1927 (BL-Yale).

38. Cabanne 1971, 75.

39. Schwarz 1969, 148.

40. Dickran Tashjian, "Henry Adams and Marcel Duchamp: Liminal Views of the Dynamo and the Virgin," speech given at the Whitney Museum of American Art, April 26, 1976.

41. Lawrence D. Steefel, Jr., *The Position of Duchamp's* Glass *in the Development of His Art* (New York: Garland, 1977), 22.

42. Cabanne 1971, 75.

43. Katharine Kuh, *The Artist's Voice: Talks with Seventeen Artists* (New York: Harper & Row, 1962), 83.

44. MD to Arensberg, Feb. 20, 1934 (FBL).

45. MD to Stieglitz, undated, but probably 1934 (BL-Yale).

46. "Lo, Marcel Duchamp Himself Descends the Stair," *NYT*, June 30, 1935.

47. MD to Dreier, Dec. 31, 1934 (BL-Yale).

48. Christie's sale, April 30, 1996; Sotheby's Amsterdam sale Dec. 1, 1997, artprice.com.

49. MD to Dreier, March 5, 1935 (BL-Yale).

50. MD to Dreier, Feb. 19, 1939 (BL-Yale).

51. Ray, 41.

52. Lebel, 53.

53. Rosalind G. Wholden, "Duchamp's Retrospective in Pasadena," *Arts*, Jan. 1964, 16.

54. Anne d'Harnoncourt, "A. E. Gallatin and the Arensbergs: Pioneer Collectors of 20th Century Art," *Apollo*, July 1974, 53; also William Seitz, "What's Happened to Art," *Vogue*, Feb. 15, 1963, 130.

55. Tomkins, *Bride and the Bachelors*, 58.

56. Alphonse Bellier, *Catalogue des tableaux, aquarelles et dessins par Francis Picabia appartenant à M. Marcel Duchamp* (Paris: Hôtel Drouot, 1926), and flyer pasted inside front cover (Reynolds Collection, Ryerson Library, Art Institute of Chicago); see also Malcolm Gee, *Dealers, Critics and Collectors of Modern Painting: Aspects of the Parisian Art Market between 1910 and 1930* (New York: Garland, 1981), 97.

57. MD to Stieglitz, March 30; [wire], May 2; and May 18, 1928 (BL-Yale).

58. MD to Stieglitz, July 2, 1928 (BL-Yale).

59. Eleanor Lansing Dulles, *The French Franc 1914 to 1928* (New York: Macmillan, 1929), 475–480.

60. Harold C. Schonberg, "Creator of 'Nude Descending' Reflects After Half a Century," *NYT*, April 12, 1963, 25.

61. "Brancusi Bronzes Defended by Cubist," *NYT*, Feb. 27, 1927, 14.

62. Gough-Cooper and Caumont 1993, unpaged, entry for Oct. 21, 1926.

63. Pach to Quinn, Oct. 11, 1916; Quinn to Brancusi, May 22, 1921, Quinn-NYPL.

64. Lebel, 53.

65. Arensberg to MD, July 27, 1930 (FBL).

66. Arensberg to MD, May 23, 1930 (FBL).

67. Arensberg cable to MD, March 7, 1932; Arensberg to MD, June 28, 1928, and Oct. 13, 1932 (FBL).

68. MD to Arensberg, Aug. 15 and 18, 1951 (FBL).

69. Katherine Kuh, "Walter Arensberg and Marcel Duchamp," *Saturday Review*, Sept. 5, 1970, 36.

70. Matthew Josephson, "Marcel Duchamp by R. Lebel," *Nation*, Feb. 6, 1960, 123.

71. MD to Dreier, Jan. 5, 1927 (FBL).

72. "Restoring 1,000 Glass Bits in Parcels; Marcel Duchamp, Altho an Iconoclast, Recreates Work," *Literary Digest*, June 20, 1936, 20.

73. MD to Dreier, Oct. 6, 1936 (BL-Yale).

74. MD to Dreier, Dec. 15, 1934 (BL-Yale).

75. Lebel, 84–85.

76. André Breton, *Conversations: The Autobiography of Surrealism*, trans. Mark Polizzotti (New York: Paragon House, 1993), 16.

77. Lebel, 70 ff.

78. MD to Dreier, Aug. 30, 1935 (BL-Yale).

79. MD to Dreier, Jan. 1, 1936 (BL-Yale).

80. MD to McBride, Dec. 7, 1935 (AAA).

81. Jean, 254.

82. MD to Dreier, Sept. 6, 1935 (BL-Yale).

83. MD to Dreier, Dec. 7, 1935 (BL-Yale).

84. Christie's New York, Nov. 2, 1999, $7,500; Farsetti, Prato, May 27, 2000, $7,000, artprice.com.

85. MD to Dreier, Sept. 4, 1936 (BL-Yale).

86. MD to Dreier, Sept. 29, 1936 (BL-Yale).

87. MD to Dreier, April 15, 1936 (BL-Yale).

88. Willy Rotzler, *Objekt-Kunst: von Duchamp bis Kienbolz* (Cologne: M. Du Mont Schauberg, 1972), 89 and 69.

89. William S. Rubin, *Dada, Surrealism and Their Heritage* (New York: Museum of Modern Art, 1968), 212; Mark Polizzotti, *Revolution of the Mind: The Life of André Breton* (New York: Farrar, Straus & Giroux, 1995), 449–52; Ray, 287–88; Jean, 281–82.

90. Breton, *Manifestoes of Surrealism*, 128 and 121.

91. Ray, 240.

92. Jean, 282.

93. Nicolas Calas, *Art in the Age of Risk* (New York: Dutton, 1968), 101.

94. MD to Dreier, March 8, 1938 (BL-Yale).

95. Polizzotti, *Revolution of the Mind*, 464–65.

96. André Breton, *Surrealism and Painting*, trans. Simon Watson Taylor (Boston: MFA Publications ["artWorks"], 2002), 86–87 and 99.

97. MD to Dreier, Sept. 26, 1939 (BL-Yale).

98. Arensberg cable to MD, June 20, 1940 (FBL).

99. Arensberg to MD, May 6, 1940 (FBL).

100. MD to Arensberg, July 16, 1940 (FBL).

101. *Tzanck Check*, Paris Loudmer, March 25, 1990; *L.H.O.O.Q.*, Christie's New York, May 13, 1999, artprice.com.

102. Arensberg to MD, Aug. 22, 1940 (FBL).

103. MD postcard to Arensberg, originally addressed to Mlle. Jeanine Picabia, Sept. 30, 1940 (FBL).

104. Arensberg to MD, Oct. 20, 1940 (FBL).

105. Arensberg to MD, Nov. 19, 1940 (FBL).

106. MD to Alice Roullier, Oct. 26, 1942 (Newberry Library, Chicago).

107. Arensberg to Alfred H. Barr, July 2, 1941 (FBL).

108. Coordinating Council of French Relief Societies, *First Papers of Surrealism*, exh. cat., New York, Oct. 14–Nov. 7, 1942, 16.

109. Sarane Alexandrian, *Surrealist Art* (New York: Praeger, 1969), 160.

110. H.-P. Roché cable to Arensberg, Jan. 31, 1941; also Arensberg to F. B. Hubachek, June 10, 1941 (both in FBL).

111. Alfred H. Barr to Arensberg, July 11, 1941 (FBL).

112. Arensberg to George Biddle, July 24, 1941 (FBL).

113. Arensberg to MD, Aug. 5, 1941 (FBL).

114. Arensberg to Hubachek, Sept. 29, 1941 (FBL).

115. Alfred H. Barr to Arensberg, March 2, 1942 (FBL).

116. U.S. Department of State wire to Arensberg, March 21, 1942 (FBL).

117. Arensberg to Hubachek, April 2, 1942 (FBL).

118. Hubachek to Arensberg, April 15, 1942 (FBL).

119. Dreier to Arensberg, April 25, 1942 (FBL).

120. Arensberg to Robert Allerton Parker, June 1, 1942 (FBL).

121. Gough-Cooper and Caumont 1993, unpaged, entry for June 25, 1942.

CHAPTER 10: BREATHING

1. H. Stuart Hughes, *The Sea Change* (New York: Harper & Row, 1975), 4.

2. Yale University Art Gallery, *Collection of the Société Anonyme: Museum of Modern Art 1920* (New Haven, CT: Associates in the Fine Arts at Yale University, 1950), 15.

3. "Artist Descending to America," *Time*, Sept. 7, 1942, 100–102.

4. Frederick J. Kiesler, "Design-Correlation," *Architectural Record*, May 1937, 53–59.

5. Dreier to MD, July 6, 1937 (BL-Yale).

6. Advertisement for Art of This Century Gallery, *VVV*, no. 2–3, March 1943, 137.

7. Thomas C. Linn, "Grand Central Galleries Finds Taste of U. S. Public for Art Is Conservative," *NYT*, Sept. 13, 1942, section 2, 2.

8. Edward Alden Jewell, "Surrealists Open Display Tonight," *NYT*, Oct. 14, 1942, 26.

9. Edward Alden Jewell, "Inner Vision and Out of Bounds," *NYT*, Oct. 18, 1942, section 8, 9.

10. Jewell, "Surrealists Open Display Tonight."

11. William S. Rubin, *Dada, Surrealism and Their Heritage* (New York: Museum of Modern Art, 1968), 160.

12. Jean, 312.

13. André Breton and Marcel Duchamp, *Le Surréalisme en 1947* (Paris: Pierre à Feu, 1947), 13.

14. Joan Tharrots, "Interview with Marcel Duchamp," *Art Actuel International*, June 1958, 1.

15. Jewell, "Surrealists Open Display Tonight."

16. MD to Dreier, Oct. 15, 1942 (BL-Yale).

17. MD to Dreier, Nov. 4, 1942 (BL-Yale).

18. Yale University Art Gallery, *Collection of Société Anonyme*, xv.

19. MD to Dreier, Feb. 29, 1940 (BL-Yale).

20. Richard Huelsenbeck, *Memoirs of a Dada Drummer*, trans. Joachim Neugroschel, ed. Hans J. Kleinschmidt (New York: Viking. 1974), 82.

21. Katherine Kuh, "Walter Arensberg and Marcel Duchamp," *Saturday Review*, Sept. 5, 1970, 36–37.

22. Yale University Art Gallery, *Collection of Société Anonyme*, xv.

23. MD to George Heard Hamilton, May 27, 1960 (BL-Yale).

24. Calvin Tomkins, *The Bride and the Bachelors: Five Masters of the Avant-Garde* (New York: Viking, 1968), 61.

25. Jeanne Raynal, interview by author, New York City, March 23, 1977.

26. Tomkins, *Bride and the Bachelors*, 61.

27. William Carlos Williams, *Autobiography* (New York: Random House, 1948), 318.

28. Beatrice Wood, "Marcel," in Rudolf Kuenzli and Francis M. Naumann, eds., *Duchamp: Artist of the Century* (Cambridge, MA: MIT Press, 1989).

29. A. L. Chanin, "Then and Now," *NYT Magazine*, Jan. 22, 1956, 22 ff.
30. Huelsenbeck, *Memoirs of a Dada Drummer*, 147.
31. Cabanne 1971, 9.
32. Masheck, 151.
33. Amado Prada, interview by author, New York City, March 28, 1976.
34. Alfonso Ojen, interview by author, New York City, March 28, 1976.
35. MD to Dreier, June 16, 1944 (BL-Yale).
36. Winthrop Sargeant, "Dada's Daddy," *Life*, April 28, 1952, 100–106.
37. David Mann, interview by author, New York City, March 22, 1977.
38. Herbert S. Gershman, *The Surrealist Revolution in France* (Ann Arbor: University of Michigan Press, 1974), 17.
39. Nicolas Calas, *Art in the Age of Risk* (New York: Dutton, 1968), 13.
40. John Willett, ed. and trans., *Brecht on Theater: The Development of an Aesthetic* (New York: Hill & Wang, 1964), 4.
41. MD to Dreier, Feb. 9, 1937 (BL-Yale).
42. "Artist Descending to America," 102.
43. MD's answers to official immigration form, Aug. 21, 1941 (FBL).
44. Untitled clipping, *NYT*, March 20, 1945 (NYPL).
45. Yale University Art Gallery, *Collection of the Société Anonyme*, 148.
46. Tomkins, *Bride and the Bachelors*, 65.
47. Lebel, 70.
48. William Copley, interview by author, New York City, March 30, 1976.
49. Hans Richter, *Hans Richter*, ed. Cleve Gray (New York: Holt, Rinehart and Winston, 1971), 54, 147 and 151; also Jean, 330–32.
50. Schwarz 1997, 773–77.
51. Janet Flanner, *Paris Journal 1965–1971* (New York: Harcourt, Brace, Jovanovich, 1971), 287.
52. Edward Lasker, *The Adventure of Chess* (New York: Dover, 1959), 184–85.
53. Cabanne 1971, 85.
54. Agnes de la Beaumelle, "Note sur une nouvelle acquisition: Allégorie de genre 1943, Marcel Duchamp," *Cahiers du Musée National d'Art Moderne*, June 1987, 180.
55. Alfred H. Barr, Jr., ed., *Fantastic Art, Dada, Surrealism* (New York: Museum of Modern Art, 1936), 113.
56. Cleve Gray, ed., "Marcel Duchamp 1887–1968: A Symposium," *Art in America*, July 1969, 20–43.
57. "Be Shocking," *Time*, Oct. 31, 1949, 42.
58. Hans Belting, "The Fetish of Art in the Twentieth Century," *Diogenes*, fall 1998, 83.
59. Dawn Ades, "Philadelphia and Houston, Cornell & Duchamp," *Burlington Magazine*, March 1999, 196–97.
60. T. H. Robsjohn-Gibbings, *Mona Lisa's Moustache: A Dissection of Modern Art* (New York: Knopf, 1947), 7, 15, 95–96, 118, 167, 145–46 and 189.
61. "Art Was a Dream," *Newsweek*, Nov. 9, 1959, 118–19.
62. MD, *Salt Seller*, 133.
63. Tharrots, "Interview with Marcel Duchamp," 1.
64. Cabanne 1971, 70.
65. Janet Flanner, *Paris Journal 1944–1965* (New York: Harcourt, Brace, Jovanovich, 1965), 586.
66. Ray, 241.
67. Mark Polizzotti, *Revolution of the Mind: The Life of André Breton* (New York: Farrar, Straus & Giroux, 1995), 527–34.

68. William S. Rubin, *Dada, Surrealism and Their Heritage* (New York: Museum of Modern Art, 1968), 216; Sarane Alexandrian, *Surrealist Art* (New York: Praeger, 1969), 190; Breton and Duchamp, *Le Surréalisme en 1947*, 6, 8, 110, 129.

69. Flanner, *Paris Journal*, vol. 1, 79–80.

70. Barbara Rose, *American Art Since 1900* (New York: Praeger, 1975), 147–48 and 163.

71. *Life*, Aug. 8, 1949, 42–44.

72. *Life*, Jan. 15, 1951, 34.

73. Joseph Torch, interview by author, New York City, March 28, 1976.

74. William Copley, interview.

75. Anne d'Harnoncourt and Kynaston McShine, eds., *Marcel Duchamp* (Greenwich, CT: New York Graphic Society, 1973), 191–92.

76. William Copley, interview.

77. Jeanne Raynal, interview.

78. Ecke Bonk, *Marcel Duchamp: The Portable Museum* (London: Thames & Hudson, 1989), 282–83.

79. Jacqueline Matisse Monnier, interview by author, San Diego, CA, April 24, 2000.

80. Calvin Tomkins, *Duchamp: A Biography* (New York: Holt, 1996), 353–59.

81. Joseph Solomon, interview by author, New York City, March 30, 1976.

82. Hubachek to d'Harnoncourt, June 1, 1973 (HA).

83. Dorothy E. Baker, F. B. Hubachek's secretary for thirty-five years, interview by author, Chicago, March 30–31, 1977.

84. Janet Flanner, "The Escape of Mrs. Jeffries," *The New Yorker*, May 22, 1943, 23–28, May 29, 1943, 32–39 and June 5, 1943, 45–57.

85. Tomkins, *Duchamp*, 375.

86. Frank Brookes Hubachek, interview by author, Chicago, March 30–31, 1977.

87. Art Institute of Chicago, *Surrealism and Its Affinities*, 2d. ed. (Chicago, 1973), 5–6.

88. Statement by F. B. Hubachek concerning his acquisition of various works of art by MD and their subsequent disposition by him, draft dated Nov. 22, 1974 (HA).

89. MD to Hubachek, Jan. 23, 1962 (HA).

90. Hubachek to d'Harnoncourt, June 2, 1969 (HA).

91. Hubachek to John Maxon, director of the Chicago Art Institute, Sept. 13, 1965 (HA).

92. Masheck, 74.

93. Hubachek to author, April 13, 1976.

94. Statement by Frank B. Hubachek, Nov. 22, 1974 (HA).

95. Arensberg to MD, June 23, 1942 (FBL).

96. MD to Arensberg, Nov. 11, 1942 (FBL).

97. Arensberg draft letter to MD, May 21, 1943 (FBL).

98. MD to Arensberg, March 5, 1943 (FBL).

99. MD to Arensberg, July 8, 1950 (FBL).

100. Naomi Sawelson-Gorse, "The Art Institute of Chicago and the Arensberg Collection," *Museum Studies*, vol. 19 (1993), no. 1, 81.

101. Mary Roberts and George Roberts, *Triumph on Fairmount: Fiske Kimball and the Philadelphia Museum of Art* (Philadelphia and New York: Lippincott, 1959), 257.

102. William Copley, interview by Moira Roth, New York City, Feb. 22, 1973.

103. Anne d'Harnoncourt, "A. E. Gallatin and the Arensbergs: Pioneer Collectors of 20th Century Art," *Apollo*, July 1974, 53 ff.

104. Arensberg to MD, April 11, 1950 (FBL).

105. Kuh, "Walter Arensberg and Marcel Duchamp," 36.

106. Roberts and Roberts, *Triumph on Fairmount*, 255.

107. Ibid., 258–66; Louise Arensberg to Dreier, April 25, 1945 (BL-Yale).

108. Ibid., 255–60.

109. Kuh, "Walter Arensberg and Marcel Duchamp," 17, 58.

110. Ibid., 36–37.

111. MD to Arensberg, May 8, 1949 (FBL).

112. MD to Arensberg, Aug. 8, 1949 (FBL).

113. Roberts and Roberts, *Triumph on Fairmount*, 274.

114. James Thrall Soby, "Arensberg Collection," *Saturday Review*, Nov. 6, 1954, 60.

115. Walter Arensberg obituary, *NYT*, Jan. 30, 1954, 17.

116. Roberts and Roberts, *Triumph on Fairmount*, 274–75.

117. Sawelson-Gorse, "The Art Institute of Chicago and the Arensberg Collection," 89.

118. MD to Arensberg, May 6, 1952 (FBL).

119. MD to Arensberg, April 19, 1951 (FBL).

120. Soby, "Arensberg Collection," 61.

121. Fiske Kimball, "Cubism and the Arensbergs," *Art News Annual*, Nov. 1954, 118–19.

122. Roberts and Roberts, *Triumph on Fairmount*, 294.

123. MD to Arensberg, Jan. 23, 1954 (FBL).

124. MD to Hamilton, July 5, 1954, Miscellaneous manuscripts (BL-Yale).

125. Cecil Striker, ed., *Medical Portraits* (Cincinnati: Academy of Medicine, 1963), 221–22.

126. John Russell, obituary, "Alexina Duchamp, Dada Artist's Wife and Colleague, 89," *NYT*, Dec. 22, 1995; Calvin Tomkins, "Dada and Mama," *New Yorker*, Jan. 15, 1996, 58.

127. For details of Henri and Pierre's relationship, see John Russell, *Matisse: Father & Son* (New York: Abrams, 1999); see also: Tomkins, "Dada & Mama," 58.

128. Cabanne 1971, 76; also: Jeanne Raynal, interview; Gough-Cooper and Caumont 1993, unpaged, entry for Jan. 16, 1954.

129. Jacqueline Matisse Monnier, interview.

130. Cabanne 1971, 88–89.

131. Jeanne Raynal, interview.

132. Lebel, "Zusammen mit Marcel," in Alfred M. Fischer and Dieter Daniels, eds., *Übrigens sterben immer die anderen* (Cologne: Museum Ludwig, 1988), 272.

133. William Copley, interview by Moira Roth.

134. Arman (Armand Fernandez), interview by Moira Roth, New York City, Feb. 26, 1973 (taped).

135. Deed in Hunterdon County (New Jersey) records, bk. 551, 265, June 28, 1955.

136. Kathryn Slater, interview by author, New York City, March 20, 1977.

137. Pierre Cabanne and Pierre Restany, *L'Avant-garde au XXème siècle* (Paris: André Balland, 1969), 216.

CHAPTER 11: ANTI-FAME

1. From *Guises of Ray Gun*, unpublished notebook, in d'Harnoncourt and McShine, 214.

2. William Seitz, "What's Happened to Art," *Vogue*, Feb. 15, 1963, 113.

3. "Duchamp," *Newsweek*, Oct. 14, 1968, 94.

4. Clement Greenberg, "Counter-Avant-Garde," *Art International*, May 1971, 16.

5. Alfred Neumeyer, *The Search for Meaning in Modern* Art, trans. Ruth Angress (Englewood Cliffs, NJ: Prentice-Hall, 1964), 73.

6. Barbara Rose, *American Art Since 1900* (New York: Praeger, 1975), 216–17.

7. Robert Jensen, "The Avant-Garde and the Trade in Art," *Art Journal*, winter 1988, 366;

A. Deirdre Robson, *Prestige, Profit, and Pleasure: The Marketplace for Modern Art in New York in the 1940s and 1950s* (New York: Garland, 1995), 118–25.

8. Raymonde Moulin, *Le Marché de la peinture en France* (Paris: Éditions du Minuit, 1967), 77.

9. Alain Jouffroy, *Une Révolution du regard: à propos de quelques peintres et sculpteurs contemporains* (Paris: Gallimard, 1964), 107.

10. "Dadadada," *Time*, April 27, 1953, 93.

11. Hans Richter, *Dada: Art and Anti-Art* (London: Thames and Hudson, 1965), 89.

12. Richard Huelsenbeck, *Memoirs of a Dada Drummer*, trans. Joachim Neugroschel, ed. Hans J. Kleinschmidt (New York: Viking. 1974), 84.

13. Dore Ashton, "Marcel Duchamp, bricoleur de génie," *XXe Siècle*, June 1965, 99.

14. Arman (Armand Fernandez), interview by Moira Roth, New York City, Feb. 26, 1973 (taped).

15. Jacqueline Matisse Monnier, interview by author, San Diego, CA, April 24, 2000.

16. Paul Matisse, "The Duchamp Defense," *October*, fall 1979, 22–24.

17. Moulin, *Le Marché de la peinture en France*, 471.

18. Denis de Rougemont, "Interview: Marcel Duchamp," *Gazette Littéraire*, Oct. 5–6, 1968, 32.

19. A. L. Chanin, "Then and Now," *NYT Magazine*, Jan. 22, 1956, 25.

20. Krasne, "Profile of Marcel Duchamp," *Art Digest*, Jan. 15, 1952, 24.

21. Quoted in Schwarz 1969, 114.

22. MD, *Salt Seller*, 137.

23. Joan Tharrots, "Interview with Marcel Duchamp," *Art Actuel International*, June 1958, 1.

24. Jeanne Raynal, interview by author, New York City, March 23, 1977.

25. Rodolfo Abularach, interview by author, New York, March 29, 1976.

26. *The Almost Complete Works of Marcel Duchamp*, exh. cat., Tate Gallery, June 18–July 31, 1966 (London: Arts Council of Great Britain, 1966), 5.

27. Olga Popovich, director of Rouen Musée des Beaux Arts, interview by author, Sept. 22, 1977.

28. Jensen, "Avant-Garde and the Trade in Art," 364.

29. Tomkins, *The Bride and the Bachelors: Five Masters of the Avant-Garde* (New York: Viking, 1968), 24.

30. Amelia Jones, *Postmodernism and the En-gendering of Marcel Duchamp* (New York: Cambridge University Press, 1994), 106.

31. Francis M. Naumann, *Marcel Duchamp: The Art of Making Art in the Age of Mechanical Reproduction* (Ghent: Ludion, 1999), 18.

32. Cabanne 1997, 162, 166, and 176.

33. Tomkins, *Off the Wall* (New York: Penguin, 1980), 170–71.

34. Lebel, 71.

35. Jean-Louis Bédouin, *Vingt ans de surréalisme 1939–1959* (Paris: Denoël, 1961), 271.

36. Michel Carrouges, *Les Machines célibataires* (Paris: Arcanes, 1954).

37. Bédouin, *Vingt Ans de surréalisme*, 274–75.

38. MD, *Salt Seller*, 138–40.

39. Abraham A. Davidson, "Marcel Duchamp: His Final Gambit at the Philadelphia Museum of Art," *Arts Magazine*, Sept.–Oct. 1969, 247.

40. Grace Glueck, "300 Hippies Protest at Opening of Modern Museum Dada Show," *NYT*, March 26, 1968, 38.

41. Gough-Cooper and Caumont 1993, unpaged, June 23, 1966.

42. André Gervais, "Du BYOgraphique," *Les Cahiers du Musée National d'Art Moderne*, summer 1995, 102; Calvin Tomkins, *Duchamp: A Biography* (New York: Holt, 1996), 439–41.

43. John Russell, "Art: Exhibition Marks Duchamp's Centenary," *NYT*, Jan. 16, 1987.

44. Sheldon Nodelman, review of recent books about MD, *Art in America*, Jan. 2000, 39.

45. Lebel, 154 and 176.

46. Schwarz 1969, 372.

47. Schwarz 1997.

48. MD to Hubachek, April 2, 1963 (HA).

49. MD to Hubachek, Oct. 31, 1963 (HA).

50. Eve Babitz, "I Was a Naked Pawn for Art," *Esquire*, Sept, 1991, 164–66.

51. Rosalind G. Wholden, "Duchamp's Retrospective in Pasadena," *Arts*, Jan. 1964, 65.

52. Jean Schuster, "Marcel Duchamp vite," *Le Surréalisme, même*, spring 1957, 143.

53. Helen Wurdemann, "In Pasadena," *Art in America*, 142.

54. "Marcel Duchamp," *New Yorker*, April 6, 1957, 26–27.

55. Harold Schonberg, "Creator of 'Nude Descending' Reflects After Half a Century," *NYT*, April 12, 1963, 25.

56. Lawrence D. Steefel, Jr., *The Position of Duchamp's Glass in the Development of His Art* (New York: Garland, 1977), 7.

57. Robert Goldwater, quoted in Moira Roth's interview with William Copley, New York City, Feb. 22, 1973.

58. Cris Hassold, *The Possibilities of Chance: A Comparative Study of Stéphane Mallarmé and Marcel Duchamp* (Ph.D. diss., Florida State University, 1969), 150–51.

59. "Pop's Dada," *Time*, Feb. 5, 1965, 85.

60. A. Deirdre Robson, *Prestige, Profit, and Pleasure: The Marketplace for Modern Art in New York in the 1940s and 1950s* (New York: Garland, 1995), 251, 255.

61. Francis M. Naumann, "Minneapolis: The Legacy of Marcel Duchamp," *Burlington Magazine*, Feb. 1995, 137.

62. Richter, *Dada: Art and Anti-Art*, 208.

63. Grace Glueck, "Duchamp Opens Display Today of 'Not Seen and/or Has Seen,'" *NYT*, Jan. 14, 1965.

64. Pierre Cabanne and Pierre Restany, *L'Avant-garde au XXème siècle* (Paris: André Balland, 1969), 216.

65. Grace Glueck, "Duchamp Parries Artful Questions," *NYT*, Oct. 25, 1967.

66. Moira Roth and William Roth, "John Cage on Marcel Duchamp," *Art in America*, Nov. 1973, 76.

67. Arturo Schwarz, interview by author, Milan, Nov. 9, 1999.

68. Ibid.

69. Schwarz 1969, 543; Schwarz 1997, 836.

70. artprice.com

71. Francis M. Naumann, "Arturo's Marcel," *Art in America*, Jan. 1998, 36.

72. Schwarz 1997, 832, 836, 838–41, 844, 854–64, 868–69.

73. International Collectors Society, undated flyer, 1967 (NYPL).

74. artprice.com.

75. Cabanne and Restany, *L'Avant-garde au XXème siècle*, 9 and 211.

76. Cleve Gray, "Retrospective for Marcel Duchamp," *Art in America*, Feb. 1965, 103.

77. Leonard Lyons, "The Lyon's Den," *New York Post*, May 19, 1967, 47; Jacqueline Matisse Monnier, interview.

78. Robert M. Coates, "Art News," *New Yorker*, Jan. 30, 1965, 92–95.

79. David Mann, interview by author, New York City, March 22, 1977.

80. artprice.com.

81. Roth and Roth, "John Cage on Marcel Duchamp," 79.

82. Ray, 241–42.

83. MD to Hubachek, Sept. 17, 1963 (HA).

84. Gough-Cooper and Caumont 1993, unpaged, June 10, 1963.

85. Ibid., June 12, 1963.

86. Lebel, 30.

87. John Russell, "Exile at Large," *Sunday Times* (London), June 8, 1968.

88. Alain Jouffroy, "Les Objecteurs," *Quadrum*, XIX, 1965, 8–9.

89. artprice.com.

90. Jeanne Raynal, interview.

91. Olga Popovich, interview.

92. Merce Cunningham, interview by Moira and William Roth, New York, Feb. 2, 1971 (taped).

93. Anne d'Harnoncourt and Kynaston McShine, eds., *Marcel Duchamp* (Greenwich, CT: New York Graphic Society, 1973), 201.

94. Francis Steegmuller, "Paris Celebrates: A New Art Center and the Brothers Duchamp," *Atlantic Monthly*, June 1977, 89.

95. Alain Jouffroy, *Une Révolution du regard: à propos de quelques peintres et sculpteurs contemporains* (Paris: Gallimard, 1964), 118.

96. Gray to MD, June 13, 1965 (AAA).

97. MD to Gray, June 28, 1965 (AAA).

98. William Varley, "Beyond Irony," *Stand*, Feb. 1966, 36, 38.

99. Schwarz 1969, 194–95.

100. Quoted in Molly Nesbit, "Last Words," *Art History* 21, Dec. 1998.

101. F. B. Hubachek to Barbara Burn of Viking Press, June 1, 1971 (HA).

102. MD will, Hall of Records, City of New York.

103. Schwarz 1969, 112.

104. Yale University Art Gallery, *Collection of the Société Anonyme,* 148.

105. "Art Was a Dream," *Newsweek*, Nov. 9, 1959, 118.

106. Leonard Lyons, "The Lyon's Den," *New York Post*, Nov. 3, 1967, 55.

107. Dana Adams Schmidt, "London Show Pleases Duchamp and So Do Museum's Patrons," *NYT,* June 19, 1966.

108. David Thompson, "Then and Now," *Architectural Review*, Sept. 1966, 212.

109. John Russell, "Life in a Peephole," *Sunday Times* (London), Oct. 5, 1969.

110. "Two Duchamp Art Works Get the Brush," *New York Post*, July 26, 1967, 22.

111. Olga Popovich, interview.

112. Roth and Roth, "John Cage on Marcel Duchamp," 76.

113. "Hommage a Caissa" at Cordier and Ekstrom Gallery, New York, Feb. 8–26, 1966.

114. Schwarz 1969, 68.

115. Arman, interview by Moira Roth.

116. Schwarz 1969, 579.

117. Gough-Cooper and Caumont 1993, unpaged, Sept. 9 and 22, 1968.

118. Roland Penrose, *Man Ray* (Boston: New York Graphic Society, 1975), 35–36.

119. Gough-Cooper and Caumont 1993, Oct. 1, 1968.

120. Alexina (Teeny) Duchamp, interview by author, Paris, Oct. 7, 1977.

121. Olga Popovich, interview.

122. Alfred M. Fischer and Dieter Daniels, *Übrigens sterben immer die anderen* (Cologne: Museum Ludwig, 1988), 11.

1. Janet Flanner, *Paris Journal 1965–1971*, vol. 2 (New York: Harcourt, Brace, Jovanovich, 1971), 287.
2. Pierre Restany, "Obituary for Marcel Duchamp," *Domus*, Oct. 1968, 40.
3. "Duchamp and the Rest of Us," *Chicago Daily News*, Oct. 5, 1968.
4. "Marcel Duchamp," *Life*, Oct. 11, 1968, 127.
5. John Canaday, "Iconoclast, Innovator, Prophet," *NYT*, Oct. 3, 1968, 51.
6. Robert M. Coates, "Art News," *The New Yorker*, Nov. 11, 1968, 173.
7. Lawrence D. Steefel, Jr., *The Position of Duchamp's* Glass *in the Development of His Art* (New York: Garland, 1977), 5.
8. In the Archives of the Philadelphia Museum of Art. Published by the museum in 1987 as *Manual of instructions for* Étant Donnés: 1. la chute d'eau, 2. le gaz d'éclairage.
9. Schwarz 1969, 557–62.
10. Bette Krieger, interview by author, New York, Oct. 21, 1977.
11. Anne d'Harnoncourt and Walter Hopps, *Reflections on a New Work by Marcel Duchamp* (Philadelphia: Philadelphia Museum of Art, 1973), 8.
12. Schwarz 1969, 562.
13. MD, *Salt Seller*, 27–28; see d'Harnoncourt and Hopps, *Reflections*, 19.
14. Olga Popovich, interview by author, Sept. 22, 1977.
15. d'Harnoncourt and Hopps, *Reflections*, 3.
16. Original manuscript at Philadelphia Museum of Art.
17. Edward Ball and Robert Kanfo, "The R. Mutt Dossier," *Artforum*, Oct. 1988, 118.
18. Ibid., 119.
19. Alix M. Freedman, "His Heart Belonged to Dada, His Head to Chess," *Wall Street Journal*, Oct. 9, 1987.
20. Mario Naves, "Duchamp and Cornell," *New Criterion*, Jan. 1999, 48–50.
21. Luk Lambrecht, "Marcel Duchamp: Ronny van der Velde," *Flash Art*, Jan. 1992, 171.
22. "Marcel Duchamp: The Art of Making Art in the Age of Mechanical Reproduction," curated by Francis M. Naumann, at Achim Moeller Gallery, New York, Oct. 2, 1999 to Jan. 15, 2000.
23. Achim Moeller, interview by author, New York City, March 16, 2000.
24. Philip Pearlstein, "Censorship on Stylistic Grounds," *Art Journal*, winter 1998, 69.
25. Jacques Barzun, *From Dawn to Decadence: 500 Years of Western Cultural Life* (New York: HarperCollins, 2000), 722.

CHAPTER 1

8: Philadelphia Museum of Art: Marcel Duchamp Archive
Gift of Jacqueline, Peter, and Paul Matisse in memory of their mother, Alexina Duchamp

11: Mark Tansey, *The Enunciation*, 1992
Oil on canvas
Museum of Fine Arts, Boston 1992.251
Ernest Wadsworth Longfellow Fund, the Lorna and Robert M. Rosenberg Fund, and additional funds provided by Bruce A. Beal, Enid L. Beal and Robert L. Beal, Catherine and Paul Buttenwieser, Griswold Draz, Joyce and Edward Linde, Martin Peretz, Mrs. Myron C. Roberts, and Anonymous Donors

CHAPTER 2

16, 17: Philadelphia Museum of Art: Marcel Duchamp Archive
Gift of Jacqueline, Peter, and Paul Matisse in memory of their mother, Alexina Duchamp

19: Photo courtesy of Jacqueline Matisse Monnier

23: Marcel Duchamp, *Hanging Gas Lamp*, 1903–4
Charcoal on paper
Collection of Jacqueline Matisse Monnier

33: Marcel Duchamp, *Suzanne Duchamp Seated in a Red Armchair*, 1902
Watercolor on paper
Private Collection
Photo courtesy of Arturo Schwarz, Milan

36: Jacques Villon, *Portrait of Duchamp*, 1904
Etching and drypoint on paper
Photo courtesy of Bibliothèque Nationale de France, Paris

38: Philadelphia Museum of Art: Marcel Duchamp Archive
Gift of Jacqueline, Peter, and Paul Matisse in memory of their mother, Alexina Duchamp

CHAPTER 3

46: Marcel Duchamp, *Flirt*, 1907
Chinese ink, watercolor, and blue pencil on paper
Private Collection
Photo courtesy of Arturo Schwarz, Milan

54: Marcel Duchamp, *Christmas Eve Menu*, 1907
Drypoint
Musée des Beaux-Arts, Rouen

CHAPTER 4

76: Marcel Duchamp, Study for *Bride Stripped Bare by the Bachelors*, 1912
Pencil and gouache on paper
Musée National d'Art Moderne, Centre Georges Pompidou, Paris
CNAC/MNAM/Dist. Réunion des Musées Nationaux/Art Resource, NY

81: Photo courtesy of Arturo Schwarz, Milan

83: (*top*): Marcel Duchamp, *Coffee Mill*, 1911
Oil on cardboard
Photo courtesy of Arturo Schwarz, Milan

83: (*bottom*): Musée National d'Art Moderne, Centre Georges Pompidou, Paris

90: Edward J. Steichen, *Marcel Duchamp* ,1917
Philadelphia Museum of Art: The Louise and Walter Arensberg Collection

CHAPTER 5

93: J. F. Briswold, *The Rude Descending a Staircase*, New York *Evening Sun*, March 20, 1913
Museum of Modern Art, New York

CHAPTER 6

111: Charles Sheeler, Photograph of the Arensbergs' apartment, New York, c. 1918
Philadelphia Museum of Art: The Louise and Walter Arensberg Collection

118: Florine Stettheimer, *Sunday Afternood in the Country*, 1917
Oil on Canvas
© The Cleveland Museum of Art, 2002
Gift of Ettie Stettheimer

122: Photo courtesy of Arturo Schwarz, Milan

126: (*top*): Marcel Duchamp, *Bicycle Wheel*, 1913
Bicycle wheel and fork mounted on painted stool
Original and first replica lost; 1951 replica, Museum of Modern Art, New York
Photo courtesy of Arturo Schwarz, Milan

126: (*bottom*): Marcel Duchamp, *Bottlerack (Bottle Dryer)*, 1914
Original lost, several replicas
Photo courtesy of Arturo Schwarz, Milan

129: Marcel Duchamp, *With Hidden Noise*, 1916
Ball of twine (around unknown object) between brass plates with screws
Philadelphia Museum of Art: The Louise and Walter Arensberg Collection

133: Marcel Duchamp, *Fountain*, 1917
Porcelain urinal
Original lost, several replicas
Photo courtesy of Arturo Schwarz, Milan

138: Marcel Duchamp, *Adieu à Florine*, 1918
Ink and colored pencil on paper
Photo courtesy of Jacqueline Matisse Monnier

140: Marcel Duchamp, *To be looked at (from the other side of the glass) with one eye, close to, for almost an hour*, 1918
Oil, silver leaf, lead wire, and magnifying lens on glass (cracked), on painted wood base
Museum of Modern Art, New York
Photo courtesy of Arturo Schwarz, Milan

CHAPTER 7

151: Man Ray and Marcel Duchamp, *Dust Breeding*, 1920
Photograph of dust on *The Large Glass*
© Man Ray Trust/ARS/Telimage, Paris, 2002

152: (*top*): Man Ray, *Self-portrait*, 1924
© Man Ray Trust/ARS/Telimage, Paris, 2002

152: (*bottom*): Man Ray, Photograph of Duchamp with *Rotary Glass Plates*, 1920
© Man Ray Trust/ARS/Telimage, Paris, 2002

155: Man Ray, Photograph of Duchamp as Rose Sélavy, c. 1920
© Man Ray Trust/ARS/Telimage, Paris, 2002

157: Marcel Duchamp, *Fresh Widow*, 1920
Museum of Modern Art, New York
Photo courtesy of Arturo Schwarz, Milan

264: Urban Archives, Temple University, Philadelphia, Pennsylvania

268: Philadelphia Museum of Art: Marcel Duchamp Archive
Gift of Jacqueline, Peter, and Paul Matisse in memory of their mother, Alexina Duchamp

270: © Hulton Archives/Getty Images

CHAPTER 11

286: Philadelphia Museum of Art: Marcel Duchamp Archive
Gift of Jacqueline, Peter, and Paul Matisse in memory of their mother, Alexina Duchamp

291: Musée National d'Art Moderne, Centre Georges Pompidou, Paris

293: Philadelphia Museum of Art: Marcel Duchamp Archive
Gift of Jacqueline, Peter, and Paul Matisse in memory of their mother, Alexina Duchamp

CHAPTER 12

303: Richard Baquié, *Sans titre. Étant donnés: 1. La chute d'eau, 2. Le gaz d'éclairage*, 1991
Musée d'art contemporain, Lyon
Photograph by Blaise Adilon

312: Photo courtesy of Jacqueline Matisse Monnier

COLOR INSERT
(all works by Marcel Duchamp, in order of presentation)

Landscape at Blainville, 1902
Oil on canvas
Collection Arturo Schwarz, Milan

Portrait of the Artist's Father, 1910
Oil on canvas
Philadelphia Museum of Art: The Louise and Walter Arensberg Collection

The Bush, 1910
Oil on canvas
Philadelphia Museum of Art: The Louise and Walter Arensberg Collection

Paradise, 1910
Oil on canvas
Philadelphia Museum of Art: The Louise and Walter Arensberg Collection

Sonata, 1911
Oil on canvas
Philadelphia Museum of Art: The Louise and Walter Arensberg Collection

Apropos of Little Sister, 1911
Oil on canvas
Solomon R. Guggenheim Museum, New York
Photograph by David Heald, ©The Solomon R. Guggenheim Foundation, New York

Yvonne and Magdeleine Torn in Tatters, 1911
Oil on canvas
Philadelphia Museum of Art: The Louise and Walter Arensberg Collection

Young Man and Girl in Spring, 1911
Oil on canvas
Collection Arturo Schwarz, Milan

Dulcinea, 1911
Oil on canvas
Philadelphia Museum of Art: The Louise and Walter Arensberg Collection

Sad Young Man on a Train, 1911
Oil on canvas
Solomon R. Guggenheim Foundation, New York, Peggy Guggenheim Collection, Venice, 1976
Photograph by David Heald, ©The Solomon R. Guggenheim Foundation, New York

Nude Descending a Staircase, no. 2, 1912
Oil on canvas
Philadelphia Museum of Art: The Louise and Walter Arensberg Collection

The King and Queen Surrounded by Swift Nudes, 1912
Oil on canvas
Philadelphia Museum of Art: The Louise and Walter Arensberg Collection

The Bride, 1912
Oil on canvas
Museum of Modern Art, New York
Photo courtesy of Arturo Schwarz, Milan

Network of Stoppages, 1914
Oil on canvas
Museum of Modern Art, New York
Photo courtesy of Arturo Schwarz, Milan

Nine Malic Molds, 1914
Oil, lead wire, and sheet lead on glass (cracked 1915), mounted between two glass plates
Private Collection
Photo courtesy of Arturo Schwarz, Milan

Chocolate Grinder, no. 2, 1914
Oil, graphite, and thread on canvas
Philadelphia Museum of Art: The Louise and Walter Arensberg Collection

Apolinère Enameled, 1916
Graphite on cardboard and painted tin
Philadelphia Museum of Art: The Louise and Walter Arensberg Collection

Tu m', 1918
Oil on canvas with bottle brush, three safety pins, and one bolt
Yale University Art Gallery: Gift from the estate of Katherine S. Dreier

L.H.O.O.Q., 1919
Paper-over-board reproduction of Leonardo da Vinci's *Mona Lisa*, with pencil
Philadelphia Museum of Art: The Louise and Walter Arensberg Collection

The Bride Stripped Bare by Her Bachelors, Even, 1915–23
Oil, varnish, lead foil, wire, and dust on two glass panels (cracked), mounted in wood and steel frame
Philadelphia Museum of Art: The Louise and Walter Arensberg Collection

Box in a Valise, 1940
Miniature replicas of works by Duchamp, in cloth-covered cardboard box, leather valise
Musée National d'Art Moderne, Centre Georges Pompidou, Paris
CNAC/MNAM/Dist. Réunion des Musées Nationaux/Art Resource, NY

Genre Allegory (George Washington), 1943
Gauze with iodine, mounted on cardboard with thirteen stars on nails
Musée National d'Art Moderne, Centre Georges Pompidou, Paris
CNAC/MNAM/Dist. Réunion des Musées Nationaux/Art Resource, NY

Given: 1. the waterfall, 2. the illuminating gas, 1946–66
Mixed media assemblage (includes oak door, bricks, velvet, pigskin over metal frame, human hair, gas
lamp, twigs, glass, iron, and electric motor)
Philadelphia Museum of Art: Gift of the Casandra Foundation